PEOPLE IN
VOGUE

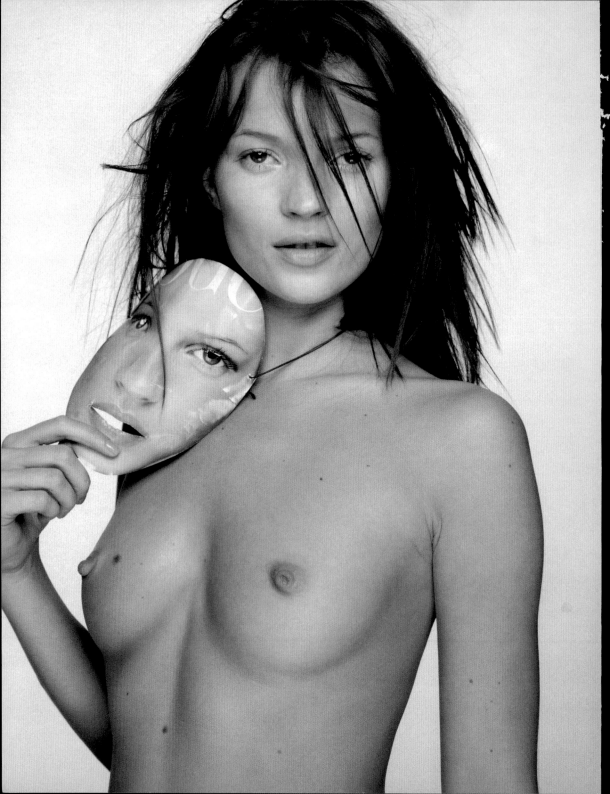

PEOPLE IN
VOGUE
A CENTURY OF PORTRAITS

EDITED BY ROBIN DERRICK AND ROBIN MUIR

LITTLE, BROWN

First published in Great Britain in 2003 by Little, Brown
This paperback edition published in October 2005 by Little, Brown

Designed by Robin Derrick with Stephen Jenkins in Line and Gill Sans.

A CIP catalogue for this book is available from the British Library.

ISBN 0 316 73114 5

Colour origination by Radstock Reproductions.
Printed and bound in China by C&C Offset Printing Co., Ltd.

Little, Brown
An imprint of Time Warner Book Group UK
Brettenham House
Lancaster Place
London WC2E 7EN

www.twbg.co.uk

The following photographs are © The Condé Nast Publications Ltd:
Pages 10–19, 21–22, 24–26, 30–44, 46–55, 58–68, 72–78, 80–83, 86–87, 90–91, 94–100, 104,
106–131, 134–149, 151–208, 210–213, 215–217, 228–230, 232–233, 247, 249, 257, 266–270,
278–281, 288–291, 294–297, 300–301, 304–305, 309–311, 316–17, 322–324, 329–330,
337–339 and 346.

Page 20 © 1924 The Condé Nast Publications Inc.
Pages 23 and 27 © 1925 The Condé Nast Publications Inc.
Pages 28–29 © 1926 The Condé Nast Publications Inc./Courtesy of *Vanity Fair.*
Page 45 © 1929 The Condé Nast Publications Inc.
Pages 56–57 © 1932 The Condé Nast Publications Inc.
Page 70 © 1938 The Condé Nast Publications Inc.
Page 71 © 1936 The Condé Nast Publications Inc.

Pages 39, 79, 84, 85, 88, 89 and 92–93, courtesy of the Lee Miller Archive.

Page 13, courtesy of Flora Biddle Miller, New York.

Page 15, courtesy of the National Portrait Gallery, London.

Pages 32–35, 42, 52, 65, 67, 73, courtesy of The Cecil Beaton Archive/Sotheby's London.

Page 50, courtesy of Hamiltons Gallery, London.

Pages 101–103, 105 and 132–3 by Irving Penn © 1948 (renewed 1976) The Condé Nast
Publications Inc., © 1949 (renewed 1977); The Condé Nast Publications Inc., © 1947 (renewed
1975) The Condé Nast Publications Inc., © 1958 The Condé Nast Publications Ltd.

Pages 133 and 209, courtesy of Norman Parkinson Ltd/Fiona Cowan.

Page 150, courtesy of the Terence Donovan Archive.

Page 223, courtesy of Desmond O'Neill Features.

Page 345, courtesy of David Bailey/Camera Eye Ltd.

Frontispiece
KATE MOSS, 1999, BY NICK KNIGHT

Inside front cover
AUDREY HEPBURN, c.1955, BY NORMAN PARKINSON

Inside back cover
JEAN SHRIMPTON, 1964, BY CECIL BEATON

PEOPLE IN
VOGUE

CONTENTS

FOREWORD by ALEXANDRA SHULMAN

As I looked through the 247 portraits in this collection, my prevailing impression was the startling familiarity of so many. *Unseen Vogue*, Robin Derrick's and Robin Muir's previous anthology, was a compilation and explanation of the unfamiliar; *People in Vogue*, conversely, demonstrates how – to use an overworked adjective – iconic many of the images from *Vogue* have become.

From the Beck and MacGregor portrait of Virginia Woolf in profile to the shot of photographer Lee Miller soaping herself in Hitler's bathroom and on to a 1978 velvet-jacketed pretty boy Martin Amis, so many of these images have become a first-stop mental reference point when we scan for a picture of a certain person.

In 1916, when *Vogue* was launched in this country, there were still relatively few outlets for portrait photography, even though it was fast gaining currency as the preferred medium for celebrity portraiture – as it has remained. Images of all sorts were much scarcer than today, and thus those that existed were more likely to become definitive. The canon of celebrity too was narrower – socialites, actresses, fashion designers and writers make up the majority of the first decade of *Vogue* portraiture. The day of the famous fashion model, photographer, sportsman, rock star, film star and person famous simply for being famous – and therefore constantly photographed – was yet to come. The 'It Girls' of the Twenties were, of course, the first of their kind, and the term was coined to describe fun-loving, pretty, high-profile social animals – those original Tara Palmer-Tomkinsons. But although they existed, they had no place in *Vogue* of their day.

And the matter of where a portrait is seen is crucial: a photograph that hangs in the National Portrait Gallery gains a credibility and validity that the same picture hanging in a front hall will rarely attain. A portrait published in *Vogue* has a different resonance from a portrait published in *The Daily Telegraph*. Environment contributes hugely to the way we regard the subject. A *Vogue* portrait anoints the subject with a fashionability and style. The former decrees them absolutely of the moment, the latter imbues them with something more lasting. The Peter Rand 1963 portrait 'The Impact Makers' is a good illustration. Here we have four artists, David Hockney, Ian Stephenson, Howard Hodgkin and John Howlin pictured with their work. In fashion terms they run the gamut of Sixties style, from Hodgkin in the sharp blokeish suit, Stephenson in velvet jacket, jeans and suede shoes, to Hockney already stunningly blond with his trademark shot of colour – a vivid pink tie – and thick black-rimmed glasses. Their poses and their personal style are

every bit as telling in this image – possibly more so – than the work with which they feature.

Forty years on, Hockney and Hodgkin are two of this country's leading artists, while the names of Stephenson and Howlin have in comparison lost the potency that they had at the time. But when you look at the picture, the group which *Vogue* decreed as 'Impact Makers', you look at the four artists with equal curiosity and interest.

This picture also illustrates another prominent feature of *Vogue* portraiture – the styling. It is significant that most of the portraits in this book have involved considerable preparation; they are the result of a team effort. Unlike a reportage photographer, who goes hunting solo, the *Vogue* photographer is usually working with a number of people to create a predestined picture, their efforts combining to realise a preconception about the subject to be conveyed.

Once the decision has been taken by *Vogue* to photograph a certain person, a photographer is assigned. What kind of photographer should it be? Since 1992, when I became editor of *Vogue*, we have used the talents of a large range of photographers – indeed every decade appears to have delivered an ever-growing roll call. In the Thirties, I would most probably have asked Beaton to photograph almost everybody who was anybody. In the Sixties, Bailey was one of the most prolific and brilliant portrait photographers of his era. Through the Nineties and since, Mario Testino, Nick Knight, Juergen Teller and Julian Broad have featured prominently; but we still have Bailey and also Snowdon, both of whom have been creating memorable photographs for *Vogue* for over 40 years.

The choice of photographer substantially determines the way that the subject will be portrayed. Are they to be the larger-than-life, powerful Bailey persona – epitomised by his famous black-and-white picture of Mick Jagger, all lips and leer? Or would it instead be interesting to see them bathed in the positive glow of Testino – Gwyneth Paltrow, for example, dissolving in laughter, sporting a child's Indian-chief feather headdress? Once that decision has been made – at which point, of course, one is already creating a person rather than simply recording them – there enter the questions of location, clothing, grooming and more.

Most of my favourite images include props of some sort – whether they are shot in the studio or outside. These pictures include some detail, possibly several, that give us additional information about the subject. Further collaborators are thus involved. Be they researchers, editors, art directors or stylists, all of

them participate in the realisation of that initial idea. They may have struck on a location which will highlight an intriguing aspect of the subject's personality, they may well have supplemented the sitter's own wardrobe with clothes and other accessories, or they may be on site during the shoot, scouring the scene with magpie eyes for that telling detail which, incorporated in the image, will make all the difference.

Take the Snowdon portrait of Bruce Chatwin – a strong close-cropped black-and-white image of this strikingly beautiful man, with hulking walking boots slung around his neck. It conveys instantly the wanderlust that drove this aesthete and writer. Who placed those emphatically worn boots in the centre of the picture? Or take the later portrait of fashion designer Marc Jacobs by Terry Richardson, standing insolently against the elegant panelling of his Parisian apartment. Draped in a black fur thrown over his T-shirt, striped underpants conspicuously billowing from his low-slung trousers and wielding a bottle of Jack Daniels, he appears the embodiment of stylish debauchery. The fur, the alcohol, the smart interior detailing, certainly the boxer shorts – each of these ingredients was a decision, and a decision that could have been made by one of any number of people, including the subject.

And it is those details, which I believe so often define the best of *Vogue* portraits, that we see here and which create the iconic status I mentioned earlier. They root the person in a time and they are signposts to their personality and achievement. The 1991 Patrick Demarchelier portrait of the late Diana, Princess of Wales, is one of the most famous instances of a *Vogue* portrait's changing the perception of a person. With the publication of this image on the cover of the magazine, the Princess changed in the world's collective mind from a young, Sloaney member of a traditional royal family into the 'People's Princess'. She gazed frankly out at us from the newsstand, plainly attired in the levelling garb of a black poloneck, no jewellery, and with a carefree hairstyle that could have been achieved straight from the shower. She was instantly accessible, but also beautiful – the perfect version of that girl next door we could all be, if only…

Over the span of nearly 90 years, *People in Vogue* demonstrates, through images such as this, that style need not triumph over content, nor vice versa. In contrast it shows with conviction that the two are natural bedfellows and that when, with a little help from *Vogue*, they merge successfully, the resulting image will be one of exceptional power and longevity.

Alexandra Shulman is editor of British Vogue

THE GLITTERING POSES by ROBIN DERRICK

The photographs in this book are portraits taken for *Vogue* and, since *Vogue* is the most fashionable of magazines, its subjects were required to be – literally – 'in vogue'. All portraits are 'of their time'; perhaps *Vogue* portraits are more so. In the twinkling firmament, *Vogue* catches a star at the moment when he or she shines most brightly and it celebrates them for exactly that. Perhaps this is why, read with hindsight, the original captions often seem so facile. But 'hindsight' and 'distance' are perhaps the preserve of collections like this…

For a 1992 *Vogue* portrait, in a sunny French garden, the singer Michael Hutchence adopts a 'crucified' stance as his girlfriend the model Helena Christensen joyfully shoots him with a giant water pistol (pages 264–5). Max Vadukul photographed them the year before I joined the magazine. Then, I lived in the same street in Paris as they did, and when they ate at the local pizzeria, as they often did, it was the talk of my office the following day. The neighbourhood was proud of this gilded couple, and seeing these pictures in *Vogue* confirmed our view. A year or two later, I met them at a *Vogue* dinner in Milan. I had never seen a man so much in love as Michael was with Helena. He kept telling me how many languages she spoke and how amazing she was. I next met Michael when he came to pick up Helena from a photographic studio. They were about to take Concorde to New York. He paced nervously up and down outside the closed set like an expectant father, still eulogising his lover. Nick Knight was photographing Helena naked, and the set was closed – more to spare the photographer's blushes than to protect Helena, who, in the way that only the beautiful can be, was nonchalant about revealing her body. They left together, giving us all kisses and waves, every inch the couple *Vogue* had previously photographed.

By 1995, Helena had publicly separated from Michael and he was, even more publicly, in a new relationship with TV presenter Paula Yates. It was a relationship that had made the evening news when they were photographed leaving a hotel together. Michael Hutchence was present when Steve Hiett took Paula's portrait for *Vogue* that year (pages 288–9). It was taken in bright sunshine in the same French garden as the Max Vadukul shoot. I had not asked the photographer to shoot in black and white and I disliked the heavy *chiaroscuro* of the pictures when I saw them at the magazine's offices, thinking them too brooding. But looking back, I can't help seeing a portent in the sombre mood of this picture. In 1997, Michael died in a hotel room in

Sydney; Paula Yates died from an overdose of heroin at her London home in 2000.

To celebrate the new Millennium for the December 2000 issue of *Vogue*, I persuaded the editor to use a silver mirror finish on the front and back covers of the magazine, looking back to the past and forward to the future. The up-beat and optimistic theme of the issue included a series of pictures by Mario Testino of a fictitious New Year party. In a line-up that included artists, pop stars, politicians, establishment figures and bright new talent (pages 326–7), the exuberant and beautiful Helena Christensen sits with her partner, rising actor Norman Reedus, at her knee. They both look relaxed and happy. Helena gave birth to their first child, Mingus, a month after this picture was taken.

Unlike supermodels, rock stars and celebrities, most people are photographed infrequently – they may be snapped at weddings, for passports, on holiday. More formally, perhaps, there is the portrait taken on graduation or to mark some other achievement or ceremony. A *Vogue* portrait is not any of these; the pictures here are not snaps, and the subjects are not sitting for an official portrait to mark a significant accomplishment. On the contrary, these are people having their moment in *Vogue*. They are being photographed at the moment the magazine deems them interesting. Their comet has come into view and is heading this way…

Christian Dior was photographed on February 12, 1947, the day of the presentation of his first collection – a collection that was not only to define Dior as one of the most important designers of the century, but one which has itself become one of fashion's defining moments (pages 94–5). All this lay ahead, however, and on that day the couturier looked tired and dour. Cheer up C D. It's going to be fine, at least for a while. Ten years later, *Vogue* photographed the moody, 21-year-old Yves Saint Laurent, who had just taken over as chief designer at Dior (pages 132–3).

Back in 1947, an equally diffident Marlon Brando, about to appear in *A Streetcar Named Desire*, came to Cecil Beaton's studio (page 97). The young actor is certainly laid back about his future. Perhaps a look of ambivalence is a good one to adopt when you're on the brink of fabulousness – like the fixed grins of actors while the winners are read out at the Oscars.

The fame of the sitter and our often intimate

knowledge of subsequent events inform us when we look at these images. Viewing in retrospect the portraits of those taken at their shining moment, it's hard not to look for hints and clues to what we know will happen. It is because these pictures are of personal peaks in the subjects' lives that they are all the more telling; these are not even-handed, objective records of humankind taken throughout the last century, and were never intended to be. That picture of a person taken when he or she was on a high makes any subsequent fall seem greater. While some of the subjects here are clearly pleased with themselves, we should acknowledge that what may have been simple *joie de vivre* can so easily be misinterpreted now as pride before a fall. The Dolly Sisters, for example, photographed in 1921, had already conquered Broadway, had London at their feet and Paris ahead of them (page 18), which explains their bright goose-stepping attitude. It is, of course, unreasonable to expect that because both twins found unhappiness in later life and attempted suicide – one of them successfully – they should have toned it down a bit in 1921.

In 1938, after her movie *Algiers*, Hedy Lamarr was photographed tugging at her hair and looking rather quizzical (pages 70–1). Does this picture anticipate in any way her starring role with Victor Mature in *Samson and Delilah*, or indeed her other role, developing the 'spread-spectrum' technology that has been used in weapons-guidance and mobile-phone systems? Or presage her arrest for shoplifting in 1991? Surely not. But this new information adds a dimension to the image that did not originally exist.

With their reliance on big pictures and short texts, magazines are the natural home of the picture caption. To the extent that a fashion picture is only a picture of a girl in a dress if it is not accompanied by a caption identifying its designer and stating the outfit's cost, a portrait of an unknown face without a caption is just a picture of a face. This book makes many references to the original copy that ran with the pictures, which often bears no relation to the text that would accompany the picture if it were published today. Captions are edited as thoroughly as if the *Vogue* staff were in the personnel department of the Kremlin. The politician Peter Mandelson, for example, was photographed in his chic London home by Snowdon (page 308). *Vogue* was sworn to secrecy over its location. Not long after publication, the address of the house had become public knowledge – as had the fact that it had been partially paid for with undisclosed funds. Often republished, this photograph is invariably

accompanied by text repeating this information.

Similarly, the contemporary caption for the picture of dinner-jacketed Claus von Bülow and his glittering wife Sunny, photographed at a party in their Belgravia home in 1968 by Patrick Lichfield, spoke of the blue-and-white trellis-work on the balconies, and the glamorous guests (pages 184–5). Any commentator on this image today would surely add that Claus was charged with Sunny's attempted murder in 1980 and that he divorced her while she was – as she remains – in a coma.

Pictures are not static; they can acquire new meanings and depth. In the late Sixties, Roman Polanski and Sharon Tate were photographed nude by David Bailey. This beautiful couple captured the *Zeitgeist* of the Sixties. The print, reproduced on page 191, is the one that Bailey used in the book *Goodbye Baby and Amen*, his 'Who's Who' of the Sixties. David Bailey's portrait reinforced the couple's position at the epicentre of cool. Sharon Tate's murder in Hollywood by members of Charles Manson's 'family' in the same year that this picture was published makes it a poignant study; one which intertwines this couple's story, and this image with a sense of disillusionment with the values of the era. Their very real, very personal tragedy is held in the picture and it has become symbolic of a bigger loss.

Photographs of couples in *Vogue* are often the most moving because the personal problems in a celebrity's life are often the most accessible part of their lifestyle – the aspect to which we can most easily relate. John Lennon and Yoko Ono, Mick and Bianca Jagger, Bryan Ferry and Jerry Hall, Kate Moss and Mario Sorrenti, Anjelica Huston and Jack Nicholson, Calvin and Kelly Klein, Johnny Depp and Winona Ryder, The Prince and Princess of Wales; all have sat for *Vogue* and all are included in this book.

A celebrity cannot exist in modern times without the images to 'celebrate' them. Pictures such as *Vogue* portraits make little sense, and are not commissioned, unless the person in them *is* a celebrity. A chicken-and-egg situation has developed. Someone somewhere has to be the person who publishes the first picture of that seemingly contradictory entity – the 'unknown celebrity'. In the end, the famous are a just a group of over-achievers whom somehow we have got to know, whose ups and downs we share; and, like popular music, their lives seem to capture a moment in our own lives and mirror our own experiences.
Robin Derrick is the creative director of British Vogue

INTO THE 1920s

HOW ONE LIVES FROM DAY TO DAY

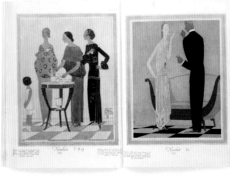

When British *Vogue* was born in 1916, readers were left in little doubt that something of grave significance was going on overseas. While the fields of Flanders were churned into mud, zeppelins threatened the skies over London and submarines menaced the merchant marine, at home *Vogue* noted that potatoes had all but disappeared. 'Let us all become "Potatriots"', it exhorted readers, featuring an unheard-of outfit, the gardening costume. Things 'suspended for the duration' by the Great War were never resumed. A new England was taking shape. Victory brought war debt, unemployment and disillusion; and a new 'Americanisation'.

British *Vogue* had been launched because the threat to transatlantic shipping meant that American *Vogue* was no longer available. Before the War, Americans had been in thrall to British taste; in the Twenties, British readers could not get enough of America, its cars, its fabulous Rockefeller and Vanderbilt wealth, its lavish lifestyle. England still had class but America had style, glamour and showmanship.

It was not *Vogue*'s purpose to debate sensitive or contentious issues, but it found ways to alert the vigilant reader to her changing role. Viscountess Astor had become the first woman to take her seat in the House of Commons in 1919. The same year saw women admitted to universities, the Bar and other professions. The emancipation of women found its way into the magazine's copy: 'Beauty Will Have its Say. Beauty will Cast Her Vote.' Readers were also made aware of the great cultural moments of the era. Picasso, Cocteau, futurism, Sonia Delaunay and the Ballets Russes were introduced to readers before 1920, so too Modigliani, Chanel, Rodin and Lady Elizabeth Bowes-Lyon. Actresses and society mavens wore the latest in 'barbarian' design – Oriental evening dresses by Leon

Bakst, worn with a turban, and tea dresses in *le style japonais* influenced by the Russian Ballet. Fur was ubiquitous: 'Some of one's friends are hardly recognisable with a litter of young leopards and tiger cubs draped over their shoulders,' observed *Vogue*. 'Bond Street has the air of a primeval jungle.' Another commentator, leafing through *Vogue*, ventured: 'Every third socialite became a photographer, opened a dress shop, wrote poetry or painted.'

If the magazine did not resign itself to the universal cry of 'no food, no frocks, no fun', it attempted restraint. 'We are not ashamed to admit that we cannot afford things,' it soothed readers, 'be they oysters or yachts.'

And then, in the mid-Twenties, the fun began. *Vogue* noted an abundance of lamé pyjamas, cigarette holders, shingled hair. Exiled princes walked the promenades of Deauville and the Riviera, Maharajahs joined English aristocrats on Norfolk shoots, Elephant-borne English aristocrats joined Maharajahs on tiger hunts. The fashionable wintered in St Moritz, guests of displaced monarchs. Before the Sixties made it *de rigueur*, titled sons and daughters mixed with self-made celebrities.

Cecil Beaton, who took his first pictures for *Vogue* in 1924, became its first star photographer. His documenting of *fêtes champêtres*, fancy-dress balls and masquerades, gave *Vogue*'s society column 'How One Lives From Day to Day' its insider knowledge. Other contributors were Evelyn Waugh, Aldous Huxley, the Sitwells and Virginia Woolf. And then, in 1929, as Patou's hemlines plummeted, so did the world's stockmarkets.

British *Vogue* had a strong constitution and it survived the vagaries of its infant years with style. 'We're getting ever a surer grip on the situation,' it reassured readers, 'a surer insight into the changing times.'

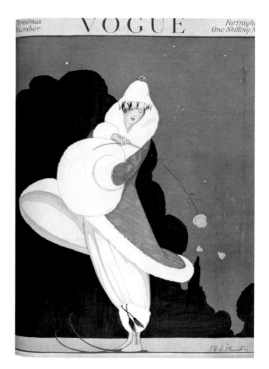

Vogue's first Christmas cover (*opposite*) contrasts vividly with the graphic style of the decade. Of two 1929 examples of the art-deco tableaux which put *Vogue* in the vanguard of style, the still life (*above*), indicating an issue devoted to beauty, is unattributed; but the herald to a summer of sunlight and fun (*right*) could only be Benito's – it remains one of *Vogue*'s best-known graphic images. *Vogue* published its first colour spread (*opposite above*), also by Benito, in 1923. Slowly, photography gained supremacy, but occasionally it combined harmoniously with illustration (*below*). Hoyningen-Huene's 1929 sunlit picture of beachwear (*above right*) was a remarkable technical accomplishment – it was shot indoors in *Vogue*'s Paris studio.

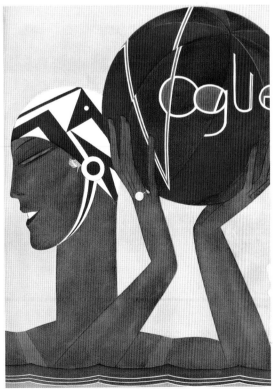

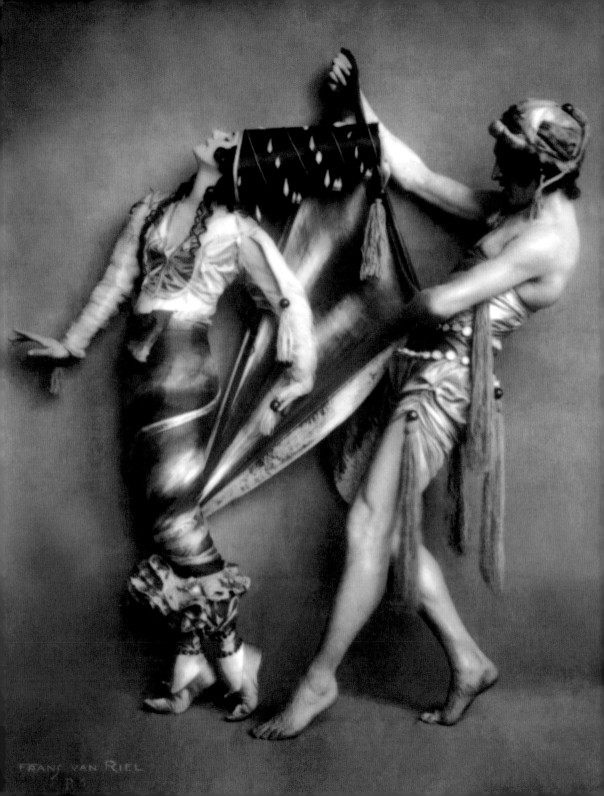

FRANS VAN RIEL

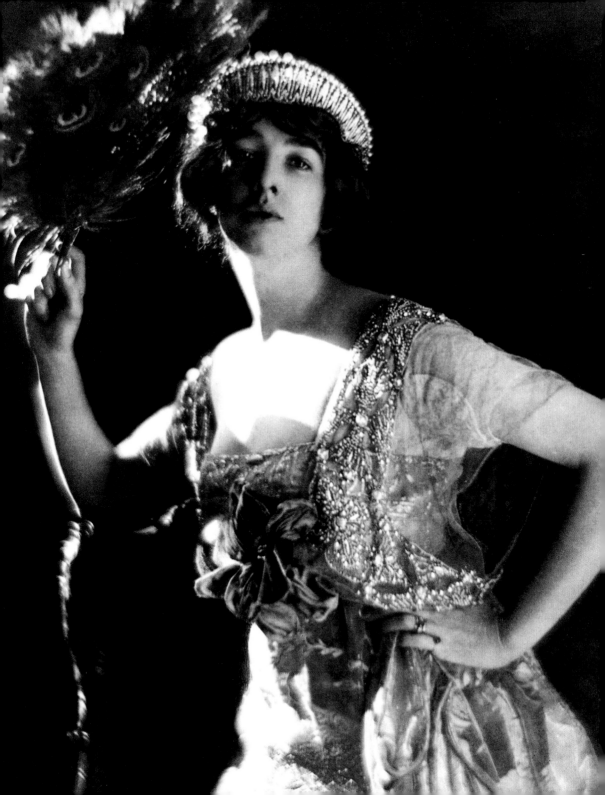

previous pages, left
ANNA PAVLOVA, 1918
BY FRANS VAN RIEL
For this tableau taken in Buenos Aires, the great prima ballerina performs a 'Syrian dance' with Hubert Stowetts. Adept at character parts, such as Giselle (which she first performed in 1903), she excelled as a nymph, wood sprite, bird or dragonfly and, most famously of all, as a dying swan in a solo choreographed for her in 1907 by Michel Fokine. Her last words, in 1931, when she herself lay dying, were reported to be, 'Get my swan costume ready'; and then, 'Play that last measure softly…' She was no stranger to the pages of *Vogue*, though on one occasion the magazine's photographer, trying everything to make her pose for a full-length shot, was rewarded only with 'No. Feets are so tired today and they do not look so well.' Nevertheless, *Vogue* applauded her 'flawless technique and imaginative fire', her 'charming naiveté' and her 'English, which is indeed inimitable'.

previous pages, right
MRS HARRY PAYNE WHITNEY, 1917
BY BARON DE MEYER
Mrs Whitney was born Gertrude Vanderbilt into one of America's richest families – its fortune estimated at $400 million at the turn of the century. Legend has it that she founded the New York museum that today bears her name when the Metropolitan Museum of Art spurned her collection. *Vogue* noted that, apart from her philanthropy, she was herself gifted as a painter and sculptor – qualities unfashionable in someone of her social standing in the years before the First World War. Her work was, as one critic has put it, 'defiantly anti-modernist'. The museum grew out of her own Greenwich Village artist's studio in 1931 to become, in time and in a different location, a Manhattan institution. Though she was a determined bohemian, she was constrained by the conventions of her class. Thus, although she rarely stepped outside without a hat, these became increasingly flamboyant. De Meyer's portrait reveals that she possessed enormous style from an early age.

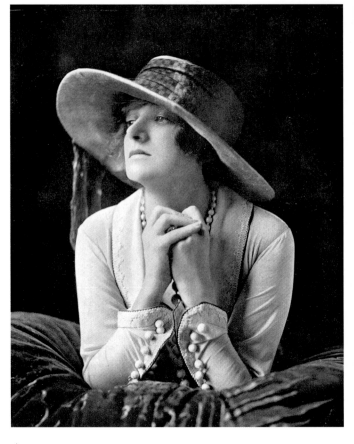

above
GLADYS COOPER, 1918
PHOTOGRAPHER UNKNOWN
Apart from her success in plays and musicals, Miss Cooper was an enterprising businesswoman. In 1917, she took over the management of the Playhouse, becoming the first female actor/manager to run a West End theatre. She was particularly admired for her interpretations of Pinero and Somerset Maugham's leading roles. *Vogue* considered her a great beauty, and she appeared regularly in the magazine for over five decades, often modelling the frocks of Captain Molyneux. Here, however, in her first *Vogue* appearance, she is dressed by Reville.

opposite
BASIL RATHBONE AND CONSTANCE COLLIER, 1919
BY HOWARD INSTEAD
This variant of a published double portrait marked Rathbone and Collier's joint success in the play *Peter Ibbetson*. A South African by birth, Philip St John Basil Rathbone eventually became famous as the quintessential Englishman, Sherlock Holmes. By the time of this picture, he had had a colourful career as an intelligence officer in the First World War, disguising himself as a tree to get nearer to the enemy. This earned him a Military Cross. He had also had a less colourful occupation as an insurance clerk. His theatre career led to fame in Hollywood and he distinguished himself in the Thirties as a villain in costume dramas, such as *The Adventures of Robin Hood* (1938) and *The Mask of Zorro* (1939). Constance Collier was born into a theatrical family and made her stage debut in 1881, aged three, as a fairy in *A Midsummer Night's Dream*. Her association with impresario Sir Herbert Beerbohm Tree led in 1906 to great success in *Antony and Cleopatra*, in which Tree played Antony. She formed a close friendship with Ivor Novello, with whom she collaborated in his first play *The Rat* (1924). In later life, Collier settled in Hollywood, alternating film roles with voice coaching. One of her students was the young Marilyn Monroe of whom she remarked, 'I hope – I pray – that she survives long enough to free the strange, lovely talent that's wandering through her like a jailed spirit…'

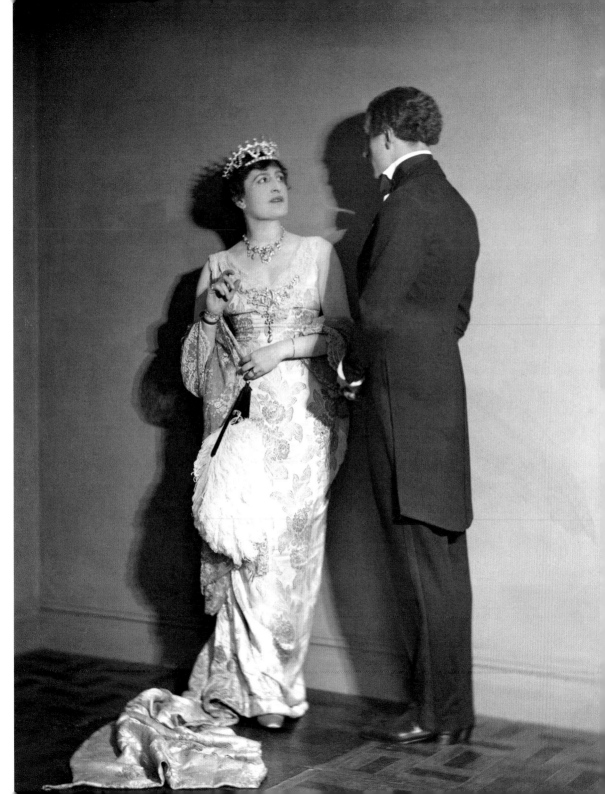

MRS VIOLET TREFUSIS, 1924
BY HAVRAH OF PARIS

The affair between Violet Keppel, the daughter of Edward VII's mistress Alice Keppel (great-grandmother to the present Prince of Wales's mistress, Camilla Parker-Bowles), and Vita Sackville-West had started when they were in their teens. The affair continued after both women had married. In 1921, their husbands joined forces to pursue the lovers to France, whence they had eloped, and persuaded them to return home. Violet's marriage was less successful than Vita's. She was a reluctant bride, and the ten years she spent with her husband, Denys Trefusis, until his death, were turbulent ones.

opposite

HON MRS HAROLD NICOLSON, 1921
BY FLORENCE VANDAMM

Surely no marriage of the last century has been so minutely dissected as that of Mr and Mrs Harold Nicolson. Mrs Nicolson is better known as the poet, novelist, biographer and gardener Vita (Victoria) Sackville-West. She had married Nicolson, a diplomat and writer, in 1913 and with him travelled to Turkey and to Persia. She described the journey in her book *Passenger to Teheran* (1926). A year later she was awarded the Hawthornden Prize for her poem *The Land*. In 1928, Virginia Woolf published her novel of sexual ambiguity *Orlando*. Mrs Nicolson, who had had an affair with Woolf, was the model for the aristocratic hero. Paradoxically, Vita's marriage was essentially happy, in spite of her notorious extra-marital activities. Harold Nicolson himself admitted to homosexual inclinations, and their unorthodox union endured until Vita's death in 1962, which left her husband heartbroken. Together they had transformed the gardens of their home, Sissinghurst Castle, Kent, into one of England's great horticultural treasures.

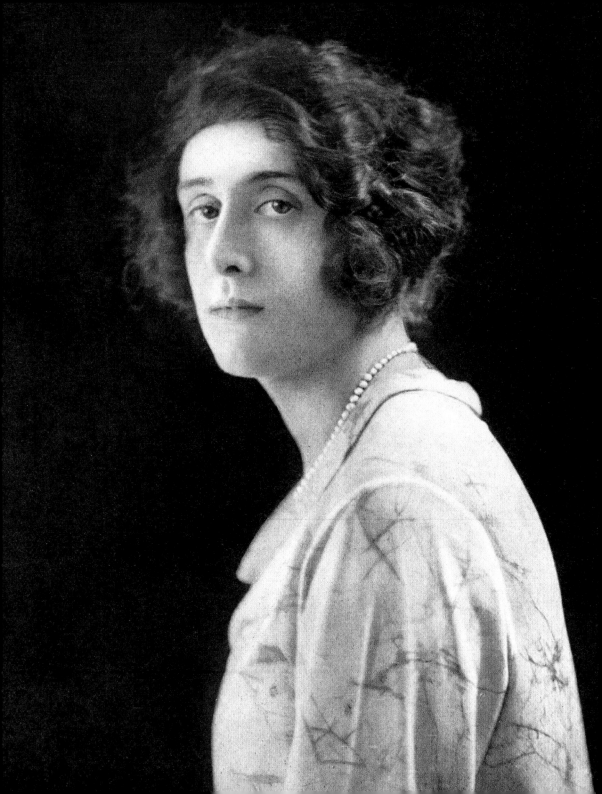

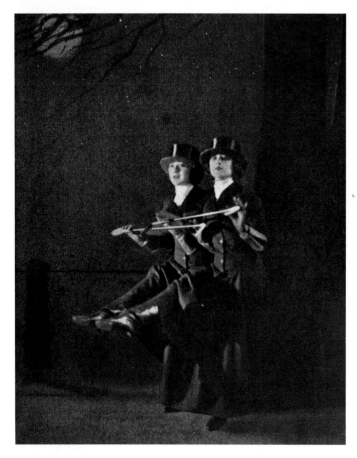

THE DOLLY SISTERS, 1921
BY HOWARD INSTEAD

Identical twins, Rosie and Jenny, who entranced Broadway audiences in the early years of the last century, were born Roszika and Yancsi Deutsch in Budapest. When Florenz Ziegfeld cast them in his *Ziegfeld Follies* of 1911, they were an instant hit and attracted legions of fans – one of whom presented Rosie with a Rolls-Royce tied up with ribbons. They made a successful transition to silent films, notably for D W Griffith. In 1918, they played themselves in *Million Dollar Dollies*. Jenny married Harry Fox, often credited with inventing the foxtrot, while Rosie married Jean Schwartz, composer of popular songs such as *Rock-a-Bye Your Baby (with a Dixie Melody)*. By the time of this appearance in *Vogue*, in 'dashing equestrian attire' and with both their marriages over, The Dolly Sisters had London at their feet; ahead of them lay Paris. Their bobbed hair and off-duty languor made them celebrated style leaders, whose conquests included the Prince of Wales, the Aga Khan and King Alfonso of Spain. On their retirement in 1927, both sisters were very rich – Jenny, it was rumoured, broke the bank at Monte Carlo four times. But their fortunes brought them no lasting happiness. Jenny hanged herself in 1941, and Rosie also attempted suicide, with an overdose of sleeping pills – she survived.

opposite
VISCOUNTESS ASTOR MP, 1922
BY BERTRAM PARK

In 1919, Virginia-born Nancy Astor became the first woman to take her seat in the House of Commons. When her husband, Waldorf Astor, succeeded to his father's title and seat in the House of Lords, he relinquished his seat in the Commons. His wife contested and won the ensuing by-election. Lady Astor was not, however, the first woman to be elected to the Commons; that distinction had been claimed the year before by Constance Markievicz. However, as a member of Sinn Fein, Markievicz had refused to take the oath of allegiance and was therefore debarred from taking her seat. Despite Lady Astor's many speeches – her maiden speech was in support of the Temperance Society – she is remembered for a private member's bill that successfully raised to 18 the minimum age for purchase of alcoholic drinks. An energetic hostess – though teetotal herself – she is celebrated too for her bons mots, often targeting the intemperate habits of others. Receiving an invitation to one of her costume balls, Winston Churchill asked her what disguise she suggested for him. 'Why don't you come sober, Prime Minister?' she replied.

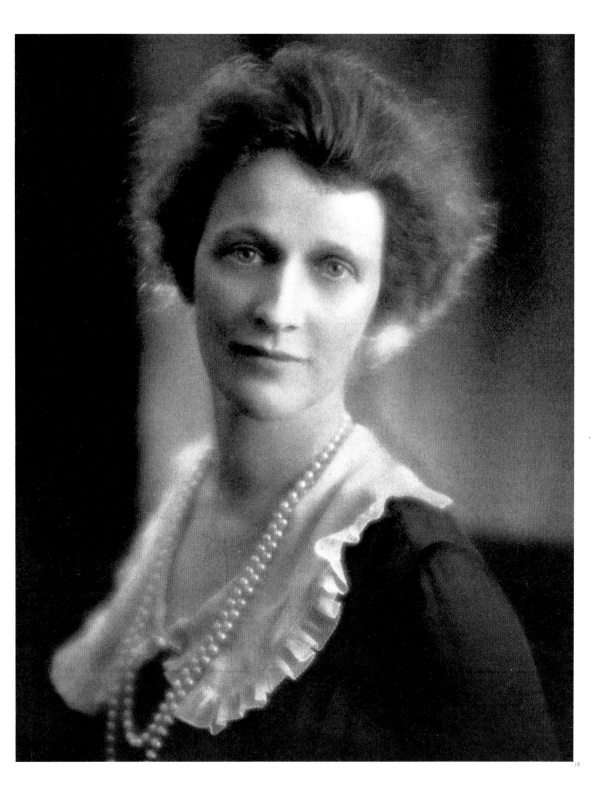

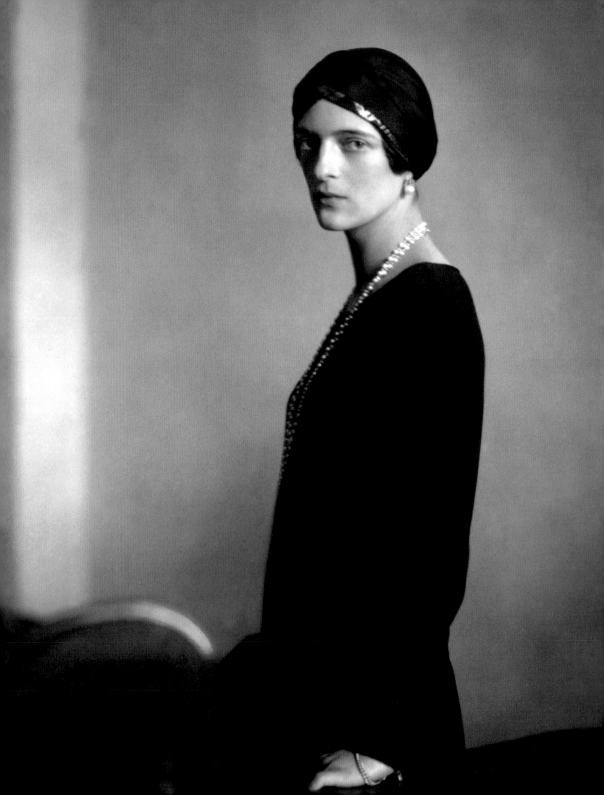

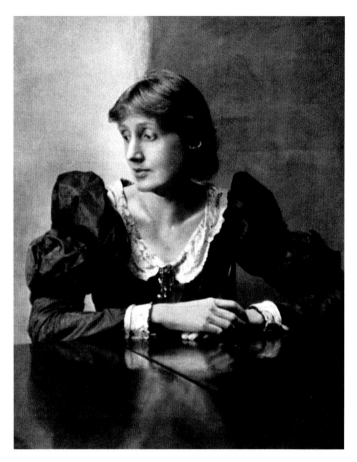

above

above
VIRGINIA WOOLF, 1924
BY MAURICE BECK AND HELEN MACGREGOR

The Bloomsbury Group, which dominated British intellectual life in the early decades of the last century, counted among its number Virginia Woolf. *Vogue's* then editor, Dorothy Todd, was acquainted with many of the century's leading literary and artistic figures, including Woolf, and she filled the pages of her magazine with portraits of T S Eliot, John Maynard Keynes, E M Forster and many others. Aldous Huxley was a regular book reviewer for *Vogue*, and Todd was the first in Britain to publish the avant-garde poetry of Gertrude Stein and the drawings of Cocteau. So devoted was Todd to British cultural life that she all but neglected the fashion pages. Such was her admiration for Woolf, for example, that she ran this portrait again in 1926. She was fired the same year. When she attempted to sue the magazine for breach of contract, Condé Nast, *Vogue's* proprietor, countered by threatening to attack Todd's 'morals'. As Vita Sackville-West wrote to her husband, Harold Nicolson, 'So poor Todd is silenced, since her morals are of classic rather than the conventional order… This affair has assumed in Bloomsbury the proportions of a political rupture.'

opposite
THE PRINCESS IRINA YOUSSOUPOFF, 1924
BY EDWARD STEICHEN

As her mournful expression suggests, the Russian-born Princess lived through dangerous times. She was a blood relative of the Imperial family, a Grand Duchess by birth, and her husband, Prince Felix, achieved notoriety in 1916 as the assassin of the mystic Rasputin. During the Revolution, she showed great bravery on behalf of her imprisoned family, demanding a meeting with Kerensky then head of the provisional government, and securing better conditions for them. Princess Irina's immediate family survived the Revolution, but her Romanov cousins did not. Some years after this portrait, the name Princess Youssoupoff was again in the news. The film *Rasputin and the Empress* (1934) suggested that Prince Felix had murdered Rasputin in revenge for his having raped his wife. She sued the studio MGM for libel – she had never met the highly sexed monk – and was awarded huge damages. From then on, films carried a disclaimer, most often beginning, 'Any Resemblance to Persons Living or Dead…'

RUDOLPH VALENTINO, 1924
BY MAURICE BECK AND HELEN MACGREGOR

Cinema's 'Great Lover', star of *The Sheikh* (1921) and *Blood and Sand* (1922),
and perhaps the greatest male star of the silent era, Valentino appears here to
be posing as Nijinsky in *L'Après-midi d'un Faune*. Ahead of him lay an ugly
divorce from Natacha Rambova (formerly Winifred Hudnut), a set and
costume designer, whom he had married in 1922 and who all but bankrupted
him. Within two years of this photograph, Valentino had died, aged 31, from a
perforated ulcer, although rumours that he had been shot by a jealous lover
persisted. His funeral arrangements sparked off riots as a crowd of some
100,000 fans pressed to glimpse his open coffin.

opposite
POLA NEGRI, 1925
BY EDWARD STEICHEN

Vogue's 'Pola Star of the Films' may or may not have had a romance with
Rudolph Valentino in the last months of his life. Negri certainly made a
dramatic impression at his funeral, garbed in widow's weeds and
swooning. She announced through her publicist that she and Valentino
had planned to marry.

LADY DIANA COOPER, 1926
BY CURTIS MOFFAT AND OLIVIA WYNDHAM

The daughter of the 8th Duke of Rutland, Lady Diana Manners was recognised as the great English beauty of her time. She appeared to international acclaim as the Madonna in Max Reinhardt's *The Miracle* (she had no dialogue). This fanciful portrait celebrates the role she made famous, showing the real-life, Chanel-clad Lady Diana viewing a picture of herself in her stage costume. She married Duff Cooper, a former First Lord of the Admiralty, who later became Britain's first postwar ambassador in Paris. Lady Diana wrote three volumes of memoirs and, during her long life, was rarely far from the fashion, beauty and social pages of *Vogue*. Indeed, she remains one of the most photographed figures in its history.

below

MR OSWALD AND LADY CYNTHIA MOSLEY
AND E V STRACHEY, 1925
PHOTOGRAPHER UNKNOWN

Oswald Mosley's ultimate political convictions are well known; less so are the vacillation and false starts that led him to them. In 1918, at 22, he entered Parliament as its youngest member, a Conservative, but soon lost faith with his party. In 1922, he was returned for the same constituency, as an Independent. By 1929, he was a Labour junior minister. He resigned and formed the 'New Party'. This was socialist in outlook but short-lived, suffering crippling defeat at the next general election (1931). Mosley progressively drifted further to the right, forming the British Union of Fascists a year later. Broadly modelling himself and his party on Mussolini's Italian Fascist party – down to its uniform of black shirts – he advocated radical measures to curb unemployment. His vituperative and abusive speeches, mostly directed against Britain's Jewish population, masked his great gifts as an orator and a formidable, if flawed, intellect. Unrepentant, he was interned during the Second World War with his second wife, the former Diana Mitford. His first marriage was to Lady Cynthia, known as 'Cimmie', the second of the three glamorous daughters of Lord Curzon, Viceroy of India. After Cimmie's early death in 1933, Mosley was linked to Alexandra, the youngest Curzon daughter, who later married the Prince of Wales's close friend 'Fruity' Metcalfe. Here, with Lady Cynthia and their companion, E V Strachey, Mosley is pictured in unusually off-duty mode; he is most often depicted in the East End of London, in black with an armband, haranguing a crowd.

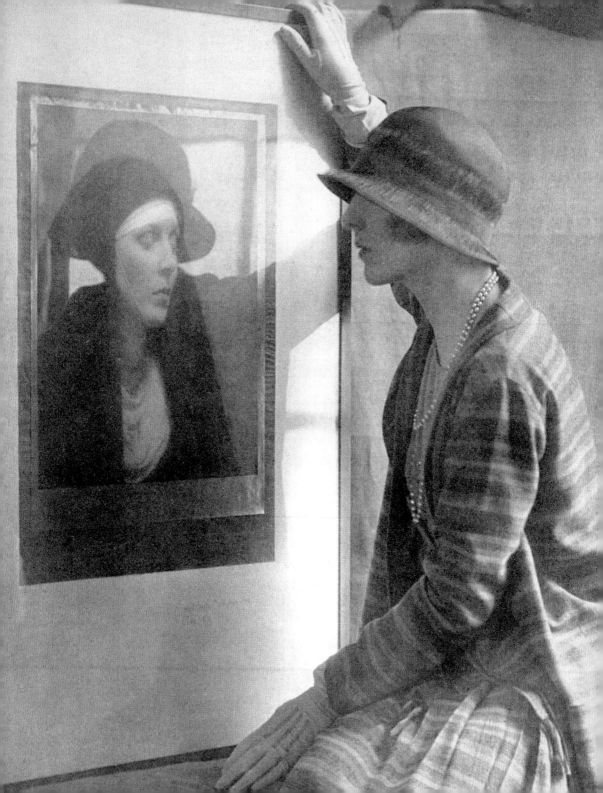

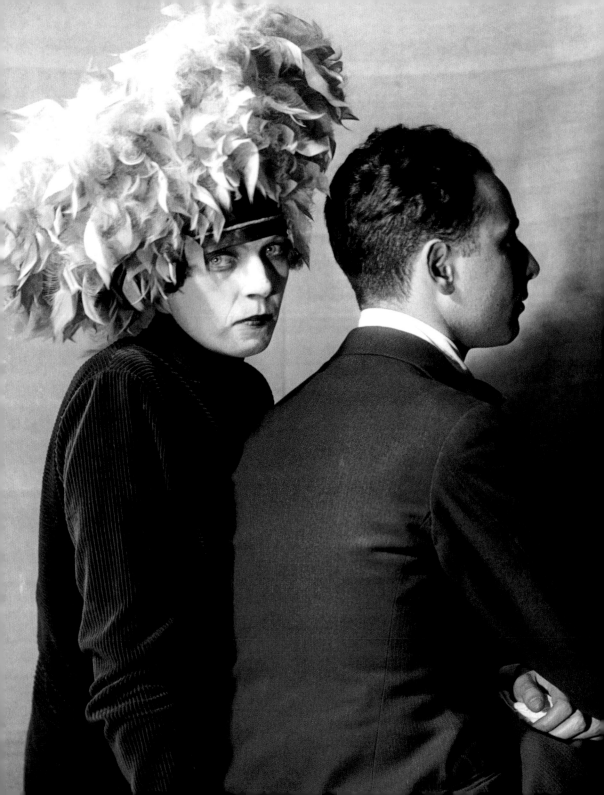

MARION MOREHOUSE, 1925
BY EDWARD STEICHEN

In 1923, Steichen succeeded Baron de Meyer as *Vogue*'s chief fashion photographer. He had chanced upon a recent copy of *Vogue*'s sister magazine *Vanity Fair* and discovered himself hailed as 'the greatest living portrait photographer'. The writer (*Vanity Fair*'s editor Frank Crowninshield) regretted Steichen's abandoning the camera in favour of painting. Steichen wrote to correct this misapprehension and was promptly offered the chance to succeed de Meyer. His acceptance introduced realism to fashion photography, in tune with the modernism of the early Twenties, and replacing de Meyer's soft-focus aesthetic, which now looked outmoded and trivial. *Vogue*'s proprietor, Condé Nast, once told Steichen: 'Every woman de Meyer photographs looks like a model. You make every model look like a woman.' As Steichen himself explained: 'I felt that a woman, when she looked at a gown, should be able to form a very good idea of how that gown was put together and what it looked like.' To this end, he chose as his favourite model Marion Morehouse (here wearing a dress by Lelong), who was, he maintained, as uninterested in fashion as he was, but soignée enough to wear it strikingly. She was clearly equipped with a *joie de vivre* and, as Steichen revealed later, a keen sense of adventure too. He had suggested that they do a series of nude photographs and his model readily agreed. On learning that she was a married woman, Steichen destroyed the negatives to spare his collaborator any future shame. He then discovered she was married to the avant-garde poet e e cummings, who of all husbands, he surmised, might have applauded the results of their experimentation.

NANCY CUNARD AND LOUIS ARAGON, 1926
BY CURTIS MOFFAT AND OLIVIA WYNDHAM

Harold Acton described Nancy Cunard, a descendant of the shipping-line family, as possessing a head 'carved in crystal with green jade for eyes'. She moved to Paris from London in 1920 with her equally exotic mother, Lady Emerald. There she became a highly visible, if second-rate, avant-garde poet and a patron of Ezra Pound, Man Ray and Samuel Beckett. By the time of this portrait, Cunard had published *Parallax*, her third volume of poetry. Ahead of her lay decades of political activism, the scandal caused by her love affair with Henry Crowder (an African-American jazz musician), and the publication, at her own expense, of *Negro* (1934), an anthology of black American and European writing. Her companion is believed to be the surrealist poet, Louis Aragon, whose verse she helped publish.

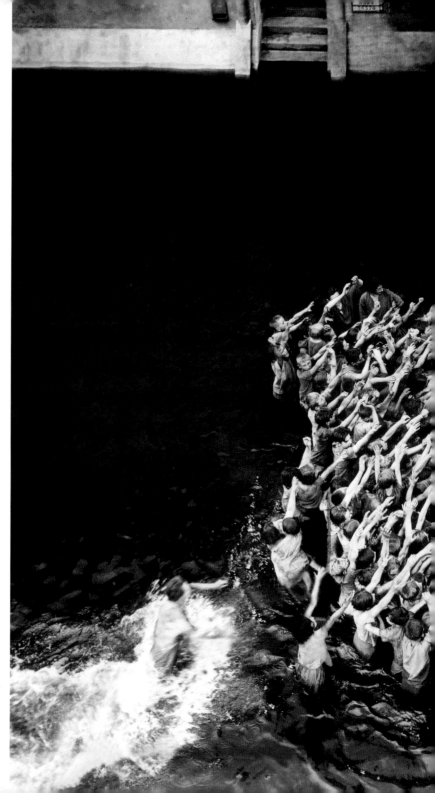

FRITZ LANG ON THE SET OF 'METROPOLIS', 1926
PHOTOGRAPHER UNKNOWN

Lang's futuristic allegory of human isolation in
the face of mass production and technological
advancement was executed on an epic scale.
Here in their subterranean city, the labourers'
children fight to escape the rising tide of flood
water, which will soon engulf them. To the left of
Lang (with megaphone) a young girl is about to
strike the huge gong behind him, in warning, and
the crowd of children will surge forwards. The
camera then moves into the mass, 'thus,' *Vogue*
noted, 'making the audience part of the scene'.
As well as using a megaphone, Lang carried on
the traditions of the imperious German auteur
in Hollywood by wearing a monocle.

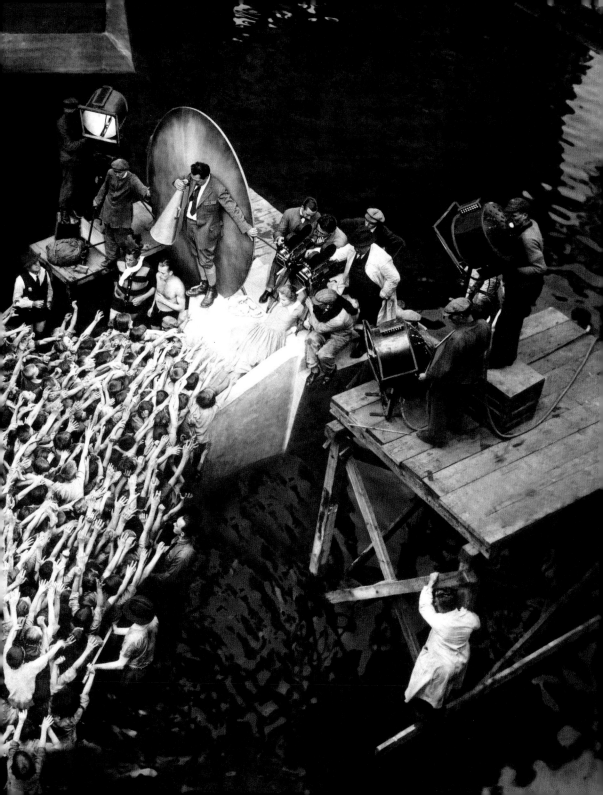

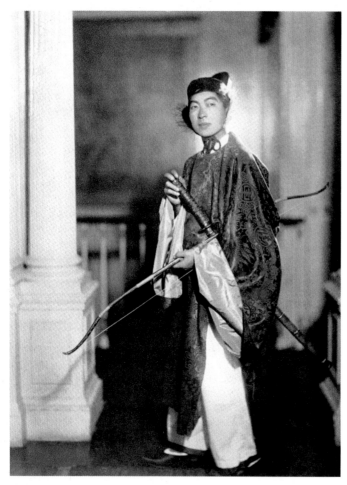

HRH PRINCE CHICHIBU OF JAPAN, 1926
BY LENARE

The younger brother of Emperor Hirohito, Prince Chichibu was second in line to the Chrysanthemum throne. Not quite possessing the status of his elder brother as 'living god', he was able to circumvent the rigours of royal protocol to excel as a sportsman. Prince Chichibu was considered by the West to be unusually enlightened: he was pro-democracy, vehemently opposed to war, and a particular friend to Britain. This was partly due to his wife's affection for her place of birth, Walton-on-Thames, and his own student days at Oxford. In this portrait by the royal photographer Lenare, Prince Chichibu is at his most Westernised, albeit in 'the gorgeous costume of his royal ancestors', attending a ball given by Mrs Guinness.

opposite
EDITH SITWELL, 1927
BY CECIL BEATON

Beaton found natural sitters in the two Sitwell brothers, Osbert and Sacheverell; but he was entranced by the unconventional looks of their sister, the poet Edith. He often portrayed her for *Vogue* at Renishaw Hall, the family seat in Derbyshire. 'She lay on the floor on a square of chequered linoleum,' Beaton wrote in his *Photobiography* (1951), 'disguised as a figure from a medieval tomb, while I snapped her from the top of a pair of rickety house-steps. At Renishaw Hall... the ivy-covered ruins, stone terraces ornamented with large Italian statues, and the tapestried rooms made wonderful backgrounds for pictures of her. Here was the apotheosis of all I loved. With an enthusiasm that I felt I could never surpass, I photographed Edith playing ring-a-ring-of-roses with her brothers, plucking the strings of a harp and, wearing an eighteenth-century turban and looking like a Zoffany as, in a huge four-poster bed, she accepted morning coffee from a coloured attendant.'

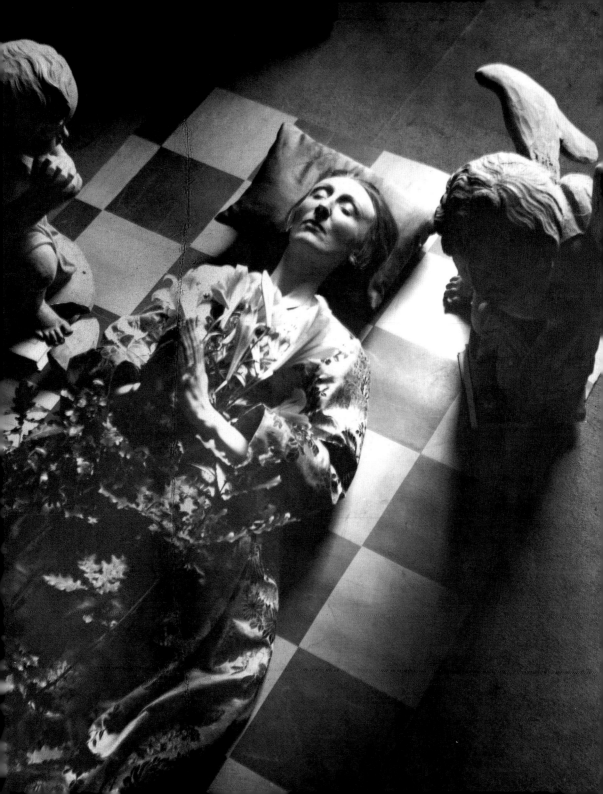

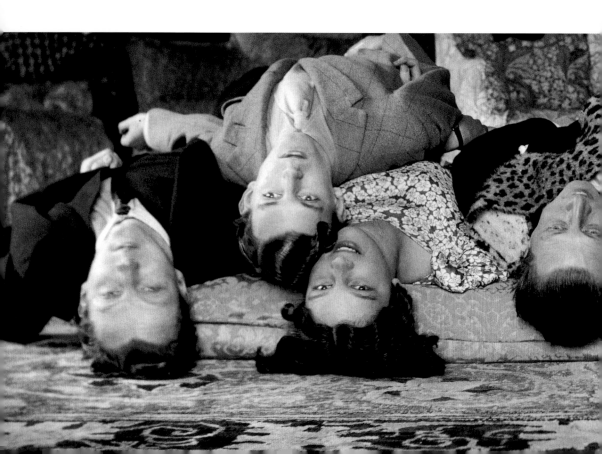

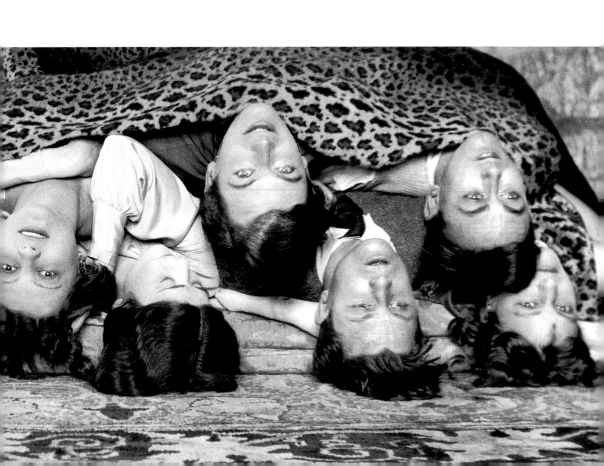

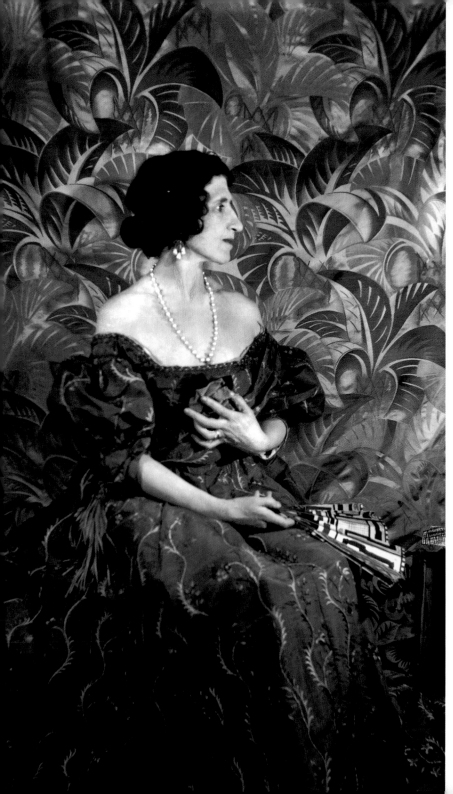

left

LADY OTTOLINE MORRELL, 1928
BY CECIL BEATON

During the First World War and into the late Twenties, Lady Ottoline presided over a salon of the brilliant – and often eccentric – minds of her age. Marriage to the Liberal MP Philip Morrell brought the former Lady Bentinck to Garsington, a historic manor house near Oxford. Under her guidance, it became a meeting place for artists and poets, aristocrats and politicians, an arena for the exchange of views and ideas. She was herself a memorable figure and posed often for the cameras of Beaton and Baron de Meyer. She was the model for several character studies in contemporary fiction. D H Lawrence found her mercurial charm and sheer physical presence – she was nearly 6ft tall – inspiring. 'Her long, pale face,' he wrote in *Women in Love*, 'that she carried lifted up, somewhat in the Rossetti fashion, seemed almost drugged, as if a strange mass of thoughts coiled in the darkness within her.'

opposite

MRS DUDLEY WARD, 1928
BY CECIL BEATON

That Edward, Prince of Wales, belonged to a 'fast' set was no secret to *Vogue*'s readers. In her social history of the interwar years, *Society in Vogue*, Josephine Ross observed that 'though probably better informed than any other publication where royal amours were concerned, *Vogue* maintained an absolute, high-bred discretion on the subject.' But to those who could read between the lines, the appearance twice in 1928 of Mrs Freda Dudley Ward in the magazine's pages meant one thing: that she was still the heir to the throne's favourite married mistress. She had been for 15 years until, within a few years of this portrait, she was superseded by Thelma, Viscountess Furness. 'I swear,' Edward once wrote to Freda, 'I'll never marry another woman but YOU!!! Each day I long more and more to chuck in this job and be out of it and free for you, sweetie.' They had met in 1918, sheltering in a Mayfair doorway. By coincidence, it was the door of the house owned by the sister of Ernest Simpson. Simpson's wife, Wallis, later ensured that the Prince of Wales never saw Lady Furness or Freda Dudley Ward again.

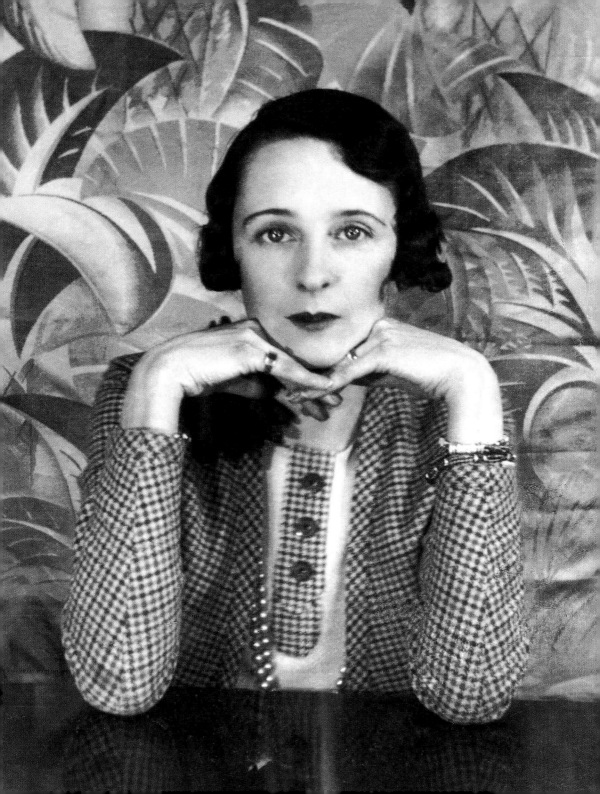

'FOUR DEBUTANTES OF 1928'
BY CECIL BEATON

Making their debut this season were, from left: Hon Georgiana Curzon;
Lady Anne Wellesley; Miss Nancy Beaton (the photographer's sister); and
Miss Deirdre Hart-Davis, a niece of Beaton's friend Lady Diana Cooper.
The behind-the-scenes illustration by Beaton shows the gaggle of mothers,
governesses and canine companions Piggie and Beckie also in attendance.

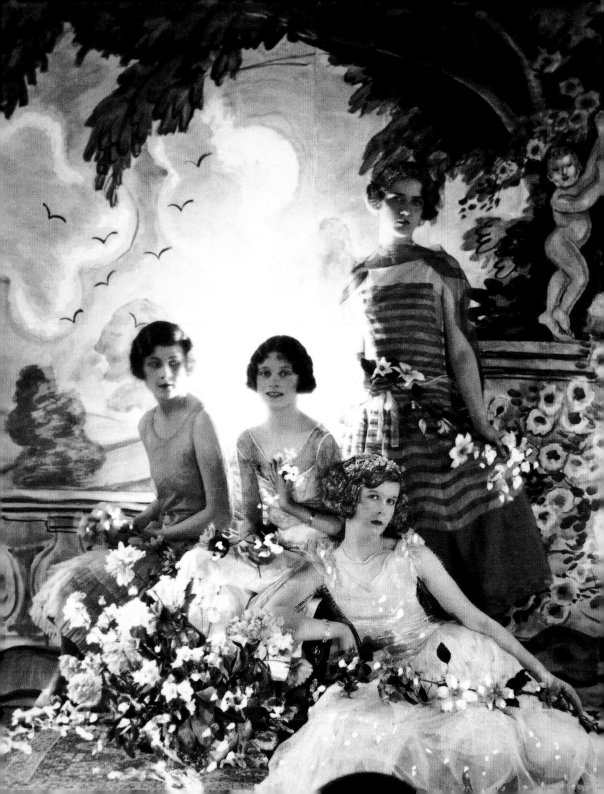

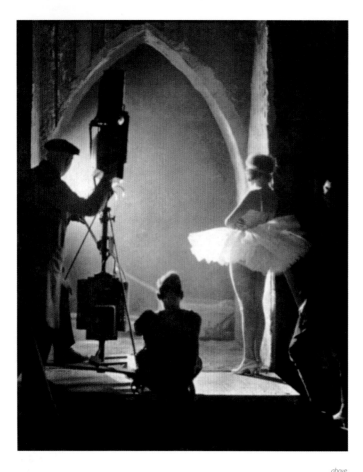

above
LENI RIEFENSTAHL, 1928
BY JAMES ABBE
Before she shackled her reputation to the fortunes of the Third Reich,
Riefenstahl was a popular actress and dancer. For the director Arnold Franck
she made several mountaineering movies (*Bergfilme*), such as *The White Hell of
Piz Palü* and *The White Frenzy*, in which the human participants were invariably
dominated by the majesty of the snowy settings. This photograph was taken
on the set of *The Holy Peak* (1929). Riefenstahl's subsequent career has been
dominated by her ambiguous role in the Nazi propaganda machine. For Hitler
she made *Triumph of the Will* (1934), a paean to the pageantry and aesthetics
of the Nuremberg rallies, and *Olympiad* (1938), her record of the Berlin
Olympic Games of 1936. The latter opened on Hitler's birthday, its premier
delayed for a month by the annexation of Austria.

opposite
LEE MILLER, 1928
BY GEORGE HOYNINGEN-HUENE
Two years before this portrait, an 18-year-old American girl strayed off a
Manhattan sidewalk and into the path of an oncoming car. She was pulled back
at the last minute by another passer-by. The young girl was Lee Miller, her
rescuer was Condé Nast, doyen of the eponymous American magazine-
publishing company. Condé Nast was intrigued enough by Lee to offer her
work as a fashion model for *Vogue*. Her association with the magazine lasted a
quarter of a century. During that time, her war reportage in words and
photographs propelled *Vogue* into the modern age, confirming that the
magazine was never merely a repository of light-hearted photography. Lee,
though, was to supply her fair share of such ephemera in the fashion and
beauty pictures she took before war intervened. The progress of Lee Miller
from upstate, small-town girl to fashion model, to sophisticated expatriate in
Paris, to fashion photographer, to photo-essayist, to confidante of Picasso
seems to have been punctuated by lucky accidents. She remains one of *Vogue*'s
heroines, her life story scarcely credible.

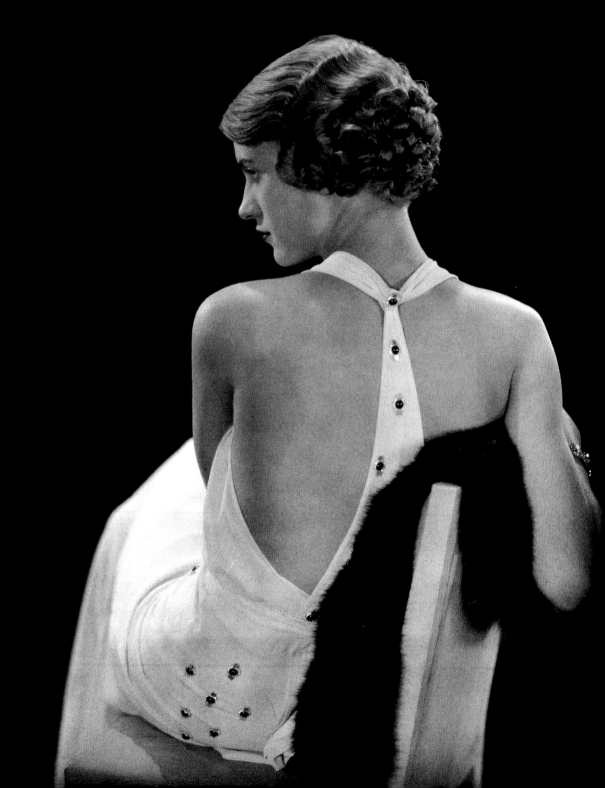

love all on at sides

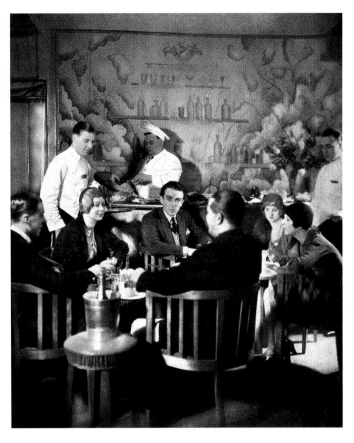

above
BRIAN HOWARD, 1929
BY HOWARD AND JOAN COSTER
Brian Howard holds court – and the eye of the husband-and-wife
photographers – at his favourite table at the '500 Club'. As a precocious
schoolboy aesthete, he had sent his poetry to Edith Sitwell and found it
well received. However, as he relayed to his friend and fellow dandy Harold
Acton, he was disheartened when he first met Sitwell to be given 'one
penny bun and a cup of rancid tea in a dirty cottage mug'. Here, however,
he is clearly in his element. As *Vogue* notes, 'The 500 Club is a favourite
social rendezvous for the cocktail and sandwich meal that refreshes some
of our most crowded days.' George the chef 'carves a succulent ham'
beneath Houghton Brown's murals. Later, Howard would write in his diary,
'Drink has become a No.1 problem'. He subsequently died by his own
hand, a hopeless alcoholic. Evelyn Waugh knew both Howard and Acton
well, and his epicene dandy Anthony Blanche in *Brideshead Revisited* (1945)
is a blend of both men. Howard also appears, lightly disguised, in novels by
Nancy Mitford and Cyril Connolly.

opposite
TALLULAH BANKHEAD, 1929
BY CECIL BEATON
Famous for her flamboyant personality, her uninhibited off-stage behaviour
and a propensity for making frank, husky-voiced revelations in interviews,
Bankhead was for a time the leading American stage actress of her day.
Commenting on her starring performance in the *Lady of the Camellias*,
Vogue was ecstatic, comparing her to Sarah Bernhardt and Eleanora Duse.
Here, for Beaton, she takes on the Bernhardt persona, posing as the 'Divine
Sarah'. Though her debut was in New York in 1918, it was on the London
stage that Bankhead found the greatest success of her early career. She
responded to this acclaim by becoming an enthusiastic Anglophile. Of her
London days, *Vogue* observed that 'she became almost instantly the giddiest
kind of public idol. Her gowns, her gestures, her house in Mayfair have been
of passionate interest…'. Later, she made a successful, though ultimately less
memorable, transition to Hollywood films.

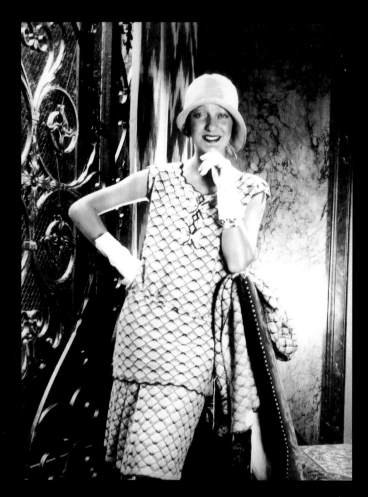

GERTRUDE LAWRENCE, 1929
BY CECIL BEATON

Noël Coward and Gertrude Lawrence met as 13-year-olds at the elocution lessons that all but obliterated her cockney accent. Twenty years later, after their acclaimed performance in Coward's *Private Lives* (1930), they were the most popular double act on the English stage. But Lawrence first had to endure roles such as 'Miss Lamb of Canterbury' and 'Miss Plaster of Paris' in the provinces. In 1936 they followed *Private Lives* with the revue *Tonight at 8.30*. Five years later Lawrence was triumphant on Broadway in *Lady in the Dark* (1941) and, in the year before her early death, in *The King and I* (1951). She had an instinctive sense of style, though occasionally eccentric in her choices. Here, she models a three-piece 'sports costume' designed by Chanel and a cloche hat by Marie-Christiane.

opposite
SYBIL THORNDIKE, 1929
BY GEORGE HOYNINGEN-HUENE

Dame Sybil was eventually hailed as the greatest stage actress of her generation. Her biggest success was perhaps in Bernard Shaw's *Saint Joan* – which he wrote with her in mind. She played the title role first in 1924; she played it again in a 1931 revival. During her lifetime, she calculated, she played the part 2,000 times, worldwide. Her husband, Lewis Casson, was invariably her producer and often her co-star. Years later, *Vogue* noted that their early repertory company was like a glorious finishing school: Laurence Olivier and Carol Reed had carried her train in a production of *Henry VIII* in 1925. 'Dame Sybil,' it continued, 'a vibrant woman with lapis-lazuli blue eyes and Sir Lewis, rockily British and erect, appear, off stage, a tea-cosy couple interested in their 10 grandchildren…' Dame Sybil, however, was characteristically frank: 'On stage, we argue like hell.'

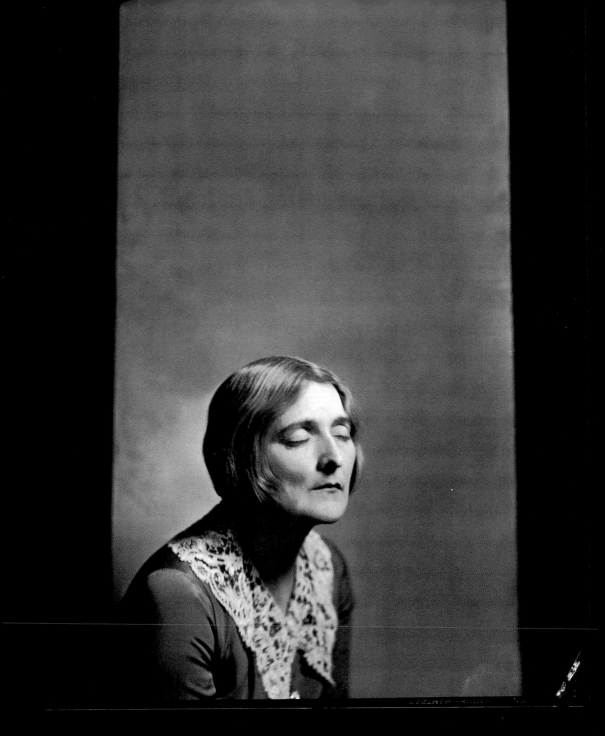

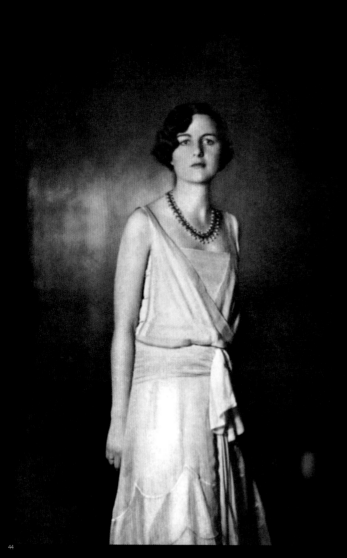

HON NANCY MITFORD, 1929
BY HOWARD AND JOAN COSTER

Nancy was the eldest of the six daughters of the eccentric 2nd Baron Redesdale. She was high-spirited, bohemian and determined that life should never be boring; *Vogue* noted that she was 'a very popular member of the younger set'. 'Miss Mitford,' it continued, 'is seriously interested in art and it is understood she will shortly study in Paris.' She was, and did, and became a committed Francophile, giving her house over to de Gaulle's Free French during the War. But it was her satirical novels of upper-class English life that put her on the artistic map. So sharply observed were the characters in her best novels, *The Pursuit of Love* (1945) and *Love in a Cold Climate* (1949) – which were both in part autobiographical – that her friend Evelyn Waugh accused her of being an 'an enemy from within'.

opposite

DOLORES DEL RIO, 1929
BY EDWARD STEICHEN

Mexican beauty Dolores Del Rio was a star of silent films, fabled for a complexion which was attributed to the unsubstantiated rumour that she ate flowers. Her debut was in *Joanna* (1925) and she followed its success with *What Price Glory?* (1926). However, with the coming of sound, her unmistakably Hispanic accent, combined with her sultry looks, limited her roles to gipsy or peasant girl, and, more often than not, she was the stereotypically 'exotic' focus of films such as *The Loves of Carmen* (1928), *Bird of Paradise* (1932) and *Girl of the Rio* (1934). Her early Hollywood success reached its apogee with *Flying Down to Rio* (1933), despite the competition in the same movie of the sensational debut of Fred Astaire and Ginger Rogers. Here, as a model, she sports a three-quarter-length wrap – 'in high favour this season' , pronounced *Vogue* – by Augustabernard, in pale grey/beige velveteen with a huge collar and border of white fox.

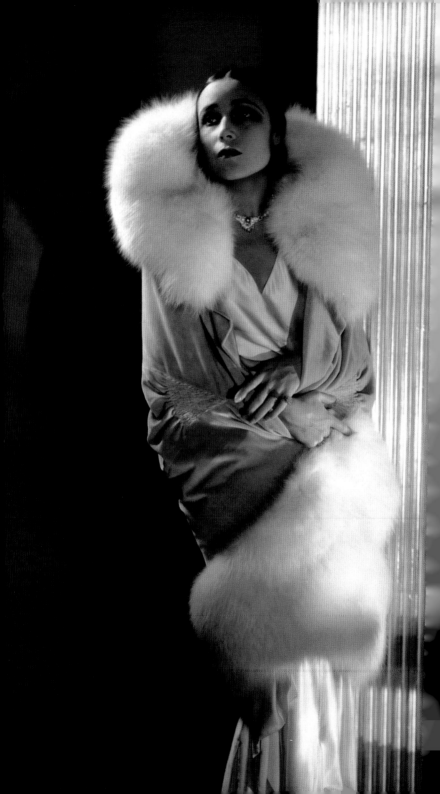

1930s

PRESERVING THE ARTS OF PEACE

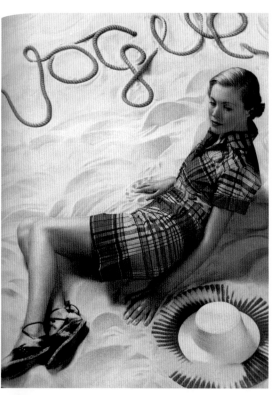

The decade before the Second World War started much like the previous one. The stock exchange had crashed, there were 3 million unemployed, a 1931 hunger march was dispersed with baton charges, and the 'Bright Young Things' and their elder bluestocking sisters veered towards the Left. 'If you haven't lost money,' advised *Vogue*, 'pretend you have. Mayfair has gone native; no champagne, and dinner cut to two courses.' Servants were released. One served one's own cocktails or perhaps copied Mademoiselle Chanel and arranged 'buffet-style meals'. 'Guests toss their own salads,' reported *Vogue*. To flaunt wealth would not do at all – 'one is still grand, but one is poor,' remarked Cecil Beaton.

Still, Society could always travel – hiking in Austria, the opera at Bayreuth, a week or two in Manchuria – but something was brewing in middle Europe. 'I am becoming aware,' wrote American *Vogue's* Johnny McMullin, 'of the supremacy of youth in Germany. One feels nothing but youth, the power of youth, and the importance given to youth. There is a cult of youth…' Fascism was on the rise in Britain, too. Unity Mitford, one of the even-then legendary Mitford girls, was patted on the head by Herr Hitler and told she was 'the perfect Nordic woman'. Intellectuals such as George Orwell and Cecil Day Lewis joined the International Brigade and headed for Spain and the anti-Franco factions. Others decamped for a new life across the Atlantic, among them Aldous Huxley, W H Auden and Christopher Isherwood.

The abdication crisis left Wallis Simpson largely ostracised and the man who would not be king despised as a dilatory weakling. *Vogue* had certainly known what was going on – Beaton knew the Prince of Wales and the Queen and the circles surrounding both – and made veiled references to Mrs Simpson's ubiquity: 'Of course it would be Mrs Ernest Simpson who first thought of the wonderful combination of seeded white grapes with little cubes of Dutch cheese – she impales them on sticks as she chats – quite charming!'

Beyond politics, dominating drawing-room conversation were the movies. *Vogue* still preferred the stage: 'Do you follow Laurence Olivier's career as an actor?' asked the magazine in 1935. 'You should.' But the public appetite for Fred Astaire and Ginger Rogers, Marlene Dietrich, Charlie Chaplin and Shirley Temple could not be ignored. 'Hollywood,' observed *Vogue*, 'is inhabited almost entirely by gods and goddesses of beauty… it is very much what one was told heaven was like as a child.' The photographs of Horst and Hoyningen-Huene added further brilliance to the star power on display. So flattering was Horst's lighting that, years after his first sitting with her, Dietrich cabled him from the set of *Kismet* to ask him how he did it.

On the fashion horizon, the rivalry of 'Coco' Chanel and Elsa Schiaparelli spurred both on to heights of daring, chic and surrealist absurdity.

'Munich broke over our defenceless dunderheads like a clap of thunder,' wrote *Vogue's* Lesley Blanch a little later, 'and split the country asunder. Appeasement or war? It was the parting of the ways.' When war came, it at least resolved dinner-party argument. In 1939 it may have been a 'phoney war', but *Vogue* took nothing for granted and featured a leather bag designed to accommodate a gas mask. 'We shall preserve the arts of peace by practising them,' it pronounced. 'It's your job to spend gallantly to keep the national economy going, to dress decoratively, to be groomed immaculately – in short to be a sight for sore eyes.'

FOR SCOTLAND·FROM SCOTLAND

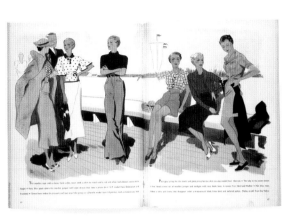

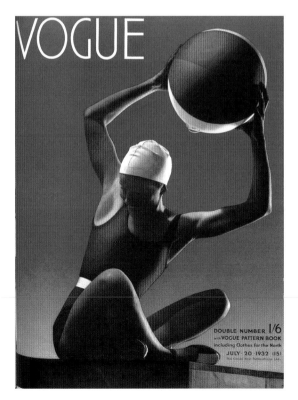

After *Vogue*'s first photographic cover in 1932 (*left*) by Steichen, photo-engraving technique improved rapidly. Indeed, Anton Bruehl, whose summer reverie (*opposite above*) included a trompe-l'oeil logo, shared his credit with *Vogue*'s laboratory chief, Fernand Bourges. Hirsch's simple palette made for a striking summer cover in 1939 (*above*), but illustration still reigned supreme – Frances Marshall's stylish spread (*above left*) also dates from 1939. The divergent styles of two great fashion photographers are revealed in a 1938 modernistic, *plein-air* shoot by Arik Nepo (*opposite below*), and a calm, surrealist approach by Cecil Beaton, 1936 (*below*).

'BABA' BEATON, WANDA BAILLIE-HAMILTON AND
LADY BRIDGET POULLETT, 1930
BY CECIL BEATON

This charming study of three debutantes includes Beaton's younger sister
Barbara ('Baba'). Before it appeared in *Vogue*, it had been a poster for the
chemicals and household detergents company Lever Brothers, and was
exhibited at the London Salon of Photography as 'Soap Suds'. This is
Beaton at the height of his 'high-style' romanticism, with more than a hint of
the baroque. Years later in his compilation *The Glass of Fashion* (1954), he
confessed to having 'indulged myself in the generally prevailing recklessness
of style. My pictures became more and more rococo and surrealist. Society
women as well as mannequins were photographed in the most flamboyant
poses, in ecstatic or mystical states, sometimes with the melodramatic air of
a Lady Macbeth caught up in a cocoon of tulle… ladies of the upper crust
were to be seen in *Vogue* fighting their way out of a hat box or breaking
through a huge sheet of white paper… backgrounds were equally
exaggerated and often tasteless. Badly carved cupids from 3rd Avenue junk
shops would be wrapped in argentine cloth or cellophane… Christmas
paper chains were garlanded around a model's shoulders, and wooden
doves, enormous paper flowers from Mexico, Chinese lanterns, doilies or
cutlet frills, fly whisks, sporrans, eggbeaters or stars of all shapes found their
way into our hysterical and highly ridiculous pictures.'

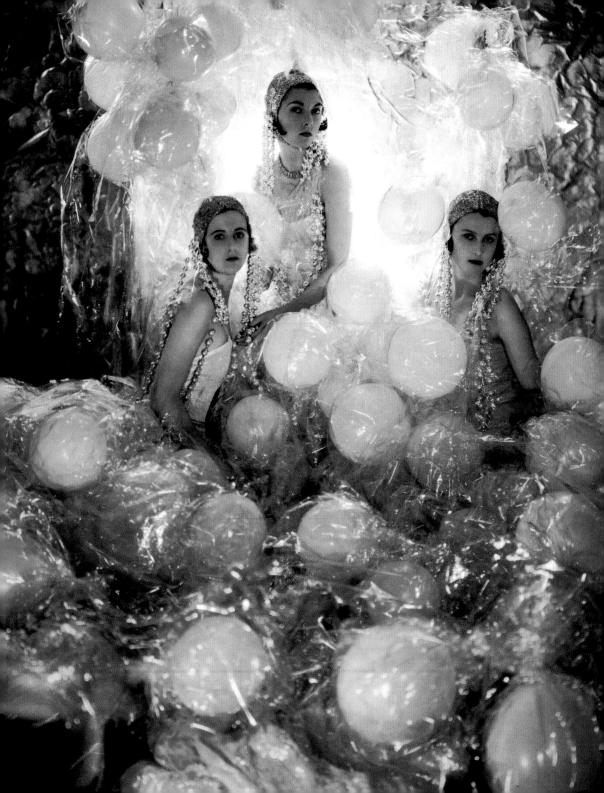

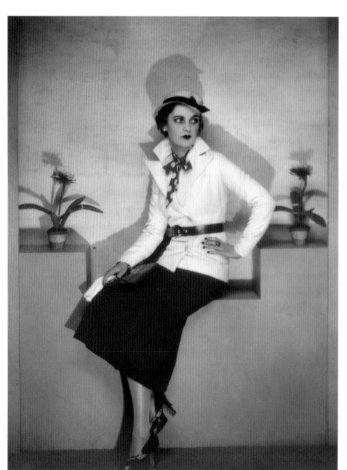

MARGARET WHIGHAM, 1932
BY DOROTHY WILDING

'You're the nimble tread/ Of the feet of Fred/ Astaire/ You're Mussolini/ You're Mrs Sweeney/ You're Camembert…' Cole Porter's *You're the Top* gives some indication of the reputation enjoyed by 1930s Deb of the Year Margaret Whigham, later Mrs Charles Sweeney, and later still Margaret, Duchess of Argyll. She was a legendary green-eyed beauty, the daughter of a self-made Scottish industrialist. The events in her life, such as her breaking off engagements to the Earl of Warwick and Prince Aly Khan, dominated society headlines. Mussolini may have presented the nation's manhood with greater danger, but if one believed the gossip columns, few were safe from 'Marg of Arg'. As well as the infamous set of incriminating Polaroid photographs produced during her divorce case, her husband revealed the contents of her diary, which finely detailed the attributes and 'form' of her many lovers – 'almost,' *The Daily Telegraph* put it, 'as though she was running them at Newmarket'.

opposite
DOUGLAS FAIRBANKS JUNIOR, 1930
BY CECIL BEATON

Having started life as the son of the most famous star in the world, and with 'America's Sweetheart' Mary Pickford as stepmother, Douglas Fairbanks Junior showed remarkable determination to match the success of his father, Fairbanks Senior, in all but his roguish charm. 'I was determined to be my own man,' he once said, 'although the name Fairbanks did make it easier to get into an office to see someone…' In real life he possessed as much pluck as his screen roles in *Sinbad the Sailor* (1947) and *The Prisoner of Zenda* (1937) suggested. He was decorated as the first American to lead a commando raid. Married three times (once to Joan Crawford), he admitted to affairs with Marlene Dietrich and Gertrude Lawrence, among many others. But his liaison with Margaret, Duchess of Argyll (*left*), was the most scandalous, giving rise to the now legendary piece of evidence presented at her divorce trial – the 'Headless Man' photographs. Polaroid snaps (then a recent invention), they showed the Duchess, clad only in three strings of pearls, in flagrante delicto in her Mayfair boudoir; her lover's head was out of shot. Of the many suspects – they ranged from junior ministers to secretaries of state, from German diplomats to the public-relations man of The Savoy Hotel – Douglas Fairbanks Junior now seems to have been the most likely contender.

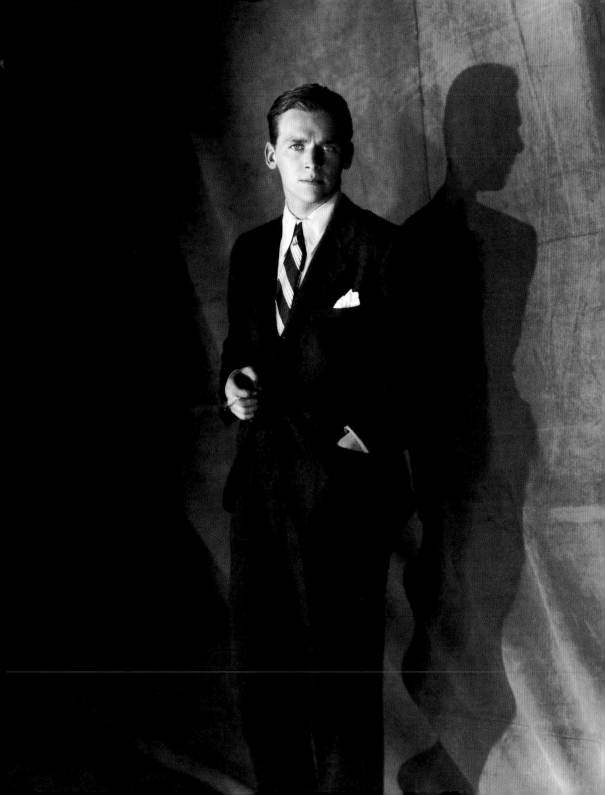

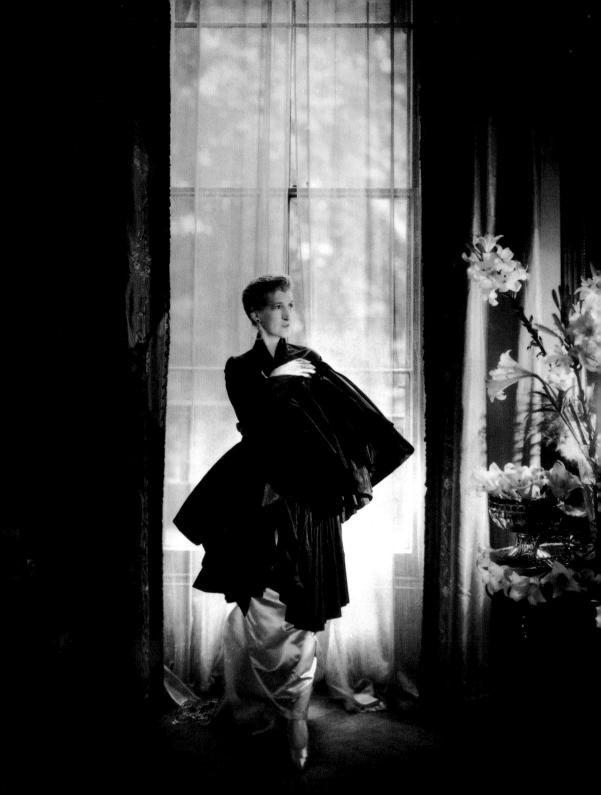

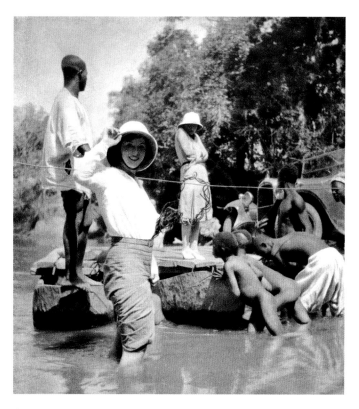

above
MADAME CORNIGLION, 1931
PHOTOGRAPHER UNKNOWN

In the interwar years, *Vogue* was particularly moved by the spirit of adventure revealed in otherwise undistinguished women, and particularly if they were soignée in adverse conditions or difficult climates. Madame Corniglion, a minor French artist, knee-deep in a tributary of the Niger, epitomises this womanly ideal. Approving of her makeshift car-transporter, the magazine's caption writer was particularly admiring of the wardrobe she had chosen for the task: 'This is the almost regulation uniform of shorts, shirt and sun helmet that is so useful in places like Kenya and Nigeria, where life has its ups and downs. You may indulge in pyjamas and evening dress in your off moments, but on occasions of stern necessity you will thank heaven for shorts and shirt.'

opposite
THE COUNTESS OF OXFORD AND ASQUITH, 1931
BY CECIL BEATON

Margot Asquith was the second wife of Herbert Henry Asquith, British Prime Minister from 1909 to 1916. Unlike her husband, described by one commentator as possessing 'a modesty amounting to deformity', Margot Asquith was a gregarious political hostess. In wit and quickness of mind, she was the match of her contemporary and rival Nancy, Viscountess Astor. And redoubtable too. When the American actress Jean Harlow dared to address her by her first name, she corrected her: 'The "T" is silent, my dear. As in Harlow.' A large aquiline nose dominated her distinctive looks, and *Vogue*'s photographers, such as Howard Instead, often resorted to soft focus to diminish its blatancy. Cecil Beaton, however, preferred to place his camera a little distance away from her formidable presence.

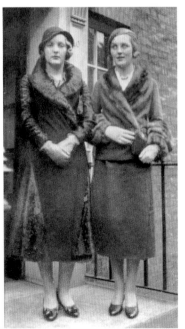

left
THE HONS UNITY MITFORD AND
MRS BRYAN GUINNESS, 1932
PHOTOGRAPHER UNKNOWN

Unity Mitford and Mrs Guinness were sisters, two of the six famous
'Mitford Girls', who included Nancy Mitford. Mrs Guinness is better known
by her second husband's name – she became Diana Mosley. Both women
are now famous for their right-wing sympathies during the War. Unity, who
had travelled widely in Germany and spoke the language fluently, met most
of the Nazi party hierarchy. Another sister, Jessica, wrote in *Hons and Rebels*
(1960) of Unity's fascination with the Nazis. It ran so deep that, when Unity
was back in England, her favourite form of greeting to everyone, including
the local village postmistress, was the 'Heil Hitler' salute, with arm
outstretched and upraised. Diana left her first husband, Bryan Guinness, for
the leader of the British Union of Fascists, Sir Oswald Mosley. At the
outbreak of war in 1939, Unity shot herself; she survived, though she was
disabled. Diana and her second husband were briefly interned. Unity died
in 1948, and Diana, Lady Mosley, died in Paris, 2003.

right
VISCOUNTESS FURNESS AND
MRS REGINALD VANDERBILT, 1932
BY DOROTHY WILDING

'The separate loveliness of these twin sisters is intensified when they are
together,' observed *Vogue*. Thelma, Viscountess Furness, was the married
mistress of the Prince of Wales, later Edward VIII. She was also the inventor
for him of 'Prince of Wales check'. Gloria was the widow of Reginald C
Vanderbilt, who drank himself to death shortly after the birth of their
daughter Gloria, the original 'Poor Little Rich Girl' and the subject of a
drawn-out custody battle. Fatefully, the year this joint portrait was taken,
Thelma introduced the heir to the throne to her friend Wallis Simpson.
Thelma and the Prince became frequent guests at Wallis and Ernest
Simpson's daily cocktail parties and in return the Simpsons were weekend
guests at Fort Belvedere, the Prince's country estate. In 1934, Thelma left
for New York with her sister, to help fight her custody battle over little
Gloria. She asked Mrs Simpson to look after the Prince while she was away.
Mrs Simpson did not fail her. In her memoirs, Thelma observed, a little
acerbically, that she looked after him 'exceedingly well…'

LORETTA YOUNG, 1932
BY EDWARD STEICHEN

Loretta Young's career in films started in 1918 when, at the age of five, she was cast as a screaming child on an operating table. For most of her early career, she played home-loving heroines, but in *Midnight Mary* (1933) her part was that of a murderess from the wrong side of the tracks. She later starred with a succession of matinée idols: Ronald Coleman, Gary Cooper, Douglas Fairbanks Junior, Clark Gable and Cary Grant, among others. *Vogue* may have fallen for her 'fluffy look of a round-eyed kitten', but this sweetness masked a rugged ambition. Her Hollywood nickname was 'The Iron Madonna'.

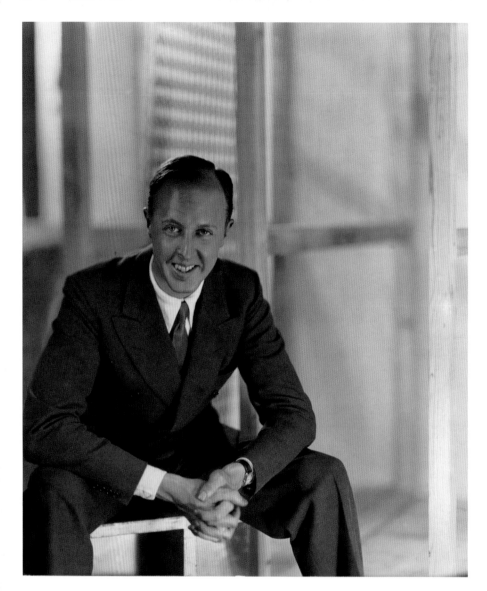

above
GEORGE HOYNINGEN-HUENE, 1934
BY CECIL BEATON

Noted as 'volatile' in nearly every biography, Huene was born a Baltic baron in St Petersburg. His father was the Chief Equerry to the last Tsar; his mother, the daughter of the American ambassador. Having worked for *Vogue* since the mid-Twenties, Huene reached the height of his success as its most coveted fashion photographer during the Thirties. He was also much in demand socially. Cecil Beaton and Huene's own protégé Horst mimicked his elegant personal style and his modernist photographic one. However, in the year this photograph was taken, his enviable position started to unravel. Huene disputed a clause in his annual *Vogue* contract and, at lunch with the visiting art director of American *Vogue*, Dr Agha (*opposite*), became so irate he up-ended their lunch table – so the story goes – and walked out of the restaurant and, indeed, *Vogue*. Horst took his place at *Vogue* and Huene went to its rival *Harper's Bazaar*, but never quite matched his earlier photographic success.

opposite
DR MEHEMED FEHMY AGHA, 1930s
BY LUSHA NELSON

Also known as 'The Terrible Turk' – though not to his face – Agha was the cynical and fearsome art director of American *Vogue*. The 'Dr' denoted a doctorate in political science. He trained in typography and graphic design at the Bauhaus, and first applied its rigour and his own to an early incarnation of German *Vogue*. One commentator recalled that so ruthless was he in stamping his imprimatur on his magazines, that he became 'a man who knew too much ever to like anything'. In 1929, he came to New York and was quickly appointed to oversee American *Vogue*'s page layouts and later those of *Vanity Fair*. His innovations had great influence. He used lower-case lettering for article headlines and introduced a sans-serif typeface to his magazines. He also produced the first magazine page to contain a 'full-bleed' photograph; that is, one that covers the entire page instead of being framed with a white border. In his honour, his portrait here is full bleed.

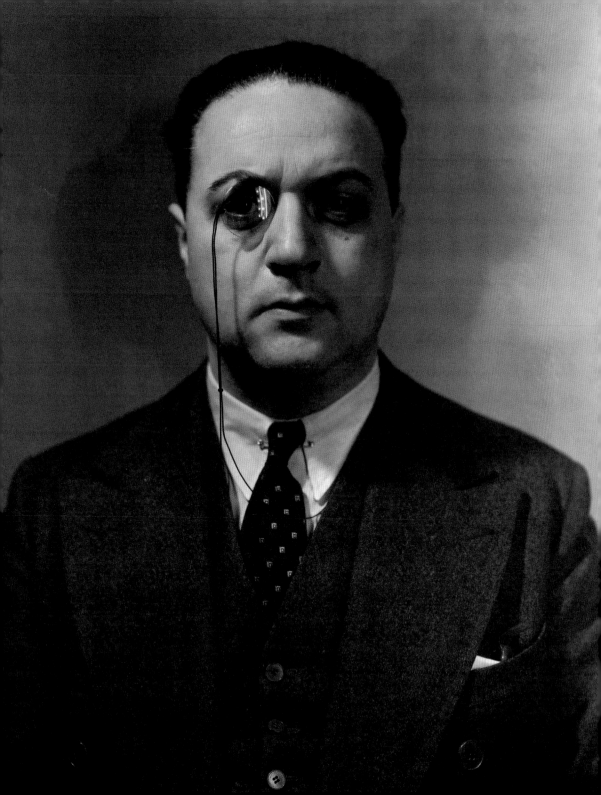

CHRISTIAN BERARD, 1936
BY CECIL BEATON

In a productive, short life, Christian 'Bébé' Bérard spread his gifts far –
from set design for Cocteau, among others, to portrait painting, fabric
and interior design and, most enduringly, lively fashion illustration for
Vogue. Here, he is caught making a likeness of the model Doris Zelensky.
The magazine snatched him from its rival *Harper's Bazaar* not because it
admired his draughtsmanship – *Vogue*'s proprietor, Condé Nast, could not
abide his 'faceless drawings' – but because he was the toast of Parisian
social and cultural life. *Vogue* called him, admiringly, 'a True Bohemian,
impulsive, unpunctual, untidy and ready to sit all night at a café in a
passionate discussion of art'. He had been the protégé of Vuillard and his
neo-romanticism was an antidote both to the formal Bauhaus style and
to the absurdities of surrealism in full spate. He was an influence on the
designs of Elsa Schiaparelli, and the inaugural collection of Christian Dior.
The *Vogue* editor who poached him never came to terms with his
bohemianism:'He used the ladies' room at the office, but you could
hardly call what went on there washing up. He just went in and threw
paint about…' He was a regular collaborator of Elsa Schiaparelli, whose
new fashions he often sketched for *Vogue*.

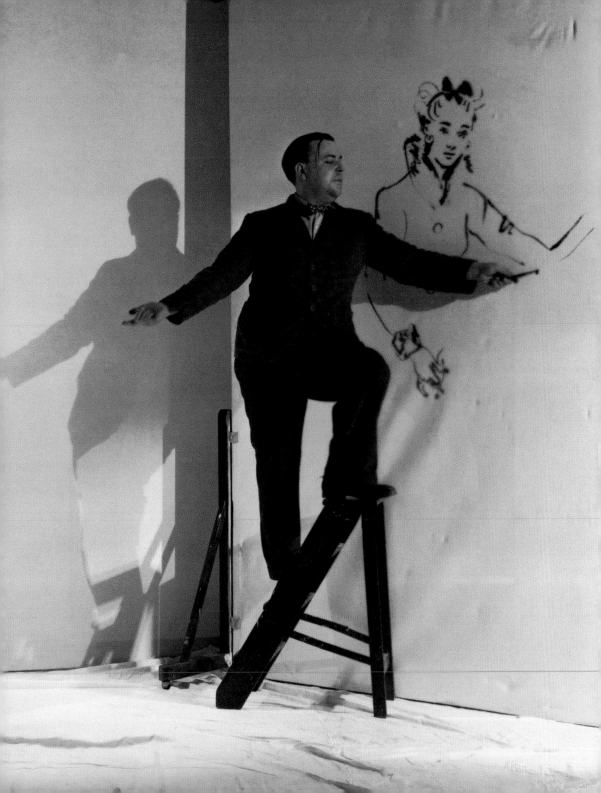

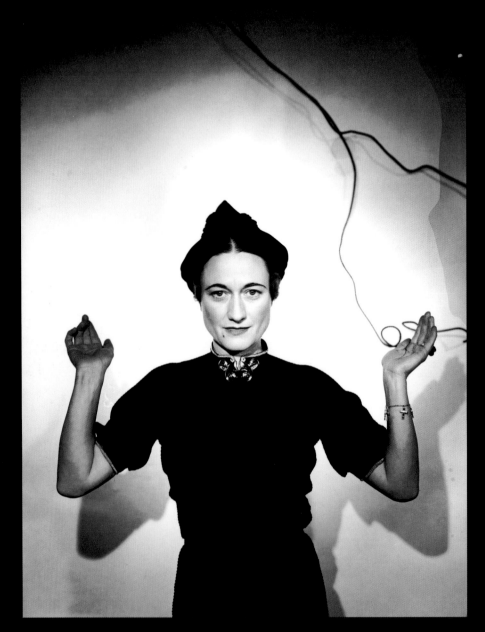

MRS WALLIS SIMPSON, 1936
BY CECIL BEATON

Beaton's friendship with the former King Edward VIII and his wife lasted from the Thirties, when he photographed their wedding, to 1960 when they sat for him for the last time. Mrs Simpson (as she was in 1936) was the most talked-about woman of her era – chic, soignée, divorced and never far from the pages of *Vogue*. However, as her affair with the heir to the throne became established, the British edition decreased its coverage of her dresses, interior decoration tips, menu lists and other random thoughts. The Americans, however, could not get enough. As Sir Roy Strong has pointed out, Beaton treated the Duke and Duchess 'as though they were society figures in *Tatler* – or even fashion models in *Vogue* – rather than part of the tradition of monarchy'. Beaton walked the delicate tightrope expertly, for he was also Queen Elizabeth's favourite photographer. That he took the newly abdicated King's wedding photographs – at the Château de Candé, near Tours in France – did not appear to irritate the new Queen. This picture was taken in the year of the abdication but was not published at the time.

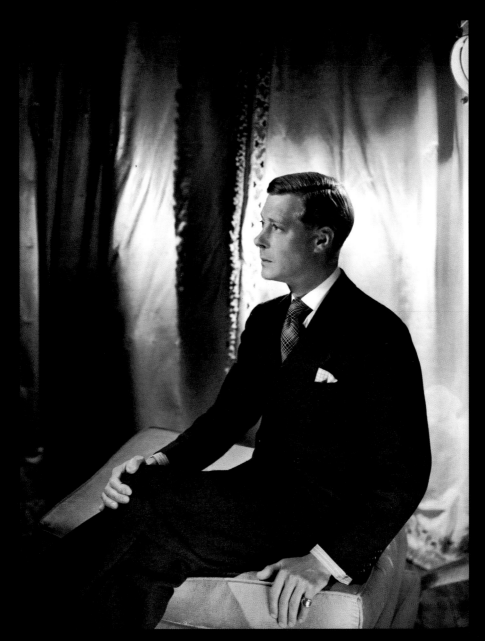

HRH THE DUKE OF WINDSOR, 1937
BY CECIL BEATON

This formal portrait, against an improvised backdrop, was taken at the Château de Candé on the day of the Duke and Duchess's wedding. Though his wife, the former Mrs Wallis Warfield Simpson, was acclaimed for her elegance, and changed outfits many times during a long day, the Duke's eye for impeccable tailoring was no less impressive. Beaton started with the Duke, and this is his account: 'He was very pliable and easy to pose and trying his hardest to make it less difficult for me – he will not allow himself to be photographed on the right side of his face and only likes his parting to be shown. He looked very wrinkled but essentially young and schoolboyish and he had great vitality and keenness… his expression though intent was essentially sad; tragic eyes belied by an impertinent tilt of nose. He has common hands – a little like a mechanic – weather-beaten and rather scaly, and one thumbnail is disfigured. His hair at 45 is as golden and thick as it was at 16. His eyes fiercely blue do not seem to focus properly, are bleary in spite of their brightness and one is much lower than the other.'

opposite
LADY LOUIS MOUNTBATTEN, 1939
BY SALVADOR DALI

As Edwina Ashley, the future Countess Mountbatten of Burma was a noted society beauty and avid partygoer. This portrait, as *Vogue* admitted, was a 'rather unusual' one, and taken on the eve of a war in which the public's perception of her was transformed. In the following years, she was rarely far from the pages of *Vogue* but only in uniform, stalwart in her home-front duties for the Red Cross and St John Ambulance Brigade. *Vogue*'s Lesley Blanch gave readers an indication of her energy: 'Her day begins at 7am and often goes on late into the evening. She tours the country, organising and supervising, seeing for herself. She will not delegate… During the worst of the Blitz she worked in the shelters – the real ones – the fetid, lousy, damp, overcrowded shelters of the East End. She was there night after night, nursing, organising, improving. No polite bandaging for her. She is as avid for work as she used to be for play… She has had experience of hospital staff work too, working in the theatres. She is still, on the face of it, too shimmering, too elegant a creature to make her work in the operating theatres credible…' She died in North Borneo in 1960, on duty as Superintendent-in-Chief of the St John Ambulance Brigade.

right
SALVADOR DALI, 1937
BY CECIL BEATON

For eight decades until his death, Dalí, with his waxed moustaches, cryptic paintings and flair for self-publicity, ensured that he was seldom out of the headlines. An illustrator, set designer, author, poet, film-maker and iconoclast, in the end he was perhaps most famous just for being Salvador Dalí. Here, wearing a fencing outfit, he hides behind two panels of his *Couple with Heads Full of Clouds* (1936). 'Who is the handsome young man on the facing page?' *Vogue* asked in an imaginary dialogue with its readers. 'Mr Salvador Dalí.' 'Is he a fencer?' 'No.' 'Then why is he dressed like a fencer?' 'Because he is a surrealist.' 'What is a surrealist?' 'A surrealist is a man who likes to dress as a fencer, but does not fence; a surrealist is also a man who likes to wear a diving suit but does not dive. Mr Dalí recently delivered a speech in London dressed in a diving suit (he was nearly smothered to death, because someone forgot to open the air valve).'

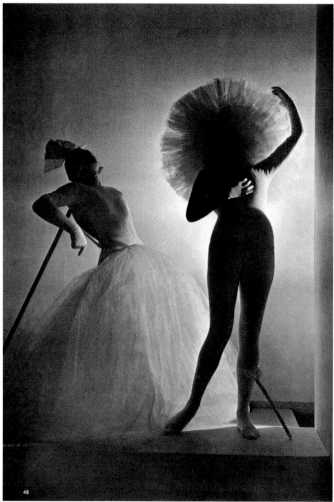

48

left
'BACCHANALE', 1939
BY HORST

Gabrielle Chanel collaborated with Salvador Dalí to produce these costumes for Leonid Massine's ballet *Bacchanale*. The choreographer found them impractical and they were never used, but *Vogue* ran the picture anyway. Taken on the eve of war, this picture marked the first time that Horst worked with the iconoclast: '[He] had just broken with surrealism,' recalled Horst. 'He and Chanel came to the sitting to fit the costumes.' Horst worked with Chanel, however, on many occasions. Once, when he refused payment for a sitting, she invited him to her home and took him on a tour of her magnificent furniture, much of it in store cupboards. Anything he admired was delivered to him the next morning.

opposite
GABRIELLE 'COCO' CHANEL, 1937
BY CECIL BEATON

'Coco' Chanel was one of the prime forces of twentieth-century fashion. *Vogue*'s excitement at being allowed, here, a preview of her next collection was palpable: 'a gown so new that it will not be shown until her autumn collections'. Photographed in her Paris apartment, next to an elaborate torchère, Chanel was also fêted as a taste-maker and patron of applied artists. 'Very often,' recalled her friend the *Vogue* photographer Horst, 'you ate with gold knives and forks.' In the postwar years, Chanel was disgraced, suspected of collaboration with the Nazi occupying forces – despite closing her salon two years after this portrait. She left Paris for Switzerland. In 1954, she made a comeback with the classic 'Chanel suit' in tweed or jersey and accessorised with gilt jewellery and fake pearls. This has been continually reworked by her successors at Maison Chanel. Chanel died in Paris in 1971, but lived long enough to see – or at least to hear reports of – *Coco*, a disastrous Broadway musical about her life, with costumes by her 1937 photographer, Cecil Beaton.

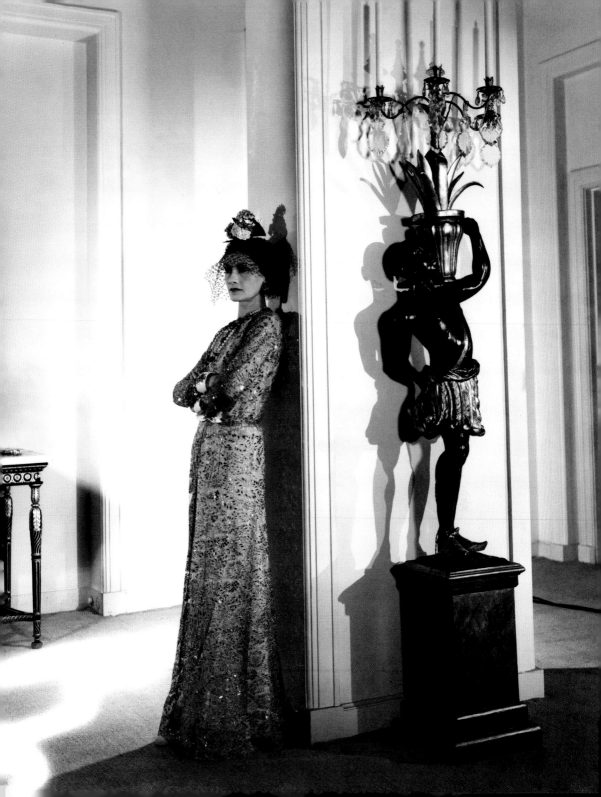

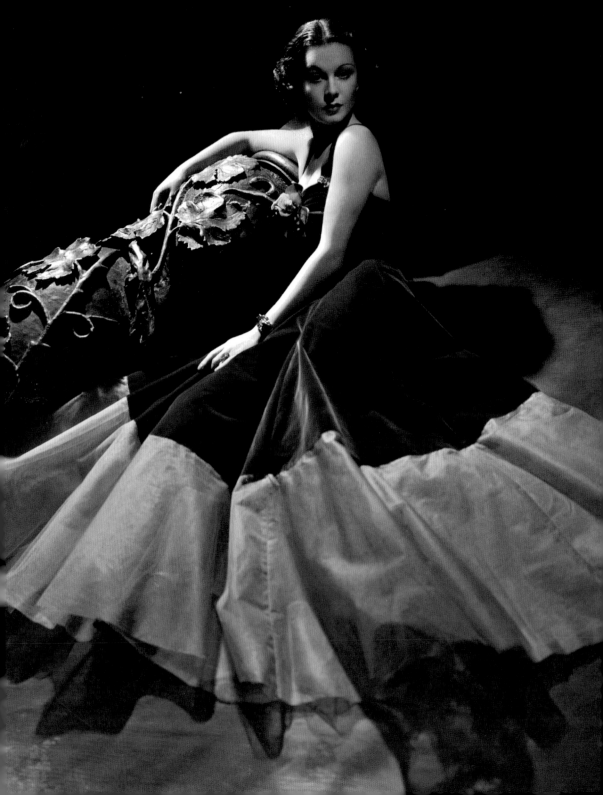

VIVIEN LEIGH, 1937
BY JOHN RAWLINGS

Here, Vivien Leigh is all but Scarlett O'Hara – a year before she won the role – in Victor Stiebel's taffeta dress with magnificent tulle-edged skirt. Her 'Southern Belle' look was no accident, as the search for *Gone with the Wind*'s heroine was a widely publicised mini-drama of its own, with every leading actress vying for the part. In an effort to secure it, Leigh put her all into *A Yank at Oxford* (1938), her first 'American' film, and her efforts did not go unnoticed by producer David O Selznick. He gave her the coveted role and it earned her her first Oscar. She had changed her name to Vivien Leigh only some three years before, having acted under her husband Herbert Holman's surname: she had briefly considered 'April Morn'.

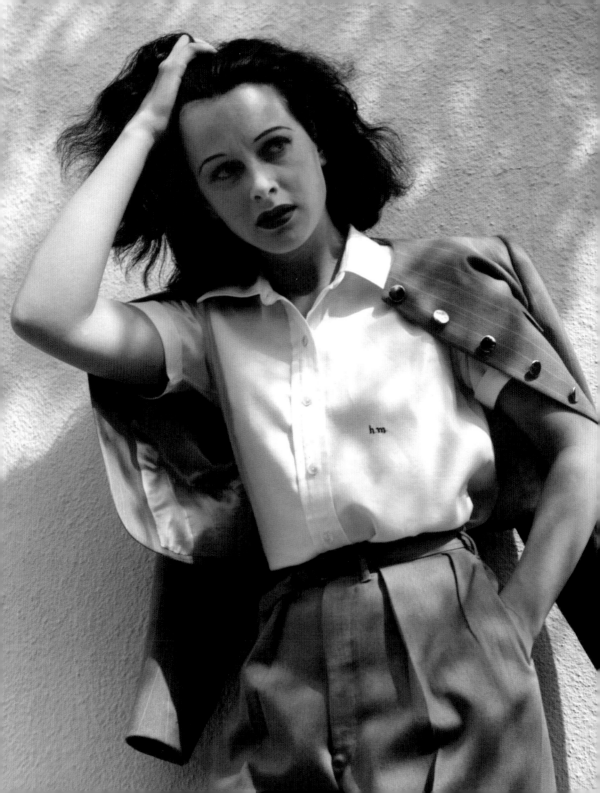

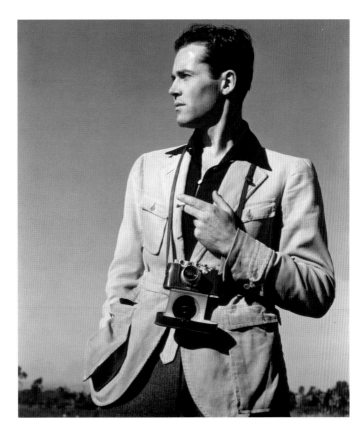

above
HENRY FONDA, 1936
BY EDWARD WESTON
Though his career was to span half a century and nearly 100 films – he received an Oscar for Best Actor only in 1981 for *On Golden Pond* – Henry Fonda was 30 when he made his screen debut. A year later, by the time of this portrait, he made a great impression as a backwoodsman in *The Trail of the Lonesome Pine*, the first film to be made outdoors in Technicolor. He followed it with *Wings of the Morning*, the first British film to be made in Technicolor, and the first of the five films in which he starred in 1937. With this portrait, *Vogue* celebrated his recent casting in *Jesse James*. When the film was released three years later, with Tyrone Power in the title role, Fonda's portrayal of Frank, Jesse's brother, so eclipsed the leading man that he was given his own film, *The Return of Frank James* (1940). In 1968, at the age of 63, after roles in classic Westerns such as *Drums Along the Mohawk* (1939), *My Darling Clementine* (1946) and *How the West was Won* (1962), Fonda played another Frank in Sergio Leone's masterful Western *Once Upon a Time in the West*. Fonda loathed the film and his malevolent and brutish character so much that he refused ever afterwards to mention either, though it was one of his most memorable roles. His friend Richard Widmark once called him 'The frontier American – part history, part folklore, part mythology'.

left
HEDY LAMARR, 1938
BY TONI FRISSELL
Born Hedy Kiesler in Vienna, Lamarr shocked audiences in her homeland with a 10-minute nude scene in the notorious Czech film *Ecstasy* (1930), relocated to Hollywood and changed her name at the insistence of Louis B Mayer. MGM trumpeted her unashamedly as 'The Most Beautiful Woman in the World'. This appearance in *Vogue* coincided with her first American film *Algiers*, in which Charles Boyer invited her to 'come with me to the Kasbah…' She did not have an instinct for a great part, having turned down the role in *Casablanca* that made Ingrid Bergman a star, and *Gaslight*, which earned her an Oscar. However, Lamarr had another career that has since eclipsed her films, which were mediocre. (Cecil B De Mille's *Samson and Delilah* was an exception; but even in that, as Groucho Marx observed, she was miscast – Lamarr should have played Samson and Victor Mature Delilah as he had the bigger breasts.) She married a leading Austrian arms manufacturer and was an attentive wife, to the extent that she acquired a highly developed scientific knowledge. With the avant-garde composer George Antheil, she invented a system of torpedo guidance that used 'frequency hopping' to avoid detection and disablement by radio 'jamming'. They refined it, using their piano keyboard and dozens of paper pianola rolls. Patented in 1942 and at the disposal of the Allied navies, the system was not taken up until after the War. It has since been used in certain modern defence systems and is a now an essential element of mobile-phone technology, eliminating much interference and preventing illicit eavesdropping. Lamarr did not profit from her joint invention. In 1966 she was arrested for shoplifting a pair of bedroom slippers and acquitted, but was up on the same charge in 1991 at the age of 76. 'Here,' *Vogue* observed half a century earlier, 'she is caught in a moment of passionate intensity… or is it perplexity over the moot hair question?'

The Noel Coward paper doll illustration includes the following printed labels:

VERSATILITY THREE-PIECE SUIT WITH DETACHABLE SINGING HEAD

ACTOR'S COSTUME WITH HOOFER ATTACHMENT FOR TAP-DANCING

VOGUE'S OWN PAPER DOLL, BASIC OUTFIT

WUNDERKIND PLUSH ROMPER SUIT AND FAUNTLEROY WIG

GLOBE-TROTTER, PALM-BEACH-COMB-ER'S KIT, WITH STUBBLE TO TASTE

PRODUCER'S OUTFIT WITH SCRIPT AND MRS. CALTHROP ATTACHMENT

MAN-ABOUT-TOWN ENSEMBLE WITH DETACHABLE ROYAL INVITATION CARD

above
'THE NOEL COWARD PAPER DOLL', 1938
BY CONSTANTIN ALAJALOV

Coward was *Vogue*'s 'Wonder Boy of English Literature', and though his career as a playwright, actor, songwriter, revue artist, author, film and theatre director, and raconteur spanned half a century, at no time was he more prolific or visible than in the Thirties. This was the decade which began with *Private Lives* (1930) and ended with *Words and Music* (1939), and along the way took in *Design for Living* (1932), *Conversation Piece* (1934) and *Tonight at 8.30* (1936). In the turbulent years to come, Churchill praised him as 'a unique national asset' for films such as *In Which We Serve* (1942), but *Vogue* in 1938 paid tribute to his versatility, effortless charm and an indefatigable talent for self-promotion. His urbanity, cultivated in private, was enhanced by a range of motifs, which Alajálov was assiduous in pinpointing for *Vogue*'s readers.

opposite
CHARLES HENRI FORD, 1937
BY CECIL BEATON

Ostensibly a surrealist poet, Ford was a peripatetic member of the circles surrounding Gertrude Stein in Paris and Pavel Tchelitchew in New York. Here he is attired for a surrealist ball in a costume of applied rubber gloves designed and photographed by Cecil Beaton. Published in Paris and simultaneously banned in the United Sates and Britain, his novel of gay metropolitan life, *The Young and Evil* (1931), earned him brief notoriety. Edith Sitwell likened it to 'a dead fish stinking in hell'. He founded the periodical *View*, which introduced many leading figures of the avant-garde, such as Marcel Duchamp and Réné Magritte to a wider American audience. It also sponsored a surrealist puppet show. In the Sixties, the whiff of notoriety, avant-gardism and his good looks intrigued Andy Warhol enough to screen-test him.

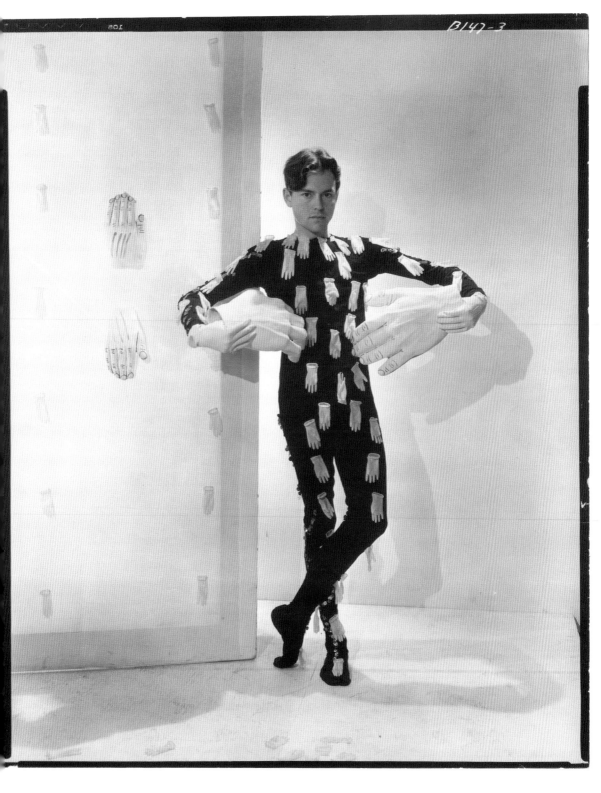

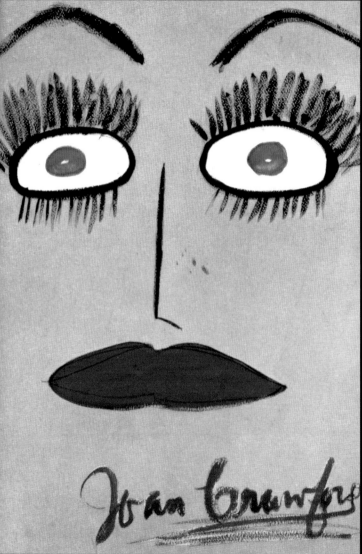

JOAN CRAWFORD, 1938
SELF-PORTRAIT

Formerly a waitress from San Antonio, Texas, Lucille Le Sueur became Joan Crawford in 1926, and by 1929 was a star. Here she makes a self-portrait, finished in lipstick and simply entitled *Me*. Horst photographed her for *Vogue* in the same year and, afterwards, observed: 'You can't do anything with this type of girl – no contact whatsoever. The face – very strong – it's all make-up, a mask not a face… the arched eyebrows, the half-closed eyes, the cheeks pulled in, the hard mouth.' To the public, however, her appeal was enduring. Nearly a decade after that photograph was taken, she received an Oscar for *Mildred Pierce*.

opposite
BETTE DAVIS, 1938
BY HORST

This portrait was taken in the year Bette Davis won an Oscar for *Jezebel*, her second. During her long career, Horst photographed her many times. Years later, he asked her to smile: 'A smile? That's not my natural tendency. I am an unsmiling woman…' She continued: 'My mother was a photographer, you know, and she was a great retoucher. I hope you are.' Horst then asked her if the light was too bright or too hot. 'I like 'em hot,' she replied.

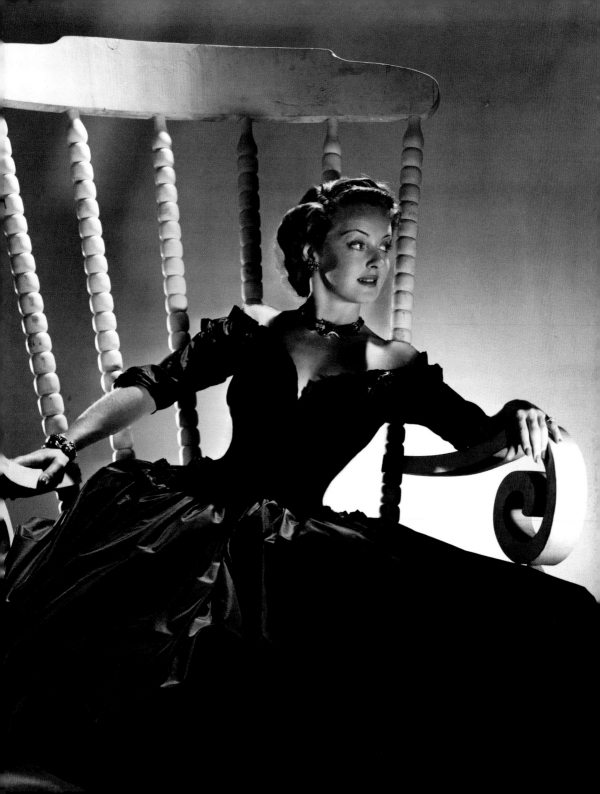

1940s

FASHION IS INDESTRUCTIBLE

While other magazines folded, *Vogue* pressed on, intended to boost morale on the home front. Paper shortages reduced its size and its circulation, and it became a monthly magazine; it had previously come out fortnightly. It did not disappoint the Ministry of War, or its readers: "Supplies may be limited but we raise the "carry-on signal" as proudly as a banner.' Staff members and photographers enlisted. Norman Parkinson retired to farm for the duration of hostilities, and Cecil Beaton roamed the world as photographer for the Ministry of Information. But it was the unlikely figure of Lee Miller, a former Vogue model and lover of Man Ray in Paris, who gave the magazine a dimension unimaginable at the outbreak of war. She became *Vogue*'s very own war photographer. She encompassed with her lens not just the 'grim glory' of blitzed London, finding an artist's harmony in the patterns of rubble and bombed-out buildings, but also the combat zone. She was the only photographer at the siege of St Malo, where napalm was used for the first time; she billeted herself in Hitler's abandoned Munich apartment; she endured the atrocious winter of the Alsace campaign; she helped liberate Paris. Pushing on into Germany as the war in Europe came to a close, she photographed the horror of Dachau and Buchenwald.

Prewar dress and dress codes were replaced in the magazine by utilitarian and functional garb and a new emphasis on the versatility of one's wardrobe. Social niceties became irrelevant and *Vogue* resigned itself to a casual rudeness born of hardship: 'When Lord Woolton orders us to lick the jam jar,' *Vogue* said wearily, 'table manners change accordingly.'

Vogue embraced the new culture of make do and mend, which brought about a curious democracy. Words of advice from

Vita Sackville-West were probably useful to only a few: 'Tether a cow on the lawn, grow sorrel and alpine strawberries (the birds don't touch them), turn outdoor grapes into sultanas and pink vinegar.' Scarcity led to absurdity in those restaurants that kept going. 'Many trimmings are added to food. Spam has assumed the sophisticated name of Ham Americaine; rabbit masquerades as "chicken" and a shell heaped high with carrots and garnished with cabbage is still "crab".' At the better restaurants you might in times of crisis slip down to the cellars. 'A recent alarm found the Dorchester shelter filling up with celebrities,' *Vogue* reported. 'Lady Diana Cooper in full evening dress, Vic Oliver in serious mood, his wife Sarah Churchill asleep on the floor, several ministers without portfolios or gas masks either...'

Victory heralded another slow and dismal recovery. The national trade deficit was almost incalculable. 'Peace is like war,' said one wit, 'but without the shooting.' Food rationing became even harsher than during wartime and continued until 1954. Two events, however, cheered the *Vogue* reader in 1947. First was the marriage of Princess Elizabeth, heir to the throne, to a dashing, if displaced, Greek prince, Philip. Their first son, Charles, was born a year after. The second was the dawn of the 'New Look' in Paris. Christian Dior's inaugural collection used yards of luxurious fabric and caused outrage and delight in equal measure.

Britain began shedding its empire, became a welfare state and limped into a more optimistic 'atomic age'. Privilege had had its day – for the time being; so, too, extreme poverty. 'The social conscience of the country has been growing steadily,' *Vogue* observed. 'The pessimist who regards progress as a myth finds no ammunition here.'

BEAUTY and YOUNGER GENERATION NUMBER with VOGUE PATTERN BOOK · AUGUST 1940 (8) · PRICE 2/6

DRESSING FOR PLEASURE

THE BRIGHT SWIMMING SHELL

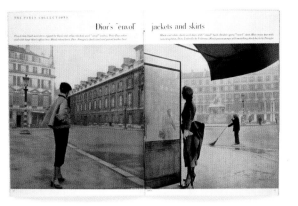

Dior's "envol" jackets and skirts

The Forties produced some of *Vogue*'s most memorable covers, among them Erwin Blumenfeld's 1949 semi-abstract beauty composition (*below*) and Horst's 1940 paean to Lisa Fonssagrives's body (*opposite*). To celebrate the 1948 London Collections, Clifford Coffin, an American expatriate, re-created the London pavement artist's sunny milieu in the *Vogue* studio (*right*). His spread of Dior couture for the Paris Collections of the same year (*above*) shows his equal skill on location, while his 1949 arrangement of American swimwear (*opposite below*) displays a surrealist eye. His rival at British *Vogue*, Norman Parkinson, collaborated successfully with his wife Wenda (*below right*, 1949) – ironically, a model 'discovered' by Coffin.

VOGUE

THE LONDON COLLECTIONS AND SPRING FABRICS

INCLUDING VOGUE PATTERN BOOK THE CONDÉ NAST PUBLICATIONS LTD. MARCH, 1948 · PRICE 3/-

VOGUE

Beauty
Younger
Generation
Hats

AUGUST 1949
PRICE 3/-

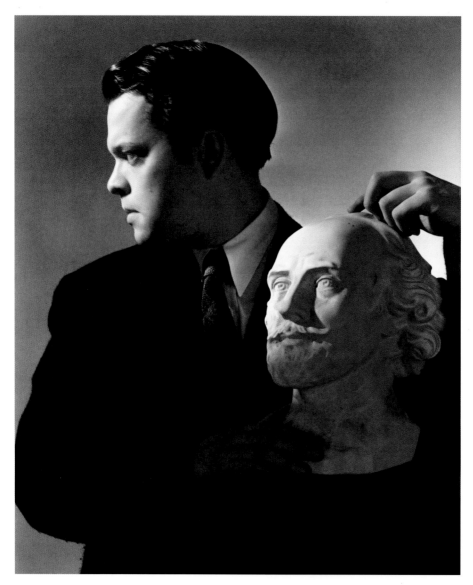

above
ORSON WELLES, 1941
BY CECIL BEATON

Marking time before the release of his long-awaited *Citizen Kane*, Welles made *Journey into Fear* with Dolores Del Rio, and with whom he had a much-publicised romance. Beaton enjoyed a close relationship with Welles and, several years before this rather serious portrait, Welles invited Beaton to create costumes for a production of *Henry IV*. The offer was rescinded after Beaton, possibly absent-mindedly, doodled an anti-Semitic remark on a *Vogue* illustration and left the magazine – temporarily – under a cloud. Despite this setback, the two remained on cordial terms.

right
CHARLES HAWTREY, 1940
BY LEE MILLER

Late in life, Charles Hawtrey regretted his move from the variety stage to the *Carry On* series of comedy films, which, being 'downmarket', he believed demeaned his talents and made it difficult for him to secure serious parts. But an early career spent almost exclusively in drag – and later he was a memorable ward sister in *Carry on Nurse* – did not help his cause; nor did his regular appearances in lightweight Will Hay comedies. He started young. In 1925, as a 10-year-old, he made his stage debut, singing *A Country Life for Me* as one of a gang of cockney street urchins. But it was his role as a 'wilting lily' in revue that first brought him to *Vogue*'s attention. In other roles, often requiring female impersonation – he was a memorable female spy for an Eric Maschwitz show – he continued to entertain wartime audiences. Radio comedy started his typecasting as querulous and camp; the television show *The Army Game* consolidated it, requiring him, as it did, to knit for Queen and Country, and 23 *Carry On* films firmly cemented him in the public eye as a spindly, bespectacled – if much loved – twit.

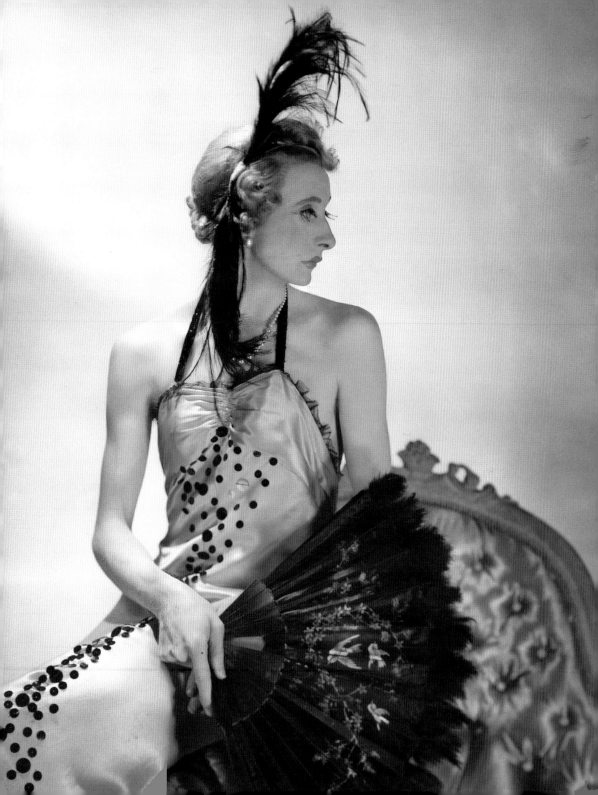

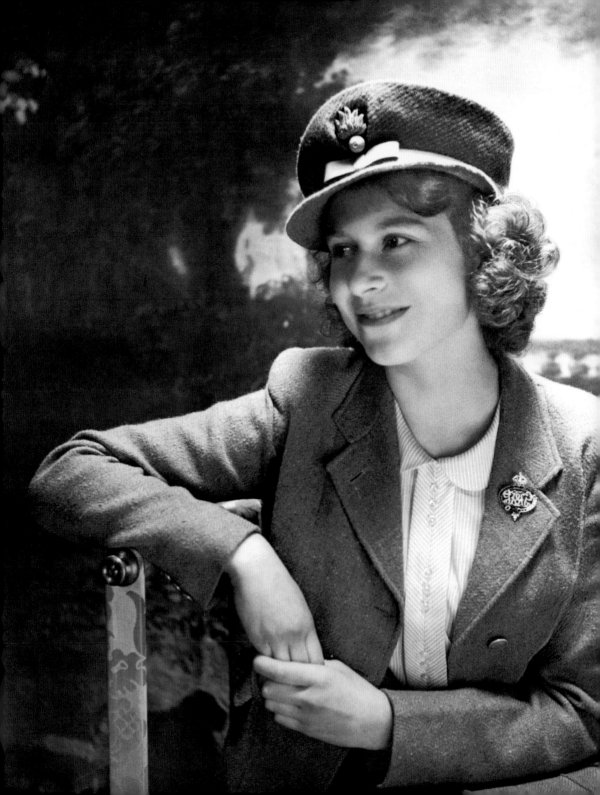

PRINCESS ELIZABETH, 1942
BY CECIL BEATON
Having been made the Colonel-in-Chief of the Grenadier Guards, Princess Elizabeth here wears their badge. Three years later, she became a subaltern in the Auxiliary Territorial Service. Beaton made this wartime study of the 16-year-old princess at Buckingham Palace, following a formal sitting with the Royal Family. The group also included Mrs Eleanor Roosevelt. Beaton was unimpressed by the American President's wife, observing, 'personal vanity is something of which she is not conscious.'

GALA DALI, 1943
BY HORST

Helena Ivanovna Diakonova, once married to the
poet Paul Eluard, proved to be the match of her
second husband, the painter Salvador Dalí. 'We shall
never,' she told him on their first meeting, 'be apart.'
Indeed their union ended only with her death in
1982. She was his lifelong muse, model, accomplice
and champion and, as important, his business
manager. In this last capacity, she was especially skilled:
Dalí earned so much money from commissioned
portraits, advertising and licensing that André Breton
invariably referred to him by an anagram of his name
'Avida Dollars'.

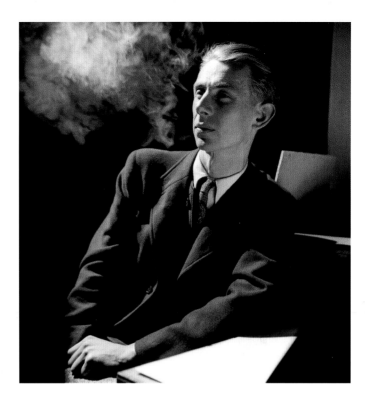

above
HUMPHREY JENNINGS, 1944
BY LEE MILLER
By 1944, Jennings was involved in documentary work for the war effort, having achieved early success with the GPO Film Unit. His friendship with the painter and enthusiast for modern art movements Roland Penrose led, in 1936, to his helping Penrose and André Breton instigate the International Surrealist Exhibition in London. Until his early death in 1950, Jennings was a frequent visitor to the home Penrose shared with his wife the photographer Lee Miller. Before her assignments as a *Vogue* war correspondent took her in a different direction, Miller frequently betrayed her own surrealist sensibilities in her work. Here, in a variant of the published portrait, a cloud of cigarette smoke threatens to obscure her sitter's face, like the floating apple or rock of a Magritte painting.

left
FRED ASTAIRE, 1944
BY LEE MILLER
Astaire's debonair and elegant style entranced Depression-era filmgoers and as a dancer/singer/actor he was unequalled in the genre of the Hollywood musical. He started out as part of a child act with his sister Adèle. They struggled for recognition – on one bill they were replaced by a comedy dog act – but in time became the biggest draw of their era. Adèle retired and Fred went solo. His easygoing self-deprecation was epitomised with his own assessment of his chances when he started out: 'Can't act, can't sing, balding, can dance a little…' His partnership with Ginger Rogers, which began with the musical *Flying Down to Rio* in 1933 and continued with nine other shows, was dissolved for the duration of the War – starting up again in 1949. Here, *Vogue's* Lee Miller catches the affable performer unawares. He is signing autographs backstage for fellow showstopping performers at the Théâtre Olympia on the occasion of the first GI show staged in Paris after the Liberation. Miller reported, 'All Paris had been talking of nothing else for a week…' She added that, true to form, 'he showed the minimum of irritability that his theatre call was hours too early.'

left
GENERAL DE GAULLE, 1944
PHOTOGRAPHER UNKNOWN

When France fell, de Gaulle, its Under-Secretary for War, was in London. The government of which he was a member refused to surrender to the occupying forces, and was hastily replaced by one that did, the Vichy government of Marshal Pétain. In exile, de Gaulle became the leader of the Free French. The identity of the photographer who captured the early moments of the general's return to Paris is unknown. He or she belonged to 'Photo Press Liberation', a group of French resistance photographers who banded together to cover the battle for Paris and its victorious aftermath. Their number, *Vogue* told readers, included Henri Cartier-Bresson and Robert Doisneau and about 50 others. This photograph was taken from a window of *Vogue*'s former offices. 'How many of our French staff were lost in 1940, we do not yet know,' declared British *Vogue*, 'the 20-year-old son of our Paris editor [Michel de Brunhoff] was shot this June by the Gestapo. The husband of another colleague is held to ransom in Germany. The daughter of a third, after years in concentration camps, is in prison in Silesia… The French concept of civilised life has been maintained, but at a heavy price.'

right
PABLO PICASSO, 1944
BY CECIL BEATON

Picasso's Spanish nationality was no guarantee of his safety and in occupied Paris during the War he took all kinds of risks. Perhaps the greatest was staying there and continuing to work. The Nazis banned the use of bronze for sculpture, but Picasso believed that anything else would have a temporary life. Bronze was for ever, and he continued to work with it, as well as to paint. When the city was liberated, Picasso was a highly visible figure in the celebrations. Here, Cecil Beaton follows him as he conducts a crowd of GI and WAAC sightseers to the studio of Adam the sculptor. He also welcomed them into his own studio for impromptu classes in art appreciation. Beaton was not the first *Vogue* photographer to greet him in postwar Paris. Lee Miller sought him out on the day of liberation and he greeted her with, 'The first Allied soldier I have seen and it's you!' Later, Picasso was not so pleased. Miller ate the fruits of a tomato plant that he had diligently cultivated and which had formed the subject of a dozen drawings. As her son and biographer, Antony Penrose, wrote, 'Lee watched with horrified fascination as his face first went white, then rapidly puce. He bunched his fists in a fury…'

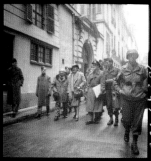
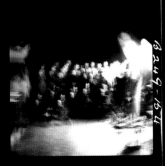

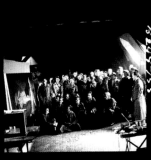

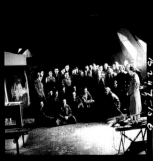

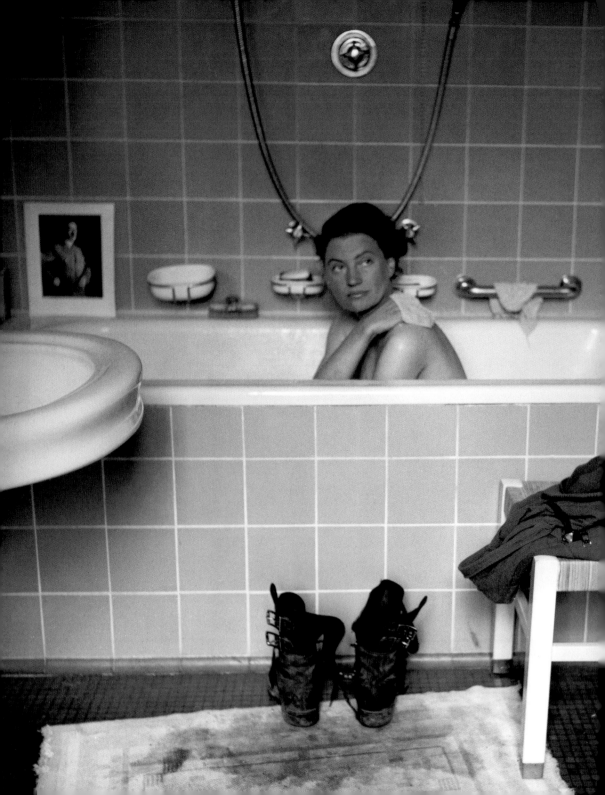

LEE MILLER, 1945
BY DAVID E SCHERMAN

In Munich, photographed by her comrade David Scherman of *Life*, *Vogue*'s war correspondent Lee Miller bathes in the bathtub of Hitler's abandoned apartment. They had just heard of Hitler's suicide. Scherman recalled that an angry lieutenant of the 45th Division of the US forces, 'soap and towel in hand, beat on the door outside'. Munich had particular resonance for Hitler, not least as the site of his 1921 *Bierkeller Putsch* and of meetings with Franco, Mussolini and Chamberlain. The latter had brought him a beer tankard shaped like the head of George VI, which played the British National Anthem when raised. Hitler's wife, Eva Braun, by now dead too, had also kept an apartment nearby, where the two photographers later billeted themselves. The next day, they travelled to Berchtesgaden, the site of the Eagle's Nest, Hitler's Alpine retreat; Miller photographed it burning – the *Götterdämmerung* of the 'Thousand-Year Reich'. Back at the press headquarters, a soldier wandered over and told them that the war in Europe was over. Miller spun it out a little longer. She travelled east, was arrested by Russian soldiers and, on her release, moved on to Budapest. There she witnessed László Bardossy, the fascist former Prime Minister of Hungary, facing the firing squad. She photographed the event (*below*) and reported to *Vogue*: 'The four gendarmes who had volunteered for the execution stood in line awaiting the order to fire. They were less than two yards from him. Bardossy's voice orated in a high-pitched rasp. "God save Hungary from all these bandits." I think he started to say something else but a ragged tattoo of shots drowned it. The impact threw him back against the sandbags and he pitched to his left in a pirouette, falling on the ground with his ankles neatly crossed.'

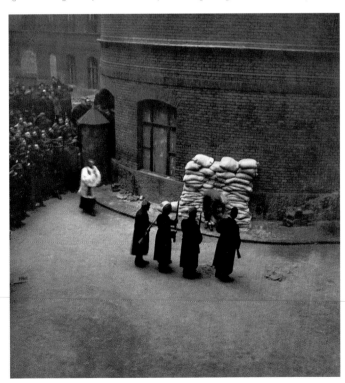

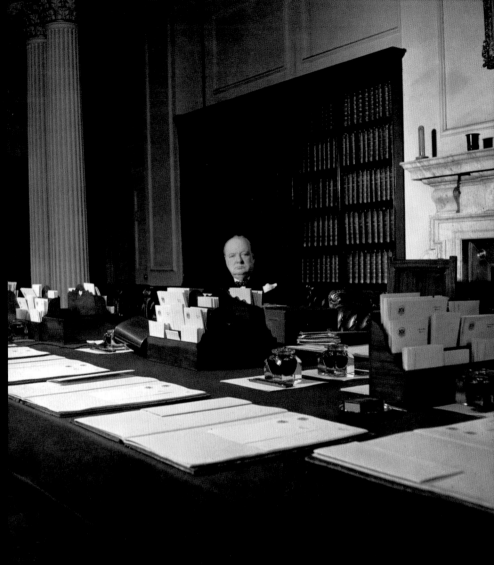

SIR WINSTON CHURCHILL, 1940
BY CECIL BEATON

The British wartime leader was photographed at his desk in the Cabinet Room at Downing Street, facing Beaton's camera with the same uncompromising disposition with which he faced the international crisis. This sitting took place only six months into his 'walk with destiny', after he had formed a coalition government, following Neville Chamberlain's defeat in May 1940. Beaton was aware that his sitting with the Prime Minister would be circulated to British newspapers, though *Vogue* would publish it first, and he resolved to 'wear down [Churchill's] grim façade'. On November 10, Beaton was ushered into Churchill's forbidding presence. 'At the centre of an immensely long table,' he recalled, 'sat the Prime Minister, immaculately and distinguishably porcine, with pink bladder-wax complexion and a vast cigar freshly affixed in his chin; fat, white tapering hands deftly turning through the papers in a vast red-leather box at his side.' Churchill did not relish the intrusion and Beaton reported that he stared into his camera 'like some sort of an animal gazing from the back of its sty'. They parted, though, on cordial terms and Beaton was invited back.

HARDY AMIES, 1946
BY ROLAND HAUPT

The British couturier was best known to the public as a royal dressmaker and as one of the last links to an age of modishness which valued such habiliments as long white gloves, tea gowns and *robes-de-chambre*. Amies's Savile Row fashion house has long survived its immediate British contemporaries and, though Amies died early in 2003, aged 93, it still flourishes. Despite his effortless-looking personal elegance, when this photograph was taken, he had most recently been employed as an assiduous liaison officer to the Allied forces in Brussels. 'Hardy always managed,' observed his friend the late Bunny Roger, 'to look dapper in uniform.' Amies was also renowned for his bons mots, such as, 'if everyone grew roses, there would be no more revolutions…'

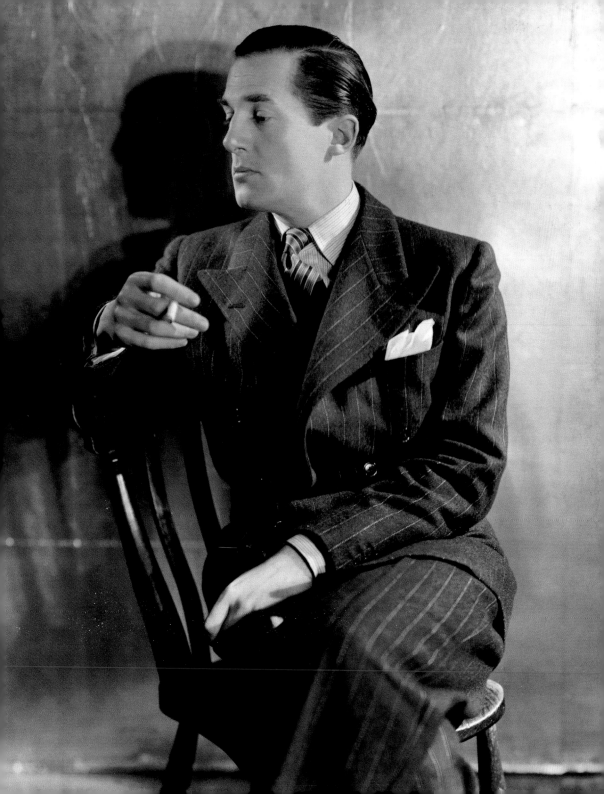

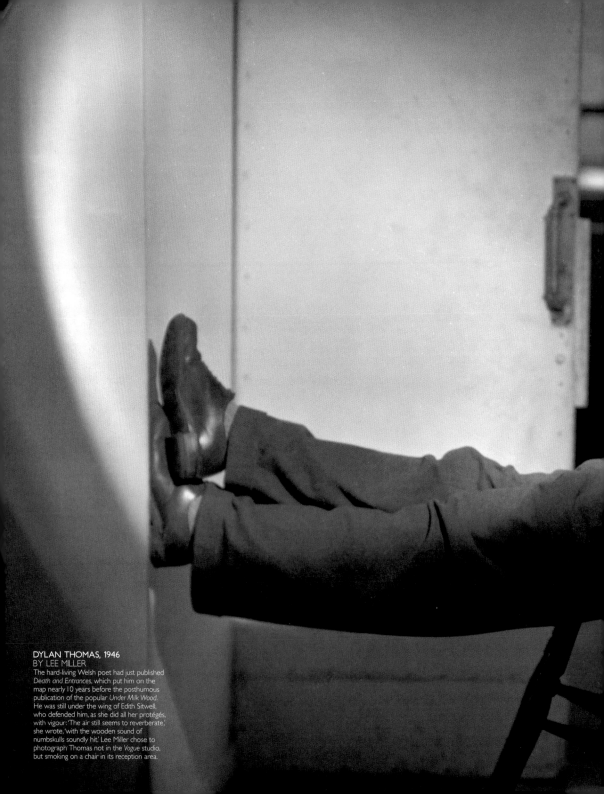

DYLAN THOMAS, 1946
BY LEE MILLER
The hard-living Welsh poet had just published
Death and Entrances, which put him on the
map nearly 10 years before the posthumous
publication of the popular *Under Milk Wood.*
He was still under the wing of Edith Sitwell,
who defended him, as she did all her protégés,
with vigour: 'The air still seems to reverberate,'
she wrote, 'with the wooden sound of
numbskulls soundly hit.' Lee Miller chose to
photograph Thomas not in the *Vogue* studio,
but smoking on a chair in its reception area.

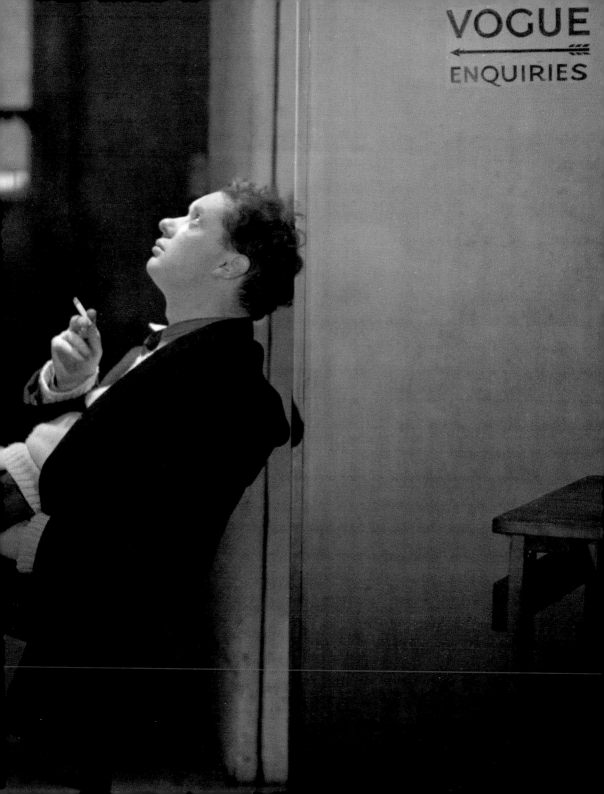

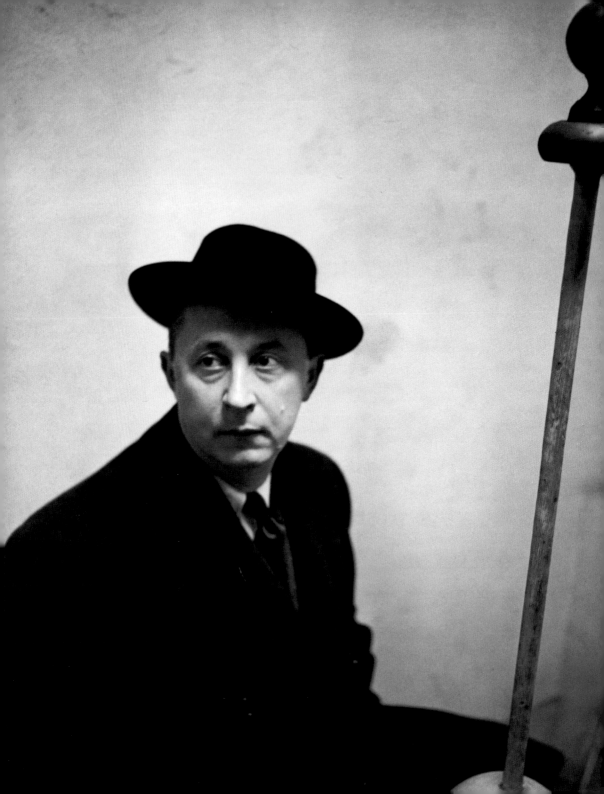

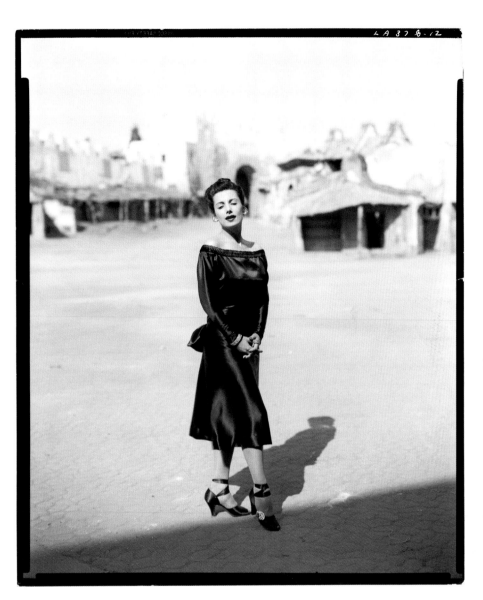

CHRISTIAN DIOR, 1947
left
BY CLIFFORD COFFIN

Coffin's portrait of a rather glum couturier on the day of his first collection (February 12, 1947) gives no hint of the rapture with which it was later reported. Dior's debut, if not *the* 'fashion moment' of the twentieth century, certainly remains one of the best known. It was an uninspired season until then. Dior's lavish use of fabric – 15 yards for a woollen day dress, 25 yards for a short taffeta evening dress – defied the austerity of the world outside his atelier. American *Vogue's* Bettina Ballard was there and, writing of the run-up in her memoirs, recorded: 'I was conscious of an electric tension… People who were not yet seated waved their cards in a frenzy of fear that someone might cheat them of their rights. Suddenly the confusion subsided, everyone was seated and there was a moment of hush that made my skin prickle…'

TAMARA TOUMANOVA, 1947
above
BY GEORGE PLATT LYNES

Legend had it that the ballerina Tamara Toumanova was born on a Paris-bound train fleeing the Bolshevik Revolution. Eventually she reached the United States and, years later, after a career with the ballet of the Paris Opéra and the Ballets Russes de Monte Carlo, she became a film actress. She still danced, and here *Vogue* was looking forward to her imminent season as *première danseuse* at the Opéra. Her debut film was *Days of Glory* (1944), in which she starred with Gregory Peck – it was his debut too. She did not enjoy the Hollywood 'star' system, retained a prima ballerina's haughty disdain for movies and famously refused all attempts to glamorise her. This did not extend, clearly, to magazine features, and she was coaxed into the bright California sunshine of the MGM lot and into a black satin dinner dress. No doubt it helped that she knew *Vogue's* photographer of old. Before (and during) his years with the magazine, George Platt Lynes was known as one of the great ballet photographers.

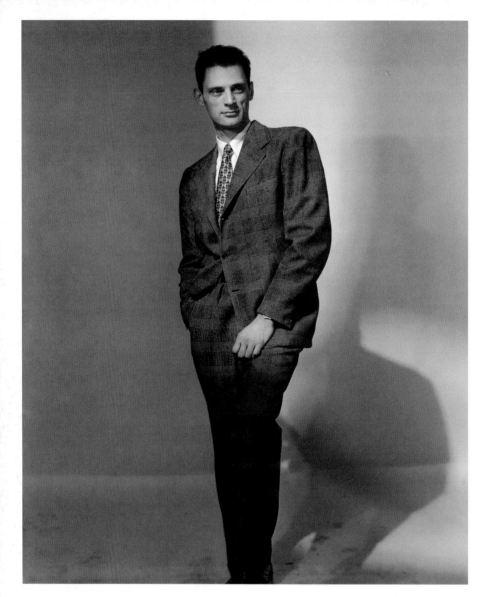

above
ARTHUR MILLER, 1948
BY CLIFFORD COFFIN

By the spring of 1948, there had been more than 200 performances of
Arthur Miller's play *All My Sons*, and it was later made into a film. Miller
had emerged as one of the twentieth century's great American dramatists,
his reputation sealed with his following play *Death of a Salesman* (1949),
written in six weeks. Later filmed, it earned him a Pulitzer Prize for Theater.
Before this success, Miller, born in New York City, had driven trucks and
washed dishes to pay his way through college. A succession of his plays on
Broadway started with *The Man Who Had All the Luck* in 1944, and
culminated in the huge success of *All My Sons*, which, as *Vogue* noted, had
just opened in London at the time of this picture.

opposite
MARLON BRANDO, 1947
BY CECIL BEATON

The young actor was about to star in Tennessee Williams's *A Streetcar
Named Desire*. He came to the photographic studio for this session, Beaton
remembered, 'as if about to be stung by wasps'. Indeed Beaton and the
brooding star-to-be never quite hit it off, though they met amicably later. In
1957, Beaton caught sight of Brando at Tokyo airport: 'He has lost his looks
in 10 years, looks like a heavy-set businessman, podgy hands, a thick build, a
"*Guys and Dolls*" hat. But his behaviour is all that could be desired,
courteous, co-operative, good humoured…'

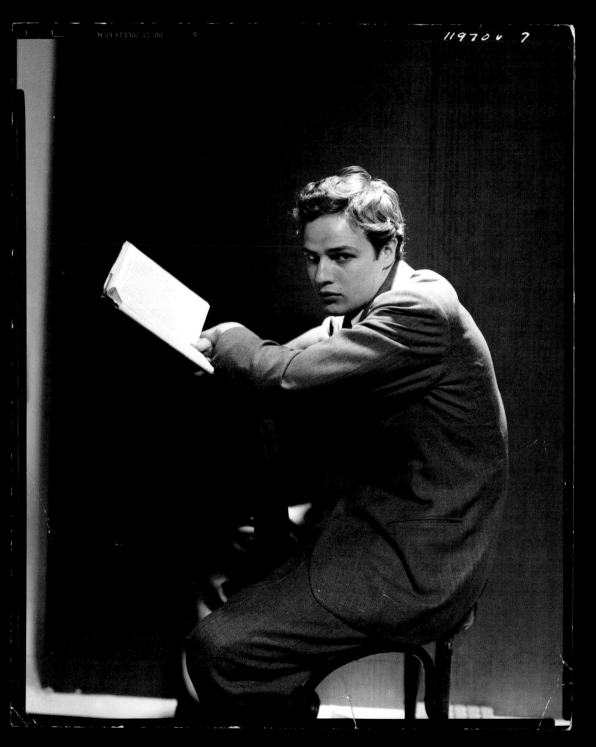

above
LUCIAN FREUD, 1947
BY CLIFFORD COFFIN

The 25-year-old artist stands in his north-lit Paddington studio next to his painting *The Greek Boy*. Freud, born in Germany, had just returned from a five-month trip to Greece – the longest he had ever spent away from London since his arrival in 1933. On his gloved hand is the second of two sparrowhawks he owned – the other had died. He had had a kestrel, too, but it deserted him near Lord's. Having traded a painting for a German Luger pistol, Freud shot rats for his birds on the canal near Regent's Park. Here, he wears a Merchant Navy sweater, which he had acquired for an abortive trip on a North Atlantic convoy to Nova Scotia in 1941.

opposite
CHRISTOPHER ISHERWOOD, 1947
BY GEORGE PLATT LYNES

Along with his school friend W H Auden, the poet Christopher Isherwood left Britain for the United States on the eve of war. Auden settled in New York and Isherwood in California, where he became an intimate of *Vogue*'s West Coast photographer George Platt Lynes. For his many novels, Isherwood was a meticulous note taker and a cool observer of human nature: 'I am a camera,' he wrote in his Berlin books, 'with its shutter open, quite passive, recording…' Isherwood was employed as a scriptwriter when Lynes made this portrait, and *Vogue* reported: 'In a large white room above a garage, Christopher Isherwood sits at a desk covered with proofs and manuscripts. The room is neat and the walls are bare, except for a few photographs and sketches. Now and then Isherwood jumps from his chair, stares out of his window at the Santa Monica beach, then sits down again, folding his legs under him like a yogi.'

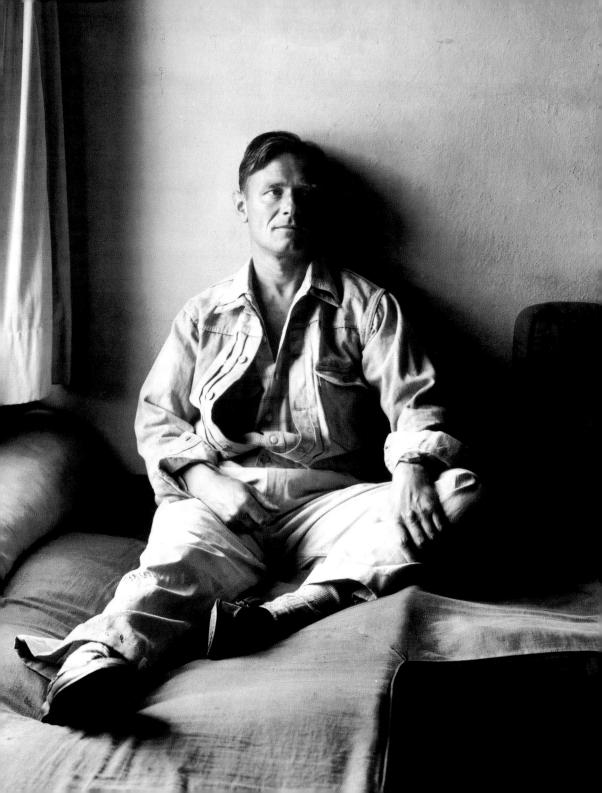

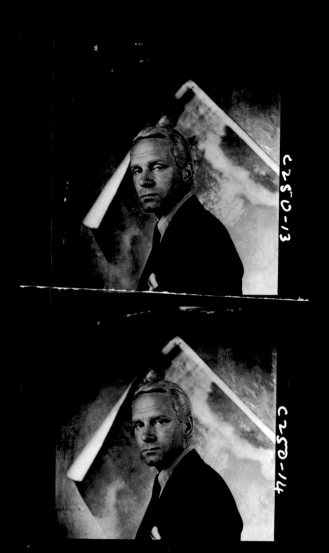

LAURENCE OLIVIER, 1947
BY CLIFFORD COFFIN

With the film of *Hamlet* (1948), which he directed and for the staming role for which he had dyed his hair blond, Olivier became 'The Greatest Actor in the World'. It won him the first Best Film Oscar for a non-American-produced-and-financed film. He was already, at least in the eyes of home crowds, 'The Greatest Stage Actor in the World' – although the accolade might reasonably have been bestowed on both John Gielgud and Ralph Richardson. All it took to convince American theatregoers, was his appearance on Broadway in Coward's *Private Lives*. At the time of this sitting (of which these pictures are the surviving fragments), Olivier had just received a knighthood. In 1970, he was the first actor to be created a life peer. His film of *Henry V* (1944), in which again he was director and star, was a vital piece of war-time propaganda. By the time Coffin took these pictures, Olivier was running, acting and directing at the Old Vic Theatre Company – in partnership with Richardson. This was the period of his *Lear* and *Richard III*. Coffin, an American photographer, spent several days documenting the company and also took a number of costumed self-portraits backstage in the prop and make-up rooms. A flamboyant and excitable figure, he was not popular there and this may explain Olivier's cold expression. A year later, neither Olivier's nor Richardson's Old Vic contracts were renewed; Olivier declared it 'the ruin of our house'.

JOHN GIELGUD, 1948
BY IRVING PENN

'He is unique in the English theatre,' wrote *Vogue*, 'for his combination of equally balanced talents – brilliant producer and unsurpassed actor.' Gielgud was the outstanding classical actor of the last century and, if heard only once in a lifetime, the timbre of his voice was unforgettable. His friend Alec Guinness likened it to 'a silver trumpet muffled in silk'; the playwright Emlyn Williams compared it to 'an unbridled oboe'. At school, his drama teacher commented that he carried himself 'like a cat with rickets'. He made his London debut in 1923, as a butterfly in *The Insect Play*. 'I'm surprised,' he said later, 'that the audience didn't throw things at me.' His *Vogue* debut was a year later, when he played Romeo on the London stage. His Juliet was Gwen Ffrangcon-Davies, who was later the focus of one of his legendary gaffes, born of his propensity for candour – a quality which endeared him to the public. Years after their debut together, Miss Ffrangcon-Davies asked him with whom he had least enjoyed acting: 'Oh, that's easy,' he replied. 'Gwen Ffrangcon-Davies. She was frightful! Not, um, you, of course, my dear… I mean the, um, other Gwen Ffrangcon-Davies…' He could also be self-deprecating: 'Oh dear!' he said after watching rushes of the film *Julius Caesar* (he was Cassius), 'my eyes are wandering as if I've just spied a policeman coming to arrest me.' In the late Forties, Gielgud was passed over in the selection of a triumvirate, which included Laurence Olivier and Ralph Richardson, to run the Old Vic Theatre Company; he was also passed over for a knighthood, though he received one in 1953, years after Olivier and Richardson. As a result, he based himself in the United States for nearly two years, and in New York sat for Irving Penn for one of his minimalist portraits. Penn's direct approach was, *Vogue* considered, 'point-blank'.

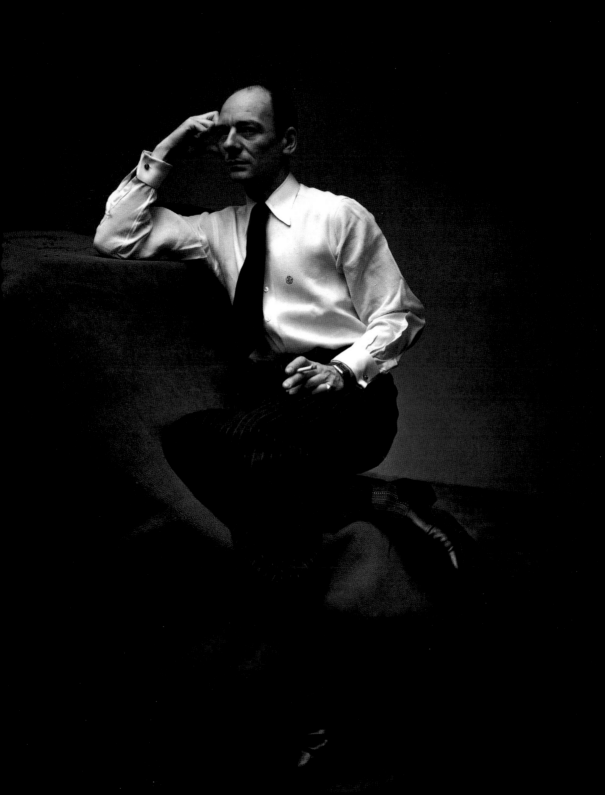

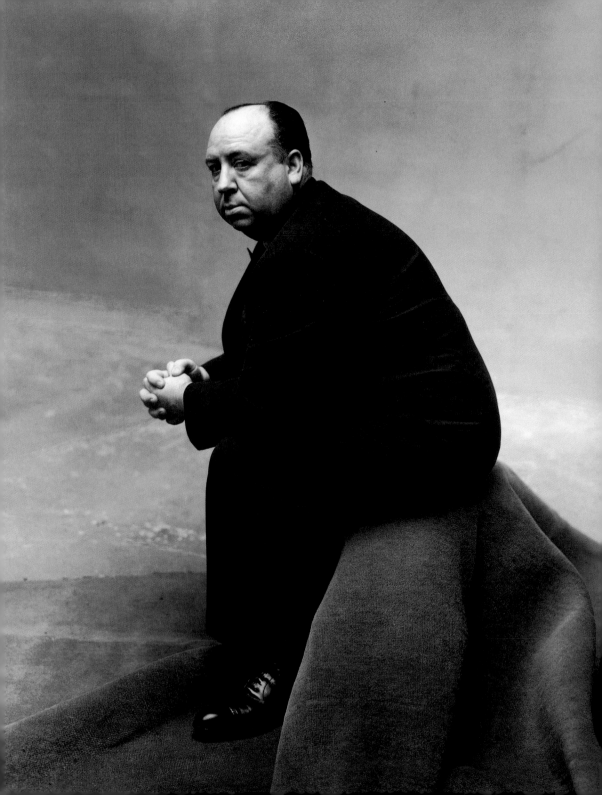

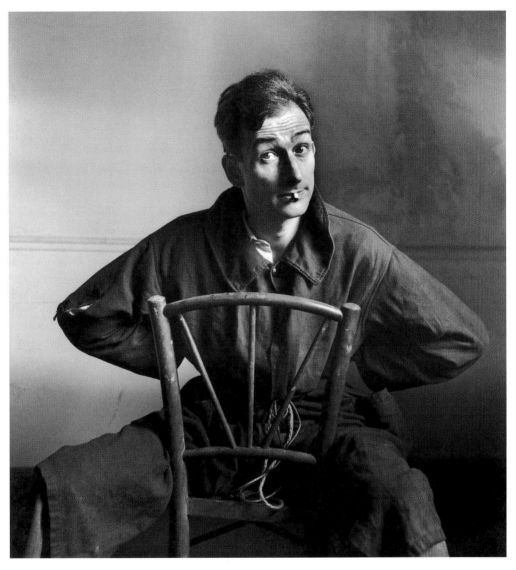

opposite
ALFRED HITCHCOCK, 1948
BY IRVING PENN

So precise was Hitchcock as a director and storyteller that *Vogue* considered that 'the Hitchcock touch' had passed into the critic's vocabulary many years previously. Hitchcock visited Penn's New York studio during pre-production for *Under Capricorn*, a Technicolor period melodrama which he sandwiched between superior films *Rope* and *Stage Fright*. In 1948, Hitchcock celebrated his first quarter-century in films. His third feature, *The Lodger*, a silent film, set the tone for what was to come – suspense, murder, suspicion, moral ambiguity, the innocent in peril and a cameo appearance from the director himself. His early oeuvre also revealed his twin personal phobias: policemen and heights, which he worked upon for his most suspenseful thrillers. Hitchcock was lured to the States on the eve of war and his first film made there, *Rebecca* (1940), won the Oscar for Best Film. He made a further 31, all meticulously crafted on paper, each shot worked out in advance, each technical problem confronted beforehand, every movement painstakingly choreographed. For Hitchcock shooting a film was a formality.

above
BALTHUS, 1948
BY IRVING PENN

'Balthus', the painter known as 'Balthus' told his collaborators on a Tate Gallery show in 1968, 'is a painter of whom nothing is known.' Even his purported real name (Balthazar Klossowski de Rola) and his ancestry (he styled himself as a Count) were contentious. He made it a lifelong resolve to appear as enigmatic and reticent as his paintings were controversial. At 92 he maintained he was only 23 – he was born on February 29 of the leap year 1908. Undisputed is that his provocative, erotically charged paintings, often of young girls, are among the most beguiling paintings to come out of twentieth-century Europe. Picasso admired him greatly and acquired his *Les Enfants* (1937), remarking, 'Balthus is so much better than all these young artists who do nothing but copy me. He is a real painter.' His sitting for a photographer was a rare event, a magazine appearance rarer still. Balthus guarded his privacy and shunned public appearances for many decades. He eventually became director of the French Academy in Rome, where he taught for almost 16 years. For his ninety-second birthday – his last – he held a fancy-dress ball. Among the bizarre collection of guests, were Tony Curtis, Bono and Nicholas, the Romanov pretender to the Russian throne. Penn took this photograph in France in the year Balthus's father died and he reclaimed his Polish lineage, assuming the title of Count de Rola.

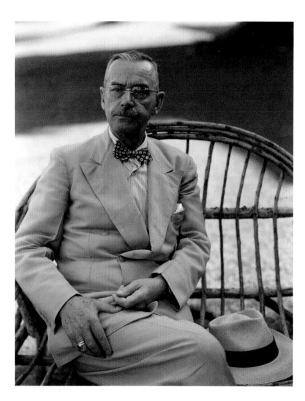

THOMAS MANN, 1949
BY GEORGE PLATT LYNES

By 1949, the great modernist author had spent 16 years of exile from his native Germany, first in Czechoslovakia, then Switzerland and the United States. He was an early and public critic of the rising Nazi party and, during the War, his anti-Hitler broadcasts were collected as *Achtung Europa*. When this picture was taken, nearly half a century had passed since his early masterpiece, *Buddenbrooks* (1901); and it was 20 years since *The Magic Mountain* (1924) had earned him the Nobel Prize for Literature in 1929. His later *The Confessions of Felix Krull*, which was unfinished at his death in 1955, was hailed as a masterpiece of German comedy. His most recent biographer, Hermann Kurzke, observes that '[Mann] went through his world like a drift-net in which everything useful was caught.' Among his many prizes, he was awarded an honorary doctorate by Yale at the same ceremony in which Walt Disney collected his.

opposite
BALLET SOCIETY, 1948
BY IRVING PENN

The choreographer George Balanchine was fond of quoting Maykovsky's 'I am not a man but a cloud in trousers'. But, pushing against the walls that threaten to enfold him and two somnolent collaborators, is the most ethereal of this quartet, the 19-year-old Tanaquil LeClerq. The 'cloud in trousers' is on the extreme right, clutching a dirty raincoat. LeClerq was in costume for *The Triumph of Ariadne and Bacchus*. A choral ballet, it was choreographed by Balanchine, composed by Vittorio Rieti (*left*), and the set design was by Corrado Cagli (*centre*). Ballet Society, formed two years previously by Balanchine and Lincoln Kirstein, was the successor to their previous ensemble, The American Ballet. 1948 saw the new company at its most illustrious. It was offered permanent residence in New York as The New York City Ballet. Balanchine was its principal choreographer from then until his death in 1983. In 1952, LeClerq became his fourth ballerina wife, succeeding Tamara Geva, Alexandra Danilova and Maria Tallchief. Her career was cut short by polio four years later. This is one of the best-known, and earliest, of Penn's 'corner' portraits; to create the confining space, he pushed together two studio flats at an acute angle. Penn recalled that this confinement 'surprisingly seemed to comfort people; soothing them. The walls were a surface to lean on or push against. For me, the picture possibilities were interesting; limiting the subjects' movement seemed to relieve me of part of the problem of holding on to them.' Another star of contemporary dance, Martha Graham, told Penn later that her session in the corner had inspired her to new choreography.

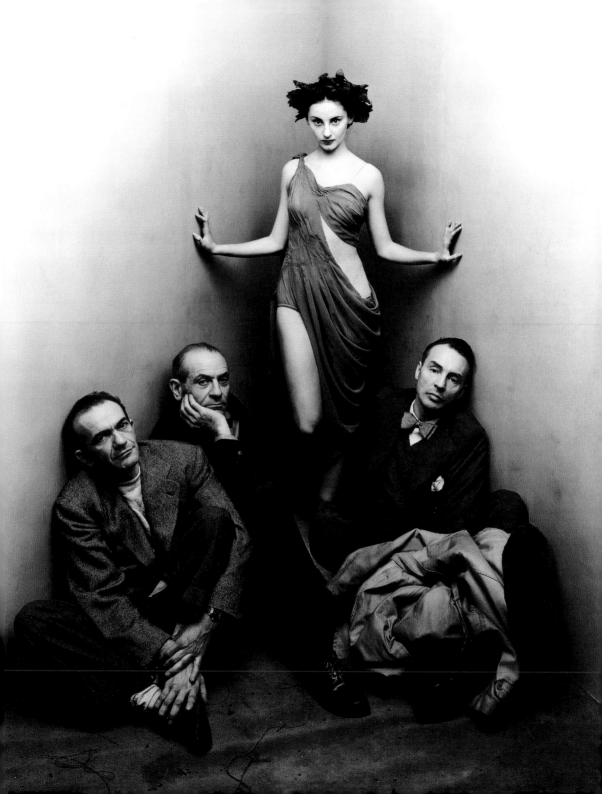

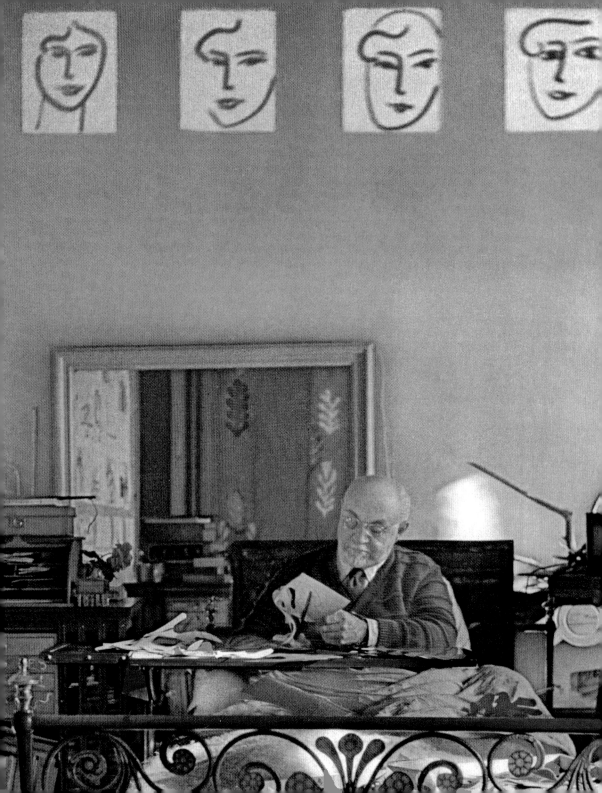

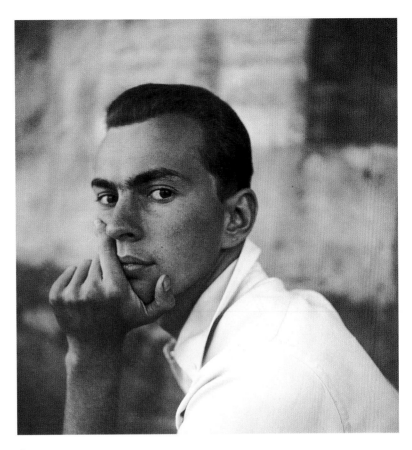

GORE VIDAL, c. 1949
BY CLIFFORD COFFIN

This portrait of the great American novelist and essayist was taken in Paris. Coffin, a *Vogue* regular, struck up brief friendships with fellow Americans Gore Vidal and Truman Capote, who had just published his first novel *Other Voices, Other Rooms*. Vidal remembered his session with the photographer as a pleasant interlude, if a little time-consuming. 'Coffin,' he wrote years later, 'preferred natural light, so we spent a morning on the Left Bank of the Seine, waiting for the right light to come off the river.' This sunlit portrait, not published by *Vogue* at the time, was chosen for the jacket of his memoirs *Palimpsest* (1995). It was taken soon after the publication of his novel *The City and the Pillar*. With its central theme of homosexuality, however, the novel did not find favour with a wide audience at that time; it was later re-issued with a different ending.

opposite
HENRI MATISSE, 1949
BY CLIFFORD COFFIN

Near the end of his life, Matisse started to design a new chapel for the Dominican convent at Vence. Here, bedridden, he makes cellophane cutouts for a maquette of the stained-glass windows. 'At Matisse's Vence villa,' wrote Rosamond Bernier in the accompanying article, 'I found him in the sunny living room, a benign figure of Edwardian elegance, sitting up in a red bed in a faded turquoise sweater and tie. Next to him, an ingenious construction epitomised his passion for order: a combination of bedside table, revolving bookcase and cabinet, which he designed himself. Outside each drawer an off-hand little drawing described its contents: a watch, a medicine bottle, a pencil – the artist's shorthand notation in white brushstrokes...'

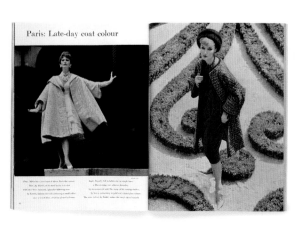

Paris: Late-day coat colour

1950s

SETTING THE PEOPLE FREE

As the new decade started, Britain still endured rationing and the economic outlook remained resolutely bleak; punitive taxes were introduced along with restrictions on travel and currency. Set against this gloom, the 1951 Festival of Britain, a cultural and technological trade fair, had a particular brilliance and provided a much-needed boost to flagging morale. 'Suddenly on the South Bank, we discover that, no longer wealthy, we can be imaginative, ingenious and colourful,' said *Vogue*. 'If all goes well, what a country we shall live in, what a Britain we shall have!' The Dome of Discovery boasted the largest roof span in the world; there were pavilions devoted to every imaginable aspect of British life, festooned with patriotic bunting. The towering Skylon became the Festival's symbol. Cecil Beaton wrote, 'it is an agreeable experience to blow one's own trumpet.'

Against this upbeat backdrop – belied by the Brutalist concrete architecture of the Royal Festival Hall – a new sense of prosperity started to take hold. This was generated by the postwar affluence that was sweeping the United States. Its symbols were the car and the television. The latest in American style, especially in interiors, and American entertainment – the movies – were eagerly embraced in Britain. *Vogue* noted that even Harold Macmillan's reported declaration, 'You've never had it so good,' was borrowed from an American union leader.

Women's lives were changing, and not just as a result of mod cons such as the washing machine, or the end of rationing; but it was a painfully gradual process. In the mid-Fifties, of the 150 top jobs at the BBC only two were held by women. Jacqueline Weldon, wife of the celebrated television producer Huw, complained that television

programmes addressed female viewers 'as if every woman sitting at home was a moron'. As ever, *Vogue*'s models looked nothing like the ordinary woman. Man-made, drip-dry fabrics and mass production resulted in an unprecedented range of affordable clothes. But Barbara Goalen and Anne Gunning, in hats and long gloves, purveyed a look far removed from everyday life.

A new breed of young photographer, such as Antony Armstrong-Jones, whose first photographs for *Vogue* appeared in 1956, began to debunk the 'myth' of high fashion. Armstrong-Jones's irreverent pastiches ushered in a new style, one for which the unapproachable hauteur of the models of the previous decades was no longer appropriate. He allowed *Vogue* – occasionally forced it – to laugh at itself. 'I was at least determined,' he once wrote, 'to have fun for myself and the reader too.' Models were encouraged to move, and provoked into reacting, either by putting them in incongruous situations or by asking them to perform unlikely and irresponsible feats. He made them run, dance, kiss – anything, he says, but stand still. And in doing so, he helped relax the rules for many later photographers of the Sixties. 'Maybe,' he remarked, '*Vogue* readers stopped to look, but I doubt if it helped to sell clothes.' This, like the angry young men, teenagers, coffee bars, Francis Bacon's paintings, Ionesco's absurdism and Sartre's existentialism, was difficult for *Vogue* to assimilate. But it did, and commissioned high-calibre writers to make sense of the new culture: Kenneth Tynan, John Osborne, Jonathan Miller, Iris Murdoch, among many others. 'Frankly,' *Vogue* conceded at the end of an exhausting decade, 'nothing any longer seems impossible. Next year, the Pacific; the year after that, the moon.'

VOGUE

YOUNG IDEAS

CONTEST: VOGUE LOOKS FOR MODELS

APRIL 1960 · PRICE 2/6

VOGUE

Headed
for holidays:
new cars,
new clothes

JULY 1957 · PRICE 2's.

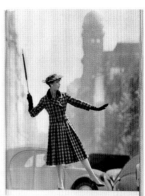

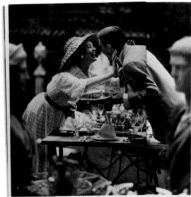

Summer
life

Summer lunch-dates in town

Having a ball!

Man, I'm flipped!

JANE BOWLES AND TRUMAN CAPOTE, 1950
BY CECIL BEATON
Capote and Beaton travelled to Morocco to stay with two American
expatriate writers, Paul and Jane Bowles, and a British one, David Herbert.
Of their hosts, Paul Bowles is the best known, the author of *The Sheltering
Sky* (1949), later made into a successful film. Beaton photographed the trip
for *Vogue* and Capote wrote it up in *Tangier Notes*. Beaton was exasperated
by the self-regarding antics of his travelling companion and here, on the
sun-baked rocks of El Farhar, Capote, as if on cue, shows off for the camera
– and is mimicked by the young Moroccan to his left, which would no
doubt have pleased the photographer.

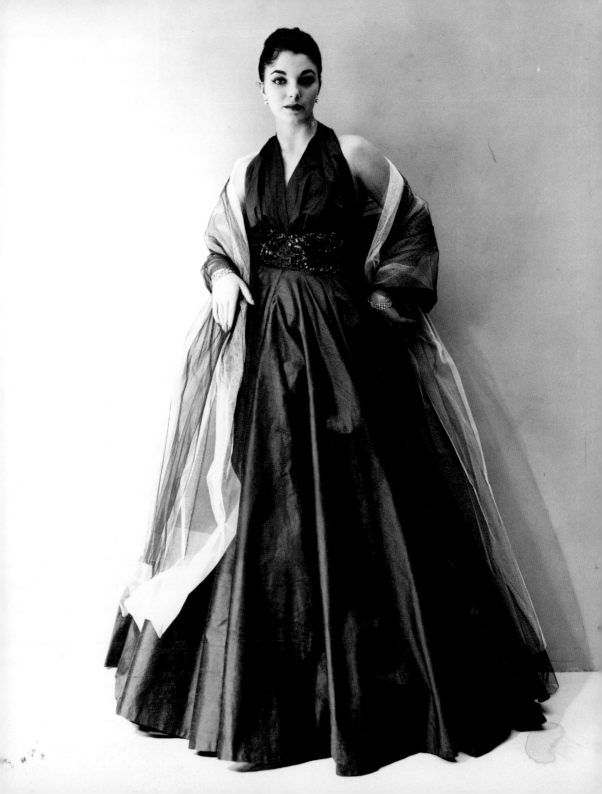

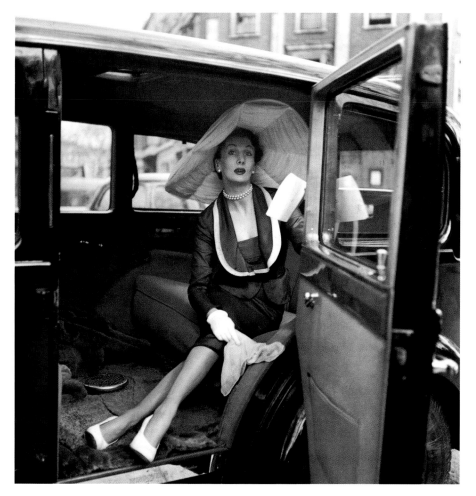

above
BARBARA GOALEN, 1950
BY EMERICK BRONSON

The epitome of mid-century elegance and the first home-grown superstar model, Barbara Goalen is shot here in an uncharacteristic pose; she usually stood proudly erect, the better to display her 18-inch waist and 31-inch hips, a figure which was perfect, when she started out in 1947, aged 26, for the designers of the 'New Look' who envisaged a clientele of women, not girls. Though well known across the Atlantic, she was much in demand for the Paris catwalks. She drew the line at Saudi Arabia. In 1954, the year she retired, she was invited to model lingerie for the King's 300 wives. She refused: 'It simply isn't done, you know,' then added wistfully, 'but the underwear really is divine.'

opposite
JOAN COLLINS, 1951
BY DON HONEYMAN

Joan Collins has appeared in *Vogue* 58 times since 1951. The last occasion was in 1996, photographed by Mario Testino. This is an outtake from her first appearance. A RADA graduate and a Rank starlet, she was pictured for a feature 'Young Talent Shows the Christmas Party Look'. She is 18, about to make her third film, *One Sinner*, and her dress, of midnight-blue paper shantung, is by Glenny. Joan Collins made dozens of films from this time on – most of them entirely forgettable – before finding global fame in middle age, on television. Vicki Woods, who sat in on her session with Testino, wrote of her 'changing one big, high-sprayed wig for another even bigger; submitting to a million-pounds' worth of Bond Street diamonds, flinging furs and feather boas about her top half with a practised arm…' She is, as *Vogue* has put it at least twice, 'indomitable'.

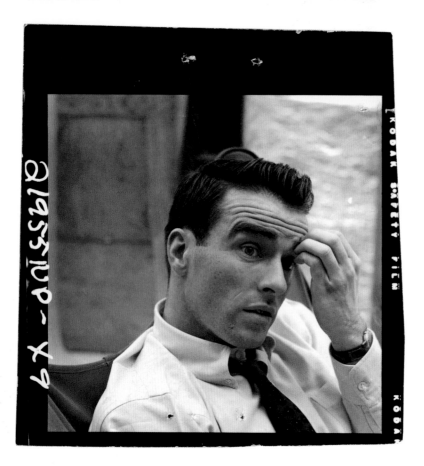

above

MONTGOMERY CLIFT, 1952
BY NORMAN PARKINSON

What *Vogue* termed Clift's 'superb ordinariness transfigured by neurosis and soul-searching' was seen at its best in *A Place in the Sun* (1950), and in Hitchcock's *I Confess* (1952). Unnerved by fame, he did not make another film for two years. His comeback role – overshadowed by Frank Sinatra's – was in *From Here to Eternity* (1954). *A Place in the Sun* had cemented his friendship with Elizabeth Taylor, with whom he starred in two further films, *Raintree County* (1956) and an adaptation of Tennessee Williams's *Suddenly Last Summer* (1959). Following a car crash, he was left with severe facial injuries. Although he went on to win an Oscar nomination for a 10-minute cameo in *Judgement at Nuremberg* (1961), he had been mentally as well as physically scarred, and became dependent on alcohol and prescription drugs. He was about to make another film with Taylor, *Reflections in a Golden Eye*, when he had a heart attack and died aged 46.

opposite

KATHARINE HEPBURN, 1952
BY NORMAN PARKINSON

In the Thirties, the start of her heyday, Hepburn was an unconventional star, preferring men's trousers to dresses. She won her first of four Oscars in 1933 for her performance as Eva Lovelace in *Morning Glory*. In spite of the trousers, the husky voice and the weeping eyes, a legacy of an infection picked up from a fall into the Grand Canal in Venice during *Summertime* (1955), Hepburn became a star and remained so until she died, in 2003, one of the last survivors of the studio system and the golden age of Hollywood. *Vogue's* Lesley Cunliffe summed up Hepburn's perennial appeal: '[she] calls herself "a weather-beaten old monument", which makes her sound like the Statue of Liberty. The Statue of Liberty might sound like Katharine Hepburn if she could change a tyre, do her own tree surgery and stand on her head for four minutes every day.' Here, *Vogue* was anticipating Hepburn's first appearance on the London stage, in Shaw's *The Millionairess*.

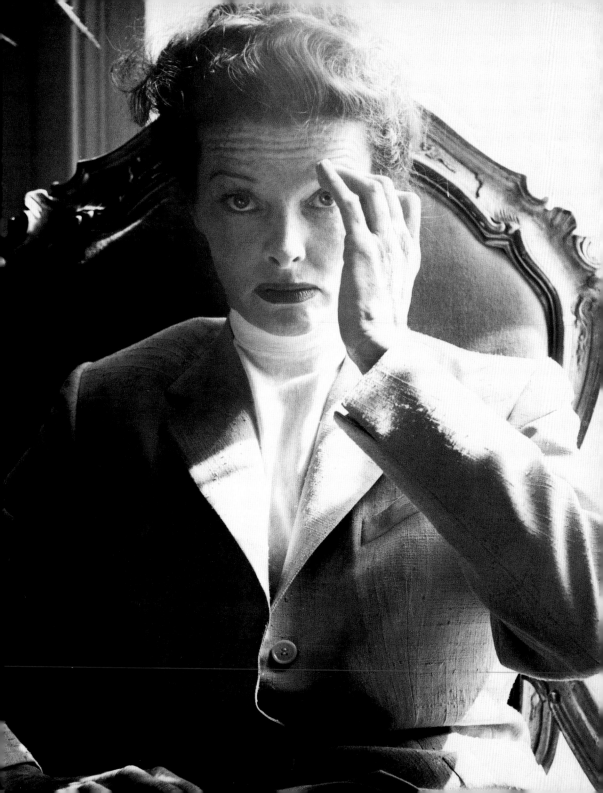

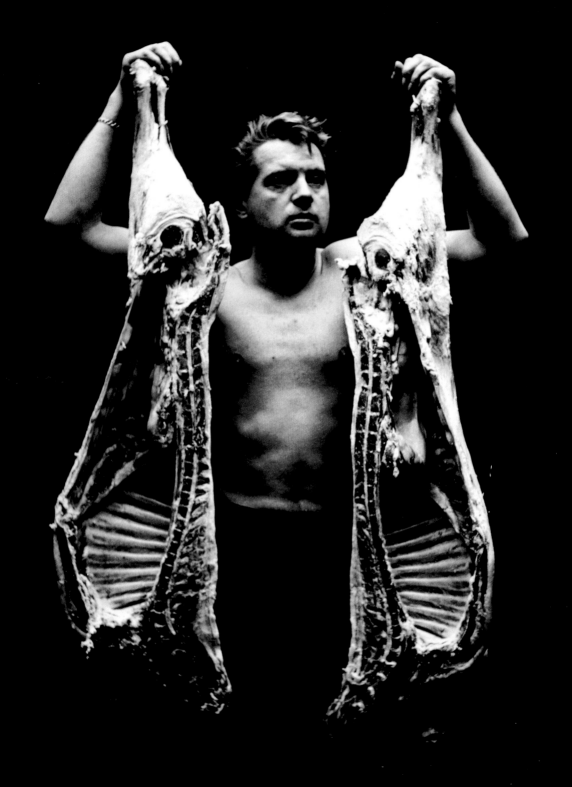

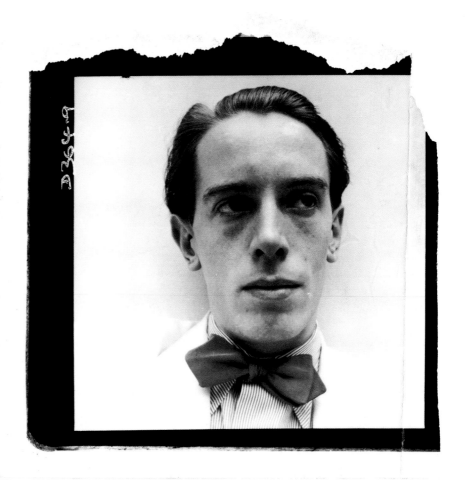

above
KENNETH TYNAN, 1952
BY JOHN DEAKIN
One of the great figures of promise of his generation, Tynan was acclaimed at Oxford as a playwright, flamboyant actor and stage director. Orson Welles wrote the foreword to his first book (published when he was 23). However, he is probably best known for his production of the risqué revue *Oh, Calcutta!* (1969), which featured much nudity on stage, and for being the first person to say 'fuck' on television. His trenchant theatre criticism — mostly for *The Observer* — and his wit, in which he was unsurpassed, was 'wonderful', as John Gielgud put it, 'when it wasn't about you'. He championed the social realism of plays such as *Look Back in Anger* (1956), and had a late career as celebrated profile writer for *The New Yorker*. Tynan's first wife, Elaine Dundy, cast the photographer John Deakin very unflatteringly in her novel *The Old Man and Me* (1964).

opposite
FRANCIS BACON, 1952
BY JOHN DEAKIN
Bacon and Deakin were intimates, part of a wide circle of painters, poets, writers and misfits who congregated in the pubs and afternoon drinking clubs of Soho. Bacon's bleak vision of humanity did not allow him to paint from life. He commissioned Deakin to take portraits of friends, which he then used as *aides-mémoire* when he painted in the solitude he preferred. This uncompromising portrait of the artist himself was intended for an article on the state of British art mid-century; but it never ran. It was published at a much-reduced size, two years later, to mark an exhibition of Bacon's work at the Hanover Gallery. A tamer variant appeared in 1962, in celebration of Bacon's imminent retrospective at the Tate. It accompanied, in a double-page spread, a reproduction of his *Figure with Meat* (1954), a pope after Velázquez and a reworking of *Painting* (1946), of which it is a pastiche.

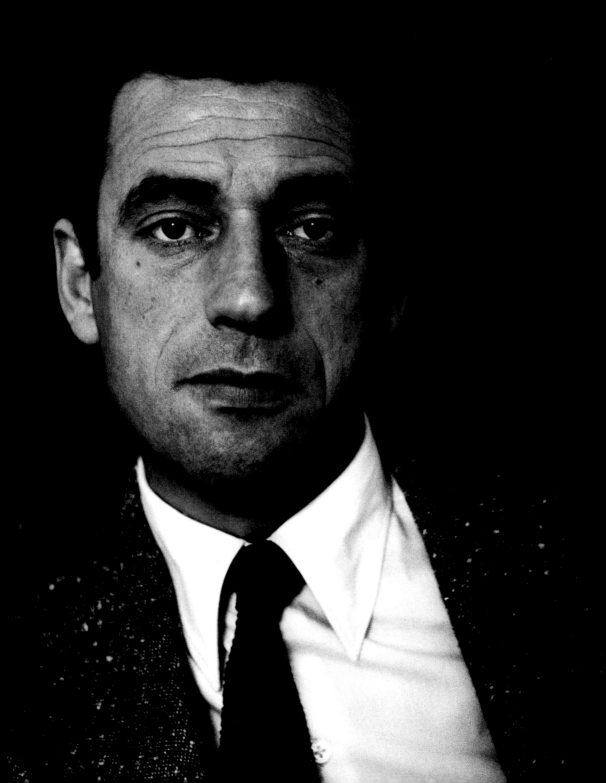

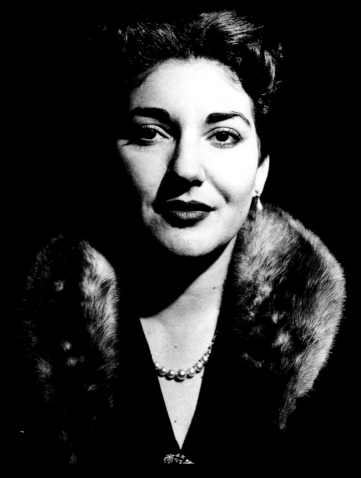

MARIA CALLAS, 1952
BY JOHN DEAKIN

The most celebrated diva of the postwar era was Greek by parentage, American by birth and upbringing, and Italian by marriage – in 1949 to Giovanni Battista Meneghini. She made her stage debut in Athens in 1941 in *Tosca*, though she had previously sung for radio. In Italy in 1947, her career blossomed under the wing of the conductor Tullio Serafin and she was offered the great roles: Aida, Brunhilde, Isolde and Norma. Her best interpretations were in Italian opera: Bellini's *Il Pirata*, Cherubini's *Medea*, Donizetti's *Anna-Bolena* and Rossini's *Barber of Seville*. This portrait was taken to mark her debut in London (in *Norma*). In 1959, still married to Meneghini, she began a much-publicised affair with the Greek shipping tycoon Aristotle Onassis; relations between them deteriorated, leading to equally publicised unhappiness. She died in Paris, in 1977, from a heart attack, aged 53.

YVES MONTAND, 1952
BY JOHN DEAKIN

Montand was one of France's great mid-twentieth-century cultural icons, along with Edith Piaf (with whom he had an affair) and Simone Signoret (whom he married). The personification of Gallic charm was in fact Italian. He started as a bistro singer and, after an inauspicious theatre debut as a singing cowboy in a cardboard hat, moved to Paris. He became Piaf's warm-up act and her protégé, and his first film role, in *Etoile sans Lumière* (1946), was as her *petit ami*. In 1949, he met Simone Signoret and married her in 1951. He was an international success with *Let's Make Love* (1960), and had an affair with his co-star, Marilyn Monroe.

GINA LOLLOBRIGIDA, 1953
BY JOHN DEAKIN

A former beauty-pageant winner – placed third in 'Miss Italy, 1947' – and subsequently a model, Lollobrigida became internationally successful as an actress in the late Fifties and the Sixties. Having appeared in over 36 Italian films by the Fifties, she also starred in English-speaking ones, including John Huston's *Beat the Devil* (1954) and the blood-and-sandals epic *Solomon and Sheba* (1959). Her forte, however, was the lightweight comedies of the era, such as *Hotel Paradiso* (1966), *The Private Army of Sgt O'Farrell* and *Buona Sera, Mrs Campbell* (both 1968). She was a style icon of the time for her 'tossed-salad' hairstyle and her curvaceous, hour-glass figure.

below

MRS LEOPOLD STOKOWSKI, 1953
BY CECIL BEATON

The wife of the famous conductor was born Gloria Vanderbilt, daughter of Mrs Reginald C Vanderbilt, née Morgan, and niece of Gertrude Vanderbilt Whitney. Her father died when she was 14 months old. The subject of a bitter and lengthy custody battle, she eventually escaped her 'Poor Little Rich Girl' tag and, by the time of this portrait, had two small sons, and was shortly to hold an exhibition of her paintings. *Vogue* admired her 'highly individual looks' and particularly her luxuriant hair, which had undergone a transformation to a 'short, scalloped coiffure'. Her fashion sense earned her praise, too. It remains obscure, however, whether *Vogue* was commending or censuring her when it observed, 'she is hardly ever seen in a hat.' Much later she gave her maiden name to a popular range of jeans.

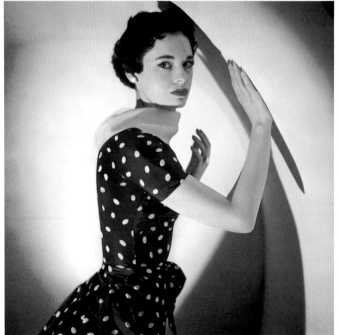

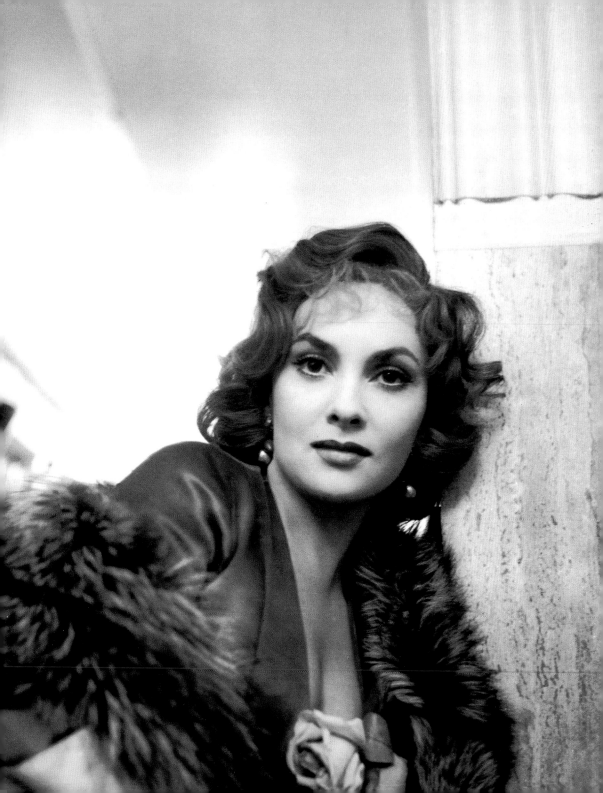

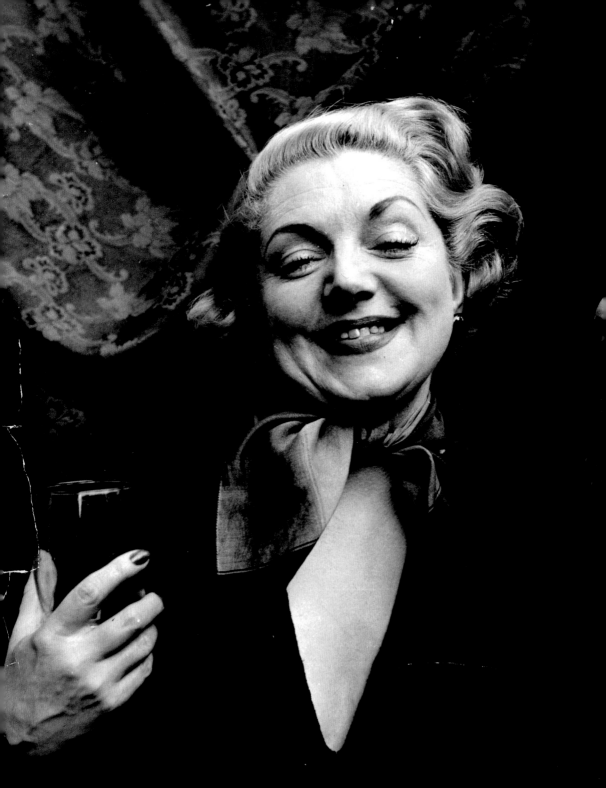

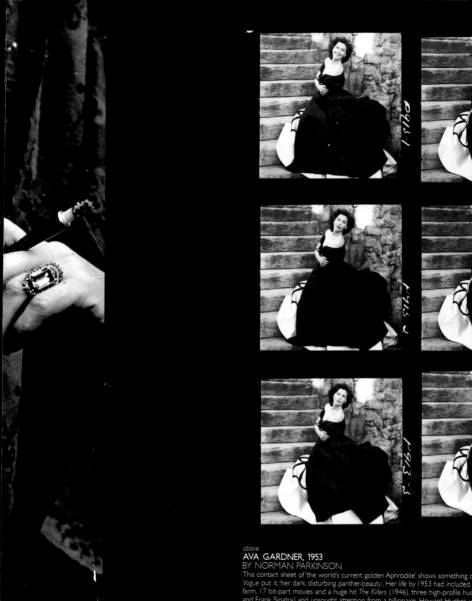

above
AVA GARDNER, 1953
BY NORMAN PARKINSON
This contact sheet of 'the world's current golden Aphrodite' shows something of Gardner's mercurial charm or, as *Vogue* put it, 'her dark, disturbing panther-beauty'. Her life by 1953 had included growing up in a dust-bowl tobacco farm, 17 bit-part movies and a huge hit *The Killers* (1946), three high-profile husbands (Mickey Rooney, Artie Shaw and Frank Sinatra) and unsought attention from a billionaire, Howard Hughes, whose advances she was forced to beat off by hitting him over the head with a candlestick. She was Oscar-nominated for *Mogambo*, which was directed by John Ford and which had just been released as Parkinson's portrait was published. A period in Spain filming *The Barefoot Contessa* (1954) left her, *Vogue* related, with 'an atavistic passion for bullfights', and she lived there for 10 years. But it was London, where these photographs were taken, that became her home from the Sixties, and it was in London that she died, in 1990.

left
HERMIONE BADDELEY, 1953
BY JOHN DEAKIN
Though she first appeared on the London stage at six, by 17 Baddeley was a huge success as a stage actress – in particular as the slum girl in *The Likes of 'Er* (1923) – before defecting to music hall and revue. She shone in *The Greeks Had a Word for It* (1934), in which she partnered her older sister Angela. So adroit and energetic was she as a multi-character actress in one revue that, when she fell ill, the producer had to hire five understudies to cover her parts. She returned to serious stage roles in the late Fifties, appearing in plays by Tennessee Williams and Bertolt Brecht, among others, and made her debut in New York in *A Taste of Honey* (1961). The high point of her film career was *Room at the Top* (1959), for which she was nominated for an Oscar, and she was familiar to a generation of American television viewers for parts in *Maude* and *Bewitched*.

TOMMY COOPER, 1953
BY JOHN DEAKIN
The trademarks of the Welsh-born Cooper were his West-country burr –
his parents moved there shortly after his birth – his catch phrase 'just like
that' and his fez. He stole the latter from a waiter during an ENSA
performance in Egypt, in World War II, when he failed to locate a pith
helmet, his then stage prop. His comic timing, invariably as part of a 'failed'
music-hall magic turn, was impeccable, and for decades he was regularly
acknowledged as 'the comedian's comedian'. Though he made a successful
transition to television variety, he died where he started – on stage.

NORMAN WISDOM, 1953
BY JOHN DEAKIN

On the reverse of the published photograph from this contact sheet, the then editor of *Vogue*, Audrey Withers, wrote, 'Is he funny?' On the evidence of his first newly released film *Trouble in Store*, she could be forgiven for her doubts. In a crumpled jacket, several sizes too small, and with a helpless grin, Wisdom, as Norman Pitkin, played a character overwhelmed by life, and prey to the unscrupulous. One of life's losers, desperate for acceptance, he provoked tears of pity as much as laughter. 'Pushed around, knocked about, he bounces back with a lunatic smile and a coy tug to his too-big hat,' *Vogue* reported. Despite its almost unbearable sentimentality, the film was a huge hit.

JAMES STEWART

above
JAMES STEWART, c. 1955
BY NORMAN PARKINSON

James Stewart had had a distinguished war. He had flown dozens of sorties over Germany as part of a bomber crew and, by the end, was highly decorated by the United States and Britain, and awarded the *Croix de Guerre* by the French. He retired from the Air Force as a brigadier, the highest-ranking actor in United States military service. The postwar years saw some of Stewart's most accomplished roles, which took him a little further each time from the drawling, easygoing ones that had made him popular. In 1946, he played the troubled banker who finds out the true value of life on earth in Frank Capra's *It's a Wonderful Life*. But it was Alfred Hitchcock who gave him the freedom to explore new psychological depths. Their collaboration started with *Rope* (1948), a study of the celebrated Leopold-Loeb murder case. A year before this unpublished portrait, he played the wheelchair-bound photojournalist scanning his neighbours in *Rear Window*, Hitchcock's paean to voyeurism. A year later they made *The Man Who Knew Too Much*, a colour remake of Hitchcock's earlier black-and-white film and then, in 1958, the classic psychological thriller *Vertigo*, which destroyed any lingering traces of Stewart's homespun folksiness for ever.

opposite
LAUREN BACALL, 1954
BY PAUL HIMMEL

On a visit to Rome, where her husband Humphrey Bogart was filming *The Barefoot Contessa*, Lauren Bacall tried out a fashionable Italian car, the Isetta. *Vogue* described it as 'rare and new, about the size of an ice-cream cart, opening in front like a sedan chair; its engine at the back'. It described its passenger, who had just appeared in *How to Marry a Millionaire*, as the 'tiger-lady of the uncaged eyes and low throaty growl'. Bacall was no stranger to the pages of fashion magazines, having been the cover model for *Harper's Bazaar* (shot by Louise Dahl-Wolfe) a decade previously; that photograph prompted Howard Hawks to cast her, opposite Bogart, in *To Have and Have Not* (1944) and again in *The Big Sleep* (1946).

192857®ROMA

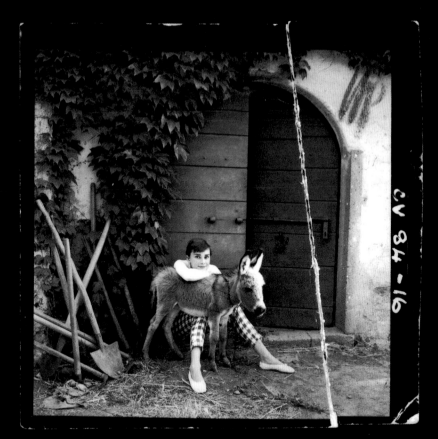

above
AUDREY HEPBURN, 1955
BY NORMAN PARKINSON

Of all twentieth-century film actresses, Audrey Hepburn remains the most photographed in British *Vogue*. Her first appearance, uncredited, was as a model for Clifford Coffin, in Paris, in 1948. By 1955, before *Funny Face*, *The Nun's Story*, *Breakfast at Tiffany's*, *Charade* and *My Fair Lady*, Hepburn's 'close drenched hair, orphan-boy alertness and limbs which fall into ballet positions' made her the magazine's new beauty ideal. In 1953, she starred in *Roman Holiday*, and in 1954 it won her the Best Actress Oscar. That year she married Mel Ferrer, with whom she had acted on Broadway in Giraudoux's *Ondine* – for which she received a Tony award. *Vogue* called the couple 'two grave unusual actors with children's eyes'. Parkinson photographed her at their villa in Rome. They divorced in 1968 and Hepburn all but retired from the screen. She had a second, late-flowering career as a roving ambassador for UNICEF.

opposite
JOHN HUSTON, 1954
BY NORMAN PARKINSON

As a film director, actor and writer, Huston was a major force in Hollywood for almost half a century. A former boxer in California and horseman in the Mexican cavalry, he went to New York to become an actor and writer – he was not successful. After losing all his money gambling, he fled to Hollywood to join his father Walter, a well-known actor. He co-wrote *Jezebel*, starring Bette Davis, and *High Sierra* for Humphrey Bogart. He directed *The Maltese Falcon* (1941), starring Bogart again, which was a critical and box-office success. His direction of his father in *The Treasure of the Sierra Madre* (1948) won both of them Oscars. He directed Marilyn Monroe in her first film, *The Asphalt Jungle* (1950), and her last, *The Misfits* (1960), and Bogart many times. A chain smoker of cigars as well as a heavy drinker and a reckless gambler, he was nicknamed 'The Monster' in Hollywood.

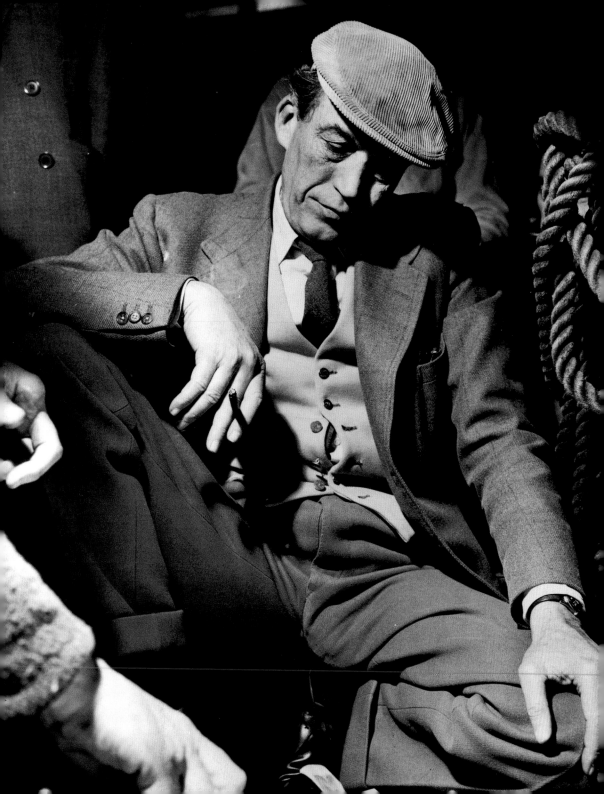

above
RICHARD BURTON, 1955
BY MICHAEL WICKHAM

The twelfth of the thirteen children of a Welsh miner, Burton won a
scholarship to Oxford at 16; he lasted there for six months. In 1943, he
made his professional stage debut. After stunning audiences in London and
on Broadway in *The Lady's Not for Burning* (1949), eclipsing John Gielgud,
he made his American screen debut in *My Cousin Rachel* (1952). He was
nominated for an Oscar, as he was for his second Hollywood film *The
Robe* (1953); despite his seven nominations for Academy Awards, he never
won. This picture was taken in London 10 years before he met Elizabeth
Taylor – whom he was later to marry, twice – on the set of *Cleopatra*.

opposite
ANITA EKBERG, 1956
BY NORMAN PARKINSON

A former Miss Universe finalist, the Swedish actress held male cinemagoers
spellbound with her force of personality and curves (39–23–37in). Her
Amazonian qualities were given full rein in her debut feature, *Abbott and
Costello Go to Mars* (1953), in which she played a voracious extraterrestrial.
She is better remembered for Fellini's *La Dolce Vita* (1961). She captivated
the debonair British leading man Anthony Steel and they married in 1956.
The marriage did not last and Steel remarked, 'It was no fun being married
to a glamour girl.' For *Vogue* at that time, she was still something of a
cartoon figure, and readers were probably surprised to learn that she was
to star in *War and Peace*. 'She plays Princess Elena Kuragin,' reported *Vogue*,
'an invention of Tolstoy's that anticipated central heating.' 'Listen,' she told
Parkinson, 'I'm not an iceberg. I am hot-blooded. I wear nothing under this.'
Parkinson, who took snuff, recalled that he had never taken it so quickly.

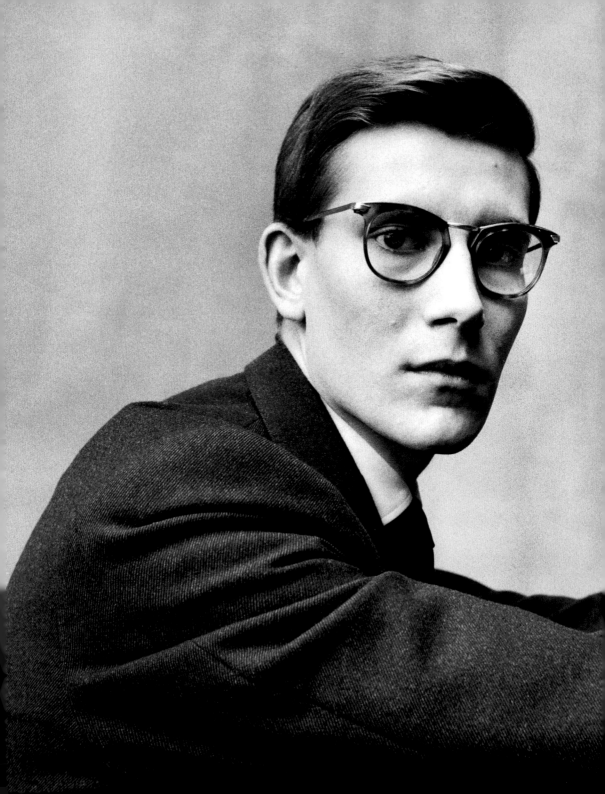

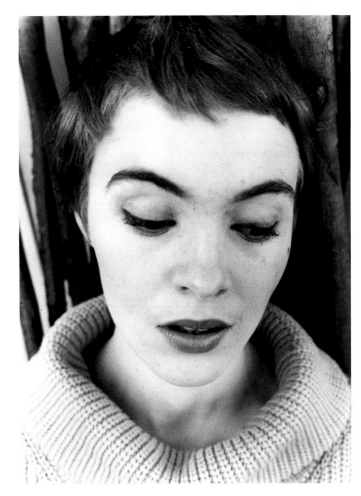

left
YVES SAINT LAURENT, 1958
BY IRVING PENN

The label Yves Saint Laurent has been one of the fashion world's most recognisable brands since the Sixties. Its creator is, according to many commentators, the greatest designer of the century. Influenced by Russian peasant costume, by the designs of Bakst for Les Ballets Russes, by chinoiserie, by the paintings of Picasso, and by the staples of the male wardrobe – trousers, blazer, tuxedo, trenchcoat and the colour black – he has had a profound impact on the way women wear clothes. At 17 he entered a design competition and won first prize for his version of a cocktail dress – the runner-up was Karl Lagerfeld with a design for an overcoat. He was then hired by the house of Dior, after a 15-minute interview. Christian Dior died four years later, and this portrait of Saint Laurent marks the moment he took over, at the age of 21.

above
JEAN SEBERG, 1957
BY NORMAN PARKINSON

Her gamine looks, doe's eyes and iconic roles as *Saint Joan* (1957) and Cécile in *Bonjour Tristesse* (1958) made her seem more French than *Vogue*'s 'chattery, engaging girl from Iowa' could ever be. When *Vogue* met her in 1957, she was 'giddy with lessons in French, art and riding'. *Saint Joan* was a legendary Hollywood flop, one magazine called it the 'worst film of the century – the century 1857–1957'. It took a French director (Jean-Luc Godard), a French writer (François Truffaut), an unambiguously Gallic co-star (Jean-Paul Belmondo) and a Continental cult film *A Bout de Souffle* (1959) to reinforce her as an American. Playing a teenager selling the *Herald Tribune* in Paris, she became an icon of the Nouvelle Vague. With hair cropped (again), and thrown-together Left Bank look, she became a style icon too. Her left-wing leanings enhanced her appeal in Europe, though it outraged Hollywood; the FBI considered her a threat to national security. She killed herself in a Paris suburb in 1979 and is buried at the Montparnasse cemetery.

TENNESSEE WILLIAMS, 1958
BY ROLOFF BENY

Three years before this unusually intimate portrait of the American playwright, Williams had won a Pulitzer Prize for *Cat on a Hot Tin Roof*. In New York it ran for 695 performances; in London, in 1958, directed by Peter Hall, it opened to unfavourable notices. *Vogue*'s was mixed. Its reviewer admired the deep morality of Williams's work and especially 'the centripetal love that forces his lonely characters together' and the 'coruscant performance' of Kim Stanley as Maggie. Leo McKern's Big Daddy, however, was 'not quite bulky enough, so that the magnificent rage of the gored elephant occasionally dwindles near the peevishness of a Peke.' Beny photographed Williams on a beach near Positano, Italy. The photographer later recalled, 'Tennessee was a gentle and most obliging man, with a curiously upper-class British accent. He wrote brilliant dialogue, but in conversation he wandered, so that I can't remember anything he said.'

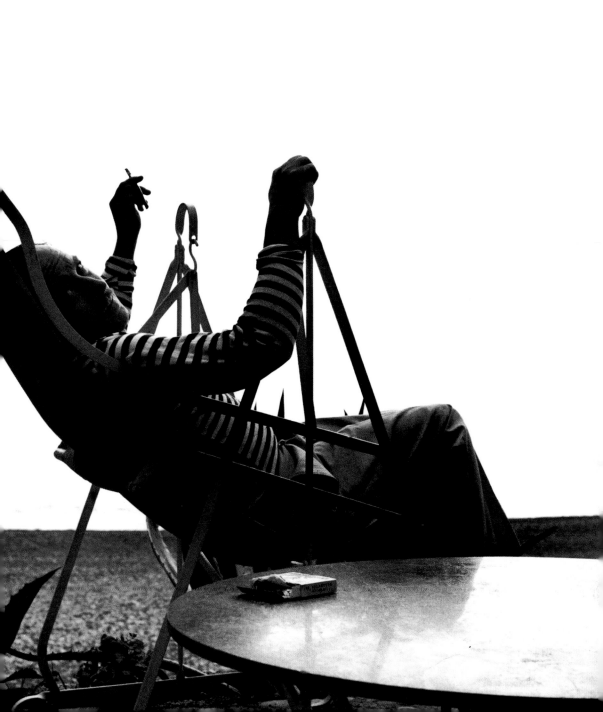

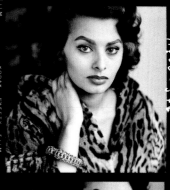
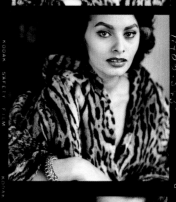

MARGOT FONTEYN, 1959
BY NORMAN PARKINSON

Vogue singled out prima ballerina assoluta of British ballet Margot Fonteyn as one of its twentieth-century 'idols; a warm lyrical artist, who takes dance to its furthest remove from acrobatics'. Apart from noting the talents that had made her a star – and a regular in *Vogue* since the Thirties – the magazine admired her 'romantic and radiant beauty as serene as her flawless purity of style'. The distinguished ballet critic Richard Buckle was moved by a recent rendering of the 'Rose Adagio' in New York: 'As the four cavaliers walked round supporting her en *attitude*, and as she displayed herself in calm, modest splendour – as perfect as the Parthenon or Vermeer's *Milkmaid* – she sustained the passionate hopes of several million British people like a vast inverted pyramid hanging invisible in the air above her.' By the time of this portrait she was Dame Margot Fonteyn and married to Roberto de Arias, a Panamanian diplomat. In this year, she was briefly arrested for her part in a failed coup d'état organised by her husband. In the early Sixties, when she was considering retirement, she met the young Rudolf Nureyev of the Soviet Union. Their subsequent partnership, which matured as she turned 44, revitalised her professionally and personally. 'When she leaves at the end of *Swan Lake*,' Nureyev once remarked, 'I would swim the English Channel to follow her…'

previous pages, left
MARLENE DIETRICH, c. 1955
PHOTOGRAPHER UNKNOWN

In an age when European royalty lost their thrones or otherwise vanished, Hollywood movie stars assumed their places. The *Vogue* photographer Horst became convinced that in the postwar years even the most formidable of Parisian socialites would 'go anywhere for a sandwich' whenever a Hollywood star was in town. Even with her best films behind her, Dietrich cast a spell over the generation that had seen her venerated, oddly, by both sides in the Second World War. In the Fifties she became a massive cabaret draw, performing the songs that had made her name in the early Thirties. Both Snowdon and Norman Parkinson photographed her for *Vogue* at this time, revealing her fondness for formal male attire – white tie, gloves and top hat. These informal moments, caught by an unidentified photographer, show that even in her mid-fifties Dietrich retained her legendary allure.

previous pages, right
SOPHIA LOREN, c. 1958
ATTRIBUTED TO HENRY CLARKE

In the early-to-mid-Fifties, Sophia Loren was engaged in a flagrant 'Battle of the Bosoms' with her rival Gina Lollobrigida, who was her equal at least in sultry-temptress roles. Lollobrigida was by then the better known. The publicity Loren garnered – and her determination honed by years of low-budget films – helped launch her in Hollywood. But her first conspicuous success was in an Italian film, De Sica's portmanteau picture *Gold of Naples* (1954), which cast her in scenes of working-class life in Naples. This was not far removed from her own childhood. She was born Sofia Scicolone into poverty in the Neapolitan slums, and nicknamed first 'Stuzzicadente' (the toothpick) and later 'Stechetto' (the stick). She had her first taste of success as 'Princess of the Sea' in a local beauty pageant. Her winnings were 23,000 lira and a rail ticket to Rome. There, while competing in another beauty contest – she was runner-up – she met her mentor and future husband, the film director Carlo Ponti. He cast her, as 'Sofia Lazzaro', in numerous Italian-language productions, and later married her, twice – the first was unrecognised by the Vatican. In 1952 she changed her name to Sophia Loren. At the time of this unpublished portrait sitting, probably with *Vogue*'s Henry Clarke, she had made her first Hollywood features. She made five back to back, starring most sensationally as a Spanish flamenco siren in the historical adventure *The Pride and the Passion*, opposite Frank Sinatra and Cary Grant, and most comically in *Boy on a Dolphin*, in which she towered over her diminutive co-star Alan Ladd – despite the trenches dug and platforms constructed to overcome this awkward mismatch. Her 'breakthrough' American film also made reference to the city she tried hard to escape – *It Started in Naples* (1960). A year later she won the Best Actress Oscar for *Two Women*, and was the first foreign-language actor ever to do so.

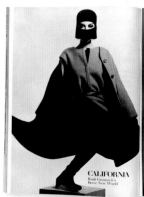
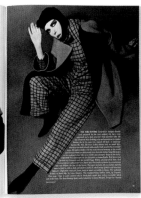

1960s

THE BEAT OF SWINGING LONDON

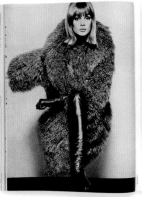
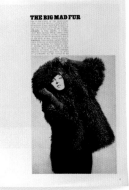

As the Sixties came to an end, *Vogue* indulged in a spot of patriotism. Whether it was *Time* magazine or *The Sunday Times* which coined the phrase 'Swinging London', *Vogue* proclaimed confidently, 'Britain is the society that has done it all, and relinquished it all, only to lead the world again!'

The Beatles and the Stones had stormed the United States, displacing Bob Dylan and the Beach Boys; Vidal Sassoon had revolutionised hairstyles; Mary Quant had liberated daughters from the tyranny of their mothers' wardrobes; British actors, such as Terence Stamp, Albert Finney and Michael Caine, and British models, such as Jean Shrimpton and Twiggy set the pace. Around 1966, a Savile Row suit, an E-type Jag or a Rolls-Royce, and an English secretary were status symbols for a certain type of American. The Sixties, observed *Vogue's* Lesley Cunliffe, was the last decade when the 'Queen looked like her stamps' and the Union Jack fluttered on public buildings and in the windows of Carnaby Street boutiques alike.

It was 'cool' to be working class or at least to appear to be. The decade's most perceptive chronicler, *Vogue's* 'spy from inside' David Bailey, with his mop of hair and winkle-picker shoes, recalled how in 1961, 'one of those *Vogue* women patted me on the head and said, "Oh, doesn't he speak cute." ' "I'll give you cute, dear," ' vowed the 23-year-old photographer. Paradoxically, it was also cool, if you were genuinely working class, to affect the trappings and nonchalance of the upper orders. Terence Stamp, who had grown up in the East End, acquired a set (a flat) in Albany, bastion of military attachés and confirmed gentlemen bachelors. Conventions were reversed: aristocrats, including the Marquess of Londonderry, dropped their titles – preferring the informality of first-name

address – and the nobly born, such as Tara Browne, numbered among their friends models and pop stars, musicians and photographers; a new 'popocracy' was born. This elite was celebrated by *Blow-Up* (1966), the grooviest of groovy London films – though made by a foreigner, the Italian director Michelangelo Antonioni. *Vogue's* Antony Armstrong-Jones had also helped to confer status on his profession by marrying the sister of the reigning monarch. 'The people in the cheap seats can clap,' said John Lennon at a Royal Variety Show, attended by members of the Royal Family, 'the rest of you rattle yer jewellery.' Elizabeth Taylor and her then husband Richard Burton were unofficial royalty and, as Lennon put it, with conscious irony, 'The Beatles are bigger than Jesus.' Mick Jagger affected a demonic countenance, and his girlfriend Marianne Faithfull revealed that young women might sleep naked under rugs. Cecil Beaton, still a *Vogue* contributor, though an increasingly infrequent one, lamented being 'over 30' – he was 62 by 1966. Thanks to the encouragement of the young and unpretentious David Bailey, he had a second wind with the magazine. It soon christened him 'Rip Van With-it'. Beaton was not the only royal-watcher to notice that even the Queen, who, one assumed, did not notice clothes, was wearing skirts with diminishing hemlines in 'an unprecedented exposure of the royal knees'.

'Documented, imitated, derided. Psychoanalysed, and frequently condemned in its own time, the Sixties promises to be the most confusing and misunderstood decade of the twentieth century.' This prediction appeared in David Bailey's and Peter Evans's valediction to the decade, published in 1969, and titled aptly, or perhaps ironically, *Goodbye Baby and Amen*.

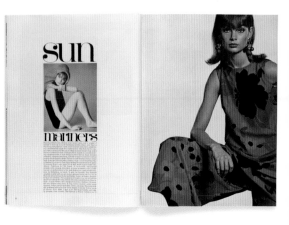

VOGUE

wells

Where's fashion

going

NOW

?

Eye-opener reports

from Paris

London Italy

Eye-catching budget clothes
at down-to-earth prices

September 1 1001 **2/6**

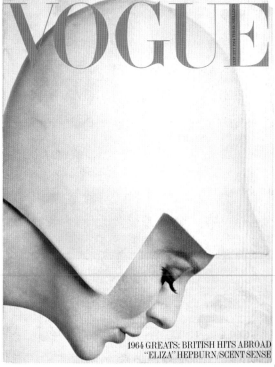

VOGUE

As London swung for the first time, the richly creative love
affair of Bailey and Jean Shrimpton was played out in
Vogue, often in startling outfits (*opposite*). From 1964 were
'running-away-to-sea clothes' (*bottom*), and vinyl boots and
Moroccan lamb (*centre*). Working with Peggy Moffat (*top*),
Bailey also shot the futuristic designs of Rudi Gernreich.
Brian Duffy contributed the cover image of James Wedge's
space-age helmet (*right*). The 1961 collaged cover (*top*)
remains unattributed. In his aeronautical shoot (*above
right*), Helmut Newton nearly beheaded his fashion editor,
and Henry Clarke's choice of props for his 1961 London
Collections shoot (*above*) proved almost as hazardous.

1964 GREATS: BRITISH HITS ABROAD
"ELIZA" HEPBURN/SCENT SENSE

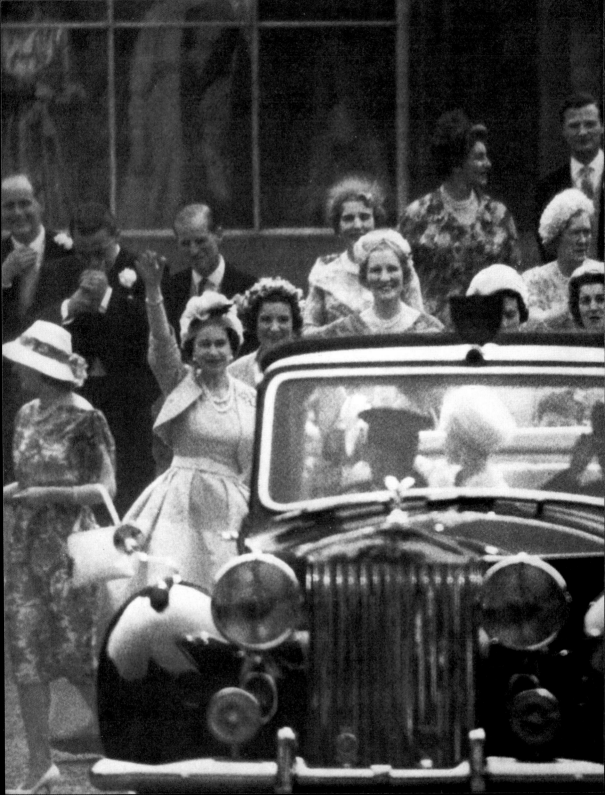

THE WEDDING OF HRH THE PRINCESS MARGARET TO ANTONY ARMSTRONG-JONES, 1960
BY BRIAN DUFFY

Tony Armstrong-Jones, later the Earl of Snowdon, took his first photographs for *Vogue* in 1956 – Edith Evans in the *Chalk Garden*, and Alec Guinness in *Hotel Paradiso*. To fashion photography in general, and to *Vogue* in particular, he has brought a lively irreverence and continues to do so, nearly half a century on. When his engagement to Princess Margaret, younger sister of the Queen, was announced, it was during a month when one of his photographs was the cover shot for the current issue of *Vogue*. Like the rest of the nation, *Vogue* was delighted and marshalled its photographers, such as Brian Duffy and Cecil Beaton, and illustrators such as Felix Topolski and Dennis Manton to record the wedding. Beaton was probably less pleased than he made out. Although Armstrong-Jones's marriage into the Royal Family removed him from serious competition for royal sittings, and he was obliged to give up working for *Vogue*, his profile remained high. Brian Duffy's photograph was a refreshingly informal one for a royal wedding in *Vogue*. Perhaps it reflected the new spirit with which the Royal Family greeted the new decade, symbolised by a bride and groom who were noticeably more relaxed than many of their predecessors in the pages of *Vogue*. 'Snob', it was said, was Snowdon's strongest term of abuse.

PRINCESS RADZIWILL, 1960
BY HENRY CLARKE

Of the Bouvier sisters, Jacqueline eventually became Mrs John Kennedy, First Lady at the White House and probably the most famous American woman of her time. Her sister Lee married first Michael T Canfield and then Prince Stanislas Radziwill. Henry Clarke photographed her in their magnificent house, Turville Grange, in the Thames Valley in Buckinghamshire. Their London house contained, according to *Vogue*, 'eighteenth-century Polish silver, early Chelsea china, Vigée-Lebrun portraits and eighteenth-century French and Italian drawings', of which the Princess was a passionate collector. Here, dressed by Givenchy, in a hat by Otto Lucas, she is photographed with her pug, Thomas, who often accompanied her to tea at the Ritz.

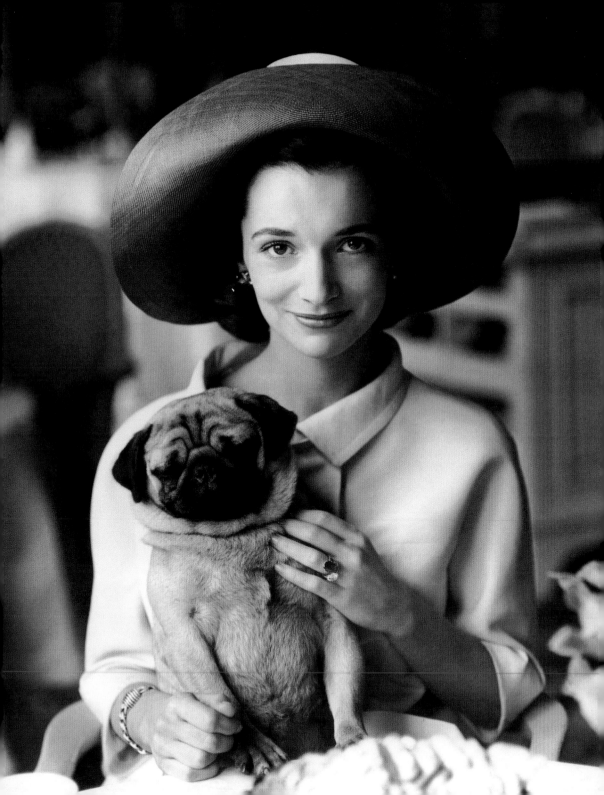

2155 2156 2157

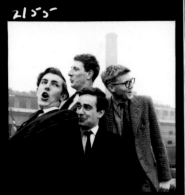
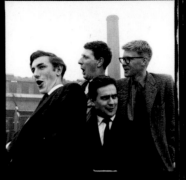
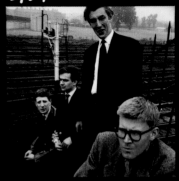
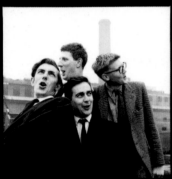
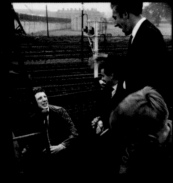
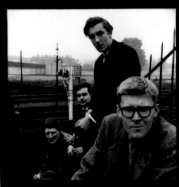
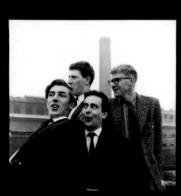
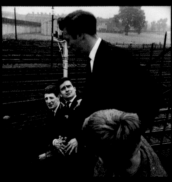
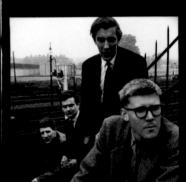

above

ALAN BENNETT, PETER COOK, JONATHAN MILLER AND DUDLEY MOORE, THE CAST OF 'BEYOND THE FRINGE', 1960
BY EUAN DUFF

Of the four original members of *Beyond the Fringe*, only Bennett and Miller survive. Both have drifted far from the satirical revue that first established them. Miller is a modern-day Renaissance Man – a doctor, writer, lecturer, painter, exhibition curator, theatre director and designer, and an innovative opera producer. Bennett is now one of Britain's best-loved literary figures – a diarist, playwright and writer, and a compelling narrator of his own works. Initially staged at the Edinburgh Festival, *Beyond the Fringe* had a considerable and enduring impact, spawning a new genre of TV satire. Afterwards, Cook and Moore continued almost exclusively in comedy, for a time in partnership. Later, Moore was successful as a Hollywood film actor, while Cook launched the magazine *Private Eye*. Cook died in 1995; Moore, in 2002.

opposite

TOM COURTENAY, 1960
BY BRIAN DUFFY

This is a contact sheet from a sitting in the year of Courtenay's professional debut (as Konstantin in *The Seagull*) and his first stage success. His next was replacing Albert Finney as *Billy Liar*, a role which he repeated for John Schlesinger's film. In the early to mid-Sixties, Courtenay appeared in kitchen-sink dramas, in which he was cast – entirely to type – as a working-class hero, never angrier than in *The Loneliness of the Long Distance Runner* (1962). For an article '…But I Know What I Like', *Vogue* asked him to describe his ideal woman. Puzzled that his opinion could matter, he prevaricated before replying that she ought to be 'elegant', adding fatalistically and in the manner of the underdog he went on to perfect: 'I'm such a scruff… I mean, she might be so busy being elegant, she'd never have time for me.'

SAMMY DAVIS JUNIOR, 1961
BY BRIAN DUFFY

An entertainer in the Vaudeville tradition, Sammy Davis Junior was a singer,
comedian, impressionist, raconteur, dancer and accomplished actor. In his
Broadway debut *Mr Wonderful*, he did all these things and played
percussion and trumpet too. 'We're lucky,' read one review, 'that it's not
called *Mr Very Wonderful*.' His first movie was *Rufus Jones for President*
(1930), in which he appeared aged five. Later, he was American TV's first
black detective and probably Hollywood's first black cowboy. Close to
Frank Sinatra and Dean Martin, he was an integral member of the
Hollywood 'Rat Pack' and appeared in its apotheosis, the movie *Ocean's
Eleven* (1960). It's said that Laurence Olivier saw his London stage act a
dozen times and replicated Davis's body movements for his Othello. The
Sixties saw Davis as an active supporter of civil rights, but one who
alienated militants by converting to Judaism and marrying a blonde
Swedish actress. At the time of this *Vogue* picture, he was in London to
promote his album *The Wham of Sam*.

149

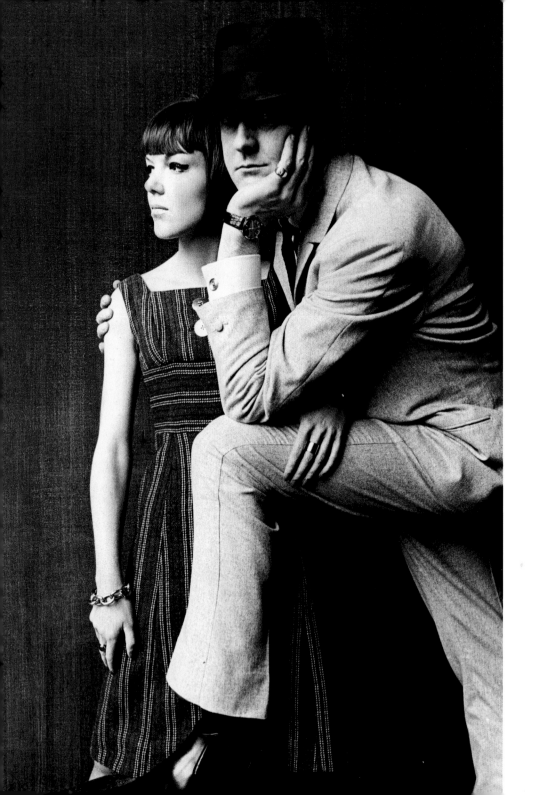

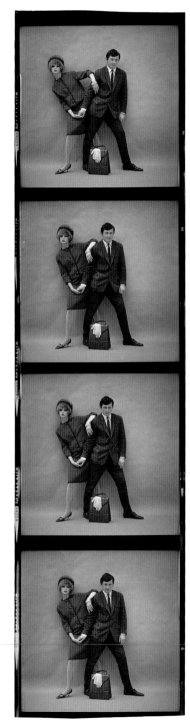

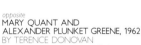

opposite
MARY QUANT AND
ALEXANDER PLUNKET GREENE, 1962
BY TERENCE DONOVAN

Despite enduring success, mostly for her cosmetics
brand, Mary Quant is inextricably associated with the
Swinging Sixties. She is popularly, though probably
inaccurately, known as the originator of the miniskirt.
She had started off well before the Sixties, opening the
King's Road boutique Bazaar in 1955. With her business
partner (and husband-to-be) Alexander Plunket
Greene, she made desirable clothes for young women,
far removed from the dowdy replicas of their mothers'
twinsets that had previously been all that was on offer.
Vogue called him 'damn-your-eyes-elegant' and her, in
her own striped-tweed dress, 'ultra front-room'. Posed
by the young photographer Terence Donovan, at the
start of the decade that would make all three famous,
Quant and Plunket Greene look effortlessly cool and
informal, in a way that the high-maintenance
mannequins – even as recently as two years before –
had never been.

right
TERENCE DONOVAN AND
JEAN SHRIMPTON, 1961
BY DAVID BAILEY

Donovan accomplished much at an early age, opening
his first photographic studio in 1959, at the age of 22.
He came to prominence, however, in the early to mid-
Sixties as part of a postwar renaissance in art, fashion
and photography, which was summed up in time as
Swinging London. A triumvirate of British
photographers – Terence Donovan, David Bailey and
Brian Duffy – revolutionised the world of the
upmarket glossy magazine. Though they approached
photography in different ways, they remain icons of a
decade of soaring ambitions. In the Sixties, and with
their impetus, British magazine photography made
more impact than ever before. 'Before us,' Duffy told
Francis Wyndham of *The Sunday Times*, 'fashion
photographers were tall, thin and camp. We're
different. We're short, fat and heterosexual.' Influenced
by the documentary work of Bill Brandt and by
periodicals such as *Picture Post*, Donovan brought a
harsh realism to his magazine and advertising work,
using, as a backdrop, the bomb-ravaged landscape of
his East End youth. He remarked that it 'had a tough
emptiness, a grittiness heightened by occasional pieces
of rubbish rustling around in the wind'. In 1963, he took
his first photograph for *Vogue* – a portrait of the
conductor George Solti, in Covent Garden – and
began an association with the magazine that ended
only with his death. His last published photograph was
for *Vogue* and appeared posthumously in February
1997, a grainy portrait of the London-based design
team Clements Ribeiro, which in style and execution
was similar to his early, ground-breaking portraits of
Mary Quant and her husband (*opposite*).

JEAN SHRIMPTON, 1962
BY DAVID BAILEY

For almost three intense years Bailey worked with virtually no other model, and the collaboration of Bailey and Shrimpton became a legend. It was, as one commentator put, it 'a whirlwind romance via the camera'. This is from one of their earliest sessions for *Vogue*. Shrimpton's allure cut firmly across cultural and social divides and for Bailey she mixed sophistication with vulnerability, a doe-eyed innocence with a sexiness she seemed unaware of; and he was entranced. For her part, as their partnership reached its zenith – a moment in the early Sixties when *Vogue* fashion seemed to be only Bailey and Shrimpton – she wrote: 'Bailey has been the greatest influence on my life so far. He says when I met him I was a county chick. All MGs and Daddy and chinless wonders. He formed my taste. He taught me to feel the mood and shape and atmosphere of clothes; and that I must be interested in everything that goes on in the contemporary scene.' Their personal and professional relationship faltered, but, throughout the rest of the decade and into the next, they continued to work together occasionally.

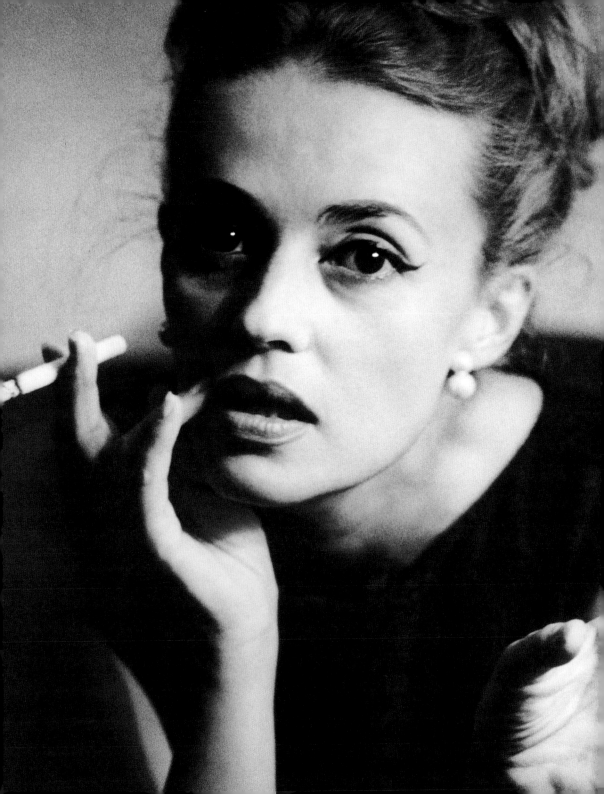

JEANNE MOREAU, 1962
BY DAN BUDNICK

At once alluring and cerebral, Jeanne Moreau was an appropriate figurehead for the flourishing Nouvelle Vague. *Vogue* found her the 'latest in the long line of sadder but wiser girls in the French cinema who love but tend to lose…' Her early films certainly bear this out: In Roger Vadim's *Les Liaisons Dangereuses* (1959) she catches fire; in Truffaut's *Jules et Jim* (1961) she drives off a parapet; in Antonioni's *La Notte* (1961) she vies unhappily with Monica Vitti for the affections of Marcello Mastroianni; and in *The Bride Wore Black* (1967), again by Truffaut, she plays a stony-hearted widow avenging the death of her husband.

RUDOLPH NUREYEV, 1962
BY CECIL BEATON

In 1961, the year of his defection to the West, *Vogue* predicted, 'a new
Nijinsky has been born,' while pausing to admire his 'high, Tartar cheekbones
and superb animal grace'. It reported that much thunderous and foot-
stomping applause had greeted Nureyev's appearance at Drury Lane, as
much for his political adventures as for his agility. The flamboyant dancer
had made a leap for freedom and political asylum in Paris, while on tour
with the Kirov Ballet. Cecil Beaton's contact sheet dates from his first
engagements with the Royal Ballet, for which, with Margot Fonteyn, he
danced *Giselle*, *Swan Lake* and, famously, *Marguerite and Armand*; the latter,
only just, for its choreographer Frederick Ashton was appalled by Nureyev's
fiery temper and rudeness. However, when Ashton saw his ballet
performed to perfection, he vowed that no one else should dance his
steps. Nureyev mesmerised photographers and sat for the greats –
Avedon, Beaton, Penn. 'Every moment he was on stage,' recollected
Snowdon, 'whether dancing or motionless, every eye in the theatre, male
and female, whether they admit it or not, was watching only him.'

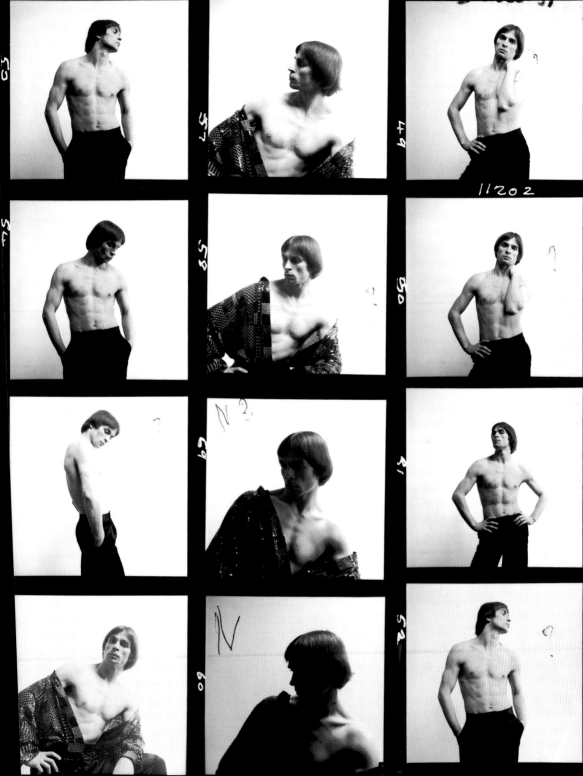

'THE IMPACT-MAKERS', 1963
BY PETER RAND

'The rather conspicuously wary expressions worn by [these] four young British painters,' explained art critic Edward Lucie-Smith, 'are not, perhaps, entirely a trick of the camera. Currently, British art is in a new mood, and wariness is one of its qualities…' Lucie-Smith's impact-makers had all shown at the Whitechapel Gallery's *British Painting of the Sixties* and are, from left: David Hockney, leaning on *Two Friends*; Ian Stephenson, sitting in front of *Panchromatic*; John Howlin, below *I'll Remember April*; and Howard Hodgkin, in front of *Julia and Margaret*. The already blond-haired Hockney was then the best-known British painter, Lucie-Smith considered, and his success the most meteoric, since that of Augustus John. Despite the polka dots of the dress and the bold colours, Hodgkin's early style bears little resemblance to the broad brush-stroke paintings which have made him one of the great figurative painters of his generation (he was knighted in 1992). Of the four, Stephenson and Howlin have since slipped slightly from view. Lucie-Smith doubted whether the brightly coloured dots of Stephenson's paintings made them abstracts: 'They are about the world around him, about the experience of seeing, about the great tracts of shimmering light which join one object to another.' Lucie-Smith enjoyed Howlin's 'Pop Abstract' style: 'He shows us the relationship between Mondrian and a packet of cornflakes.'

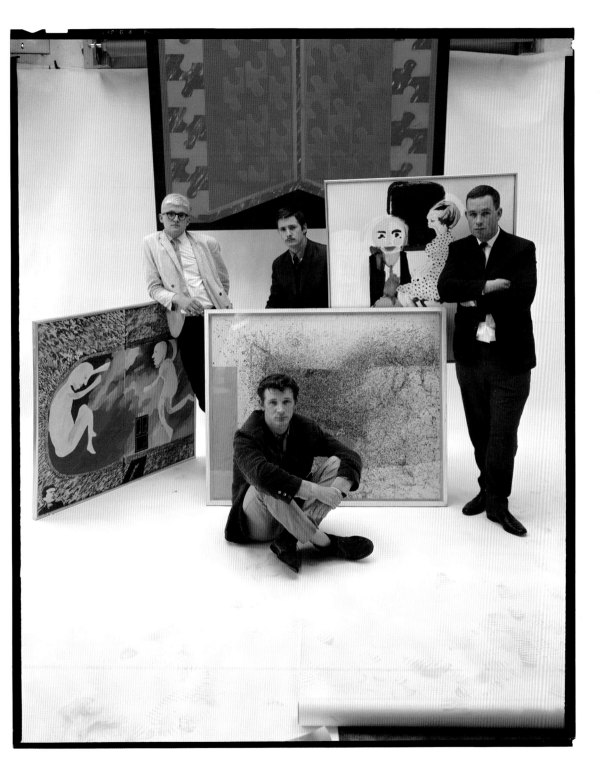

PETER USTINOV AND CHILDREN, 1963
BY JOHN RAWLINGS

For an article on the well known and their cars, Peter Ustinov was photographed with his children, standard poodle and the gleaming white Aston Martin he 'drives because he loves nervous beautiful things'. By the Sixties, the puckish and genial Ustinov was known for a wide-ranging career, which had started when he was 17, in 1939, with a series of sketches *Late Joys*. As an actor in a supporting role, he had all but stolen *Spartacus* (1960) from its lead players, and also from scene-stealer nonpareil Laurence Olivier. It earned him an Oscar. He had previously been nominated for another Roman epic, *Quo Vadis* (1951), in which he played a bewildered and oddly sympathetic Emperor Nero. As a playwright, he had had Broadway success with *Romanoff and Juliet*, in which he also starred. (He later directed the film.) His allegorical film *Billy Budd* (1962) was not a total critical success, but was applauded for its ambition. As an accomplished raconteur he was a prize catch for talk-show hosts. He also wrote sketches, drawing-room comedies and one-man shows, as well as designing sets and costumes. He is still admired for his versatility, self-deprecation and ready arsenal of aphorisms, such as, famously, 'If the world should blow itself up, the last audible voice would be that of an expert, saying, "It can't be done."'

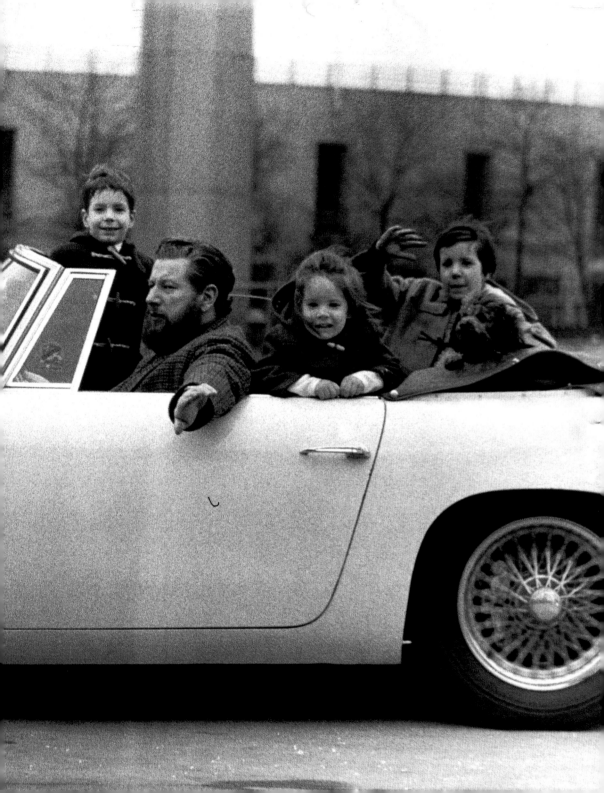

MICK JAGGER, 1964
BY DAVID BAILEY

No other rock'n'roll band behaved quite like the Stones or looked
anything like them – at once wayward and half tamed (Keith Richards), or
preening, almost effeminate (Brian Jones and Mick Jagger). No band
provoked riots in the way they did or prompted quite the media frenzy.
Vogue compared Jagger's face to one in a Botticelli painting and observed:
'The excitement the Stones generate is frenetic and frightening. They walk
onstage looking bored, and within moments of Charlie Watts hitting his
drum, the girls are screaming with ecstasy. The Stones watch unaffected.
Many people are repelled by the deliberate anti-charm of this untamed-
looking group of men – there's nothing whimsical or appealing about any
of them; but those who love them far outnumber those who hate them.
They look as if they had two more stages of evolution to go through
before they were quite *Homo sapiens*.'

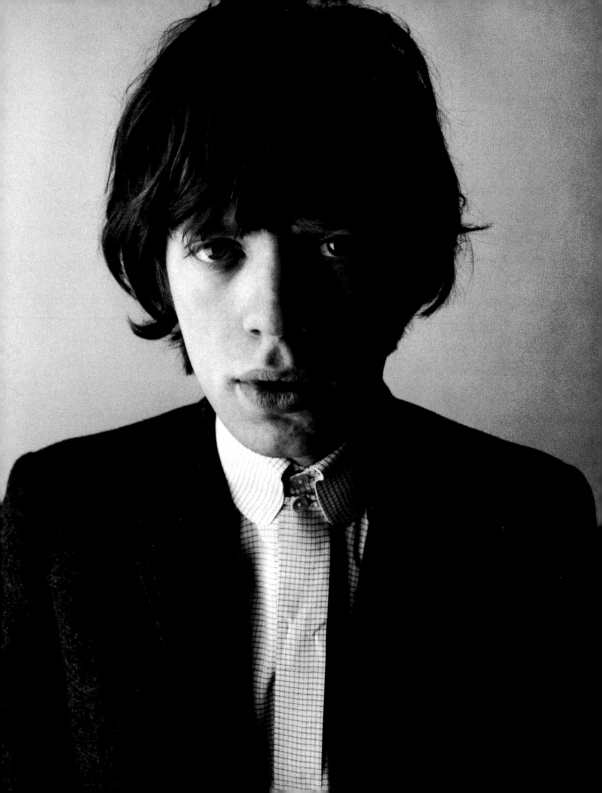

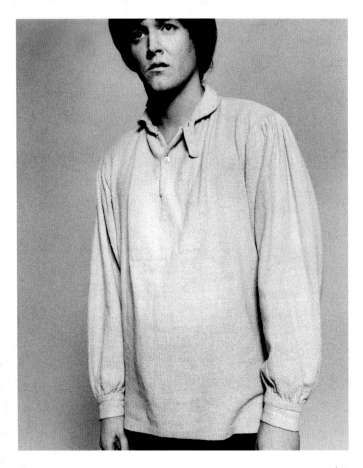

P J PROBY, 1965
BY DAVID BAILEY

At the time of this sitting, Proby was at the height of his notoriety. 'This medieval modern,' wrote *Vogue*, 'full of sound, fury, electricity and gloom, travels with his own 10-piece Proby Orchestra.' What it did not mention was that in Croydon, in January, on tour with Cilla Black, the singer burst out of his skin-tight velvet trousers to the consternation of the press – and, two days later, did it again. By February, Proby was banned from most British theatres and was considered unsafe to appear on television. In 1966, he was temporarily deported and, two years later, was declared bankrupt. He has attempted many comebacks since, and has recorded idiosyncratic versions of songs by Joy Division, Prince and Phil Collins, as well as a one-man narration of T S Eliot's *The Waste Land*. This is an unpublished outtake from Bailey's session with *Vogue's* 'summer sound magnate' of 1965.

right
MARIANNE FAITHFULL, 1964
BY DAVID BAILEY

An aspiring actress, the teenage Marianne Faithfull was discovered at a party by Andrew Oldham, manager of the Rolling Stones. 'How did he know she had a voice?' asked *Vogue*. 'He didn't,' she replied, 'and I haven't. The pop thing is only temporary for me. After a year or so I want to go into rep. I have this great big purity image. I don't mind. I'm only 17 and I did go to a convent.' The fruit of her collaboration with Oldham was her debut single the Jagger/Richards composition *As Tears Go By*, which sold 200,000 copies and revealed that she had a reedy, wistful voice. Much later, after she had spent a life lubricating it with vodka and anaesthetising it with heroin, it developed a world-worn huskiness. In 1979, it made her album *Broken English* a classic. In the ingénue years, before her three-and-a-half-year liaison with Mick Jagger, she stands on Primrose Hill, 'gently blowin' in the wind' said *Vogue* – a reference to her recent cover of the Bob Dylan classic – in a gymslip and crystal belt by Foale and Tuffin.

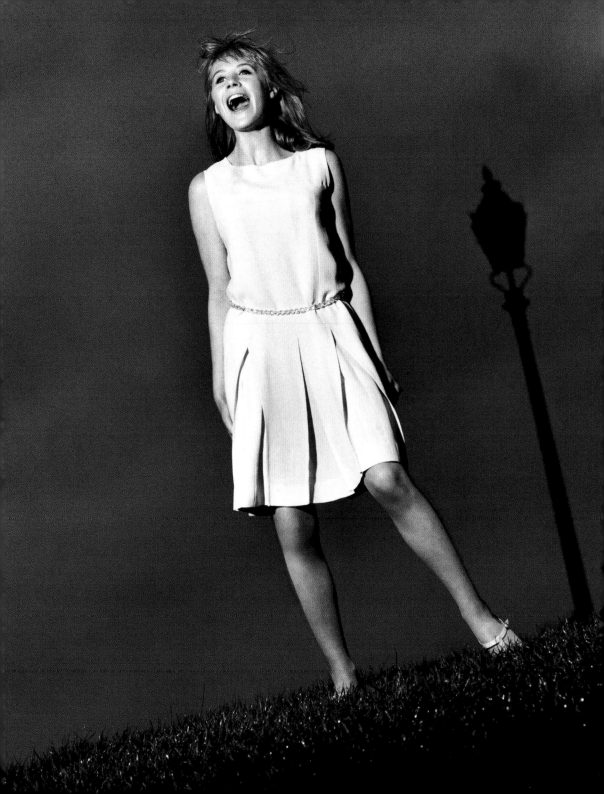

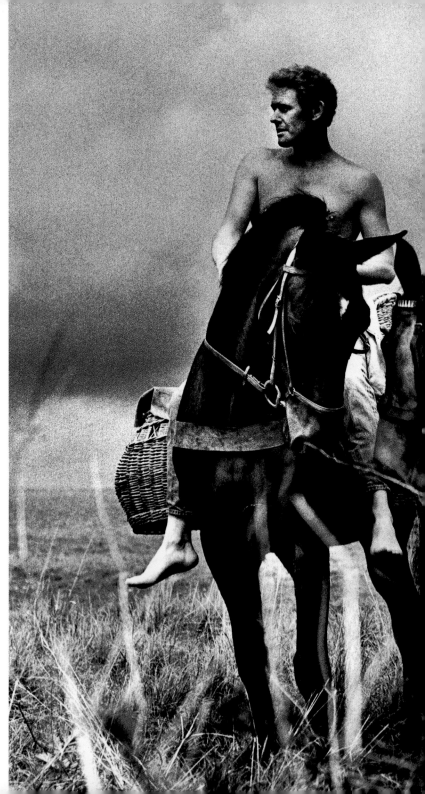

JILL KENNINGTON, 1965
BY EUGENE VERNIER

Not as instantly recognisable as Jean Shrimpton,
for a time, Kennington was Shrimpton's only
serious homegrown rival. At *Vogue* she was a
marquee name: 'Lively, lithe, lissom Jill Kennington',
whose 'talent for real style, an unspoilt assurance
and gaiety' made her the magazine's 'Young Idea
1963 Prototype'. She was certainly unfazed by this
attention. 'In the airport going to Cyprus with
Terry Donovan,' she recalled, 'I got mobbed by a
bunch of kids.' The next year found *Vogue*'s 'Face
of '63' modelling furs in the Arctic Circle and
sarongs in the heat of the Arabian desert; by 1966,
for Antonioni's *Blow-Up*, she was doing 'an awful
lot of standing around in a graphic sort of way
in front of a wind-machine'; next for *Vogue* she
was 'Pure '66' and starred in the idiosyncratic
photographs of two egocentric legends of fashion
photography Guy Bourdin and Bob Richardson.
But her collaborations with John Cowan were
what made her name – and his. For him, she was
anything she wanted to be: a sphinx, an ice-
maiden, a castaway on a balsa raft, a bareback
rider, a daredevil parachutist.

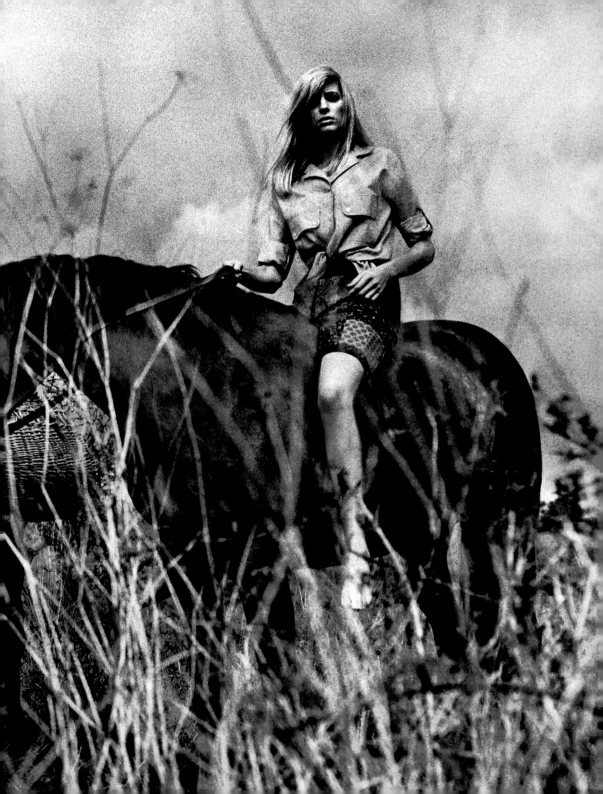

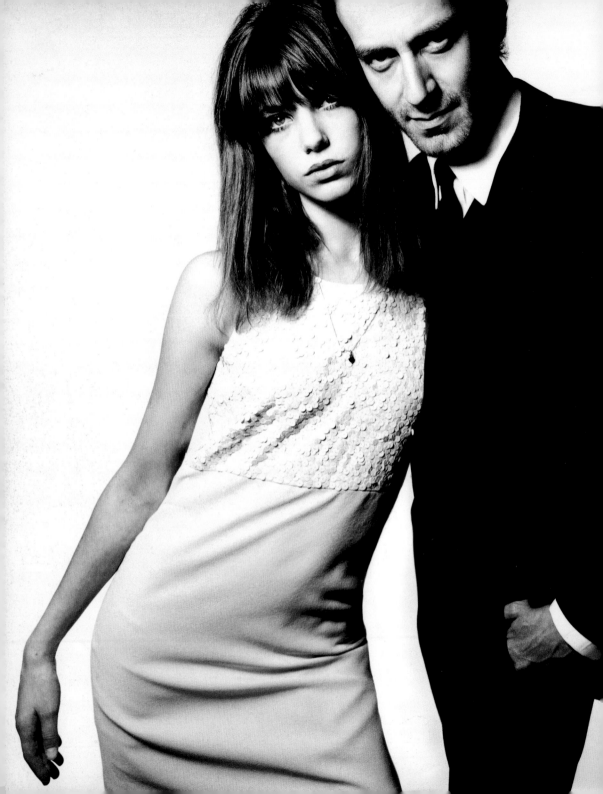

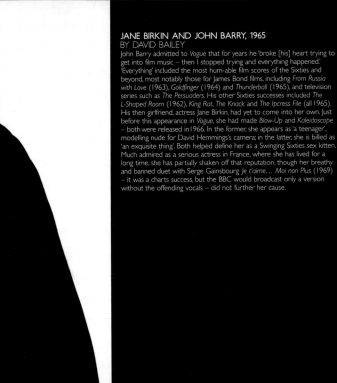

JANE BIRKIN AND JOHN BARRY, 1965
BY DAVID BAILEY

John Barry admitted to *Vogue* that for years he 'broke [his] heart trying to get into film music – then I stopped trying and everything happened.' 'Everything' included the most hum-able film scores of the Sixties and beyond, most notably those for James Bond films, including *From Russia with Love* (1963), *Goldfinger* (1964) and *Thunderball* (1965), and television series such as *The Persuaders*. His other Sixties successes included *The L-Shaped Room* (1962), *King Rat*, *The Knack* and *The Ipcress File* (all 1965). His then girlfriend, actress Jane Birkin, had yet to come into her own. Just before this appearance in *Vogue*, she had made *Blow-Up* and *Kaleidoscope* – both were released in 1966. In the former, she appears as 'a teenager', modelling nude for David Hemmings's camera; in the latter, she is billed as 'an exquisite thing'. Both helped define her as a Swinging Sixties sex kitten. Much admired as a serious actress in France, where she has lived for a long time, she has partially shaken off that reputation, though her breathy and banned duet with Serge Gainsbourg *Je t'aime... Moi non Plus* (1969) – it was a charts success, but the BBC would broadcast only a version without the offending vocals – did not further her cause.

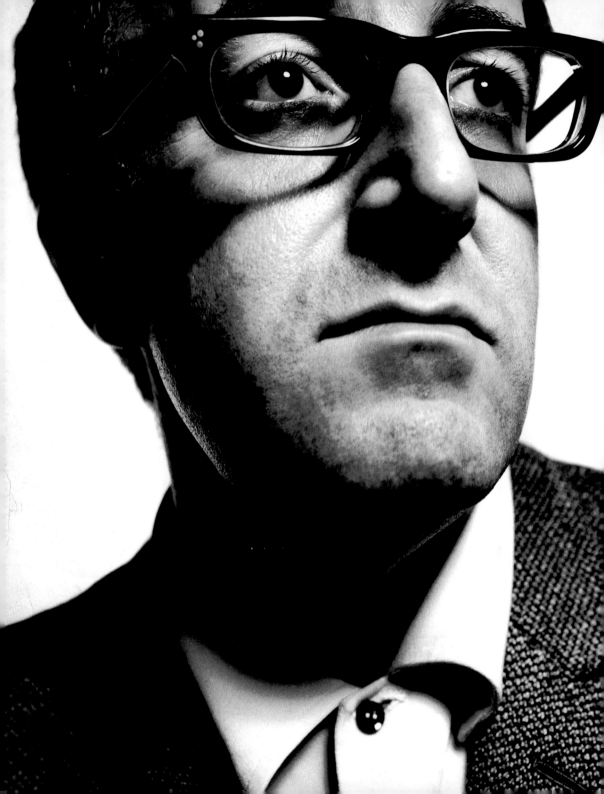

PETER SELLERS, 1965
BY DAVID BAILEY

Sellers believed that he had no personality of his own. 'I have nothing to offer the public,' he once remarked, 'nothing to project.' But his simple, unglamorous features, enhanced by broad-rimmed glasses and an infinitely malleable expression, enabled him to be anyone he chose to be. *Vogue* noted that so authentic was his mask, 'that almost every foreigner sounds like imitation Sellers. It takes genius to make a fake the standard by which we come to judge the genuine.' His mimicry made him a natural radio performer and, combined with a keen sense of absurdity, enabled him to play several different characters in the same film. This he may well have learnt from Alec Guinness in *Kind Hearts and Coronets* (1949). Sellers's first success was with Guinness in the last of the Ealing Comedies, *The Ladykillers* (1955). Before his death at 54, he played, among other characters, a hapless trade unionist, a blundering French detective, the President of the United States, a bald nuclear expert, a Chinese detective and, in one of his last films, *Being There* (1979), an idiot savant, for which he was nominated for an Oscar. He had four wives and more than 70 cars.

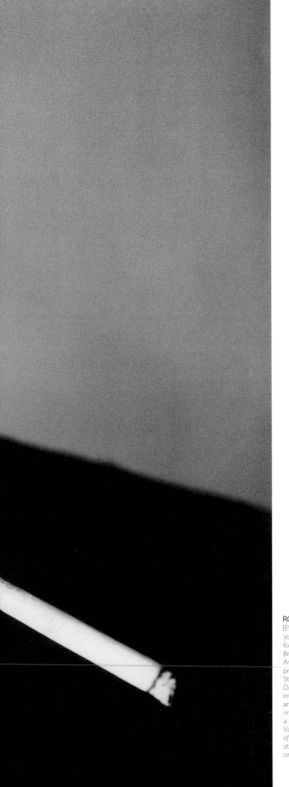

ROGER VADIM, 1965
BY DAVID BAILEY

Vogue recognised as early as 1965 that Vadim would be remembered not for his artistry but as 'Pygmalion to successive Galateas'. The first was Brigitte Bardot, whom he discovered and cast in the Vatican-denounced *And God Created Woman* (1956) – 'I will make you,' he told his 18-year-old protégée, 'the unattainable dream of every married man'; then Annette Stroyberg, around whom he fashioned an adaptation of *Les Liaisons Dangereuses* (1959); another was Jane Fonda, who starred in his intergalactic fantasy *Barbarella* (1967). All three women married him, but another Galatea, Catherine Deneuve, was harder to pin down. After *Vice and Virtue* (1963), she was content merely to be his mistress and bore him a son. Deneuve was married in the Sixties, but to David Bailey, who took Vadim's portrait for *Vogue*. Vadim's autobiography, piquantly titled *Memoirs of the Devil* (1986), revealed that he did not consider himself a Pygmalion at all; rather, 'a gardener. I simply picked the right woman, sprinkled water on a talent that had not yet blossomed and then watched it bloom.'

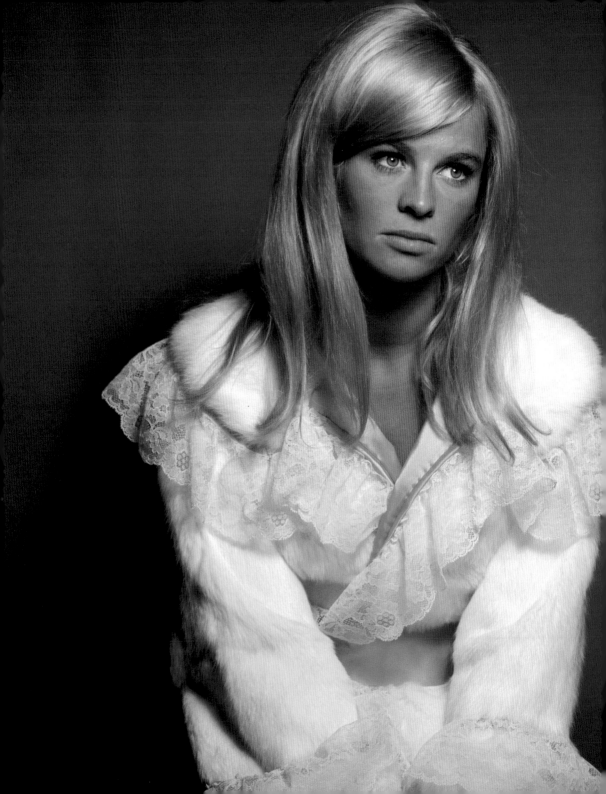

left
JULIE CHRISTIE, 1965
BY DAVID BAILEY

Born in India, the daughter of an expatriate tea-planter, Julie Christie enjoyed success early. By the time this picture was taken, when she was still in her twenties, she had appeared in nine films, won an Oscar (for *Darling*) and had been nominated for three British Academy Awards. For *Vogue*'s Christmas issue, Bailey photographed a portfolio 'The Most Bailey Girls in the World'; among them was Julie Christie. It is a tribute to Bailey's pulling-power that he was able to pin her down in the year in which she won her Oscar, and starred in the epic *Doctor Zhivago*. *Vogue* called her 'off-beat' and 'a way-out blonde', not least for her refusal to look and behave the way a film star ought to look and behave. The magazine was further nonplussed by her beauty regime, which included mixing Damaskin leg make-up with moisturiser to produce her face colour of choice; nor did she, to *Vogue*'s continuing surprise, wear false eyelashes. 'I like the idea,' she explained, 'but I'm too impatient to cope with them.' Christie survived the Swinging Sixties to become one of the few British actresses with a creditable Hollywood career. She won a second Oscar nomination for *McCabe and Mrs Miller* in 1971, and a third in 1997 for *Afterglow*.

below
CATHERINE DENEUVE AND FRANCOISE DORLEAC, 1966
BY DAVID BAILEY

Beautiful, real-life sisters Dorléac and Deneuve are seen here playing beautiful, musically inclined sisters in *Les Demoiselles de Rochefort*, Jacques Demy's pastel-hued follow-up to *Les Parapluies de Cherbourg* (1964). It also starred Nouvelle Vague director Agnes Varda as a nun and Gene Kelly, briefly, as Dorléac's suitor. In the text which accompanied his 'Most Bailey Girls in the World' portfolio for *Vogue*, Bailey, who has never been slow with an opinion, wrote of his former wife Catherine Deneuve and her sister Françoise Dorléac, 'Between them they made the perfect woman.' Here, Dorléac, the elder sister, had just finished making *Cul-de-Sac* with Roman Polanski, after which the featherweight whimsy of *Les Demoiselles* came as a relief. *Cul-de-Sac* had not been a happy shoot. It rained constantly on location (Holy Island, off the Northumbrian coast), and Dorléac was in a state of high anxiety lest the Chihuahua she had smuggled on to the island in her handbag be impounded. She also took against a specially imported cockerel and swung at it constantly with a broom. For the many takes of a particularly ambitious seven-minute tracking shot, she was required to stand naked in the ice-cold sea. On June 26, 1967, soon after she had completed these films, Dorléac's life was cut short. Her car came off the road en route to the airport at Nice and she – and her Chihuahua – were killed instantly.

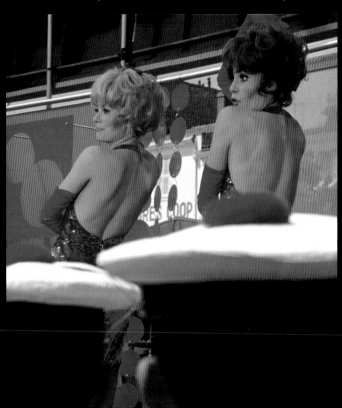

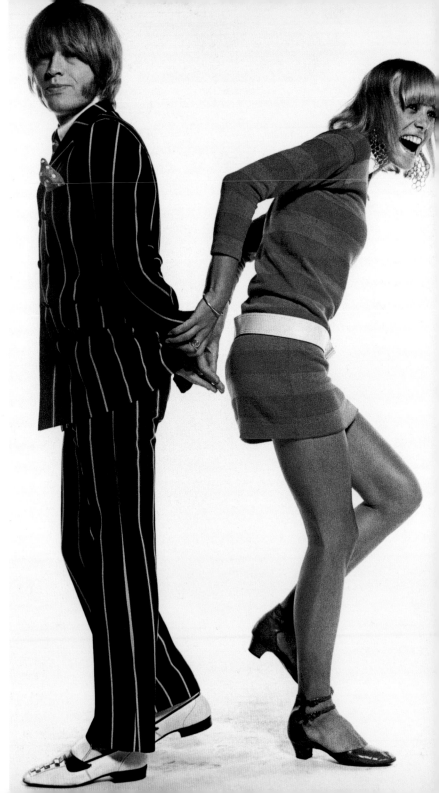

right

BRIAN JONES AND ANITA PALLENBERG, 1966
BY MICHAEL COOPER

Of all the Stones, Brian Jones was the most musically versatile and the most fastidious dresser. *Vogue* noted that he had 'strong ideas'. If he looks a little uncomfortable here, it is because *Vogue* asked his girlfriend Anita Pallenberg to dress him as she would like to find him. Michael Cooper, a *Vogue* photographer, documented the Stones from 1963 to 1973, an association which lasted until his death. As the decade progressed, Cooper was increasingly aware, as so many were, of the potency of the band and the energy its music unleashed. They were a cross-cultural phenomenon: every move, plotted or not, was played out against a background of hysterical and inflammatory newspaper coverage. 'Would you let your daughter go with a Rolling Stone?' a typically provocative headline challenged its readers.

opposite

THE HON TARA BROWNE AND NICKY BROWNE, 1966
BY MICHAEL COOPER

The longest-serving member of the House of Lords, the 4th Lord Oranmore and Browne, died in 2002, aged 100. He had taken his seat in 1927, on the death of his parents in a car crash. His marriage to Oonagh Guinness, one of the 'Golden Guinness Girls', produced three sons. The youngest, Tara, a friend of Brian Jones and Paul McCartney, is pictured here aged 21 with his wife, Nicky. Three weeks after the issue of *Vogue* appeared, he was killed when he jumped a red light in his Lotus Elan, hit a van and swerved into a lamppost. It was reported that he had swerved to take the full impact on the driver's side, allowing his passenger, the model Suki Poitier, to escape serious injury. He is commemorated as the man who 'blew his mind out in a car', part of John Lennon's contribution to the Beatles' song *A Day in the Life*.

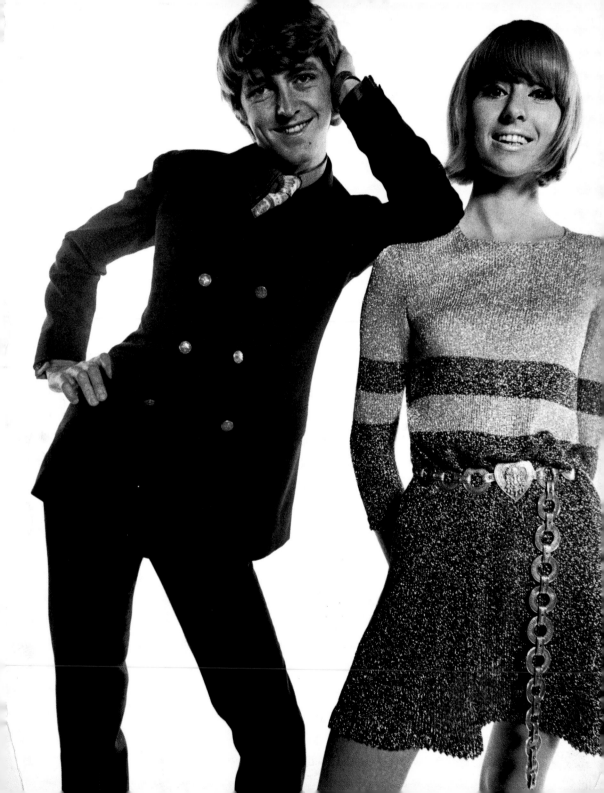

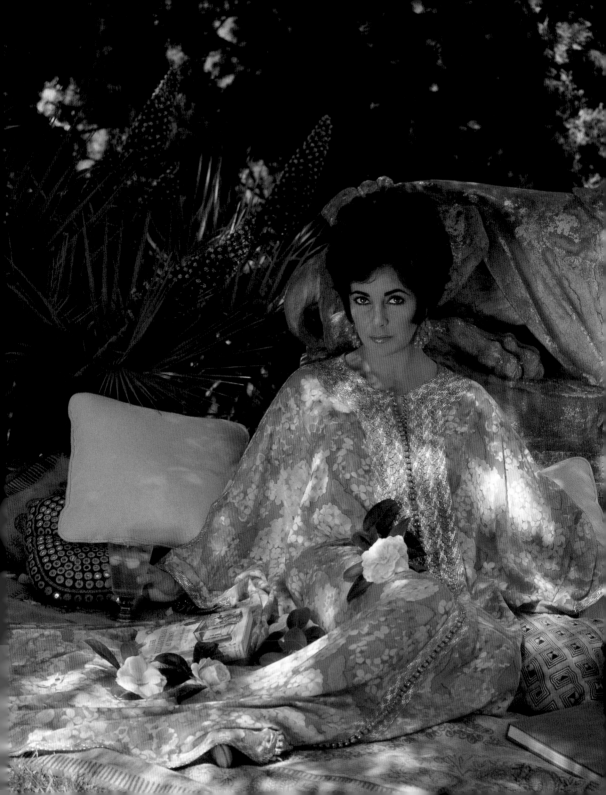

ELIZABETH TAYLOR, 1967
BY HENRY CLARKE

1966 was a busy year for Mr and Mrs Richard Burton. Between them they had made eight films and both had been nominated for Oscars for their roles in *Who's Afraid of Virginia Woolf?* They took a well-deserved break at La Fiorentina, a villa at Saint Jean Cap Ferrat, after making the film *The Comedians* together. Their daughter Maria and Taylor's daughter Liza – by Mike Todd, a previous husband – as well as their Pekingeses, E'enso and O'Fi, joined them. In the gardens, which sloped down to the sea, Elizabeth Taylor wears a silk kaftan by Graziella Fontana. Taylor made the kaftan a must-have fashion item after purchasing several on location in Dahomey (Benin). From then on, she was rarely photographed in anything else – at least for *Vogue*. Peter Glenville, director of *The Comedians*, dropped by and shared his thoughts on the glamorous couple with *Vogue*: 'Richard really like acting and Elizabeth likes Richard's acting. She is charmingly sceptical about her own talents. She has been a star since the age of 16, and the glamour of her work has grown thin. Sometimes she is apt to consider a call to the set as something approaching a professional affront… but she has a mysterious love affair with the camera.'

above
RENE MAGRITTE, 1967
BY MICHAEL COOPER

A Belgian by birth, Magritte found fame in Paris as a surrealist artist. He had been content, though not successful, as a painter in the traditional style until a chance encounter in 1926 with De Chirico's *Song of Love* led him to greater experimentation. Never a psychoanalytical surrealist like his friend Dalí, he chose to portray quotidian objects – chairs, hats, apples, trees – suspended in artificial spaces, so bestowing on them a significance beyond the ordinary. Here, in one of the last portraits of him, taken in the year and place (Brussels) of his death, Magritte mimics one of his most famous paintings *The Great War* (1964) – a self-portrait, wearing a bowler hat, with an apple obscuring his face.

right
FAYE DUNAWAY, 1968
BY JERRY SCHATZBERG

The year before she appeared in *Vogue* – she wears a patent-leather jacket by Christiane Bailly and her own beret – Faye Dunaway scored her first major hit in the violent and uncompromising gangster film *Bonnie and Clyde*. Its catch line, 'They're Young. They're in Love. They Kill People', set an industry standard, and, for her role as the female people killer, Dunaway was nominated for an Oscar. A serial chaser of beauty-queen titles in her youth – she narrowly missed being May Queen of Leon High School and was runner-up for Miss University of Florida – after *Bonnie and Clyde* and *The Thomas Crown Affair* (1968), she was an icon of cool and detached sexiness. She was married to the British photographer Terry O'Neill, whose work has often appeared in *Vogue*, and was briefly engaged to Jerry Schatzberg, the author of this portrait.

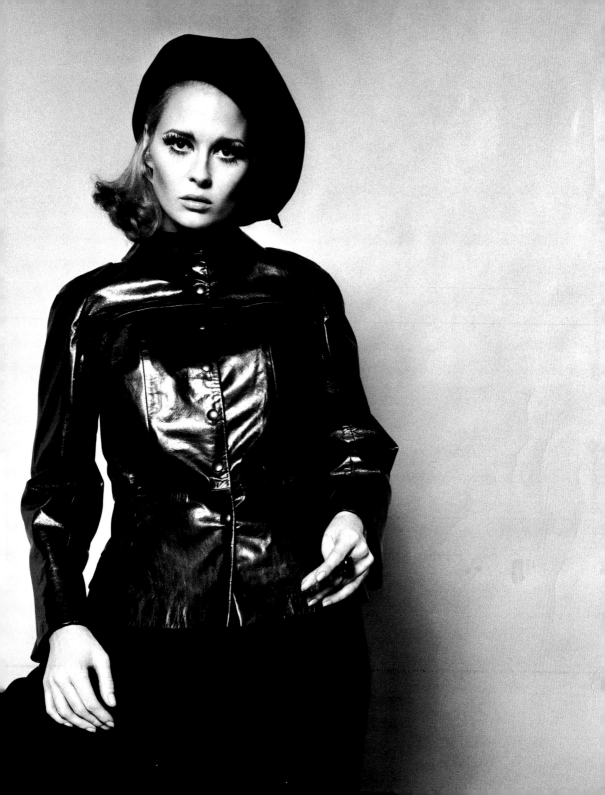

RICHARD BRANSON, 1968
BY PETER RAND

The entrepreneur nonpareil, Sir Richard Branson has stamped his Virgin
logo on enterprises as diverse as air and rail travel, record shops, bridal
wear, mobile telephones, cola-flavoured drinks, vodka and personal banking.
He is known also for his relentless promotion of his brand, for which
purpose few stunts are too extreme. *Vogue* here publicised his first
commercial venture, a national magazine for students, called simply and
effectively *Student*. Its first issue was a resounding success, selling 55,000
copies; funded entirely from pre-paid advertising, it no doubt made its
17-year-old proprietor a sizable profit. 'Richard Branson,' concluded *Vogue*,
'is very much a student – a great woolly jersey, a cheerful, rumbling energy
and a slight surprise that the world should be thought difficult.' Thirty-five
years on, nothing much has changed. He still prides himself on corporate
informality and his energy and cheeriness remain barely containable.

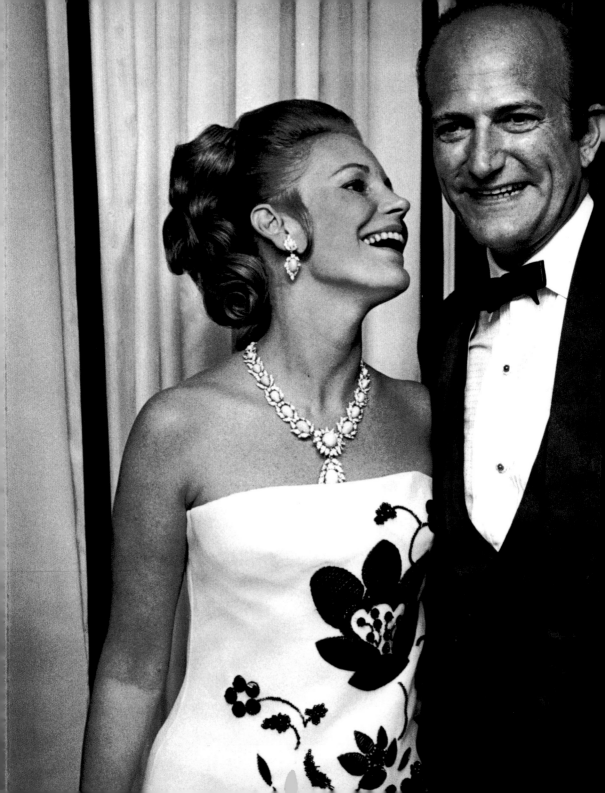

CLAUS AND SUNNY VON BULOW, 1968
BY PATRICK LICHFIELD

In December 1980, after a trip to the cinema to see *9 till 5* (starring Jane Fonda and Dolly Parton), the extremely wealthy socialite and fundraiser Sunny von Bülow slipped into a coma. Her husband Claus, a Danish barrister, who had once been assistant to the oil baron J Paul Getty, was charged with her attempted murder. It was alleged he had injected his wife, who was a diabetic, with a massive dose of insulin in order to inherit her wealth and marry his mistress Alexandra Isles. He was found guilty. For his appeal, he hired the Harvard law professor Alan Dershowitz and the decision was reversed. In 1984, he was tried again and was once more acquitted. He divorced his wife, who remains in a coma. Here Mr and Mrs von Bülow are seen in happier times at a party in their Belgrave Square home in the year they married. 'There were girls in tigerskin bikinis,' reported *Vogue*, 'sky-blue and white trellis decorated the balconies, guests flew in from New York and Paris, and breakfast was served in rooms hung with red parsley.' Their story was made into the film *Reversal of Fortune* (1990).

185

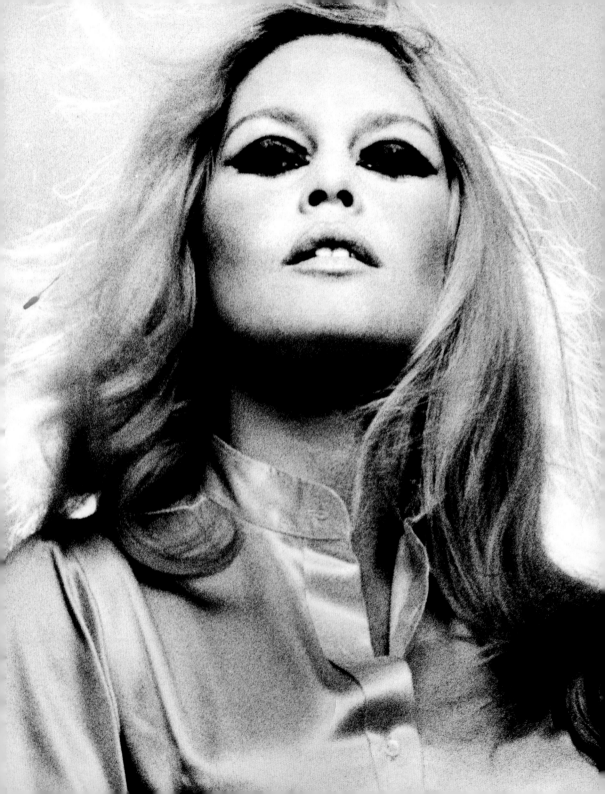

BRIGITTE BARDOT, 1968
BY JUST JAECKIN

At the time of this portrait, unfettered by the influence of her Svengali, Roger Vadim, Brigitte Bardot was married to Gunther Sachs; but her film career was in decline. She had just filmed the unintentionally high-camp *Shalako*, a 'paella' Western, shot in the sierras of Spain. Bardot co-starred with an uncomfortable leading man, Sean Connery, and bewildered character actors, Jack Hawkins and Eric Sykes. *Vogue* noted that 'the sun goddess of St Tropez' had recently launched a range of lipsticks and nail varnishes in 14 colours. Now reclusive, Bardot is best known for embracing various animal-rights causes, especially those concerning the hunting of seals.

MARISA BERENSON, 1968
BY DAVID BAILEY

Marisa Berenson's *Vogue* pedigree was immaculate. Not only was she one of its star models of the mid-to-late-Sixties, a favourite of Horst, Avedon, Henry Clarke and occasionally Bailey, but her maternal grandmother was the couturier Elsa Schiaparelli. Berenson was seldom far from the magazine's social pages, either, being the great-niece (paternally) of the art historian Bernard Berenson, and the stepdaughter of the aristocratic Marchesa 'Gogo' Cicciapouti di Guilliano; her best friends appeared to be Diane von Furstenburg and Andy Warhol. Though she had some minor experience as a film actress in the early Sixties, she came into her own in the years following her *Vogue* ones. Visconti cast her in *Death in Venice* (1971), though she was all but upstaged by Silvia Magnano and the hats created for them both by Piero Tosi. She was Lady Lyndon to Ryan O'Neal's *Barry Lyndon* in Kubrick's lavish period drama. Again, the costumes threatened to upstage the actors. Kubrick acquired wardrobes of antique clothing, which were replicated in tiny detail by a team of 35 seamstresses in the six months of pre-production. Berenson was more convincing and sympathetic in *Cabaret* (1972), as the Jewish fiancée who comes to Liza Minnelli's Sally Bowles for advice in matters of the heart. Here, with Bailey, she adds a little more to her British *Vogue* credentials, photographed in the street outside the magazine's offices in Hanover Square, wearing a grey cavalry-twill side-fastening coat, with chinchilla collar and cuffs.

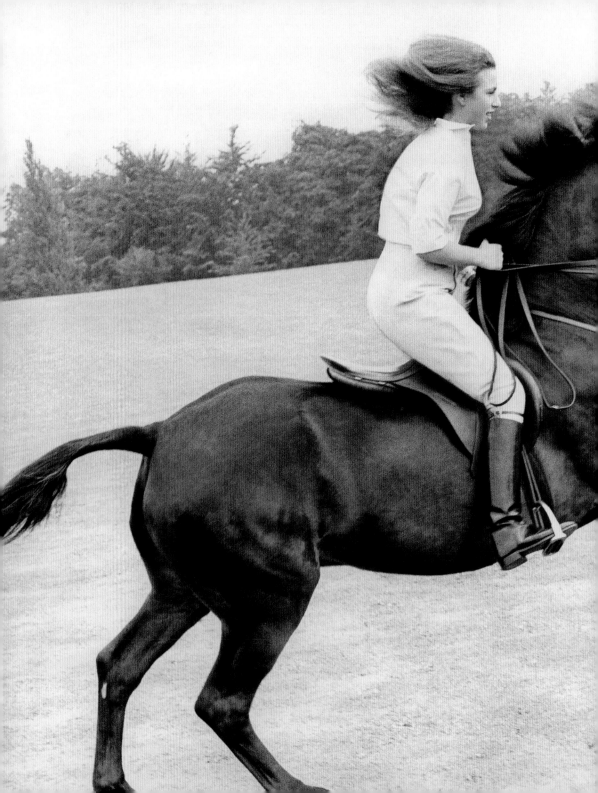

HRH PRINCESS ANNE, 1969
BY NORMAN PARKINSON

Photographed aged 19, outside Windsor Castle, riding
High Jinks, Princess Anne 'has a flippancy and an elastic
expression that makes her the most animated of the
family group', noted *Vogue*. In Vienna, a month or so
before this portrait was taken, she was invited to ride
one of the Spanish Riding School's senior Lippizaner
stallions. She put him through a piaffe, as difficult,
observed *Vogue*, as 'dancing a pas de deux with
Nureyev'. In 1976, the Princess was a member of Britain's
Olympic three-day-event team. In the years that
followed this informal equestrian portrait, a reputation
for brittleness preceded her; but she has since
impressed the public with her energy and the volume of
her workload. She regularly carries out over 400 official
engagements a year and is president or chief patron of
more than 200 organisations.

189

ROMAN POLANSKI AND SHARON TATE, 1969
BY DAVID BAILEY

The Polish film maker Roman Polanski earmarked Sharon Tate for his baroque fantasy *The Fearless Vampire Killers* (1967) after glimpsing her on location in Britain for another occult oddity, *Eye of the Devil*, which was released after his film. They married on January 20, 1968, in London – the reception was held in the Playboy Club – and became a gilded, high-profile Hollywood couple. David Bailey's portrait of Mr and Mrs Polanski was taken at the end of a *Vogue* sitting – in the magazine's pictures the couple are clothed. This print was included in Bailey's seminal work of celebrity portraiture, *Goodbye Baby and Amen*, his 'Saraband for the Sixties', published in 1969. Peter Evans supplied the text to Bailey's portraits, observing that the photographer raked his subjects by 'using his Leicas like lorgnettes'. In the caption that accompanied this print, he remarked with prescience that 'anyone who is interested in the history of the Sixties and the Permissive Society must consider the Polanskis. They knew very well the excitement, the miseries, the happiness and the fear of the times…' Shortly after the book appeared, when Sharon Tate was eight months' pregnant with her first child, she and four others staying in the Polanskis' rented Beverly Hills home were murdered by members of the Charles Manson 'family'.

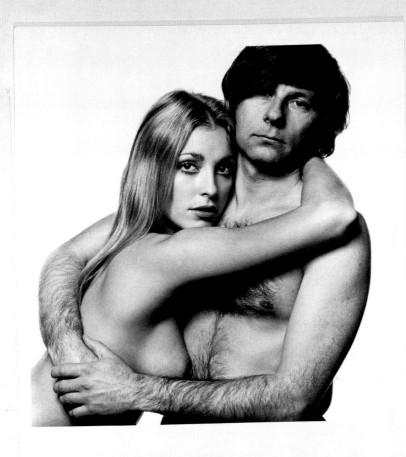

CUT OUT / ACROSS TWO PAGES

+PLUS

6 cols

11 ins deep

Is skin tone a highlight in hair.

ROMAN POLANSKI +
SHARON TATE

With blk border – curved corners ¼" radius

1970s
THE ANXIOUS HUNT FOR IDENTITY

'The Seventies,' wrote *Vogue*'s Lesley Cunliffe, 'were the hungover Monday, the day of reckoning' after the long, occasionally lost, weekend of the Sixties. There was a disheartening start to the decade: crippling inflation, the threat of terrorist attack – the IRA in mainland Britain, the Baader-Meinhof Gang in Germany, the Red Brigades in Italy. A miners' strike brought Britain to its knees, petrol rationing was threatened again and a three-day week was instituted as a frantic measure to conserve fuel. Decimalisation was introduced in 1971 to promote a more integrated, less isolationist, approach to Continental Europe, but it did not disguise gaping trade and budget deficits. The phrase 'panic buying' became common currency, the successor to the 'squirrel hoarding' of the Forties. Although it would be an exaggeration to suggest parallels with Berlin of the Thirties and life during wartime, there was, bizarrely, a brief return to Forties millinery styles and a passing, pop-chart flirtation with the music of Glenn Miller and the big-band sound.

The decade bore out the existentialists' prediction of an 'age of anxiety', and throughout it, *Vogue* sought answers to pragmatic as well as philosophical questions. Pundits approached by *Vogue* included Sir Karl Popper, the polemical philosopher/scientist, Germaine Greer (her *Female Eunuch* was published in 1970) and Arthur Koestler of *Darkness at Noon* fame. When things really got bleak, *Vogue* interviewed Samuel Beckett; when things got worse, Groucho Marx. *Vogue* advocated the virtues of plain living – scrubbed-pine furniture, lentil stews and brown rice, lace-making, and patchwork sofa covers.

The pages of *Vogue* reflected the strange, disjointed times. There was a voyeuristic streak conspicuous in many of the vibrant colour fashion pictures of Guy Bourdin, for

example. Favourite motifs include keyholes, discarded clothes, disembodied arms and legs, the distortion of facial features with goldfish bowls and mirrors, bodies hidden by vegetation, blood. Surprisingly, Cecil Beaton, *Vogue*'s perennial weather-eye, was a fan – though occasionally ambivalent: 'He insists on showing his grotesque little gamines doing ugly things in the rain, putting out their tongues or making faces.' Equally disconcerting were the sexually charged narratives of Bob Richardson, and the confrontational tableaux of Helmut Newton. More peculiarly British, though no less inventive, were the remarkable and labour-intensive beauty picture-cum-still lifes of Barry Lategan.

Fashion plundered history. A high-Victorian phase engendered pre-Raphaelite curls and peacock-hued smocks; an art-deco revival, promoted largely by Biba and featuring the model Twiggy, took the reader back to a golden age of ocean-going liners, feathered toques and crepe-de-Chine tea dresses. 'As the decade wore on,' wrote Lesley Cunliffe, 'everybody was marching to a different drummer in ever-increasing zigzags.' Alexander Walker, also writing for *Vogue*, noticed that people no longer asked, 'Who am I?' but, 'Where do I fit in?' He suggested that their sloganeering T-shirts might give an indication. The easiest tribe to identify by the decade's close was the 'punk movement'. Years later, Vivienne Westwood, one of its most celebrated proponents, told *Vogue*, paraphrasing Bertrand Russell, that 'what is orthodox is unintelligent. The vitality of a culture,' she continued, 'lies on the line between what is orthodox and what is not. I always try to be on that line.' And with that in mind, she and the like-minded confronted Britain in the Eighties, a country, as *Vogue* put it later, 'Mrs Thatcher made safe for the rich'.

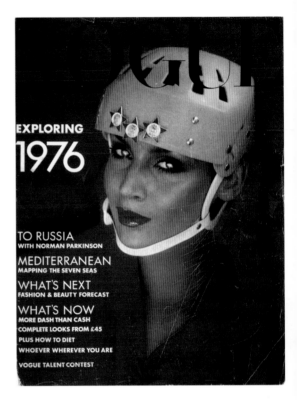

EXPLORING
1976
TO RUSSIA
WITH NORMAN PARKINSON
MEDITERRANEAN
MAPPING THE SEVEN SEAS
WHAT'S NEXT
FASHION & BEAUTY FORECAST
WHAT'S NOW
MORE DASH THAN CASH
COMPLETE LOOKS FROM £45
PLUS HOW TO DIET
WHOEVER WHEREVER YOU ARE
VOGUE TALENT CONTEST

Norman Parkinson's 1976 Jerry Hall cover (*above*) was part of a USSR shoot, *Vogue*'s first trip behind the Iron Curtain. Constructivist metaphors abounded (*opposite below right*). For Willie Christie, Hall later modelled swimwear (*below*) with high heels by Manolo Blahnik. Also in 1976, David Bailey shot Marie Helvin in Morocco (*opposite top right*). His beauty spread (*opposite top left*) featured make-up of the moment, while Willie Christie shot further ephemera – notably a double body bag by Jean Charles de Castelbajac (*opposite centre*). Guy Bourdin made a rare appearance in British *Vogue* (*opposite bottom left*) for its diamond jubilee issue (October 15, 1976).

pink · gold · water

SUMMER YOUR
LIPS
ALL OF THE TIME

Wrapping up and showing legs again— de Castelbajac and Jap put on speed

MAY
50p

all
best
new
bea
d
JUST ADD
SUNSH

WHAT'S IN A DIAMOND

.. tear-sparkled emotion

.. something to keep her

SOVIET UNION

ТВОЙ ВКЛ.
В ДЕВЯТУЮ
ПЯТИЛЕТ

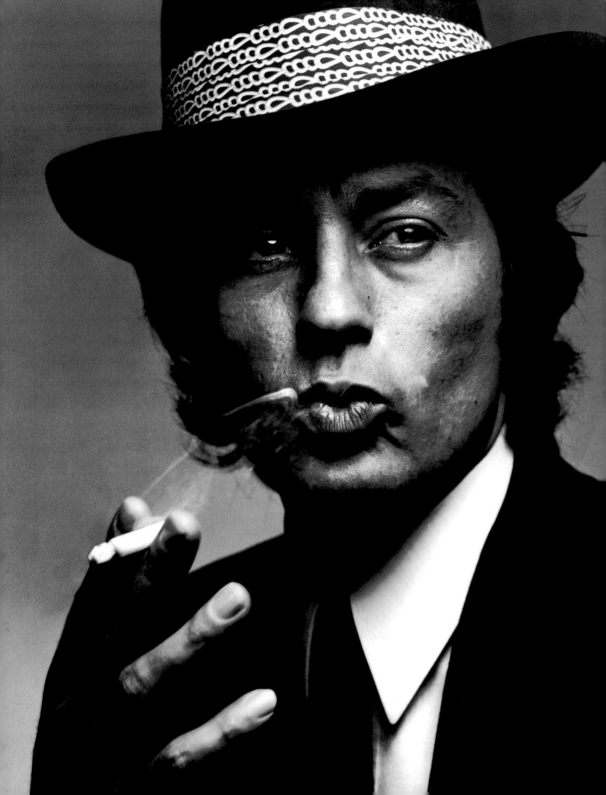

ALAIN DELON, 1970
BY CLIVE ARROWSMITH
The French marine-turned-heart-throb had worked with many great
names of twentieth-century cinema, including Visconti, Antonioni, Clement
and Malle. He turned his back on Hollywood early on: his ambiguous
sexuality, military scars and charisma had him marked out as a successor
to James Dean, who had recently died; but he reportedly rejected a
seven-year deal with David O Selznick's production company. *Vogue*
reported that he was set to star with Jean-Paul Belmondo in *Borsalino*, a
cunning tongue-in-cheek Gallic gangster movie. '*Borsalino*,' *Vogue*
commented, 'draws on the tough Cagney/Bogart films of the Forties as a
cook reads a recipe. It is fast-moving, bloody and elegant.' Years before
Matt Damon, Delon played Patricia Highsmith's ruthless, sexually
ambivalent Tom Ripley in *Plein Soleil* (1960), and soon afterwards starred in
films that won a Special Jury Prize at Cannes, the Palme d'Or and a
Golden Globe. By the Seventies, he was the one of the best-known
European film actors. He capitalised on his suave image and created a
company, Alain Delon Diffusion, which licensed his name to a range
of products from scent (AD and Le Temps d'Aimer) to sunglasses,
Champagne and Cognac.

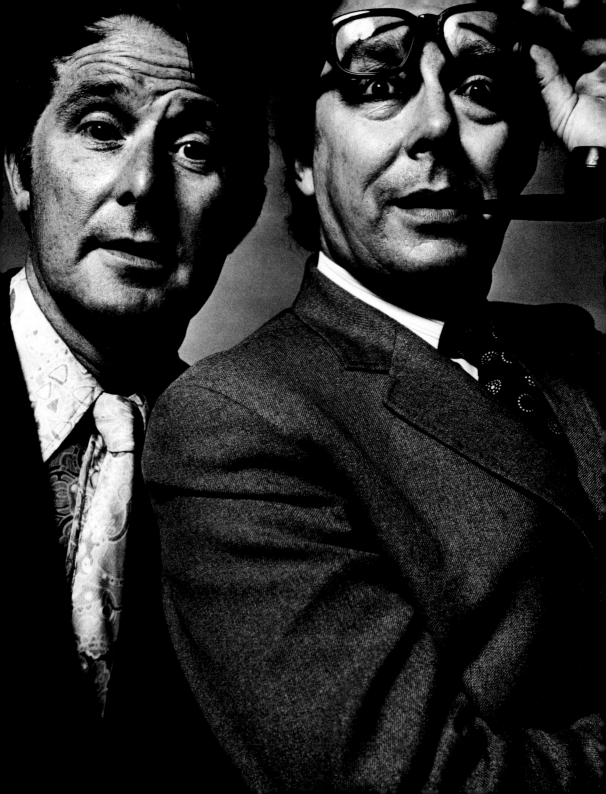

MORECAMBE AND WISE, 1970
BY DAVID BAILEY

At their peak in the Seventies, Eric Morecambe (*right*) and Ernie Wise (*left*) were Britain's most famous – and probably best-loved – comic entertainers. They met in 1939, aged 14 and 13, when Eric was still Eric Bartholomew and Ernie was Ernest Wiseman, and remained a partnership for 43 years. They were both schooled in music hall, and their earliest double act involved a clog dancer and a boy with a large lollipop. After many name changes, they settled on Morecambe and Leeds until someone said that sounded like a cheap day return and suggested instead Morecambe and Wise. Their television debut in 1954 was a disaster, and they went back to the stage for the next seven years. With better scriptwriters, they returned triumphantly to TV in 1961 and were a fixture until Eric's first heart attack in 1968. He recovered, and they made another triumphant return. For a decade until Eric's next heart attack in 1978, they were the biggest names on British television. Their Christmas shows, for which they coaxed comic turns out of unlikely figures, such as Dame Flora Robson and the former Prime Minister Harold Wilson, were eagerly anticipated. In 1984, Eric died (of a heart attack); Ernie, who had struggled in a solo career, died in 1999. In 1970, they told *Vogue* that they wanted to be remembered 'as a great comedy team. We're working on it. Every day we polish a little more, we try to make it a little better. We want to be so good, that years from now people will look back and say: "Ah, but you should have seen Morecambe and Wise."' Their 1977 Christmas show attracted 27.5 million viewers, which was then a record.

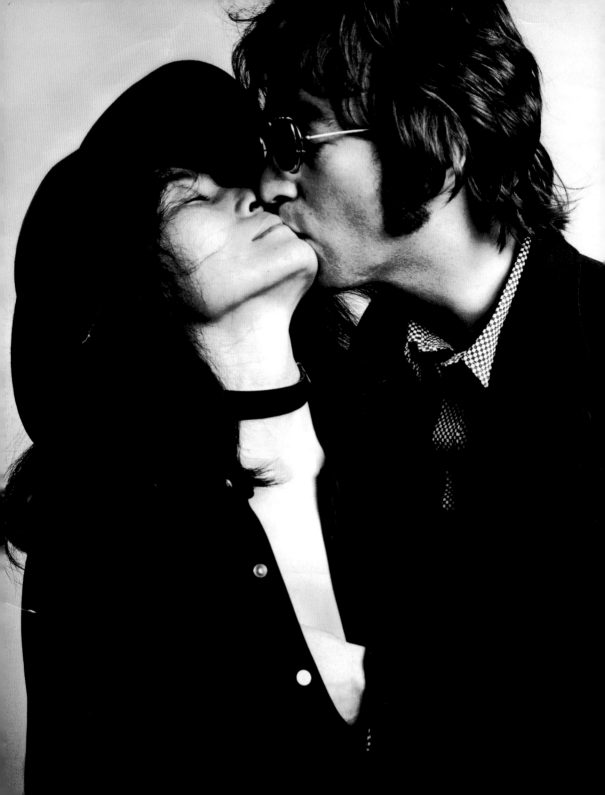

JOHN LENNON AND YOKO ONO, 1971
BY DAVID BAILEY

By the time Yoko Ono met John Lennon, she was already a leading light of
the avant-garde, a performance artist with Dada-esque leanings. With an
art-school background, Lennon was a regular gallery visitor, and met Yoko
at the Indica Gallery in 1966. As their affair developed, so too did Lennon's
interest in conceptual art. In 1968, with Ono's help, he mounted his own
exhibition at Robert Fraser's gallery, Mayfair. It consisted of an arrangement
of charity contribution boxes: disabled children in wheelchairs, bandaged
pets, and war veterans bent over sticks. The centrepiece – from which the
show took its name – was a large canvased area, in the middle of which,
Lennon had written 'You Are Here.' Volunteers filled hundreds of balloons
with helium, and, as a culmination to the opening, these were released into
the air outside to sail over the London rooftops. A tag invited the finder
of any balloon to write to Lennon at the gallery. In return, the sender
received a badge and a letter from Lennon: 'I am sending you a badge,' it
read, 'just to remind you that you are here.' Derek Taylor, the Beatles'
celebrated press officer, who was responsible, among other things, for
carrying out 'the whims and fancies of John and Yoko', has said that 'the
idea was presented to me under the all-purpose Sixties word "Great": it
may well have been great, but I can't be sure any more.' Subsequent John
and Yoko collaborations were increasingly politicised and included their
famous 'Bed-In' peace event in the Amsterdam Hilton, albums of music
with their Plastic Ono Band, and an infamous nude piece, *Smile* (1969).

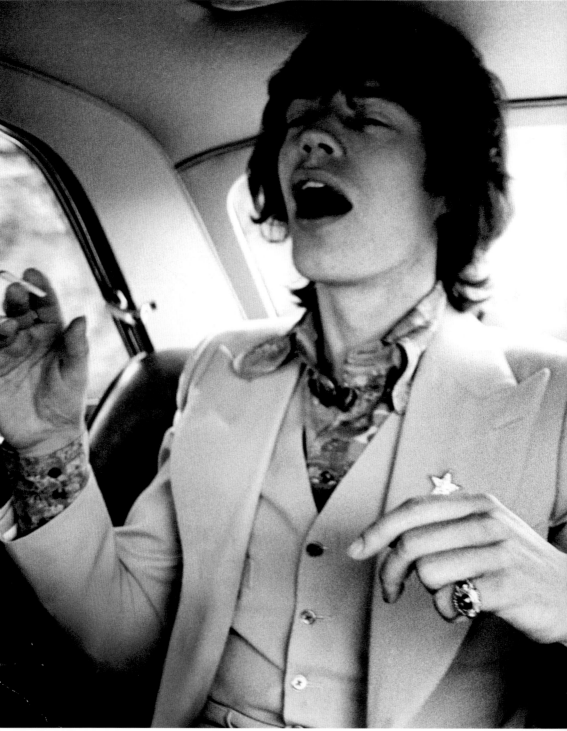

MICK AND BIANCA JAGGER, 1971
BY PATRICK LICHFIELD

'There's not going to be a wedding,' Bianca Pérez Morena de Macías told the press, 'this week, next week or ever. Mick and I are very happy together. We do not need to get married.' Nevertheless, on May 11, 1971, days after her comments, a private plane took off from Gatwick Airport and landed at Nice. On board were Mr and Mrs Joe Jagger, Mr and Mrs Paul McCartney, Mr and Mrs Ringo Starr, most of the band The Faces, the designer Ossie Clark, the Earl of Lichfield and others. A British newspaper had spotted Mrs Jagger buying a new hat in Dartford; the passengers were clearly going to a wedding. Mick and Bianca were duly married in a ceremony at the municipal chambers of St Tropez, which, according to French civil law, were open to anyone who cared to turn up. The wedding plans were now an open secret, and the chambers were packed with fans and photographers. For an hour the groom stalled – there had been last-minute wrangling over a pre-nuptial financial arrangement – and the best man, Keith Richards, had a blazing row with his girlfriend Anita Pallenberg. A church ceremony followed, at which the *Vogue* photographer Patrick, Earl of Lichfield, accompanied the new Mrs Jagger down the aisle. The best man, now dressed as a Gestapo officer, enlivened the reception by passing out. The newlyweds' wedding night was interrupted by Keith Moon, drummer of The Who, clambering through the window of their hotel suite. It was widely reported later that Mrs Jagger had declared her marriage over by the end of the wedding day.

THE DOORS, 1971
BY BARRY LATEGAN

These contact sheets are from a session with The Doors that was never published. They were taken in the year Jim Morrison, the charismatic lead singer, died, and must be among the last formal pictures taken of the band. By this time, they had made six albums and a double album of live recordings. Among their classic singles were *Light My Fire*, *Love Me Two Times* and *Hello, I Love You*. Morrison achieved cult status years before his death in Paris from a drugs overdose. In 1967, in New Haven, Connecticut, he was the first rock star to be arrested on stage – after an earlier altercation behind the scenes with a police officer, involving a can of mace. Two years – and several drunken exploits – later, he was again arrested and charged with lewd behaviour, having exposed himself on stage in Miami. Morrison, who had suggested the group's name – taken from Aldous Huxley's *The Doors of Perception* – hoped to meld rock music, existential poetry and performance art; in this respect he was influenced by the French symbolist poet Arthur Rimbaud. In 1971, following the release of *L A Woman*, Morrison relocated to Paris to escape unwelcome press attention in the United States. He died on July 3, 1971. Conspiracy theorists continue to doubt the formal identification of the corpse found in his bathroom and to question the lack of an autopsy. However, the authorities of Père-Lachaise have confirmed to one of the authors of this book that the remains in the grave are indeed those of Jim Morrison; another rock myth is laid to rest.

JACKIE STEWART, 1973
BY DAVID BAILEY

The World Champion of 1969 and 1971 and the winner of 22 Grand-Prix races, Stewart had already won the season's South African Grand Prix, was second in the Brazilian and third in the Argentinian. At the time of *Vogue*'s shoot, he was second in the drivers' table. By the end of the season, he was World Champion again and had retired from competitive driving. His record of 29 Grand-Prix wins stood for 15 years. Stewart, from Dumbarton in the West of Scotland, was born into racing. His father's garage dealt in Jaguars while his elder brother, Jimmy, had been a member of the Jaguar works team and the 'Ecurie Ecosse'. He had retired after an accident at Le Mans to allay his mother's fears for him. With similar intentions, when Jackie entered his first race, it was as A N Other. He had been discouraged from driving and had taken up shooting, narrowly missing selection for the British Olympic squad of 1960. Nevertheless, he entered

motor sport and on his Formula One debut in 1965, in South Africa, he earned his first championship point. By the end of that year, at Monza, in his eighth Formula One race, Stewart won his first victory. He followed that with a victory in Monte Carlo in 1966. The same year he had a serious accident at the Belgian Grand Prix, which left him pinned to the frame of his car for nearly half an hour, covered in petrol, until Graham Hill prised him free with the spanners from a spectator's toolkit. This experience prompted him to campaign for driver safety and, from that day on, he always drove with a spanner taped to the steering wheel. Thirty years after his first win, he formed his own racing stable, Stewart Ford, in partnership with the manufacturer of the car with which he had made his reputation. In 1997, his driver Rubens Barrichello came second at Monaco. Stewart was knighted in 2001.

HELMUT NEWTON, MANOLO BLAHNIK AND ANJELICA HUSTON, 1974
BY DAVID BAILEY

Although Helmut Newton (*left*) is exercising a camera's cable-release, the photograph is credited to David Bailey and marked the end of 'French Leave', a 20-page fashion shoot in the South of France and Corsica. This shot was taken *chez* Newton, at Ramatuelle. The actress Anjelica Huston wears a daisy-print dress of black silk by Sheridan Barnett, and patent-leather sandals by Manolo Blahnik, who sits in the middle, in a Walter Albini cream suit. Blahnik appeared on the cover of the magazine in an embrace with Huston. It was only the third time that a man had appeared on the cover of *Vogue* – the actors Alan Bates and Helmut Berger had beaten him. The distinguished fashion editor Grace Coddington, who led the *Vogue* team, wrote affectionately in her elegant book *Grace* that she was surprised that Blahnik, her epitome of male photographic perfection,'was more neurotic about his appearance than Anjelica. The only question he asked more than "Which tie do you like better?" was "Do I look all right?" Of course he looked more than all right – he looked like the man who had made women's shoes matter.'

above

NICOLA WAYMOUTH AND HALSTON, 1974
BY ERIC BOMAN

The mid-Seventies saw the glittering coalescence of fashion
and celebrity. Anyone could be famous, as Andy Warhol
pronounced, for at least 15 minutes. It helped if he or she
was based in New York, was a regular at Studio 54, and was
dressed by Roy Halston. Known simply as 'Halston', he is
photographed here with the languorous English model
Nicola Waymouth, whom he has dressed in cashmere and
red fox. Before opening his own couture house, Halston
trained as a milliner – Jacqueline Kennedy wore a Halston
pill-box hat to her husband's presidential inauguration.
Unusually for a fashion designer, he knew many of his
clients socially, and these included Bianca Jagger, Anjelica
Huston and Liza Minnelli. He gave them pared-down,
comfortable designs, which were simply constructed and
effortlessly luxurious. He is most famous for his 'shirtdress'
and a signature scent, which confounded expectations with
its commercial success.

right

MONICA VITTI, 1973
BY ELISABETTA CATALANO

Vitti's glacial, inherent sexuality was nurtured by
Michelangelo Antonioni, and reached an early maturity
in his *L'Avventura* (1960), her first film. A study of
privilege, ennui and an emotionally detached sexual
relationship, it was booed at Cannes yet won the
Special Jury Prize. It was beaten to the Palme d'Or by
Fellini's *La Dolce Vita*. Vitti made three more films with
Antonioni, with whom she was involved off-set – *La
Notte* (1961), *L'Eclisse* (1962) and *Il Deserto Rosso*
(1964) – but, after that, very little else of any
consequence. For a generation of *Vogue* readers she
was the epitome of Italian chic, fur trimmed certainly,
but also with a hard edge. In the fumbling hands of
the average magazine reader, a cheroot might have
been a preposterous novelty, but Vitti possessed that
sure 'Continental' sophistication which rendered the
unconventional stylish. *Vogue*, however, decided not to
tempt its readers into mondaine ways and dropped
the cheroot altogether.

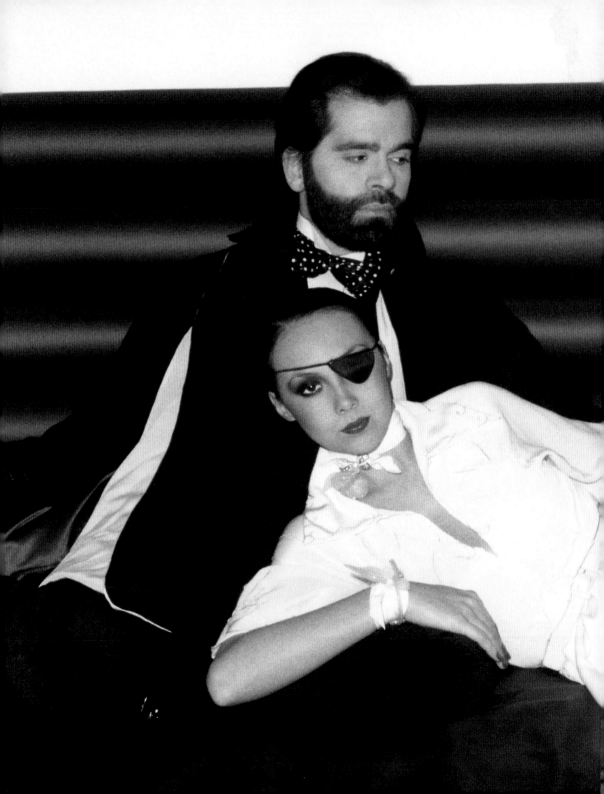

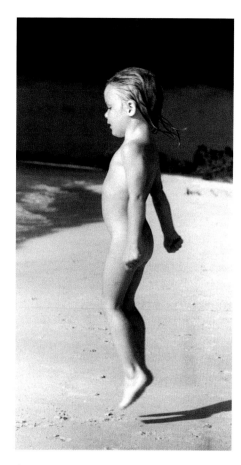

above
STELLA McCARTNEY, 1975
BY NORMAN PARKINSON

Aged three, 'The youngest Beatle,' reported *Vogue*, 'bopping up an appetite before a beach barbecue on the never-ending sands of Negril'. Twenty-eight years later, Stella McCartney is a major force in the fashion industry. A meteoric rise ensured her second catwalk show was for the house of Chloé, of which she was made head designer in 1997. Her first was her graduation show at Central St Martins – her friends Naomi Campbell, Yasmin Le Bon and Kate Moss modelled it. Her tenure at Chloé saw the fashion house's sales quintuple. Now in charge of her own house, under the umbrella of the Gucci group, she continues to dazzle. Her 'London Chick' look has effortlessly conquered Paris, always the most fastidious and demanding of markets. As one trendy Parisian retailer told *Vogue*, 'Her airbrushed T-shirts were like freshly baked baguettes. Less than 24 hours after we had put them in the window, they had gone…'

left
KARL LAGERFELD AND MARIE HELVIN, 1975
BY DAVID BAILEY

Lagerfeld finished his studies in Paris. At 16 he was working with the couturier Balmain. After three years with Jean Patou, he left to freelance for various houses, including Krizia, Chloe and the shoe designer Charles Jourdan. However, Lagerfeld is best known for the collections that bear his own name, and for steering the house of Chanel into the modern age. His reinterpretations of original designs by Gabrielle 'Coco' Chanel, most notably the Chanel suit, and his use of the double 'C' insignia have been hugely successful. With his pigtail and signature fan, he now resembles an eighteenth-century courtier and aesthete. In the Seventies, he was bearded and sans pigtail, but nonetheless languidly chic in marocain crepe pyjamas with jade-coloured revers and cuffs. In his Paris apartment, Marie Helvin (Mrs David Bailey) wears Lagerfeld's designs for Chloé, accessorised with an eye patch.

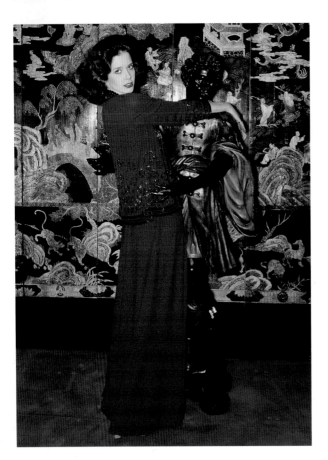

above

SYLVIA KRISTEL, 1976
BY OLIVIERO TOSCANI

Sylvia Kristel here models Chanel couture in the legendary couturier's
Paris apartment. By 1976, Kristel was herself something of a legend,
certainly to a generation of British schoolboys, as the star of the soft-porn
classic *Emmanuelle* (1974). Directed by *Vogue* photographer-turned-auteur
Just Jaeckin, *Emmanuelle* reached box-office attendance figures of 4 million
in Paris. By the time of these Paris collections, Kristel had just completed
work on *The Streetwalker*. Apart from the numerous *Emmanuelle* sequels,
Kristel appeared in several European films and undressed for *Lady
Chatterley's Lover* (1981 – again by Jaeckin) and for *Mata Hari* (1985).
Research has shown that many *Emmanuelle* aficionados are also fans of
the British TV series *Lovejoy*, based on the antiques trade. This surprising
link may derive from their knowledge that Kristel once enjoyed a
relationship with its leading man Ian McShane.

right

MARTHA GRAHAM, 1976
BY CECIL BEATON

In Martha Graham's long career in experimental choreography – she died
at 96 – she became almost an establishment figure in the era of avant-
garde contemporary and postmodern dance. In the twentieth century, the
Martha Graham Dance Company was central to a particularly 'American'
form of modern dance, communicated by expressive and exaggerated
movement, pared-down costume and sparse settings, often created by the
sculptor Isamu Noguchi. Beaton has caught her here in a characteristically
animated attitude. She once asserted that the sight of a Kandinsky abstract
in 1922 moved her to set up her own dance company. Regarding it, she
promised herself, 'I will dance like that.' She maintained that the secret to
the Graham technique, the blueprint for virtually all today's modern dance,
was in the art of breathing. 'I have distorted the body for maximum
expressiveness,' she explained, 'but in the end it all comes down to
breathing. Inhale and exhale properly.'

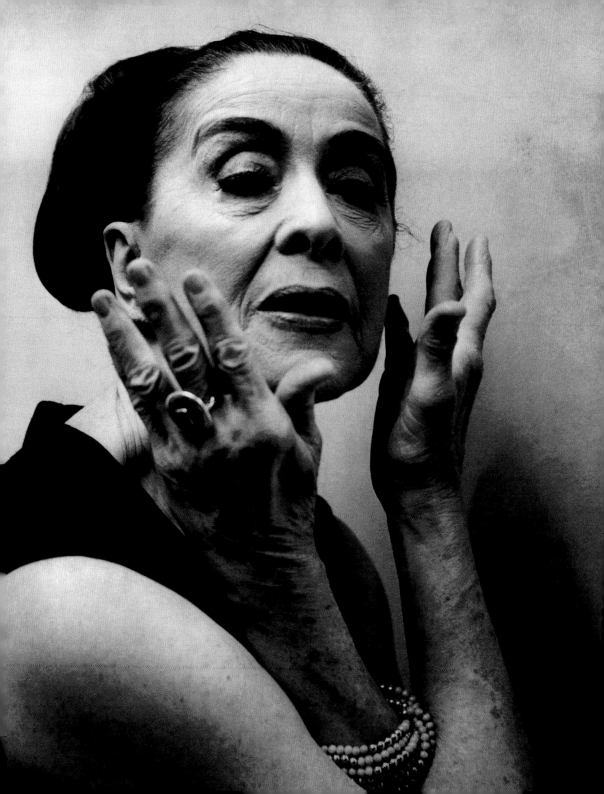

left
BRYAN FERRY AND JERRY HALL, 1976
BY DAVID BAILEY

The Texan model Jerry Hall was the seashell-accessorised cover girl
for *Siren*, the 1975 album by Roxy Music, the proto-glam band of
which Bryan Ferry was lead singer and songwriter. Ferry and Hall
became a much-photographed celebrity couple of almost
unsurpassed chic. When Roxy Music disbanded – for the second
time – Hall could still be seen yee-haa-ing on promotional videos for
Ferry's solo records *Let's Stick Together* and *The Price of Love*. Their
acrimonious break-up was a newspaper sensation involving, in no
particular order, cockroaches, Mick Jagger and Warren Beatty. Hall
and Ferry's careers diverged: Hall has made appearances on stage
and as a television hostess; Ferry continues as an impeccably
groomed gentleman rock star. With the exception, perhaps, of Beau
Brummell, no Englishman before or since has managed to wear two
neckties, in contrasting shades, at the same time, with quite the
aplomb of Bryan Ferry.

opposite
TWIGGY, 1976
BY BARRY LATEGAN

'What happened to the Beatles and me,' Twiggy told *Vogue*, 'couldn't
happen any more, I think… I was lucky that I was the right age at
the right time and in the right place.' Though the transformation of
the stick-thin Lesley Hornby from Neasden to international
superstar 'Twiggy' owed much to the efforts of Justin de Villeneuve –
despite his remarking that her voice was 'like that of a demented
parrot' – Twiggy has since taken pains to set the record straight. 'One
of the things that has really irritated me over the years,' she wrote in
her autobiography *Twiggy in Black and White*, 'is the way that just
about everybody swallowed the line that Justin was the Svengali and
I was the dumb blonde…' De Villeneuve completed his own
transformation – he was born a less exotic Nigel Davies – and
became a photographer, though the author of Twiggy's first
professional pictures was not him, but South African Barry Lategan.
Now a well-known name, Lategan started off as 'house'
photographer to the salon of the hairdresser Leonard, where Lesley
Hornby went to start her own transformation – a seven-hour
session. Lategan suggested she call herself 'Twiggy' and the results of
their sitting, pinned up in Leonard's salon, soon made it into the *Daily
Express*. The headline read: I NAME THIS GIRL THE FACE OF '66. A
decade and many collaborations later, Lategan photographed her for
Vogue's 'Diamond Jubilee' issue in 1976. By then she had won a
Golden Globe for her performance in Ken Russell's *The Boy Friend*;
posed for a David Bowie album cover; presented an Oscar for Best
Costume; and performed at the Royal Festival Hall in a diamanté-
studded, embroidered chamois jacket and trousers designed for her
by Bill Gibb, which she wears here. Her hair was styled, fittingly, by the
House of Leonard.

JODIE FOSTER, 1977
BY BARRY LATEGAN

Though a child star of some experience, Jodie Foster acquired early notoriety with her role as the teenage drug-addicted hooker in Martin Scorsese's *Taxi Driver* (1975). It was, *Vogue* commented, 'a role that made Lolita look like Mary Poppins'. This depraved screen image was reinforced some years later when the would-be assassin of President Ronald Reagan, John Hinckley, admitted he had carried out his attempt to impress Foster. She appeared in *Vogue* a decade before her first Oscar (for *The Accused*, in 1988), 14 years before her second (for *The Silence of the Lambs*, in 1991) and several before she gave it all up briefly to study at Yale. Here, aged 14, she told *Vogue*, 'If I ever had to die, I would hate to die of old age. I would want to die dramatically – in the middle of a shot. Then it would be terrific publicity when the picture came out.'

right
PIER PAOLO PASOLINI, 1976
PHOTOGRAPHER UNKOWN

The controversial Marxist poet-turned-film maker, whose oeuvre covered themes such as religious intolerance, sexual brutality and the desperation of the Italian underclass, was found dead the year before this picture was published. This fragment of a photograph illustrated a long and thoughtful meditation on his life and achievement. Attempting to bring an idiosyncratic social realism to his films, Pasolini had embraced the world and culture of pimps, prostitutes and small-time thieves. For his debut *Accattone* (1961), set in the slums of Rome, he used a non-professional cast of 'found' locals. And there, 15 years after shooting it, he was found bludgeoned to death, allegedly by a teenage male prostitute, who had repeatedly driven over the corpse with the director's own Alfa Romeo sports car. *Accattone* won awards and critical acclaim, but the opprobrium of the establishment, like most of his films. The sexually charged *Theorem* (1968), with Terence Stamp, offended virtually everyone: the Vatican denounced it as obscene and irreligious, and Pasolini's own Marxist allies thought it too sympathetic to the bourgeoisie. Nothing, though, prepared them for the disturbing *Salò* or the *Twelve Days of Sodom*, an adaptation of de Sade's novel set in the twilight of the Second World War. A stark account of atrocities suffered by a group of teenagers at the hands of their brutal Fascist captors, it was Pasolini's last film. The manner of his death shortly afterwards, at the hands of one whose circumstances he had tried to dignify with his films, was a tragically appropriate finale.

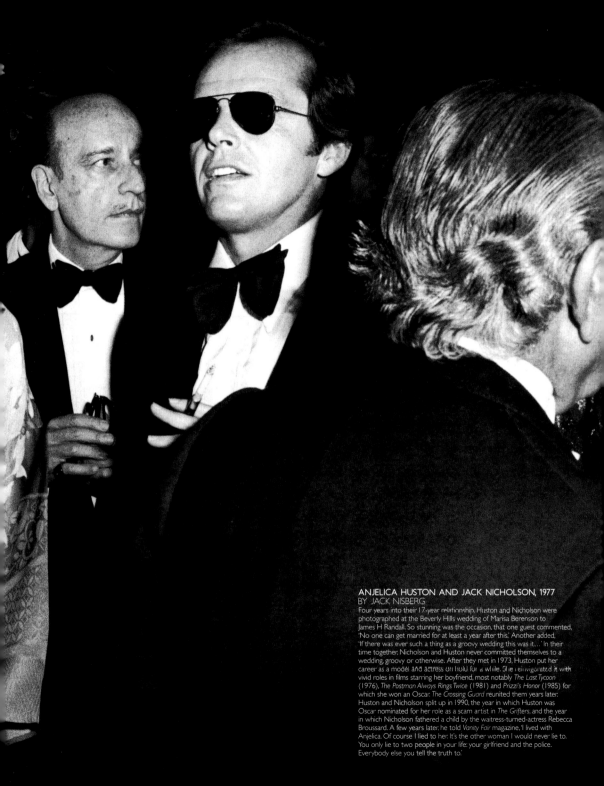

ANJELICA HUSTON AND JACK NICHOLSON, 1977
BY JACK NISBERG

Four years into their 17-year relationship, Huston and Nicholson were photographed at the Beverly Hills wedding of Marisa Berenson to James H Randall. So stunning was the occasion, that one guest commented, 'No one can get married for at least a year after this.' Another added, 'If there was ever such a thing as a groovy wedding this was it...' In their time together, Nicholson and Huston never committed themselves to a wedding, groovy or otherwise. After they met in 1973, Huston put her career as a model and actress on hold for a while. She reinvigorated it with vivid roles in films starring her boyfriend, most notably *The Last Tycoon* (1976), *The Postman Always Rings Twice* (1981) and *Prizzi's Honor* (1985) for which she won an Oscar. *The Crossing Guard* reunited them years later. Huston and Nicholson split up in 1990, the year in which Huston was Oscar nominated for her role as a scam artist in *The Grifters*, and the year in which Nicholson fathered a child by the waitress-turned-actress Rebecca Broussard. A few years later, he told *Vanity Fair* magazine, 'I lived with Anjelica. Of course I lied to her. It's the other woman I would never lie to. You only lie to two people in your life: your girlfriend and the police. Everybody else you tell the truth to.'

above
MARTIN AMIS, 1978
BY SNOWDON

'Will *Success* spoil Martin Amis?' asked William Green in *Vogue*. 'Martin Amis is now 28,' he continued. 'At last, perhaps, his age is no longer the most extraordinary thing about him. Nevertheless, it will be a few years before he shakes off the boy-wonder image, which has dogged him since his first novel.' That novel was *The Rachel Papers* (1974) and it won him the Somerset Maugham Award. He followed it with *Dead Babies* (1975), which exemplified, like its precursor, Amis's flamboyant, witty style and his often startling wordplay. This appearance, as Green's own wordplay informs us, coincided with the publication of his novel *Success*.

opposite
DAVID BOWIE, 1978
BY SNOWDON

In the mid-Seventies, Bowie was in self-imposed exile, shuttling between Los Angeles, Berlin and New York, and morphing into the latest of a series of publicly projected personae, the Thin White Duke. His personal life seemed a little rocky, and a dependency on cocaine is alleged to have provoked his infamous Nazi salute from the back of an open-topped Mercedes-Benz, and the pronouncement, in Stockholm, that what Britain really needed was 'another Hitler'. By the time of this portrait, he had starred – at his thinnest – in *The Man Who Fell to Earth* (1976) for Nicholas Roeg, and had completed his 'Berlin' trilogy of albums. He was also emerging from the Thin White Duke phase, though the thinness persisted. Of the preceding few years and his struggle with addiction, he told *Vogue*, 'My insides must have been like perished rubber. Yes, it was not a good time at all… very amusing, looking back on it… I must have been an extraordinarily hard person to relate to…'

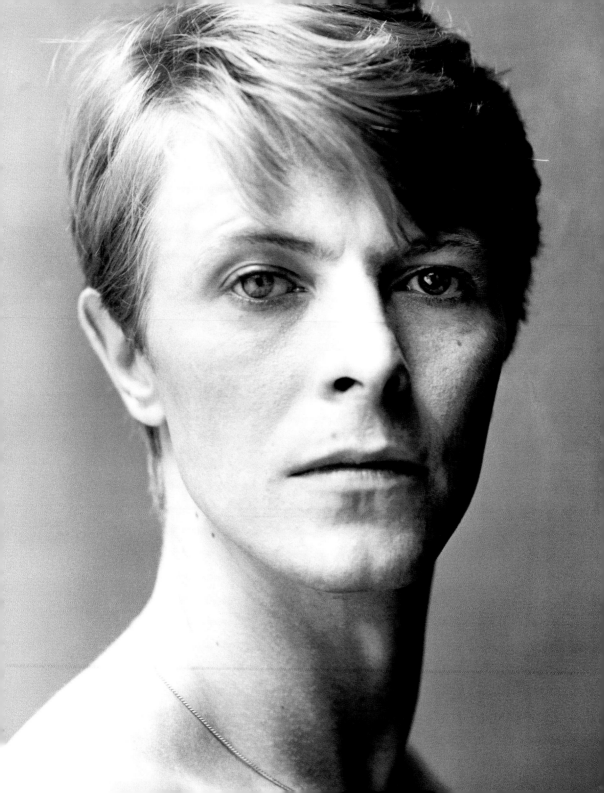

This was taken for *Vogue* in the expatriate artist's London studio. 'There is
nothing in the huge room,' *Vogue*'s William Green observed, 'drenched in
light from the wall-length windows and skylights, that does not contribute
to his painting. Nothing decorative, nothing for show, just a neatly arranged
profusion of paints, canvases and a large blue folding screen he uses as a
backdrop.' Snowdon reflected Hockney's well-known 'shower' pictures by
placing him for some shots in the bathroom. 'I also took a still life of a pin-
board on which he had put several photographs as souvenirs [*below*],
including one of a young man full frontally naked,' recalled Snowdon.
'Beatrix Miller, *Vogue*'s editor and my great friend, made me re-photograph
it with a print from the sitting placed over the offending picture.'

EARL MOUNTBATTEN OF BURMA, 1979
BY DESMOND O'NEILL

A great-grandson of Queen Victoria and, through his mother, a Prince of the German house of Hesse, HSH Prince Louis Francis of Battenberg (afterwards Mountbatten) was Supreme Allied Commander, Southeast Asia, the last Viceroy of India, and Chief of Defence Staff. Here, in one of his last public appearances, he attends the Berkeley Square Ball, in aid of groups that included the Sea Cadets – he is photographed with Sea Cadet Paul Salvator. This picture in *Vogue* is a poignant reminder of his distinguished career in the Royal Navy. He joined the Navy as a teenager during the First World War and saw active service. He rose as high as any sailor could, becoming First Sea Lord and Admiral of the Fleet. His exploits as captain of HMS *Kelly*, from whose bridge he was also commander of the 5th Destroyer flotilla, were the inspiration for the film *In Which We Serve* (1941), co-directed by David Lean and Noël Coward, who also played the part of the captain. After the War, he became Commander-in-Chief of the Mediterranean Fleet. Weeks after this photograph was taken, Mountbatten was murdered by the IRA, blown up in an explosion on his boat.

1980s

A COUNTRY SAFE FOR THE RICH

This was a decade of image-consciousness. 'If you've got it – flaunt it' was the maxim of the moment. *Vogue* suggested, subtly, that if you hadn't got it, you really ought to get it and devoted acres of spectacular photography to 'power dressing', idealised lifestyles, the creations of Karl Lagerfeld for Chanel, and the irrepressible concoctions of Gianni Versace. The decade witnessed an explosion in the turnovers of fashion houses and the epithet 'designer' applied to anything from jewellery to water. *Vogue* featured Eighties excess run riot: a leather harness for carrying one's bottle of Evian, available from Hermès; the rainbow-hued couture of Christian Lacroix exulting in unabashed opulence.

The Eighties were symbolised by one person, Margaret Thatcher, whose tenure in office spanned the full 10 years. 'Thatcherism' transcended politics. It stood for defiant individualism, enterprise and achievement. It generated the term 'Loadsamoney!' – a peculiarly British concept – the term coined in 1988 by television comedian Harry Enfield to denote aspirational free-marketeers loaded with wealth. Specifically southern English, were the expressions 'Essex Man' and his daughter 'Essex Girl' – catch-all sobriquets for those distinguished by their lack of taste or cultural interests, but large disposable income. Anything was for sale, at a price; even titles. The gap between rich and poor became a gulf, spawning a discontented and displaced underclass; the first half of the decade saw the number of millionaires in Britain double, while homelessness soared.

Fashion started off the Eighties in a restrained manner. Japanese designers, such as Yohji Yamamoto, and Rei Kawakubo of Comme des Garçons offered a post-apocalyptic chic, in tune perhaps with the nuclear threats of the time. Katherine Hamnett created a message for the masses with her sloganeering T-shirts. '58% don't want Pershing' screamed the one she wore to meet Margaret Thatcher in 1984. Within *Vogue*, two giants of Eighties photography epitomised the extremes of fashion photography. Opposites, they nonetheless co-existed harmoniously in the pages of the magazine. Peter Lindbergh's grainy black-and-white images of models dwarfed by totems of the machine age aligned themselves with the German expressionist narratives of his country's early-twentieth-century film makers. He presented a bleak, monochromatic and resolutely urban future for the masses, dehumanised – but still unmistakably (and expensively) chic in the greys and blacks of Comme des Garçons utility wear. More involving were Bruce Weber's sweeping narratives for British *Vogue*, set against the vastness of the American landscape, peopled by impossibly attractive beauty and the simple, though highly styled, portraits Weber shot were honed by pre-production on a scale as large as the locations. Weber's keen knowledge of literary and visual references made him the undoubted star of Eighties fashion iconography. Any photographer who has successfully published in a mainstream magazine a picture of a male figure, naked from the waist up or down, owes something to Weber's pioneering efforts to make it all, as he has put it, 'kind of normal'.

The decade in the end was anything but 'kind of normal'. As *Vogue* summed up, it was a decade 'marked by businessmen being knighted for go-getting (and then jailed when it was discovered how).' The Eighties, it continued, 'started out with getting your jewels out of the vault – and ended up by pretending you used unleaded in your car.'

NEW EYE ON DETAIL

Callas THENICS

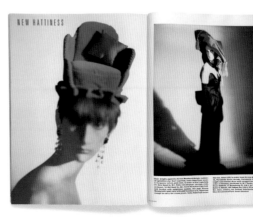

NEW HATTINESS

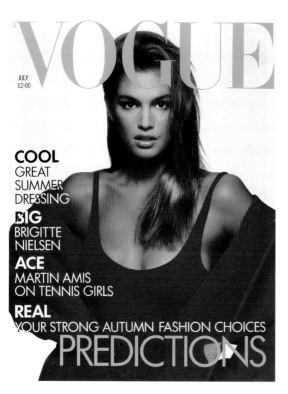

VOGUE

JULY
£2·00

COOL
GREAT
SUMMER
DRESSING

BIG
BRIGITTE
NIELSEN

ACE
MARTIN AMIS
ON TENNIS GIRLS

REAL
YOUR STRONG AUTUMN FASHION CHOICES

PREDICTIONS

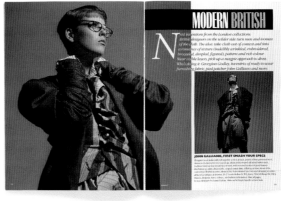

MODERN BRITISH

JOHN GALLIANO, FIRST SMASH YOUR SPECS

The 1988 *Vogue* covers of Cindy Crawford (*above*) by Patrick Demarchelier and Stephanie Seymour (*right*) by Herb Ritts, both in clothes by Giorgio di Sant'Angelo, illustrate the decade's polarities: sporty clothes shot indoors, and elaborately styled eveningwear shot outside. Ritts photographed Tatjana Patitz (*opposite centre*) with attendant male models, and there was also a male presence in Albert Watson's beauty shoot (*opposite top*). Paolo Roversi's coloured lighting gels and Polaroid film (*opposite below*, 1985) produced an ethereal style, while *Vogue*'s more fanciful styling, shot by Demarchelier in 1985 (*below*), often worked best against plain studio walls. *Vogue* spotted John Galliano early – his 1984 degree show was recorded (*above right*) by Kim Knott.

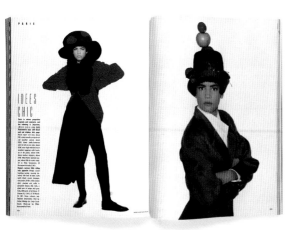

IDEES
CHIC

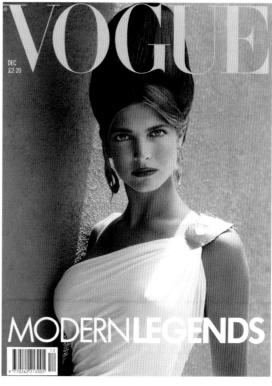

DEC
£2·20

VOGUE

MODERN LEGENDS

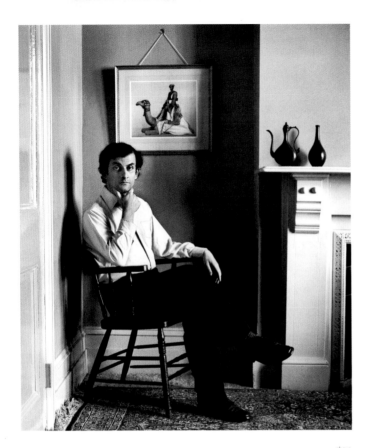

SALMAN RUSHDIE, 1982
BY SNOWDON

Rushdie was a little-known novelist before *Midnight's Children* won the Booker Prize in 1981. The novel is set around the period of India's independence, and its hero is born at the stroke of midnight on August 14, 1947, the moment of the country's formal severance from Britain. His life becomes a metaphor for the fate of the new nation. By the time of *Vogue's* portrait, the book had sold 250,000 copies in Britain alone. The controversy surrounding Rushdie's fourth novel, *The Satanic Verses* (1988), continues to eclipse his subsequent career. Certain chapters were construed as blasphemous in Islamic terms, and Rushdie was put under sentence of death by a notorious fatwa of the current Iranian spiritual leader Ayatollah Khomeini – 'an extreme form of literary criticism,' remarked the novelist V S Naipaul. Though the fatwa could not be revoked formally, a decade after its issue, the Iranian government announced that it would not seek to put it into effect.

right
BRUCE CHATWIN, 1982
BY SNOWDON

Chatwin's jacket and walking boots allude to his travel writing. Despite his early death, he was also an acclaimed novelist. His first career, however, was in the art world. At Sotheby's, he rose in a few years from porter to head of the impressionist department. Quixotic by nature, he abandoned other careers, including journalism, and passions, such as anthropology and archaeology. His first book, *In Patagonia* (1977), was reputedly written on a whim, inspired by his memory of a giant sloth preserved in a glass case in his grandmother's house. By then a writer for *The Sunday Times*, he left a message on his desk – 'Gone to Patagonia' – and didn't reappear for six months. According to one obituarist, 'He never did the same thing twice.' *Vogue's* Lucy Hughes-Hallett observed that although he was solitary and a little rootless, 'to despise possessions is not necessarily to spurn creature comforts. Chatwin keeps his fridge stocked with all the delights Belgravia's delicatessens can offer. He offered me chèvre with a superior Polish version of a Ryvita biscuit, and mulberries with crème fraîche.'

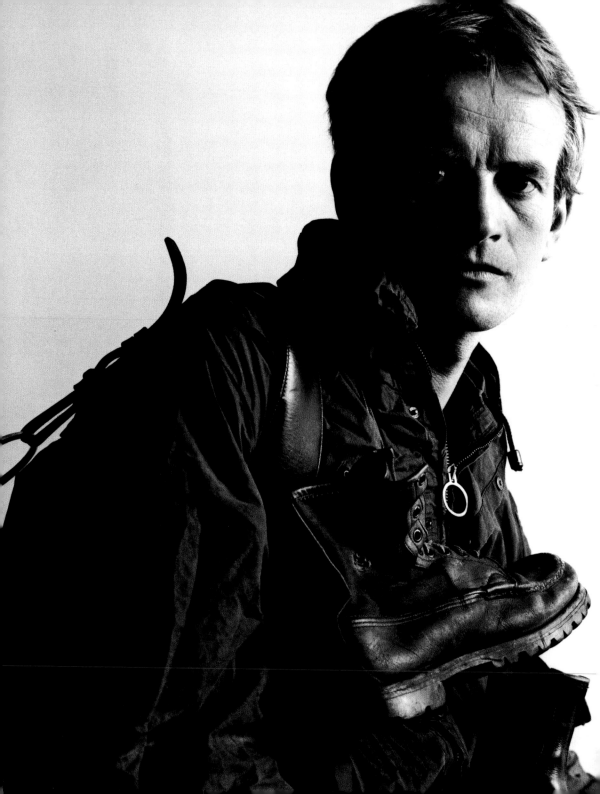

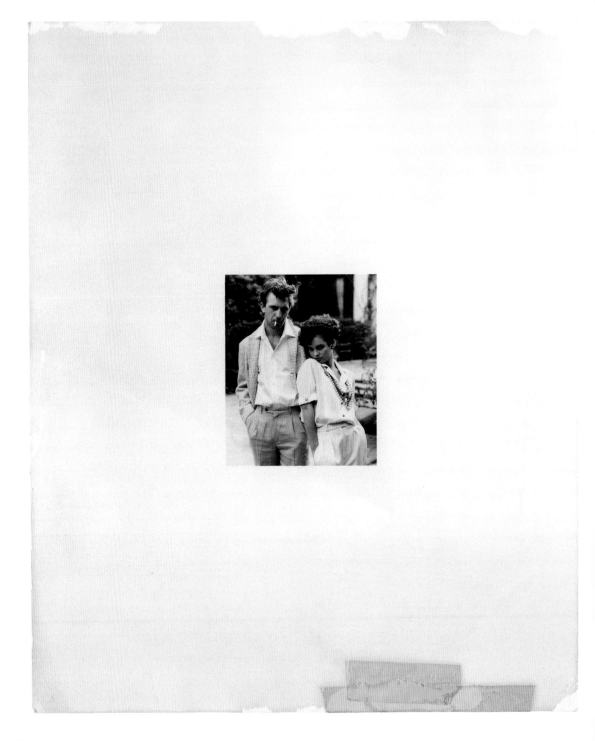

opposite
KEVIN COSTNER, 1983
BY BRUCE WEBER
The Oscar-winning actor's only appearance (so far) in *Vogue* was in an uncredited role as a fashion model. His leading lady is identified only as 'Laura', and the fashion shoot was inspired by the golden age of Hollywood. Costner affects a louche disposition in a suit by Basile, in the Hollywood home of legendary producer Robert Evans. Other aspiring stars in this early fashion story by Bruce Weber included Matt Dillon and Griffin O'Neal.

above
MATT DILLON, 1983
BY BRUCE WEBER
Posing with the model Laura for the same fashion shoot that starred the uncredited Kevin Costner (*opposite*), Dillon was by this time a leading teen idol, specialising in characters who were troubled, emotionally unstable or disaffected. His break into acting, so the story goes, was accidental. Playing truant from school, he bumped into a team of talent scouts, who were impressed by his cocksure demeanour. Later, he told his mother that he might have a part in a film 'some brothers were making'. The 'brothers' turned out to be Warner Brothers and his debut was as a playground bully in *Over the Edge* (1979). He rapidly became the spokesperson for teenage angst in *Rumblefish* and *The Outsiders* (both 1983). He made a successful transition in his screen roles from puberty to manhood, but his best adult parts continued to be those of malcontents – most notably in Gus Van Sant's *Drugstore Cowboy* (1989) and Cameron Crowe's romantic comedy *Singles* (1992).

MICHAEL CLARK, 1984
BY MARIO TESTINO

'Now and then,' declared *Vogue*, 'there are artists in any medium who cause a stir; who threaten and excite.' At 13, Michael Clark was offered a place at the Royal Ballet School, London, and, on graduation, promptly turned down the chance to work with the main company. Instead, he turned to the experimental Ballet Rambert, but subsequently abandoned that, too, to form his own dance company. The outré costumes of David Holah and Leigh Bowery distinguished his early repertoire, invariably set against the discordant music of The Fall. Drug addiction hastened Clark's first retirement, in 1988, but he reappeared to great acclaim in the mid-Nineties before again slipping from view. He returned once more, triumphantly, in the late Nineties.

right

MADAME GRES, 1984
BY SNOWDON

Photographed here at 81, Madame Grès was one of the last surviving prewar couturiers. Her signature designs of draped silk jersey possessed an almost Hellenic formality; her toiles perfected by working directly on the human form – each dress took around 300 hours to complete. The tranquillity of her sculptural creations and her personal composure belied a perilous existence in occupied Paris. Although Jewish, she was allowed to continue with her couture business, but eventually ran out of excuses for not dressing the wives and mistresses of German officers. Her atelier was closed down after she flew from its window a French tricolour fashioned from Lyons silk. After the War, although she had such high-profile clients as Princess Grace of Monaco, Marella Agnelli and Marie-Hélène de Rothschild, her labour-intensive methods drove her close to bankruptcy. With great reluctance she turned to ready-to-wear, but completed only two collections. She died in 1993, in poverty, then the oldest living couturier and all but forgotten.

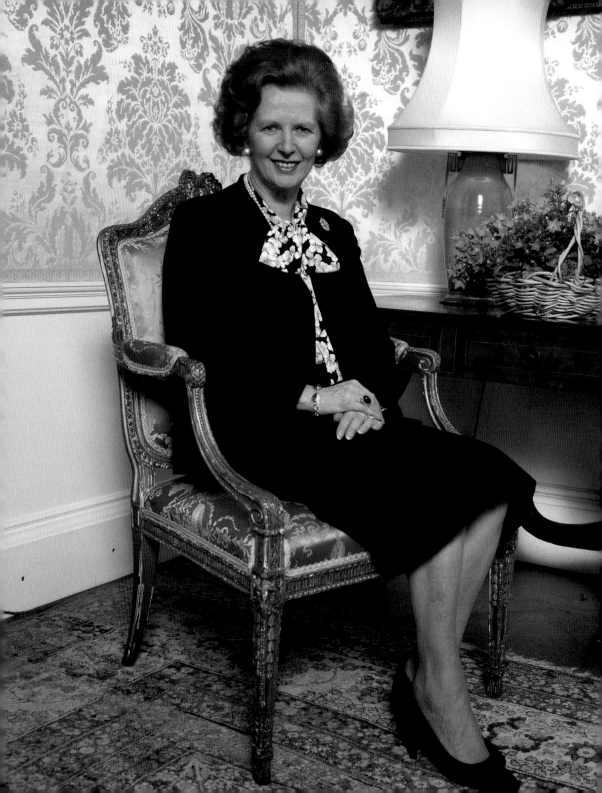

MARGARET THATCHER, 1985
BY DAVID BAILEY

When asked to contribute her views to the regular *Vogue* feature 'A
Certain Style', Margaret Thatcher had been a member of the British
Parliament for quarter of a century and leader of the Conservative Party
for a decade. She was also two years into her second term as Prime
Minister and two years later, when the Conservative Party won another
general election, she became the first Prime Minister since the nineteenth
century to serve three consecutive terms. She was known for a common-
sense frugality, and admitted that the suit she was wearing here 'was one of
the first I had, so it's about five years old. I vary it with blouses, different
accessories…' But she probably surprised readers by stating, 'I am
passionately interested in fashion… I do read *Vogue*. When we look at
fashion, ordinary people like me, we would love photographs which show
you what the clothes are actually like… When you're buying clothes, you
should not just stand in front of the mirror, but see how you move in them.
Everything matters – the cut, the linings, the finish, the detail.' Her mother,
she pointed out, had been a professional dressmaker.

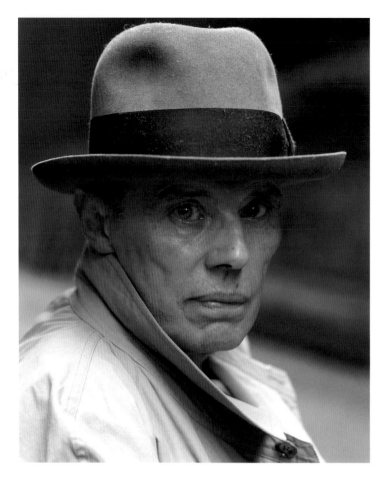

JOSEPH BEUYS, 1985
BY SNOWDON

One of the last published portraits of the avant-garde German artist, 'This was taken outside the back door of the Royal Academy,' recalled Snowdon. 'The sitting lasted about a minute. Patrick Kinmonth of *Vogue* said how clever I was to have caught the dust on the felt of his hat – just like a motif running through his work. I was going to brush it off but forgot, and was about to ask to have it retouched out.' Felt and grease – out of which he also made sculptures – had a particular resonance for Beuys. One of the crew of a wartime Luftwaffe bomber that crash-landed in the Crimea, he was swathed by his rescuers in fat and felt to keep him alive. He was a pioneer of conceptual 'action' work. 'A nice red mattress nailed to the wall is better than any painting,' he once declared.

opposite
JULIAN SCHNABEL, 1986
BY EVELYN HOFER

Schnabel was a leading exponent of 'Neo-Expressionism', and his work – oversized portraits formed from smashed crockery, for example, or, as in *The Trial*, 1985, 'oil and modelling paste on tarpaulin' – was occasionally showcased in *Vogue*. He would deliberately leave his canvases exposed to the elements because, as he once wrote, 'painting is a bouquet of mistakes.' Though gregarious by nature, Schnabel worked in isolation until the late Seventies, when the art dealer Mary Boone was moved by the smashed-plate works to give him his first solo show and to introduce him to Charles and Doris Saatchi, who bought a piece. By 1980, he was probably the most famous young artist in the United States, buoyed by the rapacious art market of the time, known for his own flamboyant taste for luxury cars and grandiose interior decoration, and supported by skilful self-promotion. He was also commissioned at the age of 35 to write his autobiography. At the time of this portrait, taken in his New York studio, he was set for a mini retrospective in London. 'What's happening now,' he told *Vogue*, 'is people aren't so fascinated by me as a person any more, and they are really starting to look at my work.' In the late Nineties, he began to make films, including a biopic of his friend the doomed artist Jean-Michel Basquiat (*Basquiat*), and one on the Cuban literary figure Reinaldo Arenas (*Before Night Falls*).

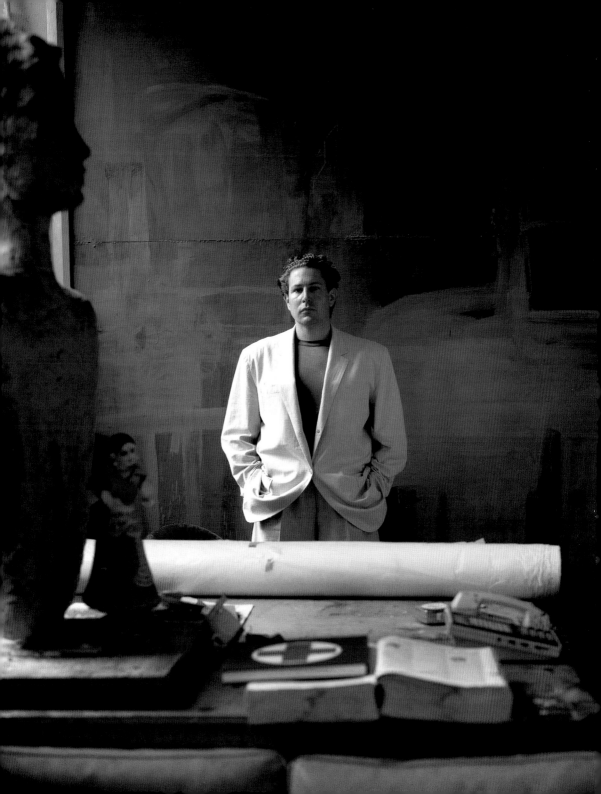

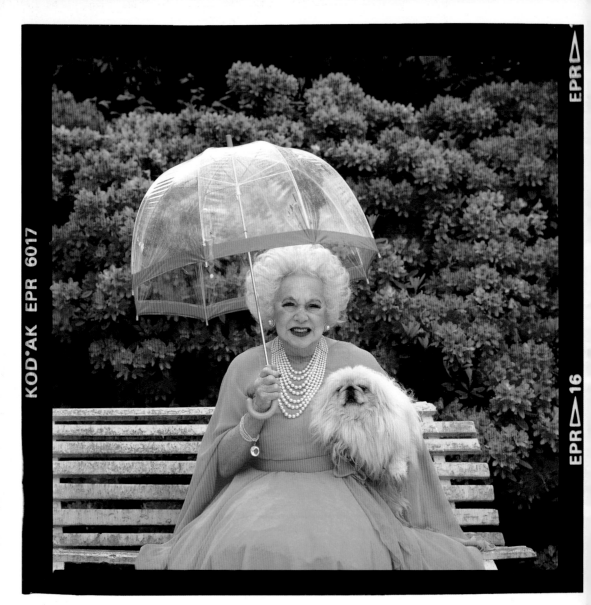

above
BARBARA CARTLAND, 1988
BY SNOWDON

Barbara Cartland was for a time the world's best-selling author, helped by a remarkable productivity – at its height, she wrote one romantic novel every fortnight. She was also a crusader for prayers in state schools, and an evangelist for health foods and homeopathic remedies. Snowdon took her portrait for *Vogue* at her house, Camfield Place, in Hertfordshire. 'Her umbrella matched the shade of the rhododendrons,' he recalled. 'When I first photographed her, she was clearly unimpressed by my small camera and lack of equipment. Thoughtfully, she kept a store of her own lights for visiting photographers and gave me very detailed instructions of where exactly to place them. She offered me some rejuvenating pills as well as lights. The pills made me feel rather sleepy.'

opposite
NANCY REAGAN, 1989
BY HERB RITTS

The former First Lady had just left the White House and was photographed on the lawn of her and her husband Ronald Reagan's Bel Air home. The mansion was acquired for the couple by a group of friends on a lease-and-buy-back arrangement, and was adjacent to the television home of the 'Beverly Hillbillies'. This portrait was arranged to coincide with the publication of *My Turn*, Mrs Reagan's own version of eight years at the White House – a corrective to the often highly coloured newspaper reports of her time there. *Vogue*'s Georgina Howell described the preparations for the shoot. The photographer, the late Herb Ritts, had arrived wearing shorts and sandals, which appeared to fluster Mrs Reagan's PR person, though the former First Lady did not bat an eyelid.' ''Will she let us do a shot sitting on the grass?'' An ironic smile slowly spreads over [her hairdresser] Julius's face. ''I do not think so,'' he murmurs softly.'

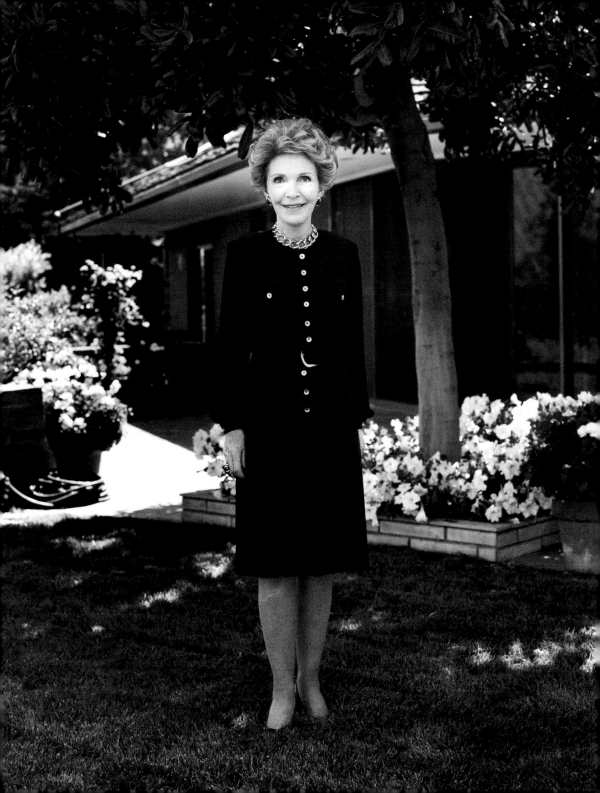

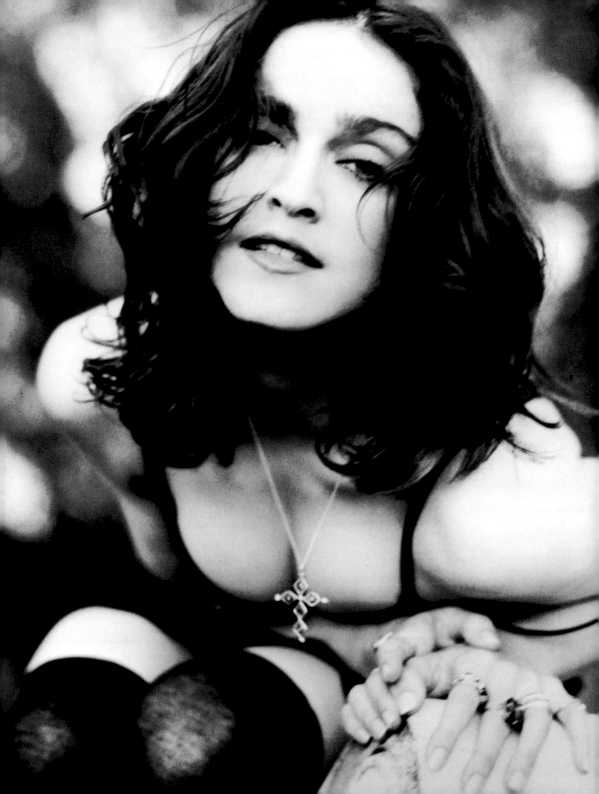

MADONNA, 1989
BY HERB RITTS

'"Come on, Herb, stop that! I want you to do me as the real me," squawks Madonna, as Herb Ritts tries to pull open her blouse to reveal more of a black bra. The "real me",' *Vogue*'s Sarajane Hoare reported, 'is Madonna stripped of her blond crop and red lips. Instead, before us is a Madonna who has stepped out of a Renaissance painting, a Mona Lisa, with long brown hair centre-parted, dark damson lips and porcelain-white skin.' This was the 'real me' for the *Like a Prayer* single and album. The latter was then considered to be her most ambitious and controversial – the Vatican did not approve of its commixture of religion and eroticism. Married since 2000 to the British film maker Guy Ritchie, the 'real me' has metamorphosed into a rural English incarnation. She is now chatelaine of Ashcombe, a magnificent Wiltshire manor house and estate, the home from 1930 to 1946 of *Vogue*'s Cecil Beaton and the location of many of his spirited early pictures.

below
MORRISSEY, 1986
BY ANDREW MACPHERSON

Morrissey's compelling lyrics set against Johnny Marr's driving guitars made The Smiths one of the most successful rock bands of the Eighties. In songs such as *Heaven Knows I'm Miserable Now*, *I Know It's Over*, *There is a Light that Never Goes Out* and *That Joke Isn't Funny Anymore*, he revealed himself as an articulate chronicler of the disadvantaged of the Thatcher era. Despite their songs' dwelling on isolation, introspection and despair, The Smiths' live performances were riotous. Morrissey – wearing a hearing aid, NHS prescription specs and, invariably, a spotted blouse from Evans Outsize – hurled gladioli at his audience; and they hurled them back. *Vogue* admired Morrissey's 'albescent features and hairstyle cut by an imaginative topiarist'. He now lives on the West Coast of the United States.

MIKE TYSON, 1989
BY HERB RITTS

Brooklyn's own 'Iron Mike' Tyson spent much of his troubled youth rearing pigeons. That he might have a future as a fighter is alleged to have been revealed when Tyson was 11, the day an older boy decapitated one of his beloved pigeons and Mike beat him to a pulp. This may have presaged Tyson's later pugilistic success, but for most of his adolescence the future world heavyweight champion lived a life of petty crime. Plucked from a correction centre by the trainer Cus D'Amato, he fulfilled his potential as a fighter in 1985 when, in his professional debut, he knocked out Hector Mercedes in 107 seconds. The following year, at 20, he became the youngest heavyweight champion in history, beating Trevor Berbick, James 'Bonecrusher' Smith and subsequently Tony Tucker. By 1988, he was indomitable, having beaten Michael Spinks. He was by now a household name and married to the actress Robin Givens. When this reflective portrait appeared in *Vogue*, Tyson had appeared vulnerable and noticeably unstable in a bout with Frank Bruno. Six months later, Buster Douglas, a relative unknown, had knocked him out. His marriage was by now on the rocks. The slide downwards accelerated when he was indicted for rape charges, tried, found guilty and sentenced to six years in an Indiana state penitentiary. But in 1995, when he was released, his rehabilitation began. He dispatched the Irish fighter Patrick McNeeley in 85 seconds, then Buster Mathis Junior, then Frank Bruno in Las Vegas, regaining the heavyweight crown. His next victory was over Bruce Seldon (109 seconds), but he himself was vanquished by Evander 'The Real Deal' Holyfield. The rematch was enlivened by Tyson's biting off part of Holyfield's ear, and his slide downwards recommenced.

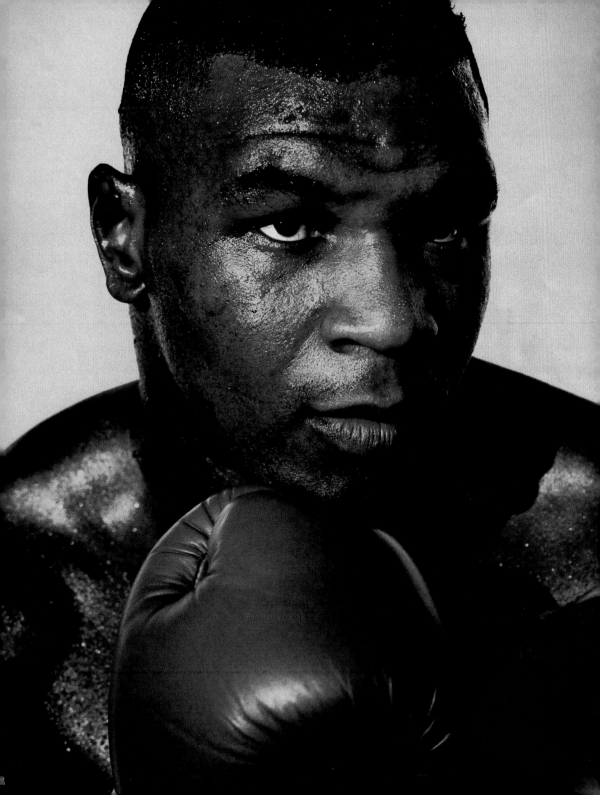

1990s AND BEYOND

YESTERDAY, TODAY, TOMORROW

In the Nineties, violence, upheaval and disaster, natural or man-made, seemed almost a way of life. The decade started with a military campaign, the Gulf War, and for Britain, 2003 marked the first serious military engagement of the twenty-first century, the Iraq War.

In 1993, John Major, Prime Minister of Britain since the decade began, was the intended recipient of a memo subsequently 'leaked' to the press – a Nineties phenomenon. The deputy chairman of the Conservative Party told him that, though his party had promised a 'classless society', the reality was 'that the rich are getting richer on the backs of the rest, who are getting poorer'. Many fashion designers and photographers responded, to an extent, to a generally heightened awareness of this socio-economic imbalance.

Side by side with the sumptuous creations of, say, Paolo Roversi and the escapist location work of Robert Erdmann and Neil Kirk, the realist photographs of Corinne Day and the naturalistic, though subdued, *mises en scène* of Juergen Teller looked unexpected in the context of *Vogue*.

There followed a robust renaissance in style and glamour. This time it was more 'hard-edged' than romantic, a reaction, perhaps, to the 'grunge' style – the term often applied to the photographs of Day, Teller and David Sims. The new look was trumpeted in *Vogue* as early as November

1993 with a coverline 'Glamour is back'. It was these photographs which consolidated the position of Nick Knight as the preeminent British fashion photographer of his generation, unafraid of subverting new technology to his finely honed aesthetic.

More traditional in outlook, while equally representative of its time and place – and often cited as a link to *Vogue's* heritage – is the oeuvre of the flamboyant and much-admired Mario Testino. His simply composed tableaux, which delight in artifice and wit, sustain *Vogue's* place in a world of rarefied privilege.

Following the dawn of the new millennium, the legacy of the late Nineties – the 'Blair effect', the residues of 'Cool Britannia', the *fin-de-siècle* boom in British arts from 'Britpop' to 'Britart' – was preserved, at least in *Vogue*, in a continuing enthusiasm for British creativity.

Vogue continues to reflect the influences that have helped make unique British art, design and music. A variety of socio-political developments have all made their mark upon its pages and helped it to define modern portraiture. The *Vogue* archive remains a precise barometer and chronicle of the social and cultural changes of the last century – a record, as *Vogue* declared on its fiftieth anniversary – of the 'people and things that have built and are building the fascinating world of yesterday, today and tomorrow'.

Black gold
The couture evening gown is a flight of fancy – by comparison, everything else is sweet reverie. Photographed by Mario Testino.

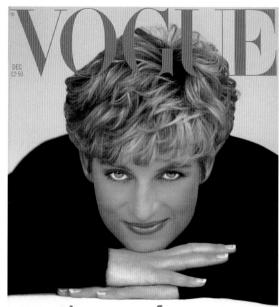

VOGUE

DEC £2·50

the year of
dance
A CHRISTMAS CELEBRATION

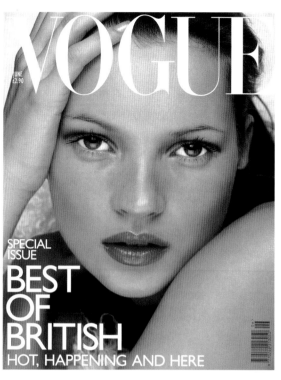

VOGUE

JUNE
£2.90

SPECIAL
ISSUE

BEST
OF
BRITISH

HOT, HAPPENING AND HERE

**StArT
ME
UP**

When style soul mates Anita
Pallenberg and Bay Garnett
decided to create a fashion
story using the clothes that
they'd collected over the years,
they knew their friend and
fellow fashion obsessive Kate
Moss was the only person who
could bring their ideas to life.
Photographed by Juergen Teller

Kate Moss has rarely strayed far from *Vogue* since the Nineties. Contrasting images show her on a cover by Nick Knight in 1998 (*above*), promoting *fin-de-siècle* British glamour, and in a shoot by Juergen Teller in 2003 (*above right*) in his hand-held *vérité* style. For a cover of 1993, Nick Knight conjures up the glamour of Helmut Newton's Seventies (*right*). For the mirror-covered Millennium issue, a high-point of the magazine's recent history, Raymond Meier presents a suitably inventive documentary approach to the classic beauty shot (*below*). The exuberant Mario Testino is represented (*opposite above*) with a restrained shot of Angela Lindvall in Versace, while the most famous portrait of the era (*opposite below*) is by Patrick Demarchelier.

VOGUE

NOV
£2.50

BEAUTY
SPECIAL

Very
Versace:
the story
of a £6000
dress

Glamour
is back

Georgina
Howell
meets
David Hockney

Face Savers:
new anti-ageing
treatments
tested

THE
TIME
OF
OUR
LIFE

We may not live for ever,
but in the next millennium,
the chances are that we are
going to live for a very long
time. Over the next few
pages, six experts look at the
impact this increased life span
might have on the way we
live our lives – from how we
will fulfil ourselves spiritually
and sexually, to the ways in
which we will prefer to work
and play. Whatever the future
holds, one thing's for certain:
the world will always be an
extraordinary and dangerous
place. Raymond Meier
photographs the youth
and beauty of the present,
reminding us of the most
affecting and evocative
images of the past.

'THE SUPERMODELS', 1990
BY PETER LINDBERGH

One of the most recognisable *Vogue* covers of all time. The supermodels are, from left: Naomi Campbell, Linda Evangelista, Tatjana Patitz, Christy Turlington and Cindy Crawford. 'Every five years or so,' trumpeted *Vogue* of these new arrivals, 'a handful of young women at the peak of their profession seem to encapsulate the look of the time… From Christy Turlington's stupendous pout to Tatjana Patitz's feline eyes, Linda Evangelista's boyish crop to Cindy Crawford's much-debated beauty spot or Naomi Campbell's puckish grin, they're emphatically individual.' They were also among the highest-earning young women of their generation. In 1990, *Vogue* estimated that should you wish to book them for a single day's advertising work, it might set you back around $100,000. Christy Turlington, though, would be out of reach because she was still, as *Vogue* put it, in 'the lucrative purdah' of an exclusive contract with Calvin Klein – rumoured to be worth $6 million. At the peak of their desirability, their fortunes rose even beyond this. Though they were by no means discovered by British *Vogue*, the magazine cultivated the notion of an inner circle of models, who would only get up in the morning for a favourite photographer and if the price was right. In return, explained *Vogue's* editor Liz Tilberis, 'they'll push themselves to the limit. If they know it's going to be a great picture, they'll go to the point of fainting to get it.'

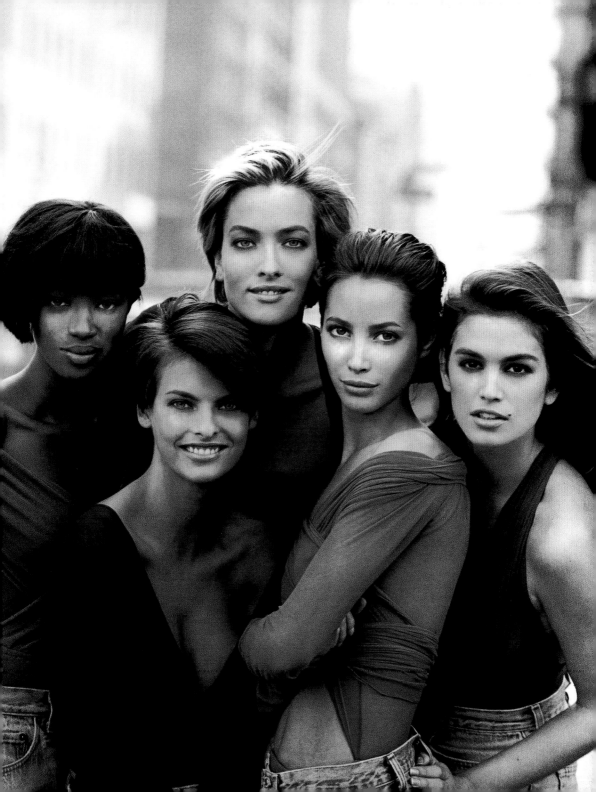

CLAUDIA SCHIFFER, 1991
BY PATRICK DEMARCHELIER

Missing from *Vogue*'s pageant of beauty on the previous page is Claudia Schiffer, whose star, though in the ascendant, had not quite reached the stratosphere inhabited by her colleagues. In time it would. By the end of the century she had outshone them – at least fiscally. She was estimated by *Forbes* magazine, among others, to be the richest model of the new millennium. Despite an underperforming dot-com business, she still earned about $10.5 million in 2000. *Vogue*'s Arthur Elgort, once said of the statuesque, Bardot-like creature whose career he nurtured: 'She's more like a movie star than a model. Strangers will approach Claudia on the street for autographs – once on location, I couldn't believe the lines at our table while we were eating. She just smiles and sighs…' In 2002 she married the film producer Matthew Vaughn. Though customarily it is the bride who changes her name after marriage, the groom discovered subsequently that he was not the son, as supposed, of former *Man from U.N.C.L.E.* star Robert Vaughn, but of the aristocratic George De Vere Drummond, a godson of George VI. Henceforth, the newly-weds and their young son are known formally as 'Matthew, Claudia and Caspar De Vere Drummond'.

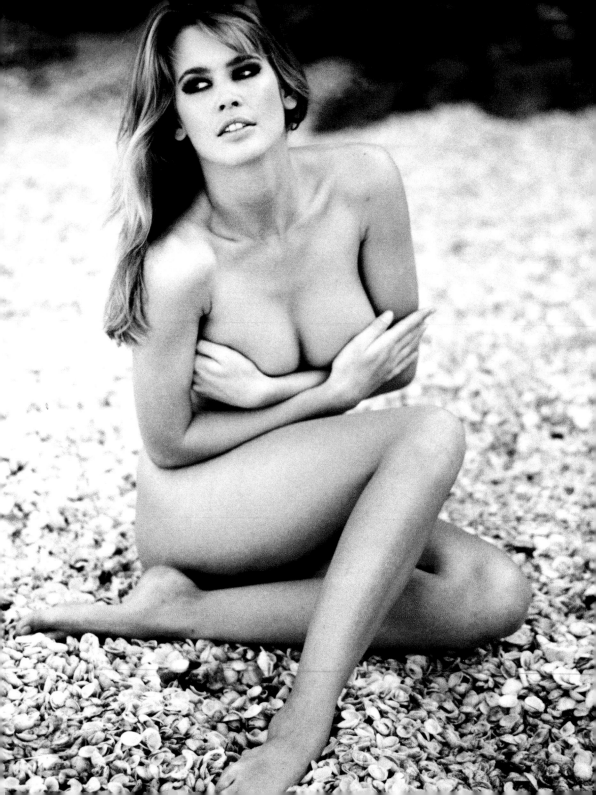

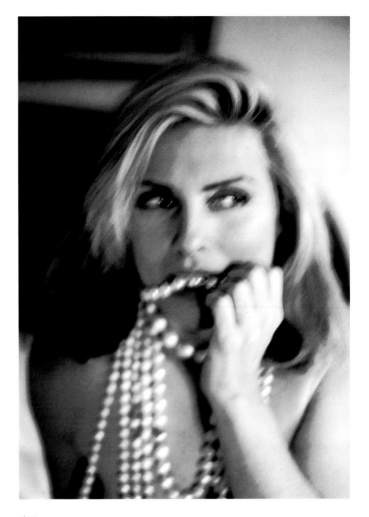

above

DEBBIE HARRY, 1990
BY MICHEL HADDI

The high-cheekbones-and-porcelain allure of platinum-blonde Debbie Harry gave her Seventies New Wave band Blondie the edge – at least commercially – over contemporaries such as The Ramones and Talking Heads. A little older than most of them – she was 32 when Blondie had its first hit record – Harry had previously worked as a waitress at the New York rock venue Max's Kansas City and was later a much-photographed fixture at the Bowery punk club C B G B. By the end of the Eighties, Blondie had splintered – though they re-formed a decade later – and Debbie Harry had released a succession of mostly underwhelming solo albums. She had a reputation as a brittle and unwilling interviewee but *Vogue* found her, at 45, placid and self-deprecating: 'You know in Australia the audience kept coming up to me and saying, "We bought all your records when we were eight, but were never allowed to come to see you," and it was, like, "Oh, these are my children…"' She was particularly anxious, on this occasion, to see the finished set of *Vogue* pictures. 'Natural Light can be so scary,' she confided, 'I'm a little older…'

opposite

SAM MENDES, 1990
BY SNOWDON

Nearly a decade before his debut film *American Beauty* won five Oscars – including Best Film and Best Director – Mendes was a prodigy of the London stage. At 24, he was a veteran apprentice of British subsidised theatre. He had brought a nineteenth-century comedy of manners, Boucicault's *London Assurance*, from the provinces (Chichester) to great acclaim in the West End, and was embarking on a production of Chekhov's *The Cherry Orchard* (with Judi Dench) at the Aldwych, as well as preparing his first productions for the RSC. Writing in *Vogue*, Nicholas Marston observed that 'the offers and invitations have started to flow and he clearly has every intention of enjoying his success. He has just won a scholarship to study in Germany… where he intends to stay out of the rehearsal room, to collect his thoughts while he can. When he returns, it seems more than likely that this name, quarter-French, quarter-Polish, quarter-Italian and quarter-west-Indian-Portuguese, will be a familiar one over old and new plays in the West End for years to come…'

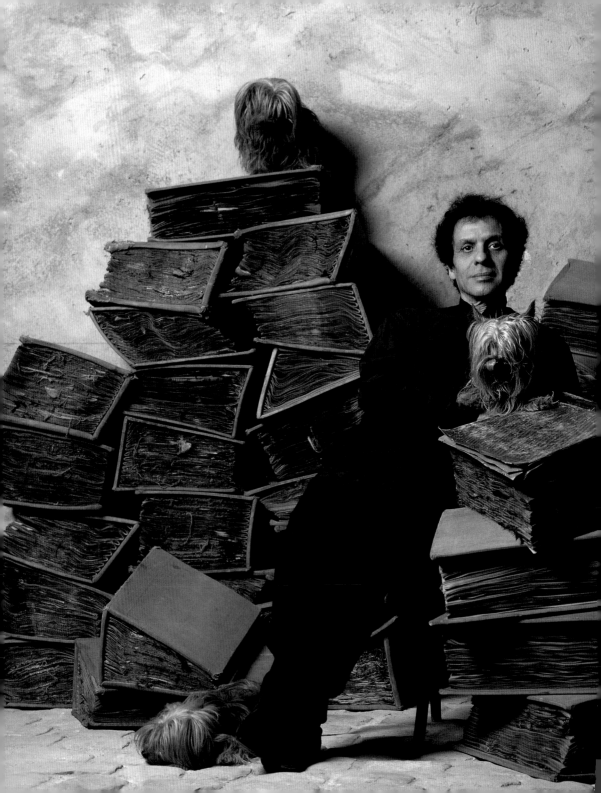

left
AZZEDINE ALAIA, 1990
BY SNOWDON
In the Eighties, the diminutive Tunisian designer Alaïa was regarded as one of the fashion world's greatest and one of its mavericks too. He has since eschewed the traditional catwalk show in favour of by-invitation-only events in *salons privés*. Even when he did put on shows, they would invariably follow two months after the rest of Paris. *Vogue* admired him deeply as 'The Man Who Loves to Dress Women' and he was able to obtain the services of the world's top models and to pay them in clothes alone. A notorious perfectionist, he would alter garments between shows. His friend Joseph Ettedgui remembers him 'proceeding to iron every item himself. No one else could do it quite right.' The designer himself has never cared what anyone thinks of him, his methods or his work, which has probably contributed to his reputation as demanding. Backstage at his 1990 winter show, he told *Vogue*, 'I try to do my best clothes, I get 37 of the most beautiful girls in the world together and I think, "Well, if the audience and journalists don't like it, that's just too bad." ' He is photographed here with three of his Yorkshire terriers, Patapouf, Barouf and Wabo.

overleaf
BROOKE SHIELDS, 1991
BY BRUCE WEBER
Bruce Weber photographed Brooke Shields at her mother Teri's ranch at Big Timber, Montana. She is wearing a long cotton-jersey T-shirt by Calvin Klein. Previously, in a successful advertising campaign, she had made the designer's jeans and herself world famous. 'Nothing,' she said in the ad, 'comes between me and my Calvins.' By 1991, she had also come a long way from a notorious role as an under-age prostitute in Louis Malle's bordello movie *Pretty Baby* (1978). Teri Shields, once an actress herself, managed Brooke's career early on: she was the face of 'Ivory Snow' soap and hailed as 'the most beautiful baby in America'. Between 1980 to 1985, Brooke Shields had appeared on over 250 magazine covers worldwide and had acted in some of the period's most risible movies including *Blue Lagoon* (1980), *Endless Love* (1981) – now best remembered as the screen debut of Tom Cruise and James Spader – and *Sahara* (1983). After these roles, she enrolled at Princeton and graduated with honours. The successful sitcom *Suddenly Susan* revealed her previously undersung talent as a comedy actress.

above

MR AND MRS JOHN MAJOR, 1991
BY SNOWDON

Fated to be the one after Thatcher and the one before Tony Blair, John Major was British Prime Minister from 1990 to 1997. When *Vogue* celebrated its seventy-fifth anniversary, he and his wife, Norma, agreed to appear in its celebration of Britishness. Often regarded as a rather characterless, 'grey' politician, Major is better known to the British public for his predilection for peas and for being the son of a trapeze artist, than for the 'robust intelligence that few who work closely with him fail to acknowledge' described by *The Economist*. His tenure at Downing Street was mired in its final years by allegations of scandal among his ministers. Despite his reputation for having more humanity than his predecessor, the 'Iron Lady', that good character has been a little tainted following the revelation of his own sexual intrigue with a former junior minister, at a time

opposite

JOHNNY DEPP AND WINONA RYDER, 1991
BY HERB RITTS

'As the camera starts clicking, it is obvious that Hollywood's current darlings are very much in love and not at all ashamed to show it...' The two young stars were then sharing a cottage in Los Angeles and were enough in love for Depp to have 'Winona Forever' tattooed on to his right shoulder. It may well have been, as *Vogue* put it, 'hip to be romantic and these two are definitely both.' But the fairy tale did not last much longer than the one they were then starring in, *Edward Scissorhands* – Depp played the eponymous topiarist and Ryder the radiant love interest. The tattoo survived a little longer but was adjusted to read, 'Wino Forever'.

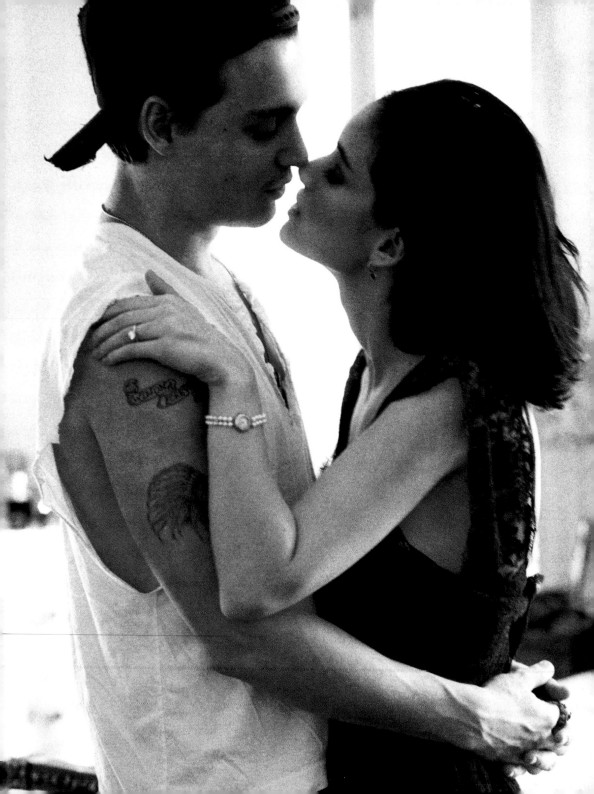

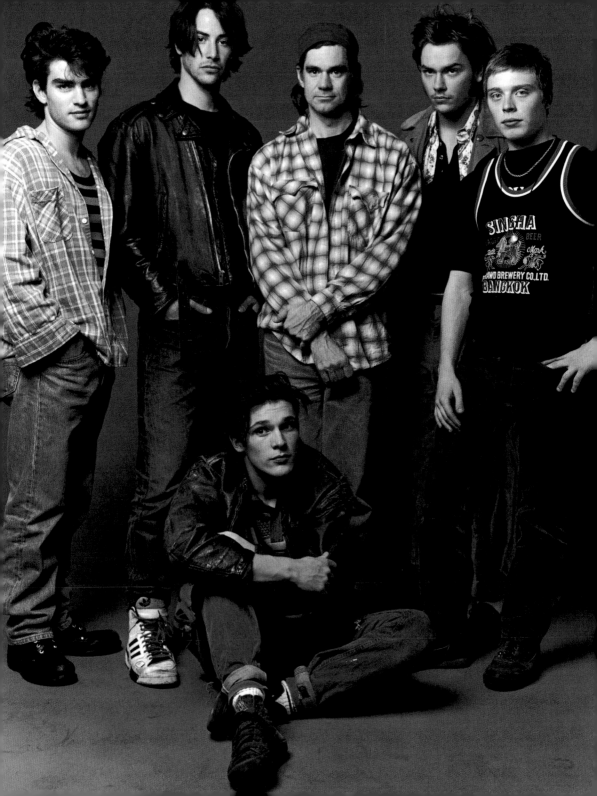

opposite
GUS VAN SANT WITH
THE CAST OF 'MY OWN PRIVATE IDAHO', 1991
BY BRUCE WEBER

Van Sant's ensemble cast play drifters and teenage hustlers in a film loosely based on *Henry IV Parts I and II*, which develops into a poetic meditation on love, desire and rootlessness. William Shakespeare is credited here with 'additional dialogue'. Photographed here with Van Sant (*standing, centre*) are, from left: Rodney Harvey, Keanu Reeves, Shaun Jordan, River Phoenix and Michael Parker. The overt homoeroticism of *My Own Private Idaho* made Phoenix's agent reluctant even to pass on the script to his client. Eventually, Phoenix played a young, narcoleptic rent boy unrequitedly in love with the 'Prince Hal' character played by Keanu Reeves, and in search of the mother who abandoned him as a child. It was one of the young actor's great performances, and, as he died 18 months after the film's release, one of his last. *Vogue* commented that it ran refreshingly against the grain 'that these young male leads should be rushing into the arms of a man who is openly gay.' While *Idaho* was shooting in Portland, indeed, Reeves and Phoenix lived at Van Sant's house, turning it into a glorified crash pad. So wild was the 24-hour-party atmosphere that Van Sant was forced to move out.'

below
ANTONIO BANDERAS, 1991
BY PEGGY SIROTA

After a decade as part of Pedro Almodóvar's repertory company – he had starred in five of the Spanish auteur's films – in 1991, Antonio Banderas launched his smouldering looks on a wider public with a cameo in Madonna's *Truth or Dare*, and his first American film *The Mambo Kings Play Songs of Love*. Up till then, his films had been in Spanish, but *Mambo Kings* required him to speak English, which he had never attempted. He managed by learning his lines phonetically. He learnt the trumpet, too. He was proficient enough in his new tongue to tell *Vogue* how Hollywood films differed from Spanish ones: 'In Spain, films are made with blood and tears. Here it is more comfortable. I've got my own trailer, the food is good…'

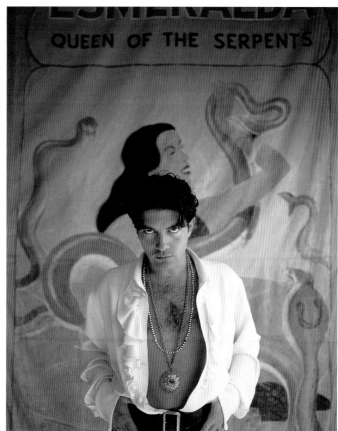

HRH THE PRINCE AND PRINCESS OF WALES
WITH PRINCES WILLIAM AND HENRY, 1991
BY SNOWDON

Snowdon's knowing and witty escapist picture of the Prince and Princess
of Wales and the two Princes at Highgrove was widely reproduced at the
time. One tabloid newspaper attached price tags to all the props and
offered advice on where to obtain each one. But, as Snowdon revealed,
'I had brought the whole lot down in the car from London. The plate in
the foreground was described as "priceless" and from the Royal Collection
at Windsor. In fact, I made it with the set designer Carl Toms in the kiln at
home.' The Princess of Wales was clearly in on the joke. She famously
disliked horses and would rarely have dressed in riding clothes.

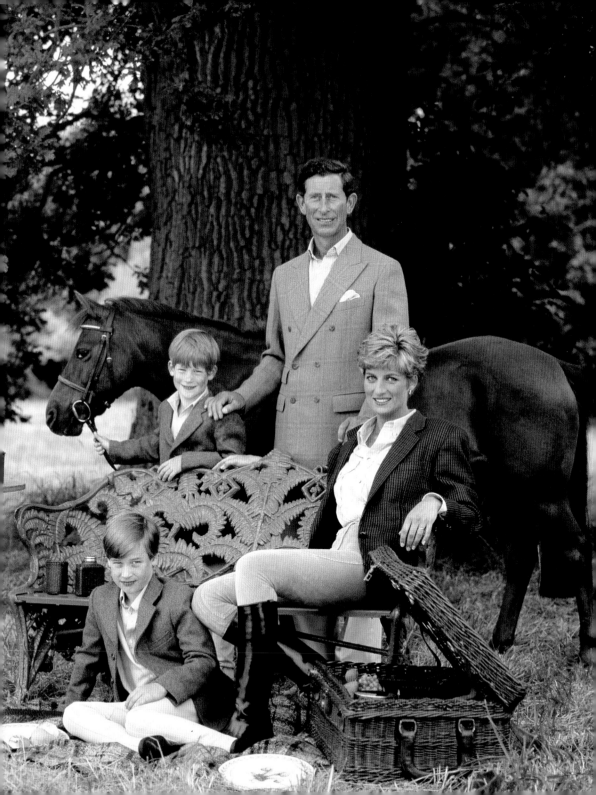

VIVIENNE WESTWOOD, 1992
BY SNOWDON

In Snowdon's tableau, the fashion designer Vivienne Westwood resembles nothing so much as Queen Elizabeth in one of Cecil Beaton's majestic late-Forties profile portraits. A one-time maverick designer, and a truculent anti-royalist through her association with the punk band The Sex Pistols, Westwood, by the early Nineties, had become, like the Queen Mother, something of a figurehead herself. The elder stateswoman of British fashion, perhaps. On the world stage, she was one of the most influential designers of the late twentieth century. Though she had started making clothes in 1971, for her shop Let it Rock, it was another 10 years before she staged her first proper catwalk show, the now famous Pirate collection of 1981. Two years later, she became the first British designer since Mary Quant to show in Paris. Though she is often cited for her earlier adaptations of street fashion, by 1992, she had cultivated a neo-romantic version of British fashion, reworking traditional materials such as wools, linens and tweeds. Here, newly crowned as British Designer of the Year – for the second year running – Westwood wears her 'Bal à Versailles' dress, the *pièce de résistance* of her summer collection.

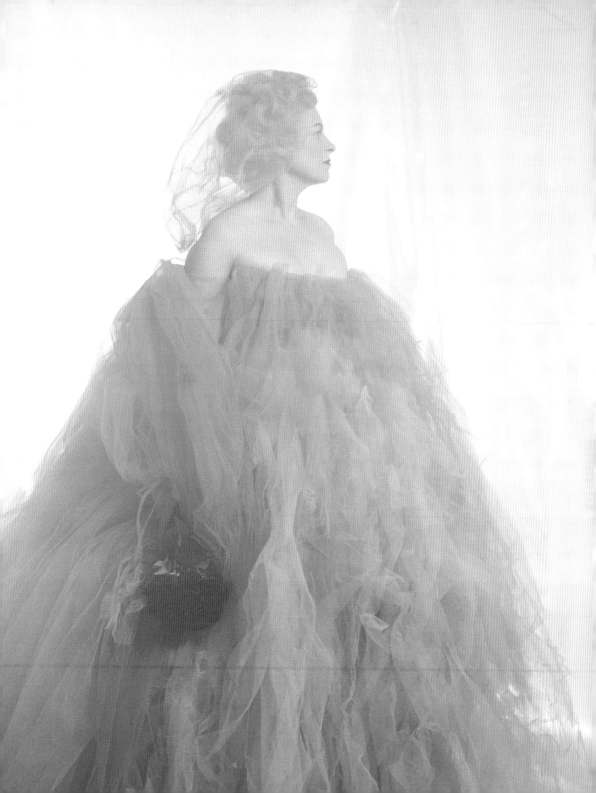

BRAD PITT, 1992
BY BRUCE WEBER

Despite Oscar nominations for its two leads, Susan Sarandon and Geena Davis, Brad Pitt was the undisputed star of the 1991 road movie *Thelma and Louise*. Almost single-handedly, he resuscitated for a new generation the near-dead genre role of cowboy drifter, in stetson and snakeskin boots. And that's when, as *Vogue* put it, 'the name-calling began' – James Dean, Marlon Brando, Paul Newman in *Hud*. But, as the young actor observed, 'I surely don't mean no disrespect to Mr Dean, [but] the thing about LA, any new guy that comes along they compare him to Brando or Dean… They don't get real inventive.'

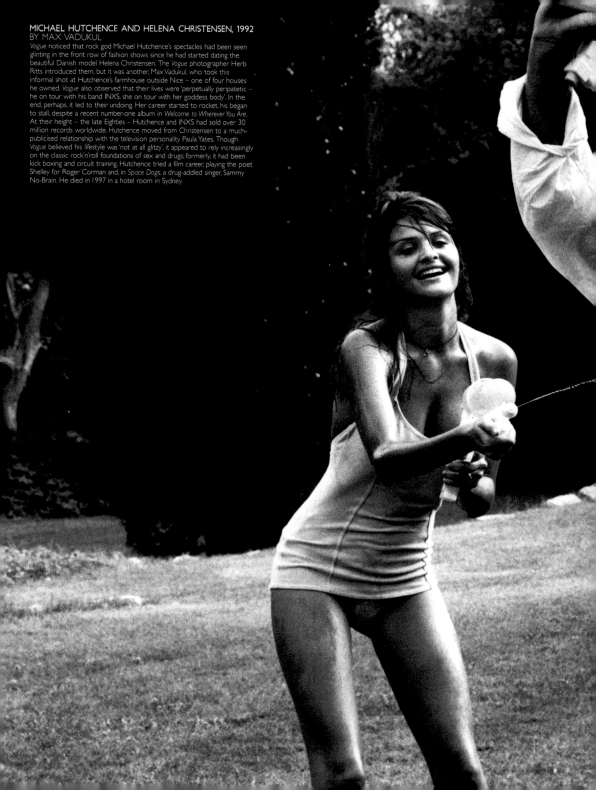

MICHAEL HUTCHENCE AND HELENA CHRISTENSEN, 1992
BY MAX VADUKUL

Vogue noticed that rock god Michael Hutchence's spectacles had been seen glinting in the front row of fashion shows since he had started dating the beautiful Danish model Helena Christensen. The *Vogue* photographer Herb Ritts introduced them, but it was another, Max Vadukul, who took this informal shot at Hutchence's farmhouse outside Nice – one of four houses he owned. *Vogue* also observed that their lives were 'perpetually peripatetic – he on tour with his band INXS, she on tour with her goddess body'. In the end, perhaps, it led to their undoing. Her career started to rocket, his began to stall, despite a recent number-one album in *Welcome to Wherever You Are*. At their height – the late Eighties – Hutchence and INXS had sold over 30 million records worldwide. Hutchence moved from Christensen to a much-publicised relationship with the television personality Paula Yates. Though *Vogue* believed his lifestyle was 'not at all glitzy', it appeared to rely increasingly on the classic rock'n'roll foundations of sex and drugs; formerly, it had been kick boxing and circuit training. Hutchence tried a film career, playing the poet Shelley for Roger Corman and, in *Space Dogs*, a drug-addled singer, Sammy No-Brain. He died in 1997 in a hotel room in Sydney.

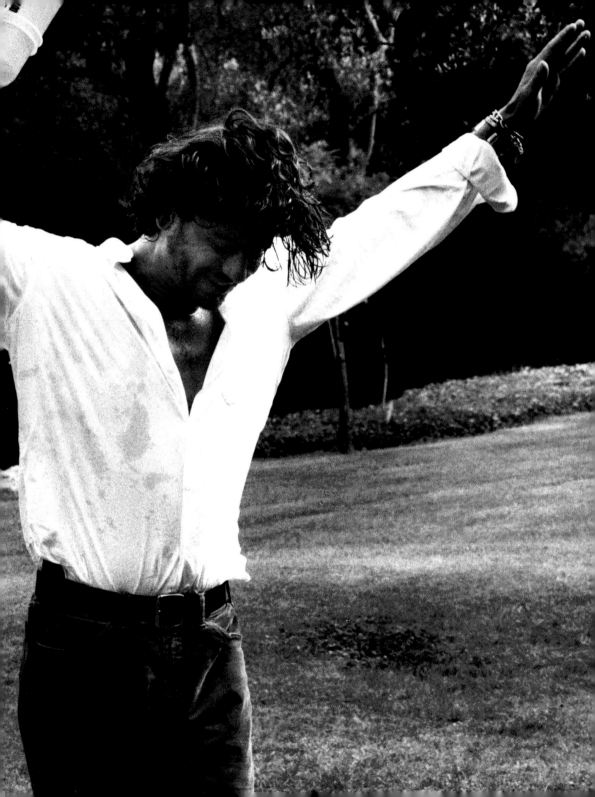

above
BJORK, 1993
BY NIGEL SHAFRAN

'A chanteuse with a dance beat will always have a place in pop,' mused *Vogue*'s Barney Hoskyns. And clearly a place in the magazine, too. This was the first of two commissioned portraits of the elfin Icelandic vocalist to appear in *Vogue* in the space of a few months. A few years previously, as a member of The Sugarcubes, she had taken time out to record an album of Icelandic jazz *Gling Glo*, which did not set the rest of the world on fire. But *Debut*, her debut album on a major label, did. It was produced by wunderkind Nellee Hooper, who gave Björk 'a techno-sonic landscape to cavort in,' and Hoskyns admired it greatly: 'With its quasi-military grooves and trance-dance narcoses, *Debut* is already one of the great dance albums of the year.' It sold 3 million copies. More recently, Björk has combined her often eccentric and experimental music with film acting. She received the Palme d'Or at Cannes for her performance in the relentlessly downbeat *Dancer in the Dark* (2000).

opposite
JOHN LEGUIZAMO, 1993
BY MARK ABRAHAMS

Leguizamo studied method acting for precisely one day. On the following day, the legendary tutor, Lee Strasberg, died. Leguizamo made his name as a sparkling comedian in off-Broadway shows such as *Mambo Mouth* (1991), which poked fun at Latino stereotypes. He followed it up with the award-winning *Spic-O-Rama*, in which he played six characters. The next, *Freak*, earned him Tony nominations for Best Play and Best Performance. Despite the interrupted drama classes, Leguizamo made a successful transition to serious acting, though he has tended to shine in flamboyant roles, such as the hipster Tybalt in Baz Luhrmann's *William Shakespeare's Romeo & Juliet* (1996), or a drag queen in Beeban Kidron's *To Wong Foo, Thanks for Everything! Julie Newmar* (1995), for which he was nominated for a Golden Globe. These were still ahead of him when he posed for *Vogue* with a cockatoo. Here, the magazine celebrated his roles in coming-of-age movies, such as *Casualties of War* (1989) and *Hangin' With the Homeboys* (1991), and a bit part in *Die Hard 2* (1991). 'My ultimate ambition,' he told *Vogue*, 'is to do five classic films that will become part of celluloid history. Actually, that's a prediction.'

KATE MOSS AND MARIO SORRENTI, 1993
BY ANDREW MACPHERSON

This was one of Kate Moss's earliest appearances in *Vogue*. Her then
boyfriend Mario Sorrenti, originally from Naples, had been the model for
a Levi's ad – in a pool hall against the strains of *Should I Stay or Should I Go?*
– but was attracting attention for his vibrant fashion photography. Having
modelled briefly for Bruce Weber in New York, he had learnt enough to
pick up a camera and make a success of it. And perhaps it was inevitable
that he would. His mother, sister and his brother, who died young, were
photographers, too. In collaboration with his almost-famous girlfriend,
Sorrenti *figlio* also made a dazzling commercial for Calvin Klein's scent
Obsession. *Vogue* noted that he had returned from the States to live in
Notting Hill, 'where he hangs out and cooks pasta for his girlfriend…
He cooks, she cleans.' The Notting Hill flat was the setting for the
uncompromising and soon notorious set of 'realist' fashion photographs
for *Vogue* by Corinne Day, which briefly catapulted both Day and Moss
into the headlines, charged with promoting eating disorders. The
domestic idyll of Moss and Sorrenti did not last much longer.

above
HONOR FRASER, 1993
BY STEVEN MEISEL
Scottish bred and convent educated, Honor Fraser was discovered by *Vogue*'s editor-at-large, Isabella Blow. Here, in her first modelling session for *Vogue* – it also marked the debut of her cousin Stella Tennant – she wears a micro-kilt, sporran and stockings by Vivienne Westwood. The magazine noted that she brought her Catholic breeding to a new 'shuttle' lifestyle taking in the international fashion destinations Paris, Milan, New York and London:' "Watch those stocking tops," she cries. My thighs are falling out."' Now a regular on Best Dressed lists, she revealed recently that she hated 'sock mittens' and that her style was best described as '50 per cent off'.

left
RIFAT OZBEK, 1993
BY CORINNE DAY
Shortly before he launched his first collection, Turkish-born Ozbek dressed up in a black poloneck for the pages of *Tatler* magazine as legendary *Vogue* editor Diana Vreeland. Around his neck was a necklace fashioned out of spanners from the photographer's tool box. The pictures were sensational and launched him in the fashion press; he has been making shrewd moves ever since. One was his all-white collection of spring 1990, which, though not a best seller, was copied and reworked up and down the high street. In 1987 and again in 1988 he dispensed with a catwalk show in favour of a video presentation made by his friend the avant-garde film maker John Maybury. He is a perfectionist every season and *Vogue* sensed that, in the end, Ozbek 'could take it or leave it; that he could walk away from his business tomorrow and be perfectly happy.'

UMA THURMAN, 1994
BY ALBERT WATSON

Like her mother before her – the model Nena von Schlebrugge, a
favourite of Norman Parkinson – Uma Thurman made her earliest
appearances in *Vogue* in the Eighties as an uncredited fashion model,
most notably in the languorous domestic interiors of Sheila Metzner. Less
than a decade later, she was an established star, and when *Vogue*
interviewed her here, she was about to appear in Gus Van Sant's *Even
Cowgirls Get the Blues*. She was also preparing for her role in Quentin
Tarantino's *Pulp Fiction*, which in time blew away any lingering traces of the
ingénue of *Dangerous Liaisons* or the delicate Botticelli Venus rising from the
ocean on a half shell for *The Adventures of Baron Münchhausen*. Tarantino
was mightily impressed with her: 'Uma has this thing about her that makes
you want to find out her mysteries,' he commented. 'She's both standoffish
and very revealing at the same time… I don't think of her as a great
beauty, but she could show up after a seven-day bender, falling down, and
still look great. She's like some Dietrich chick waiting for Von Sternberg to
put her in *Blonde Venus*…'

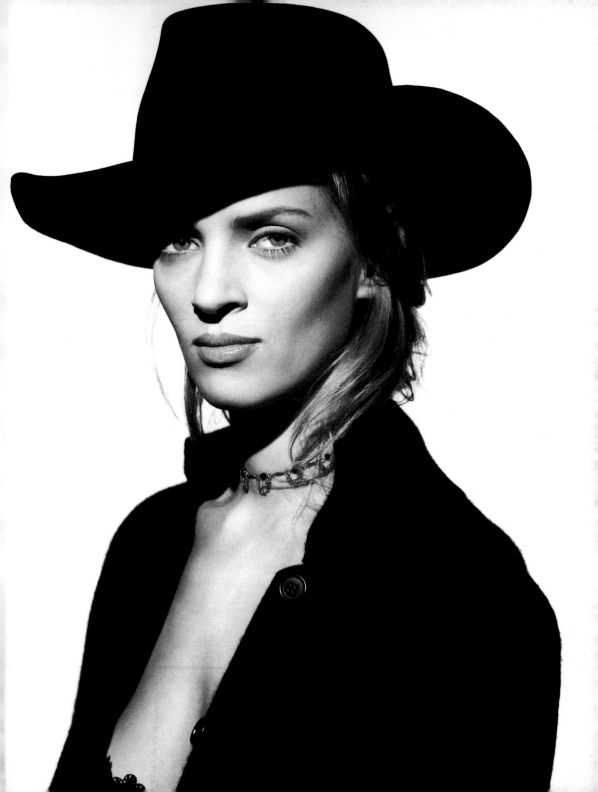

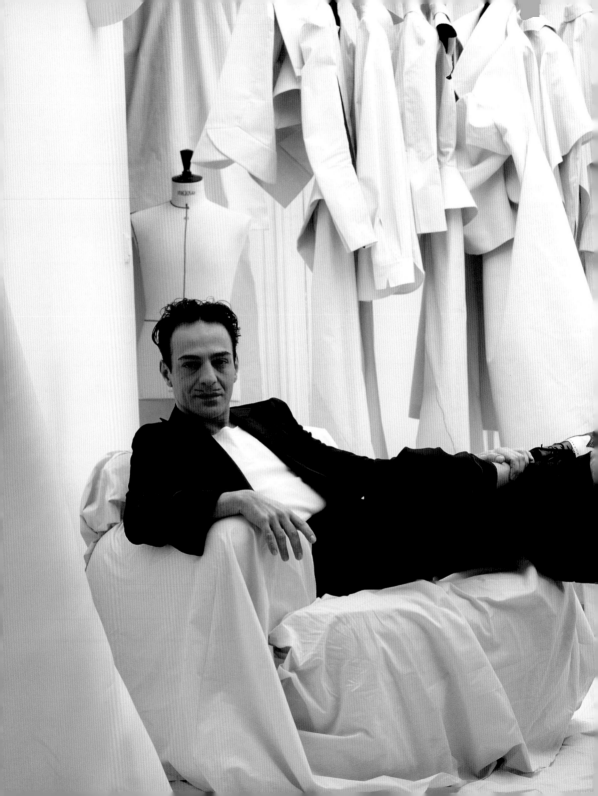

JOHN GALLIANO, 1995
BY SNOWDON

John Galliano was an immediate success. His degree collection, Les Incroyables, inspired by the costume of the French Revolution, was bought in its entirety by one retailer. He launched his own label in 1984 and his mastery of bias-cutting and exquisitely tailored suits were acclaimed in the fashion press. Financial difficulties, however, led to several false starts and, in 1990, he moved to Paris. This portrait was taken shortly before his appointment as chief designer at Givenchy. He was the first British designer to head a French couture house. A year later, he moved again, to the house of Dior, for which his initial collections confounded his critics, and where he has remained. He has steeped himself in the history of fashion and has looked for inspiration to the cut of couturiers such as Poiret and Vionnet, among others. But his opulent creations remain decisively products of his own imagination. As his one-time right-hand woman, Amanda, Lady Harlech, told Vogue, 'It's very important for John to pin it all on a character, whether it's a White Russian in exile, or an impoverished, but still glamorous aristocrat in Fifties Paris. It helps him research. If he can know the food they ate, whether they read by gaslight or candle, it helps to establish a mood for the clothes…'

CALVIN AND KELLY KLEIN, 1994
BY ALBERT WATSON

The New York Times's Bernadine Morris has called Calvin Klein simply 'a
phenomenon of our times'. The Council of Fashion Designers of America
had just doubly honoured the influential designer with its awards for
women's and menswear design; the first time a single designer had been
so honoured. Calvin Klein started his own business in 1968, with a
borrowed $10,000, having spent the preceding five years designing for rag-
trade manufacturers in New York City. He famously trundled his earliest
collection of suits and dresses on a dress-rail through the mid-town
Manhattan traffic to the buyers of department stores: 'Maybe it sounds
obsessive, but I was terrified a messenger would wrinkle the clothes,' he
told *Vogue*. In the early Seventies, he branched out into designing less
formally structured items, such as sportswear and sweaters. This heralded
his mastery of minimalism, the 'understated' look. He saw a niche for
branded denim jeans and launched the 'designer label' as a status symbol.
He was among the first American designers to be aware of the power of
marketing. Campaigns for Calvin Klein, whether it was the ads themselves
(Brooke Shields declaring, 'Nothing comes between me and my Calvins'),
or where they appeared (*Vogue* described his use of the giant billboards in
Times Square to promote his men's underwear as his 'personal memo-pad
to the universe'), gave him unprecedented coverage. In the mid-Nineties
he sold his underwear company for a staggering $64 million. Kelly Rector
came to Calvin Klein as a design assistant from Ralph Lauren. She became
Kelly Klein in 1986, and Calvin's wedding gifts to her included, *Vogue*
reported, 'a $50,000 hand-stitched saddle from Hermès, two
thoroughbred showjumpers, a $1 million apartment and the Duchess of
Windsor's eternity ring'. 'With an instinctive preference for faded jeans,'
wrote *Vogue's* Lisa Armstrong, 'and a sleek simplicity that makes her the
ultimate "real working woman", Kelly is Klein's marketing imagery made
flesh. "They make each other look fabulous," says another observer.' They
have since separated. Kelly Klein has had a successful career as a fashion
photographer, her work often showcased in British *Vogue*.

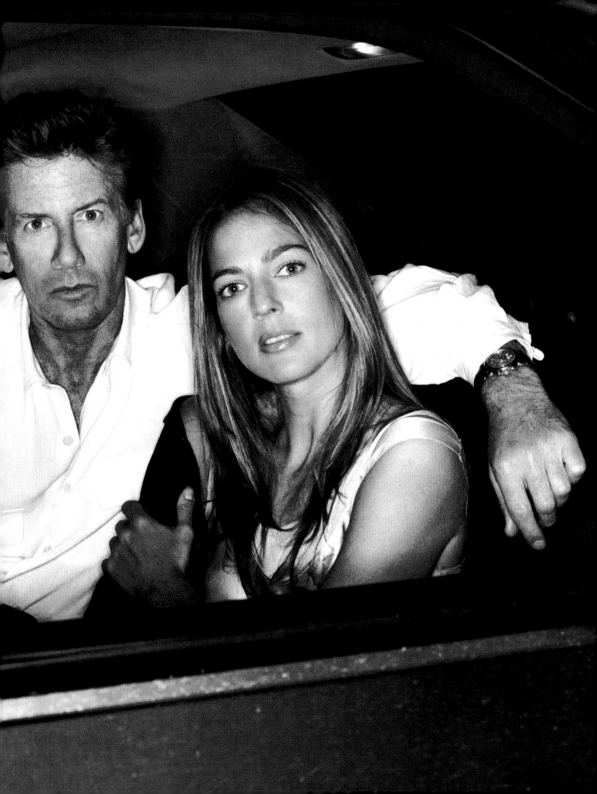

above

JANE HORROCKS, 1994
BY DAVID SIMS

At RADA, Jane Horrocks was advised to leave her Northern accent where it belonged (Rawtenstall, Lancashire), advice she ignored. After stints with the Royal Shakespeare Company she collaborated with the playwright Jim Cartwright, who wrote *The Rise and Fall of Little Voice* for her – she is renowned for her extraordinary vocal range and mimicry of famous singers. Later filmed as *Little Voice* it brought her international recognition. Closer to home, she shone as the eccentric and unreliable Bubble in *Absolutely Fabulous*. 'Those with "quirky" personalities,' her friend Timothy Spall wrote in *Vogue*, 'often find it difficult to submerge their idiosyncrasies or are encouraged to exaggerate them and make them their trademark. Miss Horrocks does neither. She can play any class and do any accent…'

opposite

HELENA BONHAM CARTER, 1994
BY JULIAN BROAD

As one commentator put it, Helena Bonham Carter was the actress most closely identified 'with corsets and men named Cecil'. This was largely thanks to her work for the Merchant/Ivory partnership. She played in three of their adaptations of E M Forster novels: *A Room With a View* (1985), *Where Angels Fear to Tread* (1991) and *Howards End* (1992). 'It would be fun,' said Ismail Merchant, 'to see her playing a big role – and a role for a beautiful, brainy girl like herself – in a modern film of ours. I know she's a bit tired of having to wear a floppy Edwardian hat…' It was, however, another period drama, in another floppy hat, directed by someone else – Ian Softley's *The Wings of the Dove* (1997) that earned her a first Oscar nomination. A descendant of the British Prime Minister H H Asquith, Helena Bonham Carter is also directly related to Condé Nast, the founder of *Vogue*, whose daughter Leslie married the Hon Mark Bonham Carter.

HUGH GRANT, 1994
BY JULIAN BROAD

Julian Broad was one of only a handful of photographers on the set of *Four Weddings and a Funeral*, a film, frankly, of which no one – bar its writer, director and players – expected much. Distinctly British – mostly morning-coat-and-carnations – despite its American leading lady, it went down a storm in the States. At the time, it was the highest-grossing British film ever. It launched the stratospheric career of Hugh Grant, much admired for his sense of comic timing, and a propensity for floppy-haired hapless embarrassment – also of an English kind – which he would reprise in *Notting Hill* (1999). *Vogue* compared him in spirit to a hybrid of James Stewart at his most bashful and Henry Fonda in *The Lady Eve*, whose character did not quite know how handsome he was. Perhaps James Caan recognised a little of this insecurity, years later when, on the set of *Mickey Blue Eyes* (1999), he nicknamed him 'Whippy'. Grant fretted about everything like 'those little whippet dogs that get nervous and you've got to put a sweater on them when they're cold,' Caan explained. By late 1994, Grant had been named by *People* magazine, with his girlfriend Elizabeth Hurley, as one of the world's most beautiful people, and was fêted in Japan as a reincarnation of Rupert Brooke. *Vogue* noted that, apart from spending most of the year being interviewed, 'he still plays for what must be the weediest football team in Britain: The Victoria and Albert Museum's.'

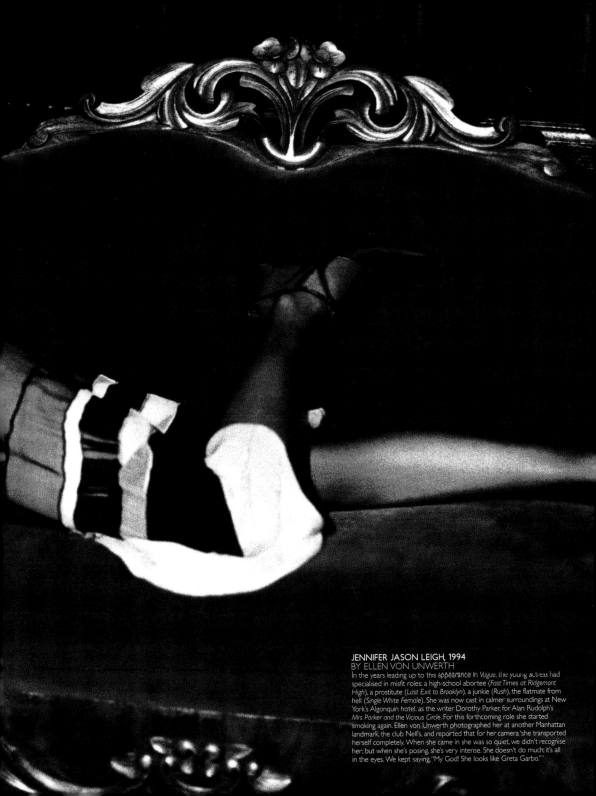

JENNIFER JASON LEIGH, 1994
BY ELLEN VON UNWERTH

In the years leading up to this appearance in *Vogue*, the young actress had specialised in misfit roles: a high-school abortee (*Fast Times at Ridgemont High*), a prostitute (*Last Exit to Brooklyn*), a junkie (*Rush*), the flatmate from hell (*Single White Female*). She was now cast in calmer surroundings at New York's Algonquin hotel, as the writer Dorothy Parker, for Alan Rudolph's *Mrs Parker and the Vicious Circle*. For this forthcoming role she started smoking again. Ellen von Unwerth photographed her at another Manhattan landmark, the club Nell's, and reported that for her camera 'she transported herself completely. When she came in she was so quiet, we didn't recognise her; but when she's posing, she's very intense. She doesn't do much; it's all in the eyes. We kept saying, "My God! She looks like Greta Garbo."'

DARCEY BUSSELL, 1994
BY NICK KNIGHT

Darcey Bussell was the first homegrown ballet star since Fonteyn to become a household name. By the time of this picture, *Tatler* magazine had just voted her legs to be the world's most perfect, she had been painted for the National Portrait Gallery by Allen Jones, and photographed both by Snowdon – frequently – and most recently by Annie Liebovitz. She had also made a cameo appearance with the comediennes French and Saunders on their popular, eponymous television show. She may not have appeared in *Vogue* as often as Fonteyn, but in 1995, at only 25, she was still young. Her debut was for Sir Kenneth MacMillan some six years previously in *The Prince and the Pagodas*, and a year later she partnered the passionate former Bolshoi star Irek Mukhamedov in *Winter Dreams*. Despite the comparisons to Fonteyn – she won extravagant praise for tackling Aurora in *Sleeping Beauty*, a Dame Margot signature role – she was, MacMillan remarked, 'very much of her own generation; she isn't bothered by the past. I love the way she can look her audience in the eye without flinching. And in rehearsal she's not fazed at all.' Here, she is very much of her own generation, too, dressed in PVC trousers by Phaze and a luminous mohair sweater by Edina Ronay with shoes from She & Me.

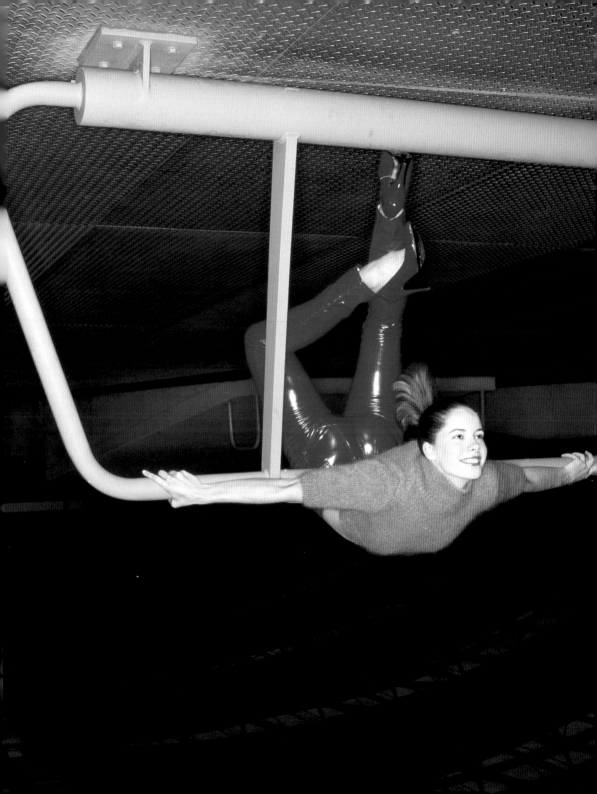

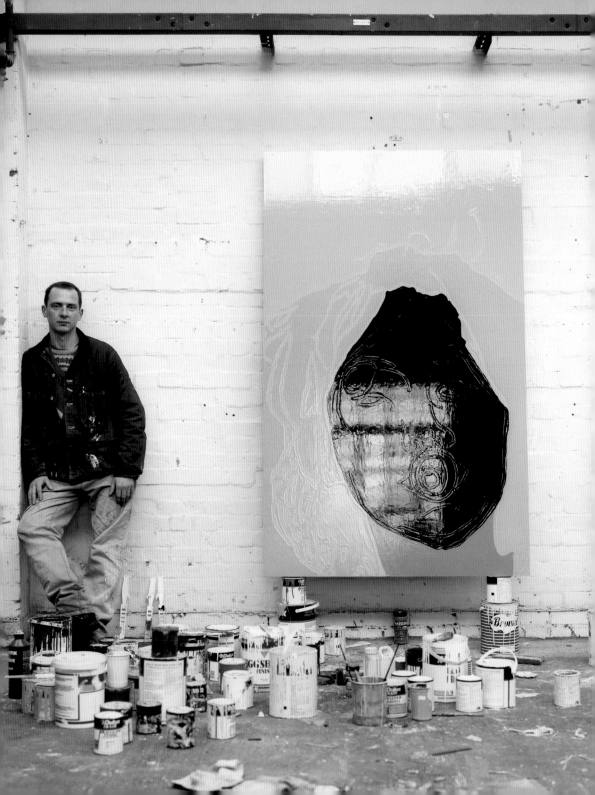

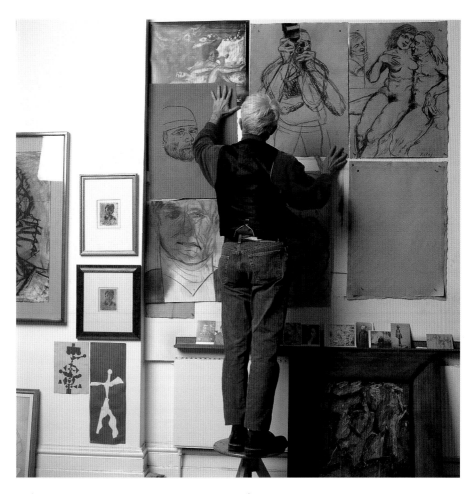

opposite

GARY HUME, 1995
BY CINDY PALMANO

Those who know consider Gary Hume the pre-eminent British painter of his generation. Certainly one of this country's most fashionable artists, he has blazed a trail, along with Rachel Whiteread and Damien Hirst, far beyond the restrictive confines of contemporary art in London. A Turner Prize-nominee in the year following this portrait, he was the British representative at the Venice Biennale of 1999, and in the same year had a well-received one-man show at the Whitechapel in London and the Scottish National Gallery of Modern Art. He had a small role in *Love is the Devil* (1997), John Maybury's film about Francis Bacon and was, by his own admission, 'the worst actor in the whole universe' – an exaggeration. He has made a very short film of his own, *Me as King Cnut*, set in a bathtub but, in the words of Andrew Graham-Dixon, writing here for *Vogue*, 'having made a King Cnut of himself, he abandoned film and returned to paint.' He is known for the quirkiness and immediacy of his subject matter: Kate Moss, bird life, Tony Blackburn, hospital doors, angels, images from magazines and newspapers. Beautifully rendered, his large panels sparkle like jewels. This has much to do with the play of light on the household gloss he is now famous for using. Vibrant with oranges, lilacs, luscious purples, bleached-blond yellows, these are the colours of nail polish with a sheen to match. As he once told the critic Neville Wakefield, '[people] recognize the colours from fruit pastilles and then, of course, everyone has a favourite one…'

above

R B KITAJ, 1994
BY SNOWDON

Though born an American in Cleveland, Ohio, Kitaj has become identified with the generation of British painters of the Fifties and Sixties, now known as the School of London. This included, at various times, figures such as Francis Bacon, Michael Andrews, Lucian Freud and Frank Auerbach. Kitaj is credited with suggesting the existence of the group and naming it. To commemorate his retrospective at the Tate in 1994, Snowdon photographed him in the studio of his Chelsea home. On the wall is an assortment of old work and work-in-progress. His right hand rests on a drawing of his friend the photographer Lee Friedlander and his left on a self-portrait. A former itinerant merchant seaman, he told *Vogue* in a rare interview that 'one thing led to another and England became a habit. Over the years, I've tried to leave but I've given up now.' However, a few years later, after the death of his second wife and disgusted by the ferocious criticism that greeted some new work, he did leave.

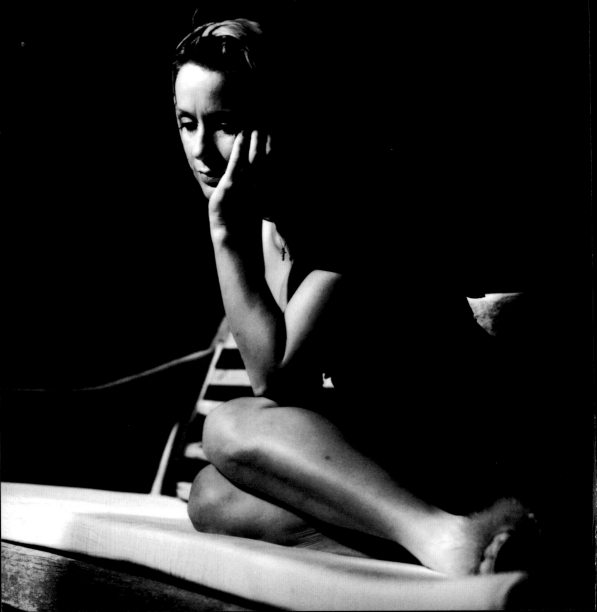

PAULA YATES, 1995
BY STEVE HIETT

There seemed little that Paula Yates would not do to retain a place in the spotlight. An irrepressible television presenter for most of her career, she cultivated a flirtatious technique that entranced viewers and interviewees alike. She conceded to *Vogue* that she hid her wit, acuity and intelligence behind a vacuous personality. 'Flirting in public for my job was a cartoon I felt safe behind. It never revealed the real me. Growing up in my family made you want to be invisible; it was like being in an emotional MI5. The image helped me stay that way.' As her own celebrity developed, she posed naked in the Reform Club for *Penthouse* magazine, conducted interviews with celebrities in bed and, in the Eighties, published a book of her photographs *Rock Stars in Their Underpants*. The latter won some praise: Andy Warhol claimed it as 'the greatest work of art in the last decade'.

Yates married Bob Geldof, formerly of the Boomtown Rats, and their three daughters rejoiced in the unconventional names Fifi Trixibelle, Peaches Honeyblossom and Little Pixie. The British press then vilified her for trading in her rock-star husband, knighted for his charity work, for another, the louche and diminutive Michael Hutchence of the Australian band INXS. But she was also admired as a devoted mother and for her indomitable spirit. Yates's custody battles with Geldof were played out in the tabloids; so too was her drug-fuelled liaison with Hutchence, which produced another daughter, Heavenly Hiraani Tiger Lily. In the years following her *Vogue* appearance, her life unravelled furiously. Hutchence was found dead, hanged by his belt in a hotel room; the identity of her real father was at last revealed to her; she was admitted to a psychiatric hospital; she attempted suicide and lost, temporarily, custody of her daughters. She died by her own hand in 2000.

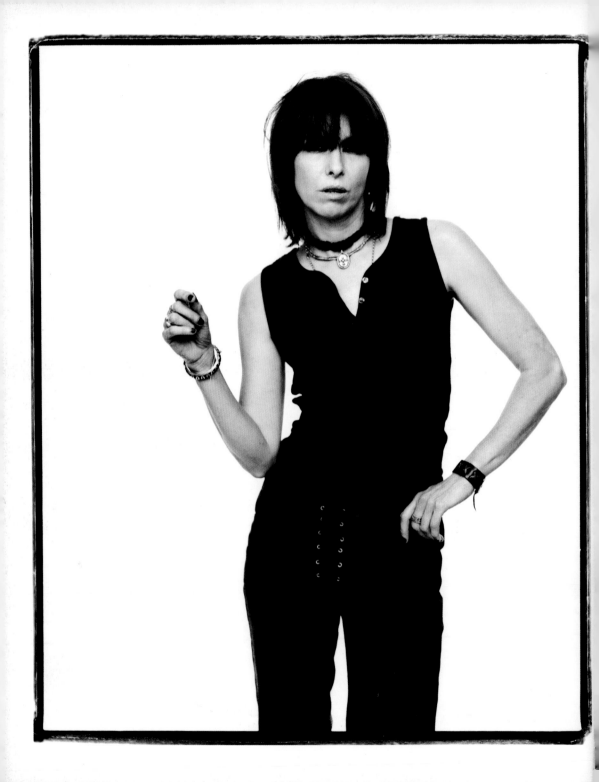

CHRISSIE HYNDE, 1995
BY MIKAEL JANSSON

With kohl-rimmed eyes, black stage garb and a fringe still flopping a quarter of a century after she first formed her band The Pretenders, Chrissie Hynde here remains the quintessential rock chick. The band exists today after many incarnations and, in 1995, at the time of this portrait, Hynde still struck the right attitude: 'She could make Tank Girl look like Snow White,' the film maker Don Letts told *Vogue*. She was interviewed in London at the Halcyon Hotel, where she started lunch by startling diners with her forthright views, reassuringly unchanged after those 25 years: 'This is a godless society. Do you know that one in 40 women in America have silicone implants? Think about it. One in 40 women walking around with plastic tits. It's sick.' She continued: 'I'd be happy to be a mother – I'm damned good at that – and let men run the show. But in my 45 years, most of the men I've met aren't really up to it. And I'm not going to be told what to do by men who are patently less intelligent and aware than I am.' She ended the interview in an upbeat mood: 'You won't hear me complaining about my job. But I'm damned glad I've got that voice. I'd be trying to sink a Norwegian whaling ship if I didn't have that.'

JAKE AND DINOS CHAPMAN, 1996
BY CINDY PALMANO

When this joint portrait appeared in *Vogue*, the Chapman brothers'
show *Chapmanworld* had recently closed. Presenting visitors with an
array of grotesquely genital-ed mannequins – only their heads visible
here – the exhibition cemented the brothers' reputation as *enfants
terribles*. They first brought their 'terrorist aesthetic' to public attention
with a vivid diorama of castrated and limbless fibreglass figures, an
interpretation of vignettes from Goya's series of etchings *Disasters of
War*. They have continued to plunder aggressively and
uncompromisingly from fine art, and to marry these images to their
own tortured, taboo-shattering applied art. Age – both are now
approaching 40 – has not mellowed them. In what was their most
extreme act of cultural vandalism, they acquired a series of valuable
Goya etchings and reworked the surfaces with colourful grotesquery
and cartoons. *The Rape of Creativity*, as they titled their new
illustrations, has on the whole met with critical approbation – which
may have confused as much as delighted the artists. Four years after
this portrait, *Vogue* eavesdropped on a meeting of Kate Moss and the
brothers. Peering at a work in progress, a detailed construction of a
war zone and concentration camp (eventually part of their *Works from
the Chapman Family Collection* show), Moss exclaimed, 'It's amazing.
I love it. Look, it's Charlie's Angels taking on the Nazis…' 'She's quite
right,' observed *Vogue*'s Justine Picardie, 'and quicker than many art
critics… to grasp the significance of this unsettling blend of banal
popular culture and terrifying, yet everyday, evil.'

HEIDI FLEISS, 1996
BY ROBERT ERDMANN

In 1993, Hollywood's most famous madam had been found guilty on five charges of pandering and was about to be sentenced for tax evasion; though it takes a dim view of pimping, California is even less tolerant of failure to declare profits. By the time of this portrait, the 29-year-old procuress was about to be sentenced to a decade behind bars. What converted a sorry tale into a worldwide headline-grabber were the potentially salacious contents of her 'little black book'. This turned out to be three red Gucci notebooks, which threatened to bring down film-studio heads, Hollywood executives, film stars and personalities of prime-time television. When they came out, however, the details did not amount to very much. A well-known actor admitted to about $50,000 worth of Heidi's wares. These were mostly blonde, surfer-girl types, in which Fleiss had cornered the Beverly Hills market. Fleiss revealed to *Vogue*'s Louise Chunn that sex was frequently the last thing on the client's mind; her girls were often decorative accessories to the client's main interest of drug-taking. The British film maker Nick Broomfield, who produced a documentary on Fleiss's notorious career, maintained that a jail sentence was inappropriate: 'What Heidi really needs right now is to be banned from Los Angeles, with all its parties and drugs and prostitution. They should put one of those electronic tags on her and send her to the Midwest.'

above
JUDE LAW, 1996
BY ALBERT WATSON

Fresh from success as an implacable joy-riding car thief in the ram-raid coming-of-age movie *Shopping* (1994), Jude Law with his emerald-eyed pixie look was irresistible, found *Vogue*: 'Puck-meets-Punk,' it concluded. The same film introduced him to his wife Sadie Frost, and he soon left his flatmates, the *Trainspotting* stars Ewan McGregor and Jonny Lee Miller. But not altogether: 'We're setting up our own production company,' he explained. 'It's frustrating just being an actor on the end of the casting process, and I see this as a way of getting my hands in the dirt.' The company formed shortly afterwards and dubbed Natural Nylon produced the film *Nora*, a drama based on the life of James Joyce's wife, and was involved in David Cronenberg's sci-fi extravaganza *eXistenZ* (both 1999).

opposite
GARY OLDMAN, 1996
BY ALBERT WATSON

'One moment you're looking for the character, the next you are the character. You know what they're thinking because you know what you're thinking.' From Dracula and Sid Vicious to Lee Harvey Oswald to Joe Orton and Beethoven, Gary Oldman has a legendary ability to metamorphose into his role's persona. He had just made *The Fifth Element* with Luc Besson, which he also produced. In this portrait, the clapperboard gives a clue to the direction Oldman had begun to take. His first adventure behind the camera, *Nil By Mouth*, was a harrowing story based on his south London upbringing. 'It's my recollection of people who have either touched or troubled me in my life,' explained Oldman. 'It's my blues, if you like, about what's outside my window…,' The film was a critical success, winning the Alexander Korda Award for the Outstanding British Film of the Year, while one of its leads, Kathy Burke, won the Best Actress award at the Cannes Film Festival. The semi-autobiographical film also featured Oldman's sister, Laila Morse, best known nowadays as the truculent Mo Harris in the soap opera *EastEnders*.

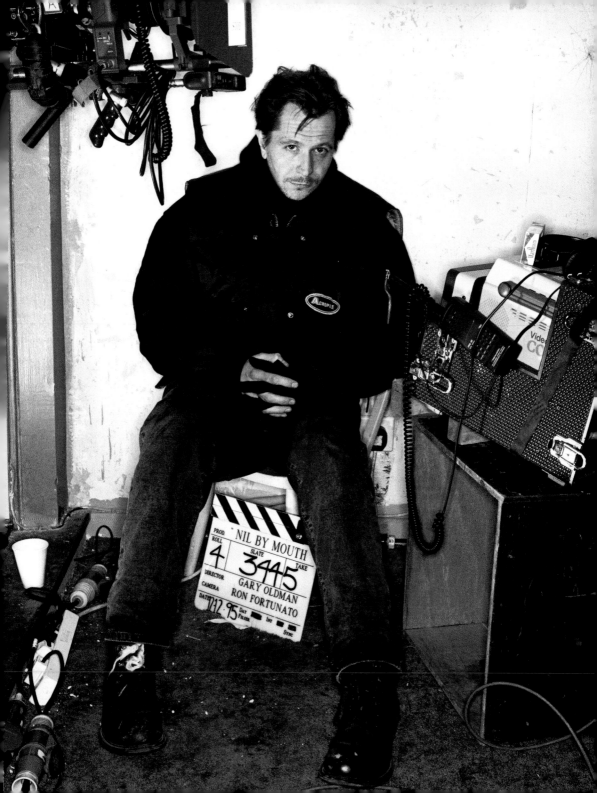

GOLDIE AND STELLA TENNANT, 1996
BY NICK KNIGHT

Vogue considered Goldie 'a force to be reckoned with'. This picture was
one of a portfolio, 'London Calling', celebrating the summer of Swinging
London's second incarnation. *Vogue* reported the 'undisputed hero of
jungle' performing 'a few impromptu push-ups' with London's model
superstar Stella Tennant. Bobbing impatiently around the photo studio,
chatting wildly as he waited for it to begin,' "Get 'em out, Stella," he shouts
cheekily. And for him, just this once, she does.'

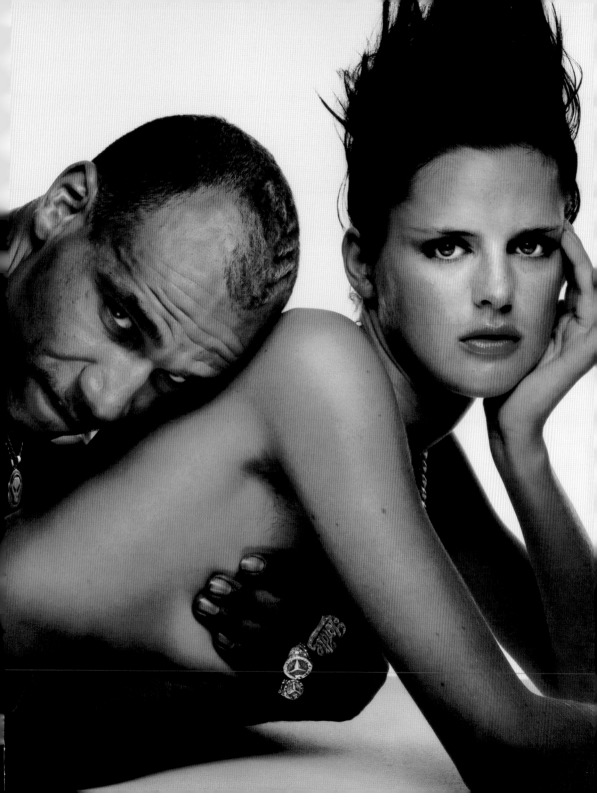

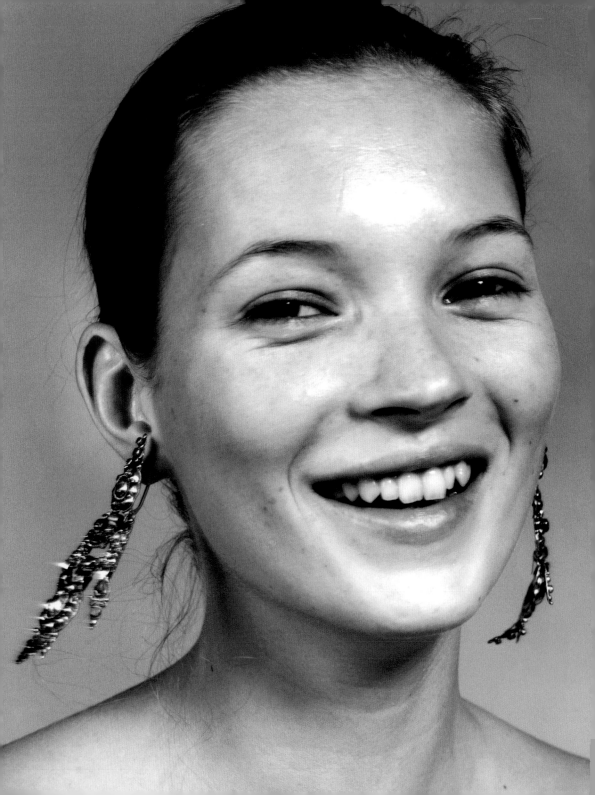

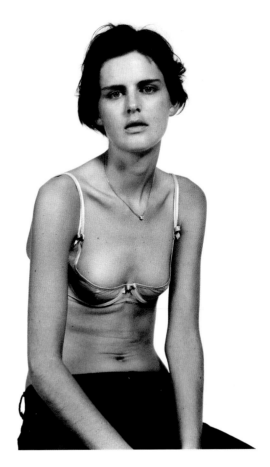

STELLA TENNANT, 1997
BY CRAIG McDEAN
Like Kate Moss (*opposite*), another model of the moment 'in her own style', Stella Tennant, granddaughter of the always-chic Duchess of Devonshire, almost beat her colleague for imaginative interpretation of *Vogue*'s brief – to present herself as she would like to be remembered. Her style was, anyway, mix'n'match Portobello Road-meets-Helmut Lang, and she admitted, proudly: 'I don't like spending lots of money on clothes. It's a waste – you know you'll hate them in six months' time.' She brought with her to the shoot a red plastic carrier bag containing a bra in turquoise tulle by Agent Provocateur. She liked it because it 'gives me bosoms. I bought it to wear underneath a see-through dress but I realised pretty quickly that you can't wear those kinds of things in real life. So now it has other uses…' But she was never conventional. Her first *Vogue* picture showed a fiercely independent spirit barely contained. She dyed her hair raven black and sported a nose ring for the debut session with Steven Meisel. But, as *Vogue* declared, at 6ft tall and irrefutably well bred, Stella Tennant 'would look chic wrapped in a shower curtain'.

opposite
KATE MOSS, 1997
BY CRAIG McDEAN
The most-photographed woman of her generation, Kate Moss had been a phenomenon for almost a decade when this picture was taken. She turned fashion on its head and changed the way British women looked at beauty and style. This is Kate Moss, as *Vogue* put it, 'in her own style'. The magazine had invited her and her colleagues Stella Tennant and Cecilia Chancellor to present themselves as they would like to be remembered. 'Clothes go in and out of fashion,' Moss told *Vogue*, 'but that's not real style. Style has to be classic.' She arrived at the studio with an Hermès holdall in one hand and a Marlboro Light in the other. Her solution to the magazine's challenge was almost Brechtian in its severity and rigorous simplicity: wear nothing at all, save a pair of symbolic earrings. And so, out of the holdall, came two leather jewellery cases. From the first emerged a large, pendant, diamond earring, which, *Vogue* reported, was 'duly admired'; from the other, a pair of nineteenth-century diamond 'flowerpots' and finally a pair of Spanish emerald and gold earrings from the same era. These won. The main ingredient of the Moss *style du jour* was clearly jewellery, jewellery and even more jewellery. But she added to this 'black eyeliner. It's my drug of choice.'

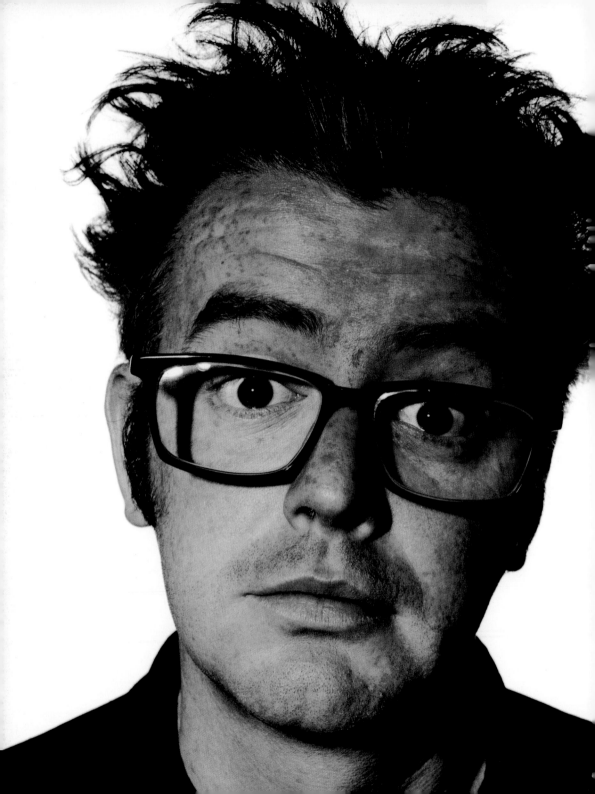

CHRIS EVANS, 1997
BY DAVID BAILEY

'Bailey's asked to photograph me for *Vogue*… If you grow up with ginger hair and glasses you don't expect to be in *Vogue*,' declared the ebullient broadcaster Evans, 'TV's bad-boy genius', breaking a self-imposed moratorium on interviews. He must have been surprised barely a year later to be asked back for another – also accompanied by a Bailey portrait, but in colour. In recent years, married and free from corporate responsibilities – he sold much of his Ginger Media group – he declared another self-imposed moratorium, this time on ambition and career direction, and has all but retired from broadcasting. He first captured the public imagination in Channel 4's anarchic *The Big Breakfast*; then formatted and presented *Don't Forget Your Toothbrush* – regularly cited as a postmodern moment in the history of the television games show; he next rejuvenated the notion of the 'breakfast show' at Radio One, and was abruptly and spectacularly fired. 'The perception was that I was a hard-nosed bastard who is out for everything I can get. It's not true. I didn't want to leave…' He joined Virgin Radio, which, *Vogue* observed, he liked so much he bought it. And then sold it. He made the frenetic early-evening show *TFI Friday*, which achieved the distinction of being repeated at full length on the very day it went out. He is currently enjoying a long honeymoon with his wife, Billie Piper. The odds are that he will not be unemployed for long, despite his assertion to Mariella Frostrup, his *Vogue* interviewer in 1998, 'I don't aspire to anything professionally now. Personally I do, though. I aspire to be happy.'

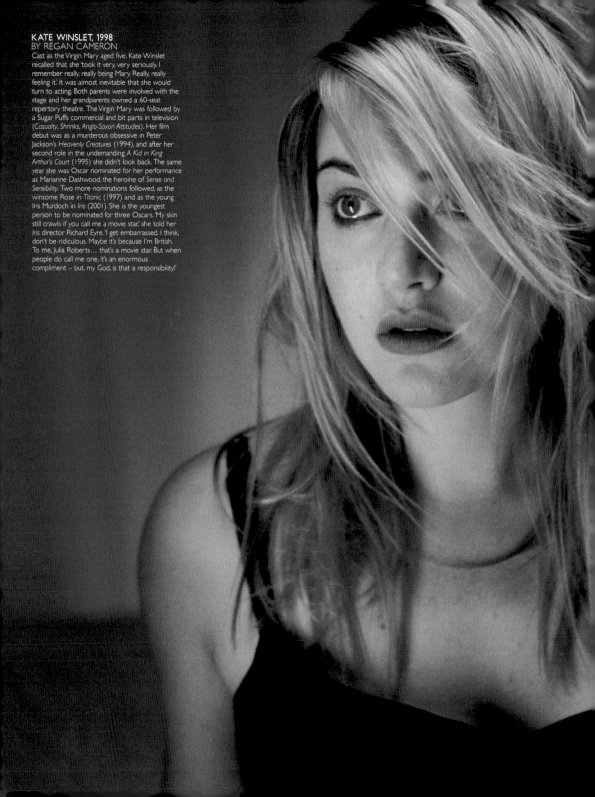

KATE WINSLET, 1998
BY REGAN CAMERON

Cast as the Virgin Mary aged five, Kate Winslet
recalled that she 'took it very, very seriously. I
remember really, really being Mary. Really, really
feeling it.' It was almost inevitable that she would
turn to acting. Both parents were involved with the
stage and her grandparents owned a 60-seat
repertory theatre. The Virgin Mary was followed by
a Sugar Puffs commercial and bit parts in television
(*Casualty, Shrinks, Anglo-Saxon Attitudes*). Her film
debut was as a murderous obsessive in Peter
Jackson's *Heavenly Creatures* (1994), and after her
second role in the undemanding *A Kid in King
Arthur's Court* (1995) she didn't look back. The same
year she was Oscar nominated for her performance
as Marianne Dashwood, the heroine of *Sense and
Sensibility*. Two more nominations followed, as the
winsome Rose in *Titanic* (1997) and as the young
Iris Murdoch in *Iris* (2001). She is the youngest
person to be nominated for three Oscars. 'My skin
still crawls if you call me a movie star,' she told her
Iris director Richard Eyre. 'I get embarrassed. I think,
don't be ridiculous. Maybe it's because I'm British.
To me, Julia Roberts… that's a movie star. But when
people do call me one, it's an enormous
compliment – but, my God, is that a responsibility!'

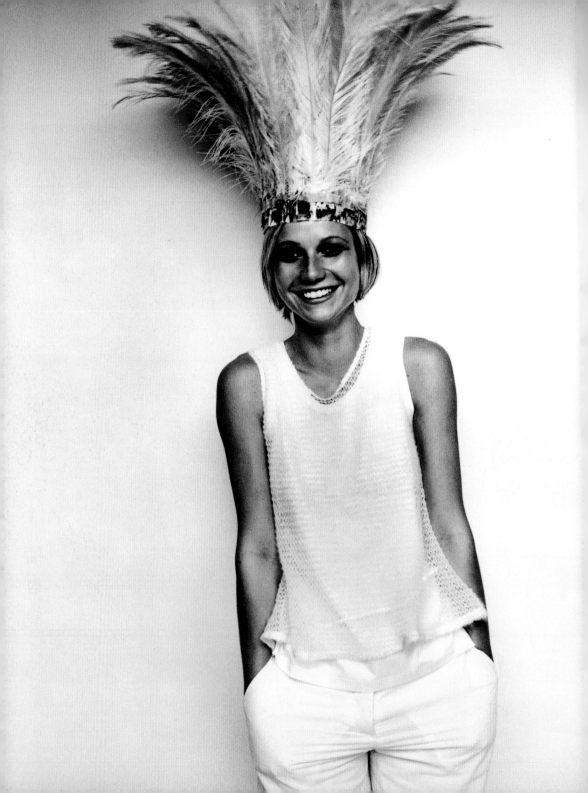

GWYNETH PALTROW, 1998
BY MARIO TESTINO

In the year she won an Oscar, the star of the soon-to-be-released *Sliding Doors* was styled in clothes that *Vogue* considered reflective of the 'new season's mood of modern ease'. Here she wears cotton and crochet vests and hipsters by Helmut Lang and his magnificent feathered headdress. This set of pictures by Mario Testino was said to be her late father Bruce Paltrow's favourite photographs of his daughter. 'She looks quite boyish in that picture,' Testino recalled later during their second session for *Vogue*, 'and I think she likes to look like that… Kate Moss does too. But now I want her to be more womanly, sexier. She has grown up and I think she trusts me enough to try new things.' The debonair *Vogue* photographer had become a firm friend: 'We have laughed and worked in the gardens of Long Island,' she wrote in his book *Alive*, 'cavorted and eaten through the raw and dark streets of Naples, and amused each other there through parties – always joking in Spanish or taking absurd snapshots of each other…' In Testino's National Portrait Gallery retrospective, there was, *Vogue* recorded, an entire room devoted to pictures of her.

PETER MANDELSON, 1998
BY SNOWDON

The Honourable Member for Hartlepool was credited as a true visionary, the chief strategist of the Labour landslide in the previous year's general election. He was also a popular dinner-party draw, 'as happy,' according to *Vogue*, 'at the Ministry of Sound as he is at Sandringham'. For his alleged machinations behind the seat of power, the media cast him as a Richelieu-like *éminence grise* or, more popularly, as an unctuous Prince of Darkness. He appeared indispensable to the Prime Minister for his dazzling skills in crisis management, though less so when the crises were of his own making. He was also, as *Vogue* put it, 'where the buck stops' for the costly (then £758 million and still rising) Millennium Dome. A year before members of the Royal Family endured the dawn of a new millennium there, he coolly maintained, 'It's going to blow your socks off.' Shortly to be appointed secretary of state for the Department of Trade and Industry, he was a roving minister without portfolio in the Cabinet Office when he sat for Snowdon in the drawing room of his house in Bayswater. Renowned for his personal elegance and slightly vulpine demeanour, he appears a little self-conscious perched on an Eames armchair in off-duty denims. The portrait came back to haunt him when it was discovered that some of the purchase price of his new home had been covered by undisclosed funds. He resigned from the Cabinet and this simple domestic cameo became one of *Vogue*'s most widely reproduced photographs. After a short period in the wilderness he was reinstated as secretary of state for Northern Ireland. But it was a short-lived appointment; within a year he had resigned again. He is still MP for Hartlepool, where he spends much time.

JAY JOPLING AND SAM TAYLOR-WOOD, 1998
BY SEAN ELLIS

Vogue caught the British art buzz early on, running in 1995 a portfolio of 29 portraits of the major players, and proved adroit in its selection. Damien Hirst, Rachel Whiteread, Sarah Lucas, Marc Quinn, Douglas Gordon, Mark Wallinger, the Chapman brothers, Jane and Louise Wilson and Gillian Wearing were introduced to *Vogue* readers years before their notoriety and celebrity became a regular feature of magazine and newspaper pages. Also present in the line-up was the young art dealer Jay Jopling, whose White Cube gallery represented many of them. By the next time round, Jay Jopling and Sam Taylor-Wood were the acknowledged President and First Lady of Brit Art. *Vogue* described him as 'the charismatic hypester who marketed Damien Hirst's shark to the world, the astute salesman responsible for the celebrity of the "Freeze" generation, the passionate promoter of all that is cutting edge, conceptual and cool.' Sam Taylor-Wood, *Vogue* noted, 'is a soft-spoken Prada-clad photographer and film maker, the thoughtful creator of work… that is original, witty and a little bit lewd.' 'Certainly the best-dressed Young British Artist', it added admiringly.

EWAN McGREGOR, 1998
BY NEIL KIRK
In 1998, the Scottish actor Ewan McGregor was already famous for being unable to remain clothed for long in his films, and *Velvet Goldmine* proved no exception. Todd Haynes's 'glam rock' extravaganza found McGregor cast as Curt Wild, an Iggy Pop-lookalike to Jonathan Rhys Meyer's androgynous David Bowie figure, the underwhelmingly named Brian Slade. McGregor peeled off his painfully tight gold lamé trousers – he wears them here – while performing a spirited rendition of The Stooges' *TV Eye*. *Vogue*'s Neil Kirk captured him in character as the epicene if raucous rock star in the production wardrobe van. For what he did manage to keep on, and for the exotic marabou-and-glitter confections created for Brian Slade and his wife Mandy (played by Toni Collette), the film's costume designer Sandy Powell received an Oscar nomination.

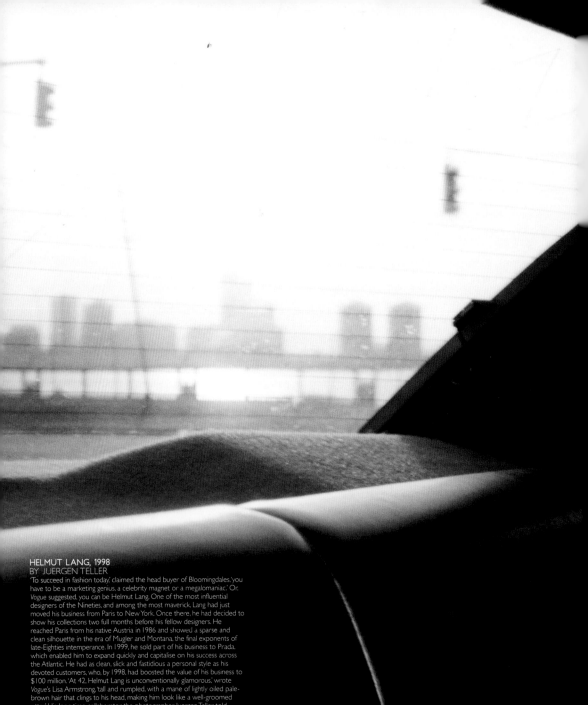

HELMUT LANG, 1998
BY JUERGEN TELLER

'To succeed in fashion today,' claimed the head buyer of Bloomingdales,'you have to be a marketing genius, a celebrity magnet or a megalomaniac.' Or, *Vogue* suggested, you can be Helmut Lang. One of the most influential designers of the Nineties, and among the most maverick, Lang had just moved his business from Paris to New York. Once there, he had decided to show his collections two full months before his fellow designers. He reached Paris from his native Austria in 1986 and showed a sparse and clean silhouette in the era of Mugler and Montana, the final exponents of late-Eighties intemperance. In 1999, he sold part of his business to Prada, which enabled him to expand quickly and capitalise on his success across the Atlantic. He had as clean, slick and fastidious a personal style as his devoted customers, who, by 1998, had boosted the value of his business to $100 million. 'At 42, Helmut Lang is unconventionally glamorous,' wrote *Vogue*'s Lisa Armstrong, 'tall and rumpled, with a mane of lightly oiled pale-brown hair that clings to his head, making him look like a well-groomed otter.' His long-time collaborator the photographer Juergen Teller told *Vogue* he admired Lang's 'exceptional loyalty' and 'the total evolution, conviction, and honesty in the way he designs. From season to season the clothes never jump arbitrarily from one thing to another. You never get the sense with Helmut, the way you do with some other designers, that he feels he has to change for the sake of it.' Unpredictable as always, Lang has now returned to show again in Paris.

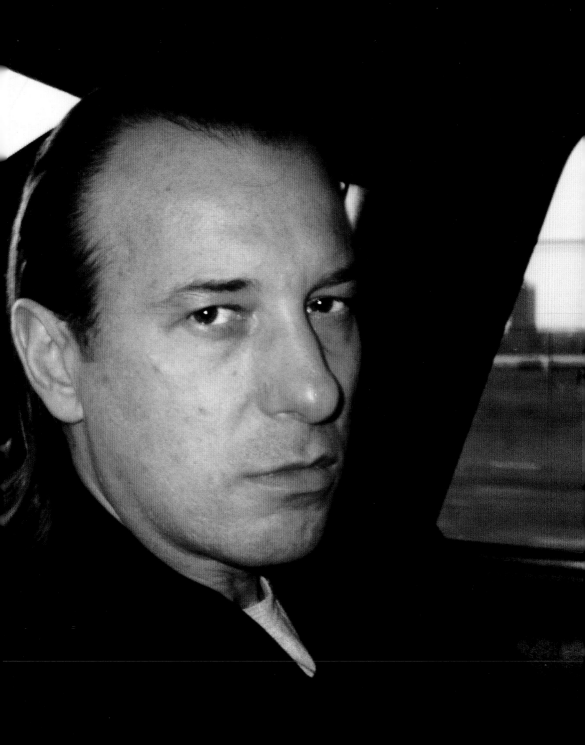

CHLOE SEVIGNY, 1998
BY DAVID BAILEY

The actress Chloe Sevigny first attracted international attention in Larry Clark's controversial film *Kids*, though she had previously been the subject of an adulatory piece by Jay McInerney in *The New Yorker*. She became an early 'It Girl' – one, at least to McInerney, who 'specially influences the times'. For *Vogue* readers she is also well known for her love of thrift-shop chic, and in this context has almost single-handedly been responsible for the replacement of the phrase 'second-hand' with 'vintage'. *Vogue* particularly relished her laugh, noting that it had variously been described as a 'mating sea-lion', 'a mallard surprised in flight' and 'a Hoover imploding'.

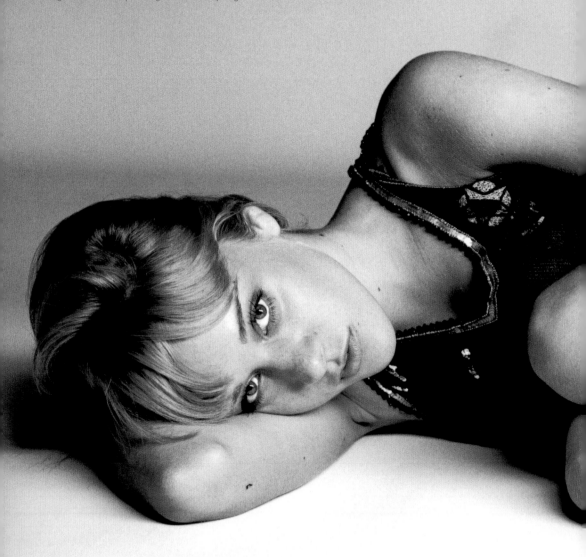

Surely nothing could faze the daughter of giant-lipped Aerosmith wild ma
Steve Tyler and former *Playboy* model and rock chick Bebe Buell. Liv Tyle
had herself been a model since she was 14, a film star at 18, thanks to
mesmeric performance in *Stealing Beauty* (1995), and could count as famil
friends other hard-living rock gods Iggy Pop and Jimmy Page. Nonetheles:
she confessed that a personal invitation by Donatella Versace to th
Versace show was her 'first fashion show thing and it scares me a bit.' Wha
also scared her a bit was being asked to take off her clothes for a scene i
Eugene Onegin. She refused but not without anxiety: 'I felt torn,' she tol
Vogue's Christa D'Souza. 'but I was, like, show my muff? Fuh-get-it!' At
press junket, she froze and not one word came out. 'It was almost like
couldn't breathe. My whole brain started throbbing and I started to get ho
flushes.' She had sheared her famous mane of hair for her role as
Mississippi catfish cleaner in Robert Altman's *Cookie's Fortune* (1999) and
here *Vogue* fashioned it into something of a Louise Brooks bob. She had
two other films coming out after that, *Eugene Onegin* (sans muff) and th
seventeenth-century-highwayman romp *Plunkett and Macleane*. D'Souza
came away from their encounter charmed: 'All I can say is that I left thinking
that she could have been brought up by the Waltons, and wouldn't it be
nice if every film star was this easy to deal with?' Toby Young, who had
interviewed her for *Vogue* two years earlier, found her similarly unspoilt. 'O
all the celebrities I've interviewed,' he wrote, 'she was the first one who's
offered to pick up the check.

above
GERI HALLIWELL, 1999
BY NICK KNIGHT

In the immediate aftermath of the Spice Girls, its most vivid member reverted to her real name Geri Halliwell (almost – she was born Geraldine Estelle Sjovik) and discarded her past. She sold her Spice Girls outfits for charity, became a goodwill ambassador for the UN Population Fund, consorted with Nelson Mandela, and sang 'Happy Birthday' on stage to the heir to the British throne, whose bottom she had previously pinched. Justine Picardie wrote of her visit to *Vogue*'s offices: '"She's so sweet, so *small*," say the fashion editors. "And so much prettier than when she was in the Spice Girls." Geri stands in the *Vogue* fashion room – 5ft 2in, scrubbed face, sensible black poloneck, knee-length black skirt – looking as nervous as the youngest, shortest new girl on her first day at school, tongue-tied and blushing beneath her freckles.' Halliwell's debut solo album, released shortly after her *Vogue* interview, was *Schizophrenic*, which she proclaimed to be a hybrid of the vocal styles of Julie Andrews and Johnny Rotten.

opposite
MR AND MRS DAVID BECKHAM, 1999
BY JUERGEN TELLER

For *Vogue* in 1999 the Beckhams were the most famous couple on the planet. She was still one-fifth of the Spice Girls, the biggest girl band ever; he arguably his country's greatest football player. At the time of this portrait, she was 23, he was 24. She was known as 'Posh'; he, simply as 'Becks'. Together, said *Vogue*, they were 'the two most joyously conspicuous consumers in the Western world.' Looking good has always been a priority: 'Prada, Versace, Gucci…' says David. 'We wear them and there's some nice stuff in their shops. But the thing I don't like is that a lot of people can go into those shops and buy the same thing.' The golden couple were still caught in the celebrity trap – imitated when people wouldn't leave them alone, put out when they did. Complaining that the *Star* had featured them 'for 30 weeks running', Victoria went on to bemoan a horrible evening at a London restaurant, The Ivy, where none of the staff had recognised them until halfway through.

ELIZABETH HURLEY, 1999
BY MARIO TESTINO

Trillions of words, *Vogue* speculated recently, have been devoted to That Dress, a black Versace number, safety-pinned in 24 places and worn in 1994 to the premier of her then boyfriend's film *Four Weddings and a Funeral*. 'The same significance in tabloid folklore,' remarked *Vogue*, 'that the Nativity has to Christians; the moment a star was born.' It helped launch her career and led soon afterwards to her lucrative Estée Lauder contract. Not much shorter in column inches was the space devoted to That Woman, the prostitute Divine Brown, solicited in a moment of madness by the same boyfriend, Hugh Grant, one balmy Los Angeles evening. When Testino took this portrait, Hurley was in the fifth year of the Lauder contract, but still couldn't quite believe her luck: 'It was like someone phoning up and asking whether I wanted to be chairman of a museum or something. Bizarre. I was 28, a rare age to think about going into modelling.' *Vogue* noted that she was now at ease with her role and with Mario Testino. Between shots she bounded towards *Vogue*'s interviewer 'mock-coyly holding a cushion in front of her exposed lower half. "I don't feel as if I can say hello to you in my knickers," she jokes.' Apart from her modelling commitments, she also ran Simian Films, a production company that in 1999 had in the pipeline *Mickey Blue Eyes*, starring Hugh Grant, who was also a partner in the company. But as Grant told *Vogue*, Hurley was firmly in the driving seat. 'Left to my own devices, I have the energy of a whelk.' Despite the balmy Los Angeles evening debacle, Grant and Hurley remained hugely protective of each other. They had met on the set of *Rowing with the Wind* (1987), a Spanish film about Lord Byron and Mary Shelley. 'I met her at the audition,' Grant explained. 'At the time I had an offer to do a serious BBC project. I couldn't decide between that and this absurd career-damaging Spanish thing. Then I saw Elizabeth, and went for the absurd Spanish thing.'

above
CATE BLANCHETT, 1999
BY TIM WALKER

In the year that saw her nominated for an Oscar for the title role in *Elizabeth*, and winning a Golden Globe and a British Academy Award, *Vogue* marvelled at Australia's finest actress's enthusiasm for buying 'light bulbs, matches and things' at a north London Sainsbury's. 'Andrew [her husband] and I were looking at all these cleaning products and we were just hyperventilating.' It also admired her 'blunt Aussie indifference' to fashion. Asked at the Golden Globes who had designed her dress, she was unable to articulate 'Alberta Ferretti'. She was also famous for not suffering fools gladly and for being blunt to the point of monosyllabism. She was particularly steely in the face of 'stupid questions about my hair'. 'I think,' she told *Vogue*, 'they may all be euphemisms for Australian.' She had learnt to be self-sufficient early – her father died when she was 10 – and was unfazed by the speed of her rise to fame, knowing, perhaps, that she could return at any time to where she started, 'a bit part in a boxing movie in Cairo'.

opposite
MARC JACOBS, 1999
BY TERRY RICHARDSON

Vogue found Marc Jacobs at home on the Left Bank, escaping the maelstrom of the run-up to his latest collection for Louis Vuitton. 'It's like Disneyland to me,' he told the magazine. 'I just make it up as I go along.' In only 15 years, Jacobs had progressed from Parson's School of Design, New York, to creative director of the luxury-goods line Louis Vuitton, in Paris. Meanwhile, he won the Perry Ellis Golden Thimble award and took up a post with Perry Ellis in 1984. His designs are very expensive but very covetable. Joan Burstein of Browns told *Vogue*, 'Last year he did cashmere sweaters that looked like Aertex. At £600 each we thought we'd never sell them, but they flew out of the door.' A workaholic, he also likes 'the party atmosphere backstage. It should always be fun,' he told *Vogue*. Beyond his Vuitton duties, he receives wild acclaim for his own line, founded in 1994. It is distinguished from his Vuitton line by being, as collaborator Venetia Scott put it, 'Kicky. That's what Marc always wants his clothes to be. More kicky.'

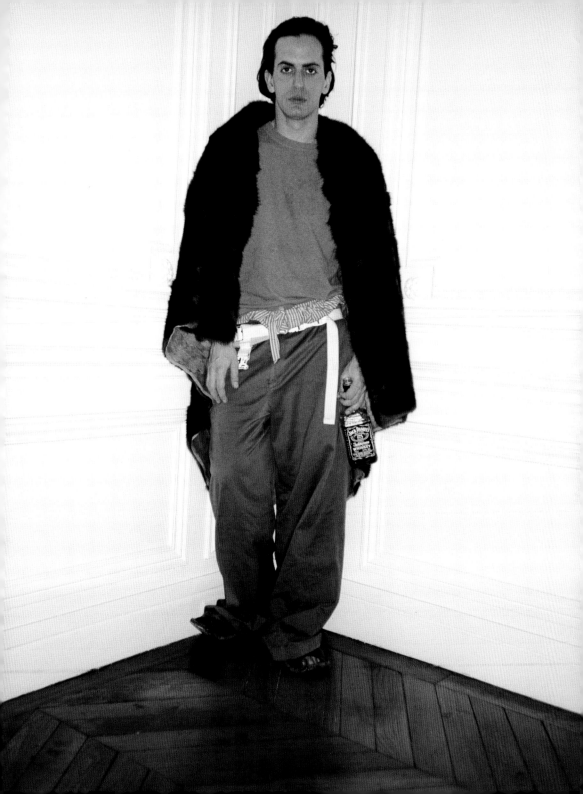

MENA SUVARI, 1999
BY CARTER SMITH

'People feel protective about Mena,' *Vogue* declared; but the 20-year-old
former model for Oscar de la Renta needed little looking after. A rare
creature in Hollywood, she did not have a publicist or a manager. She had
recently parted company with the latter: 'he kept calling every five seconds
to see if I'd brushed my hair.' The year of this slightly 'kooky' portrait also
saw the release of the two films – polar opposites – that sealed her
reputation as a lead actress. First the teen-sex gross-out *American Pie*, then
the hugely acclaimed *American Beauty*. The latter gave the world a much-
parodied image for the *fin de siècle* – the blonde, blue-eyed Lolita-esque
cheerleader stretched out on a bed of roses. The following year, she made
American Virgin (2000), which led to *Entertainment Weekly*'s declaring her
'the Most Patriotic Star' of 2000, alluding to her making three consecutive
films with 'American' in the title. If she hadn't bothered with the
underwhelming *Loser*, and had gone straight on to *American Pie 2* (2001),
it would have been four in a row.

'THE MILLENNIUM PARTY', 1999
BY MARIO TESTINO

'A party,' considered *Vogue*, 'especially a millennium party, is only as good as
its guest list.' On a rainy Tuesday morning, in an empty West End nightclub,
it gathered together pop stars, painters, supermodels, dancers, designers
and other assorted celebrities and watched the fun unfurl. The partygoers
in this tableau are, from left: Tracey Emin, Paul Smith, Alex James, Zoe
Bedeaux, Stephen Jones, Norman Cook, Vivienne Westwood, Nick Moran,
Patrick Cox, Norman Reedus and Helena Christensen. 'This is so cool! I

MILLA JOVOVICH, 200█
BY TOM MUNR█

A former child model (she had been cover girl of *Lei* and *Mademoiselle* █
11), Jovovich started her film career with *Kuffs* (1990) – a Christian Slat█
vehicle – and *Return to the Blue Lagoon* (1991). By 19, she had made h█
debut album *The Divine Comedy* which sold around 200,000 copies. Sh█
had a parallel career as a model, most notably for L'Oréal, Versace, Calv█
Klein and Prada. 'Modelling pays for my life,' she explained to *Vogue*'s Fior█
Golfar. 'It gives me such an amazing opportunity to make the movies tha█
want and to wait for the good directors.' She had just made *Joan of Arc* wi█
her newly ex-husband Luc Besson. They had collaborated a few yea█
previously on *The Fifth Element*, in which she played Leeloo, a 'cyberbabe'.
In *Joan of Arc* she wasn't at her most convincing but she was a strikir█
presence: 'As she waves her sword in a field of bloodshed, sporting █
blackened face and perfect white teeth, one almost expects fashio█
photographer Peter Lindbergh to pop up from behind a tree with h█
camera,' commented Golfa█

opposite

HILARY SWANK, 2000
BY NATHANIEL GOLDBERG

The brutal story of Teena Brandon, who, having suffered a crisis of sexual identity, lived a part of her short life as Brandon Teena, a charismatic teenage boy, before her murder in 1993, was filmed as *Boys Don't Cry*. Its star Hilary Swank, who bandaged her breasts, stuffed a sock down her pants, worked out furiously and lived as a man in the four weeks before shooting, won an Oscar for the role. It was a departure for the previously long-haired, blonde actress, whose CV included *Beverly Hills 90210*, *Buffy the Vampire Slayer* (1992) and *The Next Karate Kid* (1994). Over lunch with *Vogue*'s Christa D'Souza, she morphed effortlessly into character: 'It's something about the way she runs her tongue over her upper lip, the manner in which she narrows her eyes and gently touches her fingertips to her temples; perhaps it's the way she minutely rearranges her shoulders.' 'Whatever it is,' D'Souza continued, 'the model of Californian femininity… has suddenly transformed into someone who could quite easily give Matt Damon or Leonardo DiCaprio a run for their money.' Swank revealed that it was not her first trans-gender part. She had appeared in her school play as Mowgli, the *Jungle Book*'s man-cub.

overleaf

ROBBIE WILLIAMS, 2000
BY MARIO TESTINO

Despite the battery of press assistants, photographer's assistants, hairstylists, make-up artists and the entourage that surrounds the modern pop star, *Vogue* noted that Robbie Williams needed nothing to coax him out of his clothes. That's because 'Robbie is a boy who knows how to keep an audience happy.' He also knows how to keep a record company happy and it him. In 2002 he signed a six-album deal with EMI worth around £80 million. But his *Vogue* cover-star companion, Gisele Bündchen, was less impressed. She admitted later that she had no idea he was naked and, to his chagrin, she showed no particular interest in the 'most lusted-after boy in Britain'. *Vogue*'s Justine Picardie was also present for the unveiling 'He is so very exposed in the bright light of both the sunshine and the camera flash that you can see everything; the red spot on his pale bottom, his now-public private parts, assorted bits of soft white flesh – all of which make him look vulnerable, sexless, somehow…' She also noted that after a decade in the spotlight, more than his entire adulthood, Williams had no idea how to take care of himself – he has never kept his battles with drink and drugs a secret. 'I'm so far removed from what you do in life,' he told *Vogue*, 'getting up in the morning, opening bills, paying bills, knowing what to do when the phone goes down, knowing what your PIN number is, that right now, it's sad to say, my worst fear is that I'd have to start figuring things out for myself, if I don't carry on having hits'.

TOM FORD, 2001
BY SNOWDON

With the house of Yves Saint Laurent newly under his belt, Tom Ford was one of the world's most powerful fashion leaders with an empire valued, *Vogue* wrote, at around $8.7 billion. Apart from the YSL brand, the stable these days includes Balenciaga, Bottega Veneta, Boucheron, Stella McCartney, Alexander McQueen, Sergio Rossi and Sanofi. American *Vogue* estimated that in 2004 Ford's Gucci Group stock options would be worth $162.4 million. In eight years Ford has earned a fortune, and for over 10 has had, as *Vogue* put it, 'an uncanny knack of creating, season after season, The Shoe or The Bag that millions of women want'. He has a flair for marketing, too. His advertising campaigns, photographed by Mario Testino and van Lamsweerde and Matadin, have become increasingly audacious – a recent ad featured a model with the Gucci 'G' clipped into her pubic hair. Ford's was not an overnight success story, however. The early years as head designer at Gucci, where he moved after a spell at Perry Ellis, were enlivened by the mass-marketing strategies of the last surviving family member, Maurizio Gucci. Gucci's selling products for less than it cost to make them brought the company close to bankruptcy: 'we didn't have a photocopier at one stage,' Ford told *Vogue*. 'We didn't have any paper.' Maurizio Gucci was murdered in 1995. Eight years later, Ford explains his success: 'I'm lucky. I have mass-market taste. When I say I like a shoe, generally thousands of people will like it, too.'

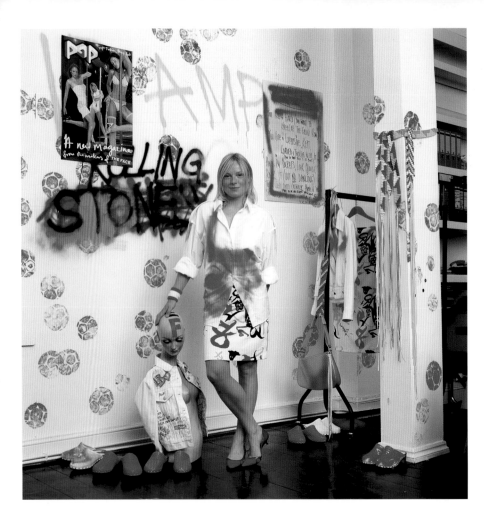

above
LUELLA BARTLEY, 2001
BY SNOWDON

For 'Home Produce', Snowdon photographed the roll call of young designers 'breathing new life into British fashion with a combination of creativity and tenacity'. One of them was former *Vogue* fashion writer Luella Bartley, who fled the magazine to become one of the most talented and inventive of British fashion designers. Buyers from American department stores stopped short of little for the first glimpse of her idiosyncratic designs. Snowdon photographed in her west London studio, against a wall decorated with the imprints of footballs dipped in paint – a recurring motif in the conceptual artwork of her friend James Moores. *Vogue* described her as a 'local heroine putting the rock back into style. Dial F for Fluoro, Luella's spring/summer collection – her fourth – is inspired by the Eighties New York post-punk scene, and delivers sassy, saucy clothes, such as her graffiti-splashed designs… just made to have fun in.'

opposite
TRACEY EMIN, 2000
BY JULIAN BROAD

Her installation *Everyone I Have Ever Slept With 1963–95* was a tent, of which the interior was embroidered with the names of everyone she had ever slept with. *My Bed 1999*, another installation, consisted of a bed, dirty sheets, condoms and the artist's knickers. Both have become icons of contemporary British art. Opinionated and irrepressible, Tracey Emin is admired for the confessional and confrontational aspect of her art, and vilified for its perceived shallowness and her own self-obsession. But she is unsparing in her self-analysis. 'I'm fucked up,' she announces in one video piece. 'I'm childless. I'm alcoholic. I'm anorexic. I'm psychotic, highly strung, highly emotional, over dramatic, whingeing, moaning…' Apart from video and other installations, Emin's work has also included neon sculpture, live performance, poetry, embroidery, painting and stark linear drawings. In a tableau devised with the photographer Julian Broad at her home in Hoxton, Emin, clutching a camera's cable-release control, poses as, perhaps, she wishes *Vogue* readers to regard her. She wears a silk dress and shoes by Vivienne Westwood, for whom she has occasionally modelled. 'Tracey,' her art dealer Jay Jopling told *Vogue*, 'has become an Everywoman by baring her soul and allowing the public to feed off it. An artist's identity has never been as open as Tracey's.'

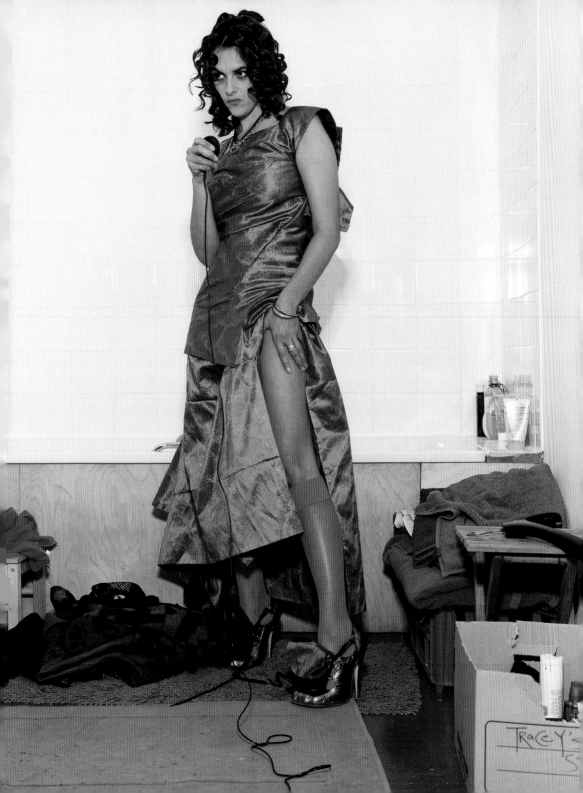

from Waenfawr in Caernarfonshire, in 1792, to prove that an isolated tribe of Welsh-speaking natives lived beyond the Missouri river. (They didn't.) Zeta-Jones from Swansea made her mark in slightly less intrepid style, simply by possessing acting talent in abundance and an old-fashioned 'star quality', encompassing charm and generosity. She also married a high-powered Hollywood player, actor and producer and UN ambassador – Michael Douglas. *Vogue* was entranced: '[she] really is an extraordinarily pleasing human being to look at, with those slanting, fastidiously kohl-ed eyes… that almost Latin colouring and that spookily perfect, cupid's-bow mouth.' A trouper since she was 16, when she hoofed her way to stardom in *42nd Street* on the London stage, she was a huge television star in Britain following her voluptuous appearance in *The Darling Buds of May*. Flicking through the TV channels, Steven Spielberg discovered her in a made-for-TV version of the *Titanic* saga. Cast in his production of the *Mask of Zorro* (1998), Zeta-Jones confirmed her place in celluloid history. Since then, she hasn't put a foot wrong. Acclaim followed Steven Soderbergh's *Traffic* (2000), and she won Golden Globe and British Academy nominations and an Oscar for her role in *Chicago* (2002). And 'nobody,' concluded *Vogue*, 'could dispute that Michael is a very lucky man.'

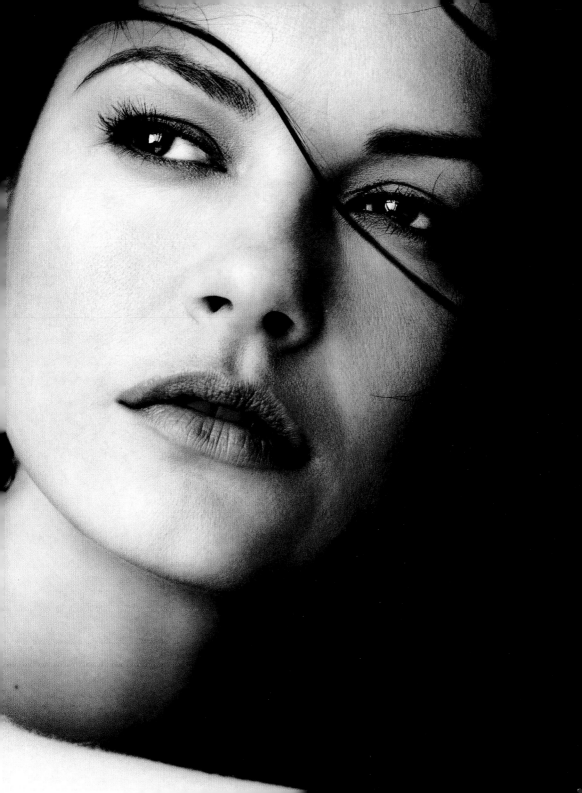

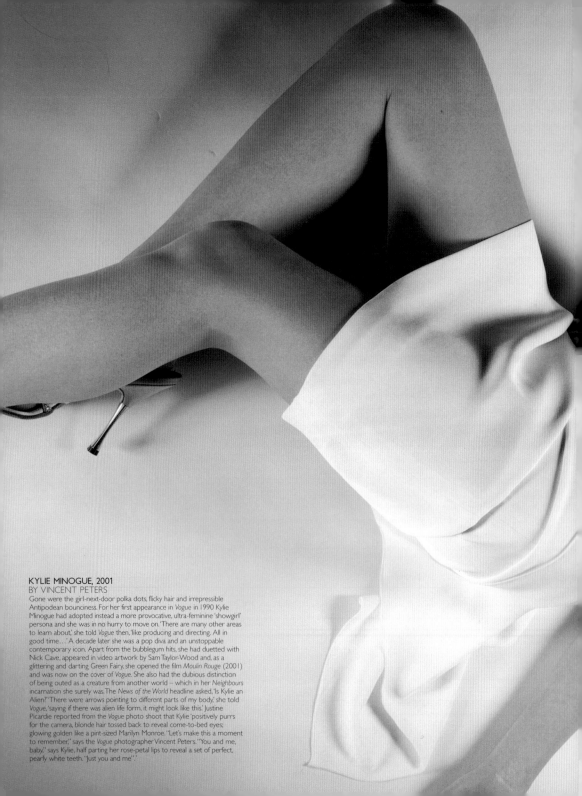

KYLIE MINOGUE, 2001
BY VINCENT PETERS

Gone were the girl-next-door polka dots, flicky hair and irrepressible Antipodean bounciness. For her first appearance in *Vogue* in 1990 Kylie Minogue had adopted instead a more provocative, ultra-feminine 'showgirl' persona and she was in no hurry to move on. 'There are many other areas to learn about,' she told *Vogue* then, 'like producing and directing. All in good time…' A decade later she was a pop diva and an unstoppable contemporary icon. Apart from the bubblegum hits, she had duetted with Nick Cave, appeared in video artwork by Sam Taylor-Wood and, as a glittering and darting Green Fairy, she opened the film *Moulin Rouge* (2001) and was now on the cover of *Vogue*. She also had the dubious distinction of being outed as a creature from another world – which in her *Neighbours* incarnation she surely was. The *News of the World* headline asked, 'Is Kylie an Alien?' 'There were arrows pointing to different parts of my body,' she told *Vogue*, 'saying if there was alien life form, it might look like this.' Justine Picardie reported from the *Vogue* photo shoot that Kylie 'positively purrs for the camera, blonde hair tossed back to reveal come-to-bed eyes; glowing golden like a pint-sized Marilyn Monroe. 'Let's make this a moment to remember,' says the *Vogue* photographer Vincent Peters. "You and me, baby," says Kylie, half parting her rose-petal lips to reveal a set of perfect, pearly white teeth. "Just you and me".'

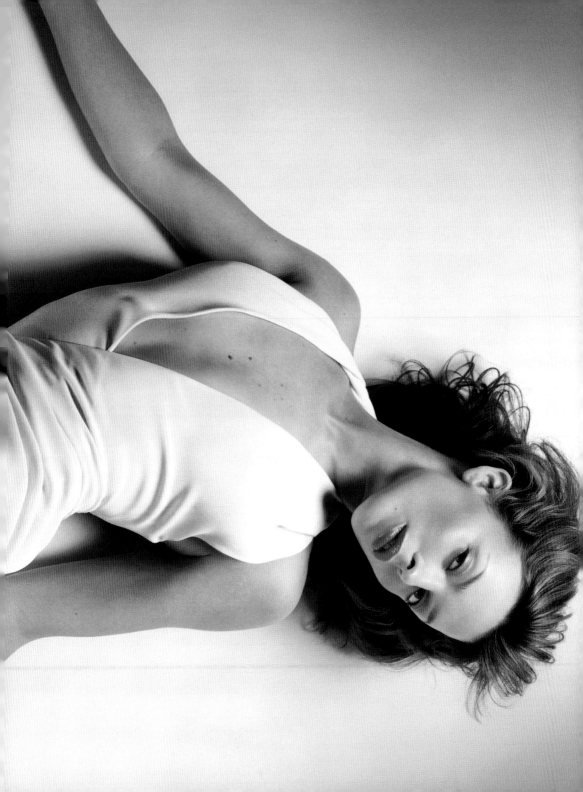

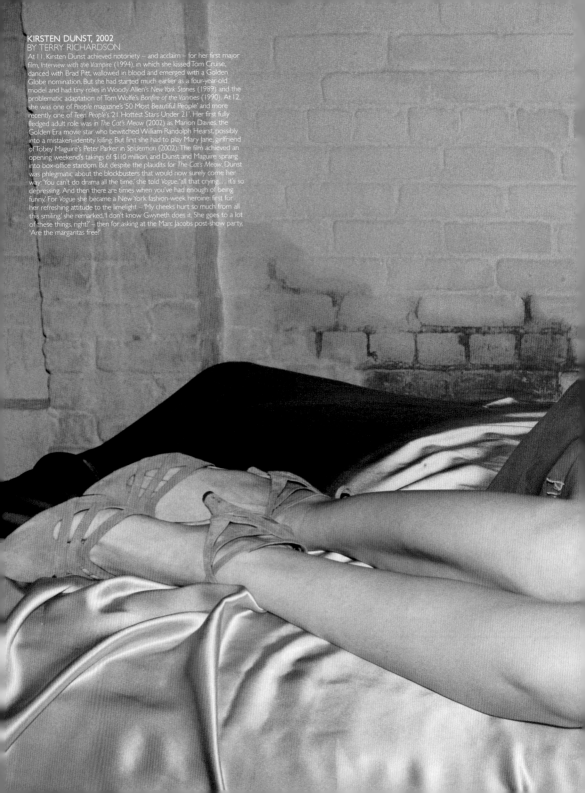

KIRSTEN DUNST, 2002
BY TERRY RICHARDSON

At 11, Kirsten Dunst achieved notoriety – and acclaim – for her first major film, *Interview with the Vampire* (1994), in which she kissed Tom Cruise, danced with Brad Pitt, wallowed in blood and emerged with a Golden Globe nomination. But she had started much earlier as a four-year-old model and had tiny roles in Woody Allen's *New York Stories* (1989) and the problematic adaptation of Tom Wolfe's *Bonfire of the Vanities* (1990). At 12, she was one of *People* magazine's '50 Most Beautiful People' and more recently one of *Teen People's* '21 Hottest Stars Under 21'. Her first fully fledged adult role was in *The Cat's Meow* (2002) as Marion Davies, the Golden Era movie star who bewitched William Randolph Hearst, possibly into a mistaken-identity killing. But first she had to play Mary Jane, girlfriend of Tobey Maguire's Peter Parker in *Spiderman* (2002). The film achieved an opening weekend's takings of $110 million, and Dunst and Maguire sprang into box-office stardom. But despite the plaudits for *The Cat's Meow*, Dunst was phlegmatic about the blockbusters that would now surely come her way: 'You can't do drama all the time,' she told *Vogue*, 'all that crying . . . it's so depressing. And then there are times when you've had enough of being funny.' For *Vogue* she became a New York fashion-week heroine: first for her refreshing attitude to the limelight – 'My cheeks hurt so much from all this smiling,' she remarked, 'I don't know Gwyneth does it. She goes to a lot of these things, right?' – then for asking at the Marc Jacobs post-show party, 'Are the margaritas free?'

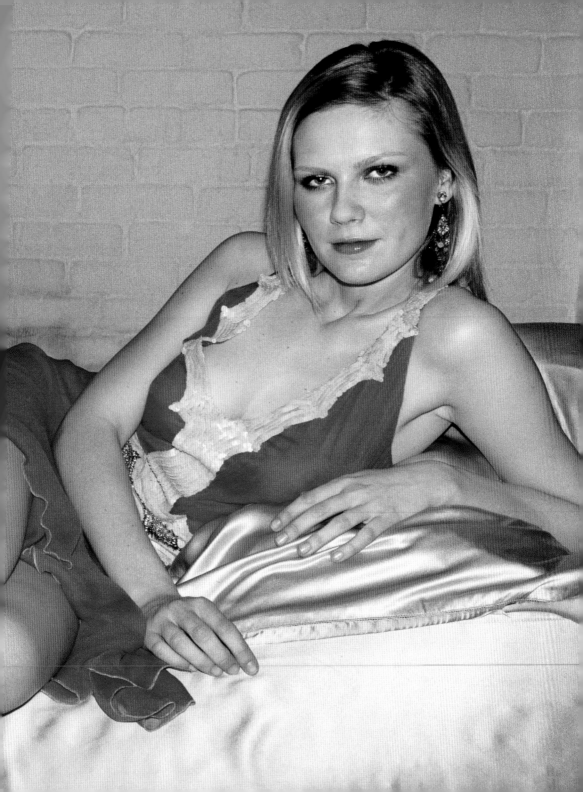

ALEXANDER McQUEEN, 2002
BY DAVID BAILEY

'My collections,' Alexander McQueen told *Vogue*, 'have always been autobiographical, a lot to do with my own sexuality and coming to terms with the person I am – it was like exorcising my ghosts. They were to do with my childhood, the way I think about life and the way I was brought to think about life. It has got a lot more commercial – and commercial's a good word – but there's still that undercurrent from before.' Starting his career as a tailoring apprentice in Savile Row, where he is reputed to have sewn profanities into the lining of the Prince of Wales's suits, by 2002 McQueen had come far. The days of inflammatory collections, such as Highland Rape in 1995 had gone, but still present in his acclaimed collections were flashes of provocative brilliance. *Vogue* commented that 'metaphorically he has visited both heaven and hell through his collections'. One for 2001 was presented behind a two-way mirror and a massive glass box, which splintered to reveal a model caught among thousands of live moths. He had been head designer at the house of Givenchy, a period of frantic hard work – around a dozen collections a year – nervous exhaustion and much unhappiness. McQueen was now poised to be the only British designer who had the potential to build himself a global fashion empire. He had sold the controlling interest in his company to the Gucci Group and in the pipeline were accessories, scent and beauty lines. Under the aegis of Gucci, sales from his first collection quadrupled. He now had slimmed-down physique and new teeth, too – a figure much changed from the man who would visit *Vogue* in his early days, chaperoned by Isabella Blow. But, as *Vogue*'s Harriet Quick remarked, it was 'bizarre to hear McQueen talk swing tags – this is a designer who plumbed the depths of generation's anxieties and expressed them in visions of fear and angst, bumster trousers and brutally sharp tailoring.'

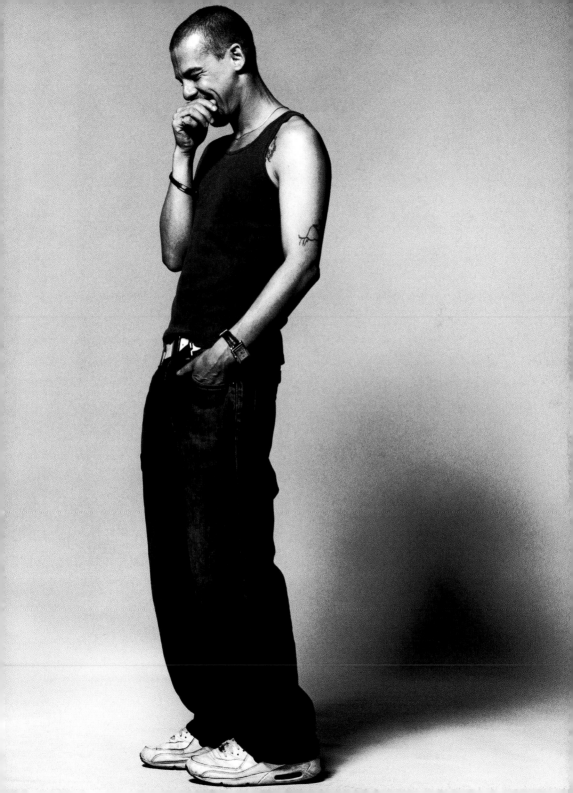

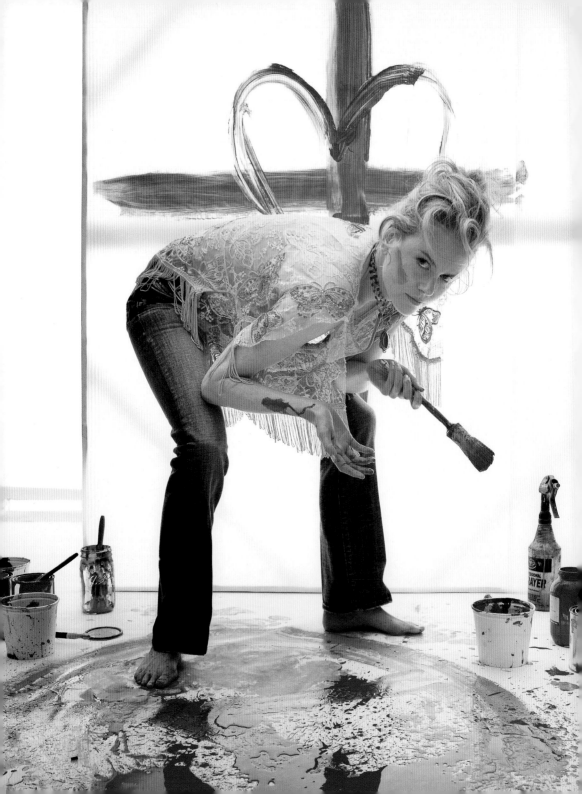

opposite

NICOLE KIDMAN, 2002
BY REGAN CAMERON

Vogue found Nicole Kidman in Sweden preparing for the film *Dogville*, to be directed by Lars von Trier, a maverick Danish auteur with a fearsome reputation. When he directed Björk in *Dancer in the Dark* (2000), rumour had it that the frustrated Icelandic chanteuse attempted to eat her own costume. *Vogue*'s correspondent reported that, so far, Kidman's Prada jacket and shoes were intact. She would have been excused idiosyncrasies of any kind after the triumphs and vicissitudes of the previous year: her high-profile divorce from Tom Cruise, her husband of 10 years, her garnering of Oscar, BAFTA and Golden Globe nominations for *The Others* and *Moulin Rouge* (both 2001) and, in a duet with Robbie Williams, a number-one hit. She had also completed her portrayal of Virginia Woolf for Stephen Daldry's *The Hours*, in which, almost unrecognisable under a prosthetic nose, she turned in a staggering performance, which earned her another Oscar. 'She is shrewd about people,' says Daldry. 'You don't have to find a language with her just because she is a star. She likes to have fun – she took me dancing at Attica and gambling at Aspinalls. She knows how to enjoy herself.' ...as she appears to be here, making an abstract artwork of the studio floor in a butterfly top by Matthew Williamson.

overleaf

'THE BRIT PACK', 2002
BY MARIO TESTINO

Vogue corralled 18 of the most recognisable British models, dressed them in Union Jacks customised by leading British designers, and asked Mario Testino (an honorary Brit) to photograph them. 'What better way,' concluded *Vogue*, 'for patriotism to run wild?' They are, from left: Stella Tennant in Stella McCartney; Cecilia Chancellor in Luella; Erin O'Connor in John Galliano; Jacquetta Wheeler in Nicole Farhi; Naomi Campbell in Julien Macdonald; Liberty Ross in Clements Ribeiro; Kate Moss in Hussein Chalayan; Elizabeth Jagger in Russell Sage and Philip Treacy; Jade Parfitt in Paul Smith; Rosemary Ferguson in Markus Lupfer; Jasmine Guinness in Boyd; Lisa Ratliffe in Sophia Kokosalaki; Karen Elson in Betty Jackson; Georgina Cooper in Antonio Berardi; Alek Wek in Belville Sassoon Lorcan Mullany; Sophie Dahl in Matthew Williamson; Vivien Solari in Robert Cary-Williams; and, finally, Jodie Kidd in Vivienne Westwood.

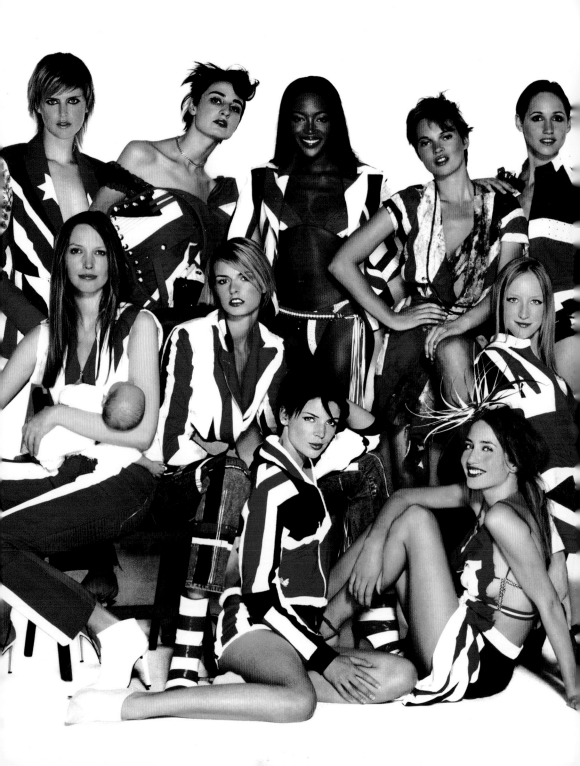

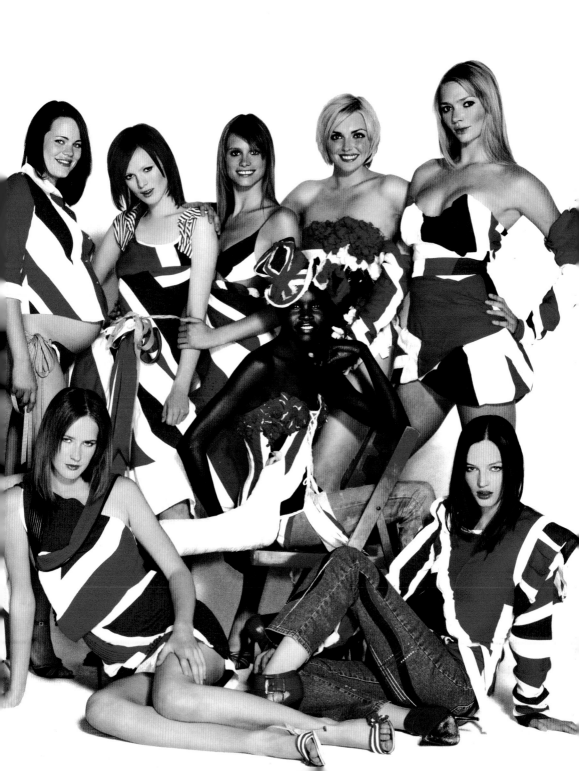

ACKNOWLEDGEMENTS

Robin Muir conceived this book in 1991, when *Vogue* celebrated its seventy-fifth anniversary, and has researched it intermittently since. It is intended as a companion to *Unseen Vogue: The Secret History of Fashion Photography*, published in 2002 by Little, Brown, and co-edited by Robin Muir and Robin Derrick.

They wish to extend their grateful thanks again to the staff of the Condé Nast Library, London (Janine Button, Simone Burnett, Brett Croft and Jooney Woodward). They would also like to thank Alexandra Shulman, editor of *Vogue*, for her encouragement and for writing the foreword to this book, and also Nicholas Coleridge and Stephen Quinn (The Condé Nast Publications Ltd) for their support. This book would not have reached publication without the unstinting help of Stephen Jenkins, who worked on the project with unfailing good humour. Nor could it have been completed without the organisational skills of Harriet Wilson and Emma Mancroft, who again played crucial roles at every stage of the book's development, for which the authors are deeply grateful. They would also like to thank Julian Alexander of Lucas Alexander Whitley.

A special debt of gratitude is owed to Teresa Marlow, managing editor of *House & Garden*, for editing the text, and for her pertinent amendments and suggestions.

Once again, in the preparation of this second book, the authors have been greatly assisted by many people within the Condé Nast Publications on both sides of the Atlantic: Leigh Monteville, Anthony Petrillose and Michael Stier (The Condé Nast Publications Inc); Jessica Firmin and Nicky Budden (The Condé Nast Publications Ltd); Anna Cryer, Francesca Martin and Liz Reid (British *Vogue*). Special thanks are due to Robin Derrick's colleagues in the art department of British *Vogue*: Aimée Farrell, Marissa Bourke, Rebecca Smith and Jo Baldwin.

They are also grateful to the following: Flora Biddle Miller; Simon Costin; David Macmillan; Filippo Tattoni-Marcozzi (Hamiltons Gallery, London); Carole Callow, Arabella Hayes and Tony Penrose (the Lee Miller Archive); Terence Pepper and James Kilvington (the National Portrait Gallery); Fiona Cowan and Leigh Yule (the Norman Parkinson Archive); Lydia Cresswell-Jones, Dr Juliet Hacking (Sotheby's London); Ian Mills (David Bailey/Camera Eye); Mario Testino, Giovanni Testino and Candice Marks (Mario Testino studio); Juergen Teller and Katy Baggott; Anne Kennedy (Art + Commerce); Leslie Lambert (Little Bear Inc); Nick and Charlotte Knight (Nick Knight Studio); Craig McDean; Terry Davis and Bob Wiskin (Grade One Photographic); Ursula Mackenzie, Vivien Redman, Marie Hrynczak and Nick Ross (Time Warner).

Robin Muir would particularly like to acknowledge his debt to Josephine Ross, whose books, *Royalty in Vogue* (1989) and *Society in Vogue* (1992), proved invaluable to the late Lesley Cunliffe, who thought that a book of *Vogue* portraits would be a good idea, and to Paul Lyon-Maris.

Finally, both authors would like to record their gratitude to all the photographers whose work is included in this book and the editors and the art directors who commissioned it. All of them have ensured that since 1916 the features pages of *Vogue* have remained as lively as its fashion pages, and many continue to do so.

INDEX